THE
ORPHEUS
CLOCK

THE SEARCH FOR MY FAMILY'S ART
TREASURES STOLEN BY THE NAZIS

SIMON GOODMAN

SCRIBNER

New York London Toronto Sydney New Delhi

Scribner
An Imprint of Simon & Schuster, Inc.
1230 Avenue of the Americas
New York, NY 10020

First Scribner hardcover edition August 2015

SCRIBNER and design are registered trademarks of The Gale Group, Inc.,
used under license by Simon & Schuster, Inc., the publisher of this work.

For information about special discounts for bulk purchases, please contact Simon &
Schuster Special Sales at 1-866-506-1949 or business@simonandschuster.com.

The Simon & Schuster Speakers Bureau can bring authors to your live event.
For more information or to book an event, contact the Simon & Schuster Speakers
Bureau at 1-866-248-3049 or visit our website at www.simonspeakers.com.

Manufactured in the United States of America

10 9 8 7 6 5 4 3 2 1

Library of Congress Cataloging-in-Publication Data

Goodman, Simon.
The Orpheus Clock : the search for my family's art treasures stolen by the Nazis /
Simon Goodman.
 pages cm
 1. Gutmann family. 2. Jewish bankers—Germany—Biography. 3. Holocaust, Jewish
(1939-1945)—Germany. 4. Gutmann family—Art collections. 5. Goodman family—
Art collections. 6. Art thefts—Germany—History—20th century. 7. Art thefts—
Investigation. 8. World War, 1939–1945—Reparations. I. Title.
 HG1552.G87G66 2015
 940.53'18144—dc23 2015017171

ISBN 978-1-4516-9763-6
ISBN 978-1-4516-9765-0 (ebook)

To my darling May, who stood by me every step of the way

In loving memory of Fritz, Louise, and Bernard

Life is infinitely stranger than anything which the mind of man could invent. We would not dare to conceive the things which are really mere commonplaces of existence. If we could fly out of that window hand in hand, hover over this great city, gently remove the roofs, and peep in at the queer things which are going on, the strange coincidences, the plannings, the cross-purposes, the wonderful chains of events, working through generations, and leading to the most outré results, it would make all fiction with its conventionalities and foreseen conclusions most stale and unprofitable.

—Sir Arthur Conan Doyle

CONTENTS

THE
ORPHEUS
CLOCK

PART I

FOUNDATION

MY FATHER'S OLD BOXES

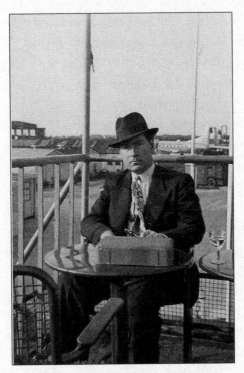

Bernard with his typewriter in
between flights, 1948.

The boxes were rather ordinary, the sort of musty, collapsing-in-on-themselves corrugated containers that one might find gathering dust in millions of attics and basements. They had arrived from Germany, of all places, at my brother's sunny hillside home in Los Angeles in the fall of 1994—the last tired remnants of our late father's estate.

Our father, Bernard Goodman, had died in Venice a few months before, on the day after his eightieth birthday, while swimming in the Adriatic Sea. The night before he had enjoyed a slap-up dinner at Harry's Bar. Cipriani, the owner, had given Pa a bottle of grappa on the house. A noted athlete in his university days at Cambridge, my father had remained physically active all his years—it was not his body that life had broken—and despite his age, he was a keen swimmer. According to the authorities, he had apparently suffered either a stroke or a heart attack and had lost consciousness in the water. As Eva, his long-time companion, had screamed and waved her arms from the shore, the lifeguards had plunged in and dragged him out, but it was too late. The official ruling was death by drowning.

His death was unexpected and somewhat unusual; eighty-year-old men do not often die while swimming in the sea. But perhaps that was only fitting. Our father had lived an unusual and unexpected life.

We arranged for his burial in a small wood outside Tübingen in Germany—and through various courts and solicitors I cleared up his financial affairs, which, sadly, were rather meager. By the time of his death he was living in what might be called genteel poverty—comfortable enough, but far removed from the circumstances into which we vaguely understood he had been born.

Then came the boxes, packed with papers and documents our father had painstakingly saved over half a century. Curious, not at all certain what we might find, my brother, Nick, and I started to go through them, ripping through the shipping labels printed in German—the language our father had once vowed never to speak again—and laying out the brittle contents in fragile piles on Nick's dining-room table.

There were sheaves of yellowing notes written in our father's own hand and blurry carbons of letters that he had pounded out on an ancient typewriter. There were stacks of government documents in English, Dutch, French, German, Italian, and Czech—except for the Czech, my father could read and speak all of them—their pages festooned with coat-of-arms letterheads and official stamps and seals. There were long-forgotten receipts and bills of sale, and black-and-

gold, expired British passports with visa pages covered top to bottom with entry and exit stamps. Shockingly to modern eyes, the prewar visa stamps from Germany featured the Nazi eagle clutching a swastika. There were some dog-eared, old art catalogs, some faded museum brochures, and in a single, unlabeled envelope three black-and-white photographic negatives—the old kind, each some three by five inches—of paintings that I didn't specifically recognize but which appeared to be French Impressionist paintings. The stacks grew higher, and then higher still.

The appearance of my father's papers gave no outward indication of secrets long concealed, no promise of dramatic revelations—certainly not life-changing ones. Yet, as we began to look more closely at them, to examine the details, certain things stood out.

The art collection that we understood had once been owned by our father's parents, the grandparents we had never known, consisted of works by some of the greatest masters, old and new—Degas, Renoir, Botticelli, Memling, Cranach, Guardi. There were also inventories of priceless Renaissance sculptures in gold and silver, of valuable tapestries and Louis XV furniture, and then a photostat of an aged, wrinkled handwritten note from my grandfather, describing the location of certain artworks and signed P. for "Papi."

Curiously, and in retrospect ominously, amid those same documents, often on the same pages, were references to some of history's most infamous figures—Adolf Hitler, Reichsmarschall Hermann Göring, Heinrich Himmler, Martin Bormann, Nazi "philosopher" Alfred Rosenberg—and to the monuments dedicated to themselves: the planned Führermuseum in the Austrian city of Linz and the Reichsmarschall's estate at Carinhall. Coupled with them were the names of men I did not then recognize, but who nonetheless somehow sounded sinister—Haberstock and Hofer, Böhler and Plietzsch and Miedl.

Within those stacks of my father's papers—stacks already tipping over and starting to spread, glacierlike, across my brother's table—were references to Theresienstadt, the Nazis' "model" concentration camp,

and to the death chambers of Auschwitz. There were allusions to the Nazi occupation of Holland, to the SS and the Gestapo, to the French Resistance and the American World War II spy service, the OSS, to Scotland Yard and the international police agency Interpol. Then came memorandums from various postwar "restitution" bureaus in West Germany, France, and Holland, followed by notations concerning corrupt Swiss art dealers, spies and collaborators, hoards of priceless art packed into Parisian warehouses and Austrian salt mines—and much more.

The papers were confusing, mysterious, enigmatic. They were, I realized, very much like the man who had assembled them.

He had not always been so. As a young boy growing up in postwar London, I remember my father as an open, loving man, perhaps a bit reserved in the British style, but not above expressions of affection. One of my earliest memories is of my father hoisting me up on his shoulders—probably painfully, I now realize, because of his war wounds—so that I could watch the funeral procession for King George VI, who had died a few days earlier on my fourth birthday. From that lofty perspective, it seemed to me that my father was enormously tall—which actually he was not—and terribly strong, which he was.

I remember also that despite the solemnity of the occasion, played out under inevitably gray London skies, to me it had a magical quality—the plumed helmets of the Life Guards, the King's coffin draped in the royal standard, adorned with the Crown Jewels, and mounted on a gun carriage pulled by a clip-clopping team of Windsor Greys. The rank upon rigid rank of marching soldiers and funereally paced cavalry came from every far-flung country of what had once been the British Empire. For a small boy, seeing the coffin of the wartime King, the last Emperor of India, there was no sense of the war's tragedy, no feeling of loss—loss of lives, of treasure, of innocence. It was all simply glorious.

The war was never far away in the physical sense. Against our parents' stern admonitions, Nick and I could not resist exploring the countless bomb sites that still scarred London even a decade after the

peace, dressing up in too-large war-surplus uniforms and balancing wobbly Tommy helmets on our too-small heads. Every Thursday I would race to the newsagent stand in the South Kensington tube station to buy the latest installment of the *War Picture Library*, a comic book series featuring the gallant exploits of World War II British commandos and fighter pilots.

Other families still talked about the war constantly, yet it seemed strangely off-limits, almost taboo, in my family. My mother seldom spoke of it, except in the most general terms. Most disappointingly for a young boy with martial fantasies, despite my father's service in the British army, in the distinguished Gloucestershire Regiment, and his having been wounded by a German bomb in the Blitz, he refused to speak even a single word about his participation in the war. His silence on the subject was unwavering and an utter frustration to Nick and me. He might occasionally, in passing, refer to some historical person or event—Field Marshal Montgomery, perhaps, or some great British victory such as the Battle of Britain—but on a personal level he seemed not to have found the war glorious at all.

I was perhaps ten or eleven before I finally pieced together, from the whispered and coded adult conversations that children instinctively pick up on, that my father's parents had somehow "died in the war." Only later did my mother guardedly, reluctantly, reveal that those grandparents, those distant, unvisualized people whom I had never known, had been, more or less, Jewish. Still later I gathered vague indications that my father's parents had also once been enormously wealthy, and that I had various aunts and cousins scattered about in Italy, America, even Mexico—although, strangely, that family, those grandparents, had apparently been German-born "Gutmanns," while we were very British "Goodmans."

Different names, different nationalities, different religions—it was all quite confusing.

Naturally, these grudgingly shared bits of knowledge raised questions. Although I knew that we were not poor, I also knew that we were not rich. And who were these far-flung relatives I had never met?

We had been to Italy on holiday, but no one had ever introduced me
or my brother to any relatives there. And if indeed these mysterious
relations did have some sort of German or Italian connections, wasn't it
the Germans, and to a lesser extent the Italians, who had been the very
enemies battled so heroically by our British soldiers every issue in the
pages of the *War Picture Library?*

I couldn't have been more confused if I had learned that I was
somehow descended from the Japanese.

And what did being Jewish mean? I was barely aware of what being
Jewish had to do with someone having "died in the war." Still, from the
coarse comments of boyhood chums—boys repeating what they had
heard from their parents—I had picked up insinuations that to be a Jew
was to be different somehow, almost "un-British," perhaps even disrep-
utable in some way. And if my grandparents had been Jewish, did it not
follow that my father was Jewish, and that I was at least partly Jewish?

But how could that be? It was true that my mother, a descendant of
Protestant Highland Scots, with an impressive string of official birth
names (Irene Doreen Rosy Amy Simpson, ultimately shortened to
Dee), had never been overtly religious. Indeed, one of her ancestors,
James Young Simpson, a physician who had discovered the anesthetic
qualities of chloroform and had subsequently been knighted by Queen
Victoria, had been a notorious freethinker—a nonbelief system that
my mother also seemed to embrace. Nevertheless, she had insisted that
Nick and I become proper Anglicans, enrolling us in a Sunday school
from which we each eventually earned a certificate for reading the
entire Bible. She had us officially christened—albeit, in my case, not
until I was at the somewhat advanced age of twelve. Was it possible, I
wondered, to be a member in relatively good standing of the Church of
England and to be Jewish, or part Jewish, at the same time? Even with
hindsight, I would never figure out if this stab at Anglican induction
had been for conventional social reasons or, in a more ominous way, as
some kind of insurance. My father was never able to show any enthu-
siasm or even interest in the whole process, but clearly my mother felt
it necessary.

These were not questions I could discuss with my parents—my father in particular. If he was silent on the subject of the war, he was even more silent, if that was possible, on the subject of his family, Jewish or otherwise. I sensed that these were things best left alone.

Yet, for me, it all led to an increasing feeling of otherness, of not quite belonging in the country and the society and even the family into which I had been born—a feeling heightened by my appearance. My older brother, Nick, had inherited our attractive mother's fair-haired, fair-skinned Anglo-Scots looks, while I, like my father, seemed to have come from a place much farther away. My hair was almost black, my eyes dark brown, my skin olive. I remember once returning from a summer in France, a vacation spent largely on a sunny beach, and having British customs and immigration officers look at my deeply tanned face and then carefully and dubiously examine my British passport. Someone even suggested that I might be an Algerian—they spoke the word like a curse. I couldn't possibly be a real English boy.

Given all this, and my youthful doubts about my place in the world, perhaps it was fortunate that for our schooling my parents chose the Lycée Français in South Kensington, where classes were taught almost entirely in French, the desks occupied by a cosmopolitan mix of the children of émigrés and refugees and various and sundry eccentrics. It was a most un-British institution, and as a consequence I felt comfortable there. Perhaps fortunate also was that our family lived in Shepherd Market, a small square in the Mayfair district of central London, just three stops away on the Piccadilly Line from the Lycée. In the 1920s, it had been an ultrafashionable address, home to any number of successful writers, actors, and artists, and although it had become a bit sketchier in the postwar years, it retained its eclectic, nontraditional character.

This environment perfectly suited my mother, a funny, vivacious, life-loving woman, who had studied at the Royal Academy of Dramatic Arts before the war and later became a successful theatrical stage manager and producer. With my godmother, Anna Wiman, she discovered the iconoclastic comedy group Beyond the Fringe at the Edinburgh Festival—featuring, among others, the young actor Dudley

Moore. When it opened, in the West End in 1960, at my impresario godmother's theater, the Fortune Theater, it became an overnight sensation.

How my father fit into all of this was, as usual, a mystery. He was in all ways a proper English gentleman—in almost all of my memories he is wearing a jacket and tie, or at least a cravat—but he did not seem to have a regular job, at least not in the sense that other boys' fathers had jobs, places that fathers went to in the morning and returned from at night. I remember he had letterhead stationery that identified him as *B. E. Goodman, Manufacturer's Agent*, with an office address in Golden Square, Soho, but I don't remember his ever actually going there, or mentioning the manufacturing of anything. Instead, he spent most of his time at home locked in his study, corresponding—as the contents of those dusty boxes would later reveal—with various lawyers and government officials. He must have given up the unused office in Soho because when I looked at his correspondence many years later, I noticed with bemusement that he had x'ed out the Soho address in the letterhead and typed in our home address. It was so very much like my father not to waste perfectly good stationery.

He traveled a great deal, mostly to Holland, but also to other countries throughout the Continent, although where he went and what he did on any particular trip I did not know, and he did not say. He was abroad so frequently that later, when he did take a recognizable job, it was as a travel agent—a position that helped facilitate his wanderings but, somehow, given his education and background, seemed a bit beneath him.

As we got older, he would sometimes take us with him on these journeys, to France, Italy, Spain, Switzerland, the Netherlands, Austria, and once to Germany—although in that case he insisted upon driving completely across that country without stopping, except once to allow us, in extremis, to go to the loo. Germany had seemed to put him in a dark mood.

The results of these trips were for us boys almost invariably disappointing. Instead of taking us to old castles and museums choked

with guns and swords and suits of armor, our father seemed primarily interested in visiting, what was for us, a seemingly endless succession of musty and boring art museums. This might not have been surprising since he had majored in art history at Cambridge. The odd thing about these museum visits, however, was that Pa did not spend them in a leisurely contemplation of the art on display, but rather rushing from gallery to gallery, scanning the walls and then quickly moving on, as if he were looking for something and not finding it. Sometimes he would park us on a bench and then spend hours with a museum curator going over old lists and catalogs—again, as always, without explanation.

There was, I remember, one notable exception. Years later we took a trip from Los Angeles to the San Diego Museum of Art in Balboa Park, where my father stood gazing for what seemed like an uncharacteristically long time at a seventeenth-century oil painting, *Portrait of Isaac Abrahamsz. Massa*, by Dutch Golden Age painter Frans Hals. Even more uncharacteristically, he told us that this painting had once been owned by his father, our grandfather, but it had to be sold during World War II. He sounded bitter about it, angry in a way that I was only just beginning to understand.

But he would say no more, and I didn't ask. It seemed like ancient history—sad, perhaps, but with little bearing on my life.

Eventually, as the years passed, I began to understand the basic outlines of my father's family story—again, through bits and snippets and vague asides. Yes, my father and his father before him had been born into one of the wealthiest, most powerful Jewish banking dynasties in Germany, the Gutmanns. Yes, my grandfather and grandmother, herself a member of a Jewish banking family, a baroness no less, had lived with their two children—my father and his younger sister—in a luxurious estate in Holland, where they had presided over not only an enormous fortune and a fabulous art collection of old masters and famous Impressionists, but also an almost priceless collection of Renaissance silver and gold works of art. And, yes, the war and the Nazis had come, and while my father had survived in England, anglicizing his name to Goodman and serving in the British army, everything else—the fabulous

estate, the vast fortune, the magnificent art collection, my grandparents themselves—had been swept away.

At the time, my scant knowledge of this history did not much affect me—any real sense of loss would only come later. As for the lost fortune, the vanished art collection, it all seemed like part of some other world. Many families have stories of lost wealth—the fortune lost overnight in the Wall Street crash, the family bank accounts squandered at the roulette wheels of Monte Carlo by some dissolute great-uncle—but by the third or fourth generation these stories usually become nothing more than interesting, and perhaps only half-believed, bits of family lore and legend. Young men think of their own futures, not someone else's past. Besides, by this time I was living in Los Angeles, and in all the world there probably is no place less conducive to pondering the past than LA.

Still, as I got older, I began to understand, or at least was better able to appreciate, the profound effect that this tragic family history had had on my father—and later, through him, on me. For my father, these terrible events had been close, real, things he had lived and experienced, not something that, like me, he had simply heard about. When I tried to imagine myself in his place, I thought, no wonder he refused to talk about the war; no wonder he never spoke of his parents. Some things, I understood, were simply too painful to talk about, buried beyond words.

But curiously, as the years passed, as the dreadful history of my father's family receded in time, their effects on him seemed to increase, not lessen. He had a growing aura of pent-up frustration and bitterness and anger about him, a sense that some mysterious defeat, some terrible failure, was weighing on him, bending his spirit and then finally, it seemed, breaking it altogether. He grew increasingly withdrawn, uncommunicative, inaccessible. When my parents would have guests over—or more accurately, when my social and outgoing mother would have guests over—I remember my father usually standing off and alone in a corner, as if he were someplace else. He could talk animatedly about cricket and football (or, as Americans say, soccer), but almost nothing else seemed to interest him.

As for the war, everything but the Allied victories now seemed off-limits. It got to the point that whenever a news report or documentary about the victims and, specifically, the Holocaust would come on the television, my mother had trained Nick and me to quickly jump up and change the channel. Otherwise my father would angrily switch off the set and then sit glumly, silently, in his chair.

There was one memorable exception. One day in June 1967, I came home to find my father alone, hunched forward in his chair, watching the BBC news reports on Israel's air and ground strikes against Egyptian military airfields and the Arab armies massing against them from Jordan, the Golan Heights, and the Sinai Desert—the start of the Six-Day War. He was cheering, shaking his fist, urging the Israelis on. That's it! Bash the bloody bastards! Nick, who was older, had already left home, and my mother was away, so for the next six days my father and I spent every spare minute following the war news together—he explaining the strategy and tactics and weapons as I listened, fascinated by this previously unseen side of him. It was the longest, most intimate time I had ever spent with my father. Yet, even then, as we watched with satisfaction as the Israelis rolled over the Arab armies at El Arish and Gush Etzion and Jericho and Jerusalem, my father barely spoke of his own Jewish heritage, or of that other, earlier war of attempted annihilation of the Jews. Then the Six-Day War was over, and the news looked elsewhere, and my father's silence returned.

Nick and I were growing up and had our own lives now. We were accustomed to Pa simply being Pa. But for our mother, the silence, the distance, the sadness, finally became too much. Sadly, they divorced. Ma eventually remarried and moved to Australia, while Pa remained in London, a quiet and somewhat reclusive aging bachelor. Later he met Eva, who, though twenty years his junior, had attended the same exclusive school in Switzerland that my father had attended as a boy. Curiously, given our family's history, Eva was German—but she had been a young girl during the war. More curiously still, he eventually went to live with her in Germany, in the small southwestern university town of Tübingen. This was another mystery for me and Nick. Nevertheless,

in Eva he found a comfortable companionship and, in his later years, perhaps some measure of peace. We noticed that he still traveled extensively. But about his past, he remained as silent as ever. Some men grow garrulous as they get older, telling the various stories from their lives again and again to anyone who will listen. Pa, as far as we could tell, had never told his story even once.

And now he was dead.

It might have ended there, except that a few months after his death I rang up Pa's sister, our aunt Lili, just to say hello. Aunt Lili was one of those rumored, far-flung relatives I had wondered about as a boy, but had not actually met until years later. Like my father, she also had an unusual life. Lili had married into an old Italian family, but her husband had been taken prisoner of war by the British in North Africa. Then when the Germans occupied Italy, she had been forced, due to her Jewish origins, to keep one step ahead of the Gestapo. After the war she divorced her first husband and later married a Greek diplomat. Now elderly and widowed, she was living in modest circumstances in Florence. During our conversation, my aunt mentioned, in passing, that since the fall of the Soviet Union the Russians had begun, for the first time, to exhibit publicly some of the "trophy art" taken from Germany during World War II. She wondered out loud if perhaps some of her father's, my grandfather's, missing paintings that had disappeared during the war—the two Degas, the Renoir, the Botticelli, the Guardis, and others—might be found there and even possibly returned to the family.

My reaction was "Missing paintings? What missing paintings?" Nick and I had assumed, when we had thought about it at all, that all that had been settled long ago or that whatever our father's family had lost had been lost irretrievably. The idea that the family might still have a claim to anything from those old days, and that a half century later it might be recovered, seemed far-fetched. Frankly, we wondered if poor Aunt Lili, who was in her late seventies, might be getting a bit dotty.

Then those old boxes arrived at Nick's house, stuffed with papers and documents.

It would take us first days, then weeks, then years, to figure it all out—and even as I write this, not all the mysteries have yet been solved. But I would eventually uncover the secrets that had been hidden since before I was born. And I can finally tell the story that my father never told me.

I would discover that for a half century after the war ended, Pa had fought a bitter and often unsuccessful battle to recover the priceless artworks that had been stolen from his family—stolen first by the Nazis, and then, in effect, stolen again by narrow-minded bureaucrats. Unscrupulous art dealers and willfully negligent auction houses, as well as museum directors and wealthy collectors, would all be party to this theft, long after the war was over. I would discover that throughout his life our father had to deal not only with the almost unbearable knowledge that his parents had been savagely murdered, but also the knowledge that their looted legacy, their paintings and other cherished artworks, were on display in someone else's gallery, hanging on someone else's wall, locked in someone else's safe—and that he could not get them back.

In discovering his story, I would come to understand the anger, the indignation, the frustration, and the sense of loss that he must have felt. For the first time, and only after he was dead, I would finally begin to understand the strange, tormented, enigmatic man who was my father.

In the years to come, my family and I would take up the search where my father had left off. The trail of our family's missing art would lead from Nazi-occupied Holland and France to Germany, Switzerland, Austria, and America; from warehouses in Paris to salt mines and castles in Bavaria; from dingy government storage facilities to the rarefied atmosphere of Sotheby's and Christie's auction houses in London and New York; from the private art collections of the fabulously wealthy to the public exhibitions of some of the world's greatest art museums. Like my father, I would spend years searching through

musty archives, haunting the back rooms of museums and libraries on two continents, tracking down clues, pursuing false leads, searching, always searching. Like my father, too, at almost every turn I would encounter indifference and apathy and at times outright hostility from people who seemed not to want to know about the grim history of the artworks they possessed. Even when they did know about it, too often they seemed not to care.

But there was one big difference between my father's quest and mine. This time, for the most part, we would prevail.

It has been a long and frustrating and, at times, an almost ruinously expensive endeavor. But over the years we have recovered dozens of paintings and many other artworks that were stolen from our family—although many remain missing, still stolen, to this day. In the process we have helped change the way the often ruthless business side of the art world is conducted and helped to effect new government protocols and regulations concerning the harboring of looted art. I hope we have made it easier for other heirs of Holocaust victims to find and recover their stolen legacies, all the while keeping alive the memory of the victims of long ago.

Oftentimes in this very public and highly publicized battle, I have been asked by newspaper and magazine writers, by television news reporters and documentary filmmakers, why I do it, what my motivation is. I give the usual, perhaps expected answer—that while I know the dead can never be brought back to life, by recovering my family's stolen legacy I hope to achieve a long-overdue sense of justice, a degree of what is popularly known today as closure.

While that is true, I have another, deeper, more visceral motivation. After learning what had happened to my family—the murders, the thefts, the lies, and the betrayals they had endured—I was angry. From that anger came a desire to exact at least some small measure of retribution—for my grandparents, for my father, perhaps even in some ways for myself.

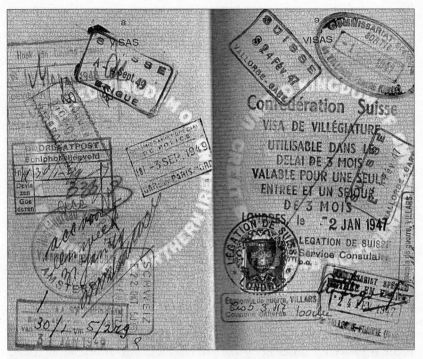

After the war, Bernard used his British and Dutch passports constantly.

THE GENERATIONS THAT CAME BEFORE

Lili Orsini, Fritz, Eugen (seated), Luca Orsini, Herbert,
Louise, and Lord the poodle, circa 1925.

I remember that as a curious young boy I had come across a faded black-
and-white photograph of my father's parents, Fritz and Louise—two
distinguished-looking, older people dressed in elegant but old-fashioned
clothes. They had stared back at me from some distant, seemingly un-
knowable past. I say "older" although, at the time the photograph was

taken, they probably were only in their thirties or forties; they never had a chance to actually become elderly. When I looked more closely, I could see my father in them, and even myself. But they seemed to belong to a world that didn't connect with mine.

Today, on the wall of my office at home in Los Angeles, I look at a portrait of my great-grandfather Eugen Gutmann. Painted at the end of the nineteenth century by celebrated portrait painter Franz von Lenbach, I found it just a few years ago at an auction in Cologne, while I was hunting for another Lenbach that is still missing. Every morning I greet Eugen in four languages—German, French, Italian, and English—and ask what the day will bring. Some days he remains impassive, and then some days I get the distinct impression he is smiling down at me—a twinkle in those gray-blue eyes—and then I know a new clue is lurking not far away. For the last few years—and as if guided by my great-grandfather's aura—I have bit by bit been able to resurrect the history of my nearly disappeared family.

BERNHARD GUTMANN

Eugen's parents, Bernhard and Marie Gutmann, were both from Bohemia, part of the old Austrian Empire. Bernhard had come from a pious family. His grandfather, great-grandfather, and many before him had been either rabbis or rabbinical judges, mostly from Leipnik and Kolin (now both in the Czech Republic).

When Bernhard was still a child, his father, Tobias, had moved to the Bohemian capital of Prague and into small-time banking, which was, at the time, probably not much more than old-fashioned money changing. For Tobias and his family, the early decades of the nineteenth century must have been like stepping out of the Middle Ages and into a new, modern world. Bernhard, in 1815, had been born into a time of upheaval. Napoléon and the French revolution had changed everything—the modern era was beginning.

Sensing that even greater opportunity beckoned, just over the

Erzgebirge Mountains in the new German Confederation, Bernhard moved to Dresden. The granting of full political rights to Jews in Germany was still a few decades away, but in the 1830s the King of Saxony lifted all economic and commercial restrictions on Jews in Dresden. Similar changes occurred throughout the new Confederation of Germany, where a long pent-up surge of intellectual and entrepreneurial energy was unleashed. Around 1840, Bernhard Gutmann founded the private bank named simply, in the fashion of the times, the Bankhaus Bernhard Gutmann.

The new bank specialized in commodities trading, currency exchange, and loans for industrial development. It prospered such that Bernhard could comfortably afford a large and elegant three-story villa overlooking the park on the fashionable Bürgerwiese. Salomon Oppenheim, a "court Jew" from Cologne and founder of the bank that still bears his name, would commission a Florentine-style palazzo just a few doors down.

Even though Bernhard was still quite young—in 1840 he was only twenty-five—he became a member of the board and benefactor of the new Dresden synagogue, a magnificent Moorish-revival building designed by Gottfried Semper, perhaps the foremost German architect of the day. The Semper Synagogue epitomized an impressive and prominent place of worship, clearly a measure of the prosperity and aspirations of the small Jewish community in Dresden, which at the time numbered fewer than one thousand. It was perhaps also a measure of the historical hopelessness of those aspirations that, a century later, Nazi brownshirts would burn the Dresden synagogue to the ground on Kristallnacht.

With the new synagogue came a new form of worship. While the major prayers were still spoken in Hebrew, many of the services were conducted in German, accompanied by choral singing—a small but significant step in the assimilation of German Jews into the surrounding German culture. As might be expected, this shift toward modernity caused tensions within the Jewish community. With the physical and symbolic tearing down of the ghetto walls, and the resulting intermin-

gling of Jews with the Gentile culture, some Jews feared that assimilation would pose a more existential threat to Jewish faith and identity than centuries of intimidation and persecution ever had.

Bernhard was, by all accounts, politically and personally a conservative man, pious and sober. He was a transitional figure between the old order and the new. Firmly rooted in his ancient community, Bernhard would uphold the Jewish traditions until his death in 1895.

His last years were lived out with great dignity and in considerable comfort in a fairy-tale white castle surrounded by a moat full of swans. Schloss Schönfeld, overlooking the Elbe River, became known as "the magic castle." It had been built in the sixteenth century and was considered the finest of Renaissance castles in the region. Bernhard had acquired it just a few years after the final restrictions had been lifted on Jews owning real estate. It was a striking testament to the remarkable rise of the Gutmann family and the emancipation of Jews in Germany.

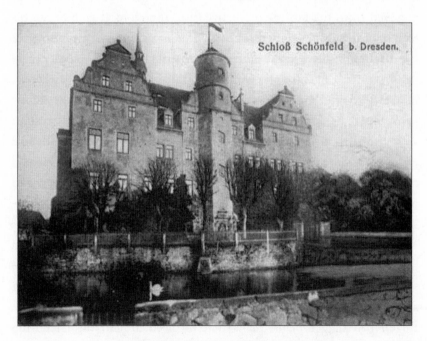

Bernhard's moated castle overlooking Dresden.

EUGEN GUTMANN

Bernhard and Marie's third child, my great-grandfather Eugen, was born in Dresden in 1840, the eldest son in a family of twelve siblings. All but one of these survived into adulthood, which was remarkable for that era. Eugen is portrayed in family lore as an outgoing and generous boy. He is also described as impulsive, perhaps even a bit of a rebel. Records are scant, but as a young boy he almost certainly was enrolled in Dresden's "Jewish school," considered even by the Gentile community to be perhaps Dresden's best grammar school, and later attended the local gymnasium (high school). No doubt, he would have been a regular attendee at the synagogue of which his father was such a prominent figure, although from what I learned about him later, I have to assume that the Jewish traditions never truly took hold.

Banking, like most businesses of the day, was taught on the job, and it was thought best for a young man to prove his mettle and aptitude removed from the father's protective care. Therefore, Eugen began his banking career as an apprentice to a different private bank, Günther & Palmié, in Dresden. Next, so he could experience the commodity market firsthand, Eugen briefly worked in Budapest for Hungary's largest lumber concern; but he soon returned to Dresden and to the family bank. Jewish banking families routinely traded sons for apprenticeships and, just as routinely, daughters for marriage. This practice of double endogamy—intermarriage among Jewish banking families—would create endlessly complicated interlocking family relationships and would later provide fodder for accusations of "conspiracy" against Jewish bankers.

The Bankhaus Bernhard Gutmann, dominated by Eugen's father, had become a prosperous concern, but it was far too restrictive, too conservative a stage for Eugen. At the same time, Germany was emerging as a powerful industrial nation. Energetic, ambitious, and in a hurry, Eugen had bigger plans, plans that revolved around his friendship with another, even more prominent Dresden banking family, the von

Kaskels, who lived just down the street from the Gutmanns on the Bürgerwiese.

The Kaskels had been among the original "court Jews" brought back to Dresden by Frederick Augustus I in the eighteenth century. The family later formed the private Bankhaus Kaskel and served as official bankers to the royal court. Unfortunately for the Kaskel Bank, but fortunately for my great-grandfather Eugen, Carl von Kaskel had only one son, Felix, who apparently was far more interested in music than running a bank. With Carl getting on in years, the Bankhaus Kaskel faced a dilemma. At the same time, Germany, now finally united as a modern nation-state after its victory over France in 1871, was awash in new capital looking for investment in more railways, factories, shipping, mining—and more banks. For Eugen, who was already a minority stockholder in Bankhaus Kaskel, it was a perfect alignment of opportunities.

In 1872 Eugen put together a deal with the Kaskels and some of the other great banking families—among them were the Rothschilds of Frankfurt, the Bleichröders of Berlin, and the Oppenheims of Cologne—to create a public joint-stock corporation called the Dresdner Bank (Bank of Dresden). The bank opened its doors in the old Bankhaus Kaskel building in Dresden with thirty employees and an initial capitalization of 24 million marks. As Chairman of the Board of Directors, Felix von Kaskel was the titular head of the bank, but Eugen, then only thirty-two years old, was the driving force as the Dresdner Bank's managing director. In 1873, less than a year later, it went public on the Berlin Stock Exchange and traded for nearly 110 percent of its initial value. Eugen became Chairman and would hold that position for almost the next half century. A famous financier of the day was quoted as saying, "Gutmann was not just the head of the Dresdner Bank; he was the Dresdner Bank."

Meanwhile, the Bankhaus Bernhard Gutmann continued as a successful private bank, under Eugen's brother Alfred, until 1921. After Alfred became ill the bank was officially absorbed into the Dresdner.

Over the next decade, Eugen launched a breathtaking series of mergers and acquisitions of smaller private banks and financial institutions. He helped pioneer the concepts of branch banking, opening smaller branches of the Dresdner in cities and towns throughout Germany. He also established individual deposit banking, allowing even the most humble of wage earners to open interest-bearing bank savings accounts—at the time a bold, even radical, innovation. Eugen famously maintained that "every civil servant, even every maid, should have a deposit account," preferably, of course, with the Dresdner. Eventually, millions of Germans from all walks of life would do just that. But perhaps Eugen's most farsighted business decision came in the early 1880s when he decided to make Berlin the headquarters of the Dresdner Bank.

Before German unification, Berlin had been an elegant but somewhat isolated city of about four hundred thousand people, the administrative capital of the Kingdom of Prussia, but a poor relation to the great, glittering European capitals of Paris, Vienna, and London. After unification, as the capital of the new German Reich, Berlin experienced the same rapid expansion that swept across almost all of Germany. By 1880, its population had soared to over a million, and it had become the undisputed political and financial center of the new German empire. Just as the Bankhaus Bernhard Gutmann had been too small a stage for Eugen, now Dresden—a beautiful and culturally vibrant city, to be sure, but still only a provincial capital—was too small a stage for Eugen's ambitions. Berlin was the key.

In 1881 Eugen opened a branch office of the Dresdner in Berlin and a few years later moved the bank's corporate headquarters to the new capital city. Obviously, a powerful bank must have a powerful and imposing headquarters, and here, too, Eugen thought in grand terms. The headquarters building had originally belonged to the family of Bismarck, whom he admired so greatly. Many even said that Eugen resembled the "Iron Chancellor." In 1887 Eugen commissioned a richly decorated, three-story neoclassical renovation of the building, on the square known as the Opernplatz, conveniently close to the

Opera House. Along with other flourishes, the building featured ornate marble columns, mosaic terrazzo floors, and coffered ceilings embellished with roses. Chancellor Bismarck and Kaiser Wilhelm II were among the many distinguished guests at the building's grand reopening in 1889.

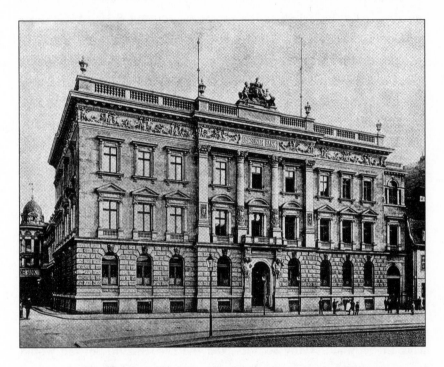

The Dresdner Bank, new Berlin headquarters, in 1884.

The building functioned as both a testament to the prominence of its occupant as well as a working financial institution. Eugen's office on the director's floor looked out over a massive "banking hall" with a thirty-foot-high glass ceiling, where ordinary Berliners—every civil servant and maid—lined up to entrust their money to the good offices of the Dresdner. The downstairs vault area also featured a "jewel room," where the haute bourgeoisie would store their valuables. Eventually, the Dresdner Bank building covered an entire city block.

Perversely, after World War II the building was used as the district headquarters of the East German Communist Party, which in good proletarian fashion covered the terrazzo floors with honest workers' linoleum and painted over the beautiful marble columns in drab Stalinist gray.

Today the building is the rather fancy Hotel de Rome. Not much remains from the original. The mosaics from the floor of the great banking hall were refurbished into what is now a ballroom. The director's room upstairs is now the dining room, and the vaults downstairs have been converted into a spa and sauna rooms. While my wife and I enjoyed coffee and cakes on a sunny morning, in 2007, I was still able to visualize my great-grandfather sitting at his impressive command post, directing an aggressive expansion of the Dresdner.

Eugen first opened branch offices across Germany and then, in 1895, the first office abroad in London—an event that would later have a profound effect on my own destiny. Eventually, the Dresdner would directly employ several thousand people, while indirectly controlling the lives and fortunes of millions more. In assets it had become the second-largest bank in Germany, behind only the Deutsche Bank.

By 1900, the Dresdner would have the largest branch network in all of the Reich. Around this time and at the height of his power, Eugen had another portrait painted by the great German Jewish Impressionist, Max Liebermann. Many decades later the Liebermann portrait would be afforded a place of honor between portraits of Albert Einstein and Walther Rathenau in the postwar Jewish Museum in Berlin.

One of the ultimate ironies in my family history is that the mighty Dresdner Bank became a major financier of the newly unified Germany and its astonishing rise as a military and industrial world power. It invested heavily in the railroad, oil, mining, pharmaceutical, and electrotechnical heavy industries that were transforming Germany into a world economic power. Krupp armaments, Bayer chemicals and pharmaceuticals, Thyssen steel and iron, Siemens electric—the Dresdner had a hand in financing expansion projects for all of them.

The Dresdner's major foreign interests would ultimately include

the Deutsche-Orient Bank, with offices in Istanbul, Cairo, and Casablanca, Victoria Falls Power Company in South Africa, Russian Union Electric in St. Petersburg, Mexican Electric Works Ltd., the German Asiatic Bank in Shanghai, the German South American Telegraph Company, and the Baghdad Railway Company—among many other powerful entities. In the United States, the Dresdner maintained a close working partnership with J. P. Morgan & Company. Additionally, Eugen served as a director on the boards of thirty-four major corporations, while his Dresdner surrogates served as board members of two hundred other companies.

Although nominally a public corporation, Eugen ran the Dresdner more like a private bank, carefully packing the board with trustworthy friends and even some family members as directors, including his younger brother, Max. One high-level Dresdner employee later wrote, with a clear sense of exasperation, "Eugen Gutmann was full of plans, but the board only heard of them after the decisions were already made. One day he was interested in mining in South Africa, the next in large construction projects in Berlin. Everything depended on his personal whim."

Eugen's management style was both vigorous and personal. He was known for peppering his people with exhortatory notes and letters, most often after the bank experienced some minor setback. "Especially in troubled times, you must keep your head up and pass the test of strength!" said one such note. "Fight on! Perhaps victory still clings to our heels!" said another.

Eugen was also known as a patriarchal and benevolent employer who greeted his employees each morning by name; if he was sometimes quick to criticize, he was also quick to reward. One of those employees was Hjalmar Schacht, later infamous as economics minister for the Nazi government; he would eventually wind up in the dock at Nuremberg. Schacht recalled in his memoirs how Eugen had once slipped him a thousand-mark note (over $5,000 today) as a personal, unofficial bonus for concluding a profitable stock deal.

A contemporary journalist described Eugen this way: "Gutmann had a personality that fascinated you right away, but he was also someone

whose congeniality made people genuinely wish to engage with him. If nothing else, it was his physical appearance, his well-proportioned figure, his taut bearing in walking with his head held high, but also his wonderfully distinctive features, bearing an astounding similarity to those of Bismarck, and above all his kind blue eyes that made him stand out from all the rest."

Eugen could also be autocratic, dictatorial, and more than a bit ruthless in his business dealings, as evidenced by his role in the so-called Hibernia Affair, a now forgotten but then quite notorious 1904 financial scandal. It was a clash between private enterprise and the Prussian state, and much to the consternation of many of his peers, Eugen took the side of the state. By doing the government's bidding, he had seen an opportunity to make a fortune. Berlin had decided it wanted to control a section of the coal industry. To avert an impending cartel, the Prussian cabinet had decided it should secretly nationalize the Hibernia Coal Mining Company.

Discreetly, the minister of commerce asked Eugen to form a consortium to buy Hibernia. The minister assumed Eugen would include Bleichröder, Bismarck's personal banker. However, Eugen started to buy up all the shares he could on his own, and the stock price rose quickly. Unfortunately rivals learned of this strategy and planned a successful defense. Ultimately Eugen's ploy failed, along with the government's attempt at nationalization. Apparently the Dresdner came out of the whole affair about even, but its good standing with the coal industry and the Ruhr was considerably set back. Outwardly unruffled, Eugen shrugged off the whole business with an "all's fair in love and war" attitude.

Politically, Eugen supported the National Liberal Party, which was not particularly liberal, but backed big business and the *Grossbürger*, or economic elite. Then, after World War I, at the beginning of the Weimar Republic, Eugen joined the Deutsche Volkspartei (German People's Party) at the request of Gustav Stresemann, later Chancellor of Germany and a Nobel Peace Prize winner. Almost all the great Jewish bankers did the same, including Max Warburg.

Henry Nathan, Eugen's close confidant and later chairman of the Dresdner board, described him as "simple and modest" and "reluctant to make public appearances." In a rare press interview, referring to himself haughtily in the first-person plural, Eugen said, "We don't pretend to have opinions upon what does not directly concern us. Politics are the affair of the government." This may have been a bit disingenuous; in a French interview Eugen went so far, with considerable vision, as to foretell a form of European union.

Without a doubt, Eugen remained a man of considerable influence, part of a network of industrialists and bankers who worked hand in hand with the German state to further Germany's interests as well as their own. They financed not only Germany's industry, but also its growing and far-flung imperial interests in Africa, the Middle East, and South America. Like Eugen, many of these key players were of Jewish origin, including Carl Fürstenberg, the Arnholds, the Rathenaus, the Warburgs, and Albert Ballin, director of the Hamburg-America Line. They came to be known derogatorily as the Kaiserjuden, or the Kaiser's Jews.

Despite his own obvious ambivalence toward Jews, Wilhelm II, a vain and impetuous man, publicly treated these Jewish industrialists and financiers with respect, inviting them to sailing regattas, to stag parties at his hunting lodges, and, most important, to roundtable meetings for their economic advice. Unfortunately this kind of access to the monarch would invoke considerable suspicion among much of the population. Paradoxically, a generation later this service to the German empire by Jewish industrialists and financiers would count for nought in the fatherland, while in Britain and the United States it would be viewed with intense suspicion.

Meanwhile, for Eugen's services to the empire and despite his much-remarked-upon sense of personal modesty, he accumulated several awards and titles. In addition to being named a Privy Councillor to the Kaiser, he was also the recipient of the Order of the Red Eagle from the Prussian government, an honorary consul in Berlin for the Italian government, and among other things a Royal Commander of

the Kingdom of Romania and a Knight Grand Cross of the Italian Crown.

I think Eugen liked collecting these honors in the same way he collected gold boxes. However, when offered the title of baron by Bismarck and the Kaiser, he declined. Perhaps he felt he just didn't need it. He was, after all, a modern man. According to the Annual of the Fortune and Income of Millionaires in Prussia—a sort of Forbes 500 of the day—Eugen was one of the wealthiest men in Germany.

On the personal side, Eugen loved women and opera; he especially loved the combination of the two. I have no evidence concerning romantic encounters he pursued as a young banker in Dresden—Eugen was not a diarist, and no youthful love letters have been found—but I do know that one love affair was with an accomplished, albeit amateur, opera singer named Sophie Magnus. Family lore has it that he fell in love just hearing her voice as he passed a window. Sophie was my great-grandmother.

For a family researcher, Sophie presents something of an enigma. A family legend—which my father believed until the day he died—claims Sophie was the daughter of an Edinburgh fur dealer named Hermann Magnus, but my research showed otherwise. Sophie, who was born in 1852, was indeed the daughter of a furrier, and he was named Magnus, but he was a Jewish wholesaler of furs in Leipzig and was originally from Hamburg, not Scotland. How this story began is a mystery. Perhaps it was because Hermann died young and his death left Sophie and her younger sisters dependent on the support of their wealthy cousins the Warburgs (the great banking family from Hamburg and Altona). This thrust Sophie into the role of surrogate mother to all her younger siblings—a role, I suspect, she did not relish. Her younger sisters resented her strictness, and this, no doubt, led to one of the feuds, I would discover, for which my family was famous.

One of Sophie's younger sisters, Alice, later married Max Warburg (who also turned down the title of baron). That distant, and then unknown, family connection with the Warburgs resurfaced years later

in the 1960s. Fresh out of high school and at my mother's insistence, I reluctantly went for an interview at the London banking firm of S. G. Warburg & Co., only to be told by Sir Siegmund Warburg himself that, due to our family connections, hiring me might smack of "nepotism." At the time I had no idea what he was talking about.

Still, despite her family's reduced fortunes, Sophie was able to study painting and opera, two appropriate subjects for young ladies of the day, and ones in which she excelled. The delicate watercolors I found among my father's papers after his death were painted by her in a sure and obviously talented hand. She even studied voice at the Dresden Opera for a time with the famous soprano Marcella Sembrich. Sophie is described as a dark, imposing beauty—perhaps by modern standards a little plump—but a young woman of intelligence and refinement.

Eugen and Sophie were married in 1872, just as the Dresdner Bank was getting started. With the increasing success of the bank, Eugen bought an impressive Renaissance-style villa on the Bürgerwiese in Dresden, just a short walk away from his parents' home and right next door to the Palais Kaskel-Oppenheim. The following year Sophie quickly bore the first of their seven children, daughter Lili. She was followed by another daughter, Toinon, in 1876, and then, to Eugen's relief, five sons in quick succession: Walther in 1877 (sadly, a sickly boy who would die young), Herbert in 1879, Kurt in 1883, Max in 1885, and in 1886 my grandfather Friedrich, known always as Fritz.

Following the bank headquarters' move to Berlin in 1884, the family had settled into a beautiful two-story villa at 10 Rauchstrasse in the Tiergarten quarter of Berlin, the most sought-after area among the emerging haute bourgeoisie.

The house, designed by noted architect Christian Heidecke, featured fifteen main rooms grouped around a central court—including a ladies' drawing room, a private office for Eugen, a gentlemen's smoking room, a glass-enclosed winter garden that also served as a music room, and a magnificent formal dining room. Sophie and Eugen's dressing rooms, as well as the children's rooms, were on the second floor; house-

hold servants lived in small rooms in the gabled attic. The house was decorated in what would be known as *le goût Rothschild* (in the taste of the Rothschilds), with extensive brocade and gilt, antique-wood paneling, and fabulously elaborate stucco ceilings. The eighteenth-century French furnishings were from the eras of Louis XIV through Louis XVI: tulipwood secretaries, mahogany bureaus, cabinets inlaid with tortoiseshell and ivory, marquetry tables, gilded mirrors, Gobelin tapestries, and vitrines full of Meissen.

The villa at 10 Rauchstrasse teemed with life. There were gardens and gardeners, cooks and maids, a butler, a carriage house, coachmen, and horses in the stables. By the turn of the century, Eugen, who was always fascinated by the new and innovative, added to the horse-drawn carriages a more modern conveyance. I was delighted to uncover a photo from around 1900 of Eugen's first *Elektromobil*, a battery-powered, chauffeur-driven electric hansom cab made by Karl Benz.

From the villa grounds echoed the sounds of horses neighing and the barking of dogs, of which there were many, especially poodles. From the upstairs rooms, where the children lived, came the usual childish cries and squeals and laughter, the screeching of violin lessons, the dull notes of scales played on a piano, and the rote repetition of verbs and declensions being chanted in several languages. Far from being a museum piece, the house on Rauchstrasse was a noisy, going family concern.

Although the actual raising of the children was left to a succession of harried nurses, nannies, governesses, and tutors, Eugen was keenly involved in his children's lives, to a degree that was unusual for the time, and particularly so for such a powerful, autocratic figure. He took a tolerant and openly affectionate view of them and closely followed their education and development. Occasionally he would even play simple card games with his children and would beam with delight when, with childish outrage, they would catch him cheating. (Years later he was still trying out the same old tricks on his grandchildren, including my father.) Considering the business and social demands on Eugen's time, these interactions were necessarily rare, which to the

children made these moments with their father even more precious. They regarded this patriarchal figure with awe. There is no doubt that he loved them, and they him.

Sophie, on the other hand, was much more emotionally distant, perhaps because of her own difficult childhood. My grandfather Fritz, the youngest, would remember that he rarely ever saw his mother, except when she would come upstairs, resplendent in evening gown, jewels, and pearls, to formally inspect the children before she dashed off for an evening at the opera or the theater, or to play hostess at the latest grand dinner party.

These glittering, glamorous affairs were numerous; Eugen's social connections were extensive. The dinner guests included all the major captains of finance and industry, and next-door neighbors the Hainauers, who represented the French Rothschilds. There was also a seemingly endless stream of diplomats, politicians, musicians, young writers such as Thomas Mann, artists such as Max Liebermann, Prussian army officers, the Baron and Baroness This and the Duke and Duchess of That. The house was filled with the passionate discussion of philosophy and politics, music and art.

So this was my great-grandfather: a pillar of finance and industry, a social lion, a man of enormous wealth, a respected and widely renowned connoisseur of art, and a loving father of a large and happy brood of children. He would seem to be the quintessential man who has everything.

BEGINNING OF
THE GUTMANN ART COLLECTION

In Eugen's time, collecting art reflected more than an appreciation of aesthetics and beauty. As a symbol of power and wealth, one's ability to afford great art could also provoke great envy. It was common for Berlin sophisticates to snicker at the wealthy parvenus and arrivistes—particularly the Jewish ones—who sought through their art collections to

achieve social aggrandizement. Eugen, though never formally schooled in art, instinctively knew the difference between the priceless and the merely overpriced. One of the most magnificent private collections of objets d'art in all of Germany was on display in those dazzling vitrines and cabinets at 10 Rauchstrasse.

Unlike the way he pursued his banking career, Eugen assembled his art collection cautiously. He started small—quite literally. He began with miniature portraits. My great-grandfather seemed from the start to have a knack for the sublime. Miniatures by now-recognized masters of the genre such as François Dumont, Richard Cosway, Peter Adolf Hall, and Peter Paillou became part of Eugen's growing collection. His passion then progressed to gold boxes: eighteenth-century *objets de vertu*—snuffboxes and containers that were exquisite in execution, masterfully fashioned, inlaid with pearls, jewels, ivory, and tortoiseshell.

Growing up in Dresden, with the Grünes Gewölbe, or "Green Vault" treasure rooms of the Kings of Saxony, would have set the standard for Eugen. Following his footsteps in Dresden, a few years ago I found myself before an entire section devoted to exotic and elaborate gilded nautilus shells. I think at that moment I came close to experiencing the same awe that must have inspired my great-grandfather—nautilus shells, jewels and gemstones, ivory and pearls, coconuts and ostrich eggs, all fashioned in gold and silver.

In 1893 Eugen made a much-anticipated trip to Paris. Just a few years before, Frédéric Spitzer, the famed Viennese antiquarian and adviser to the Rothschilds, had died, leaving one of the largest and most coveted collections in fin de siècle Europe. Dubbed the "sale of the century," the auction would last over three months. Eugen knew it would be the most hotly contested auction and the bidding would be furious. All the same, he had done his research, and he had to have several pieces. Uppermost on his list was one of the famous Orpheus clocks, of which fewer than a dozen are left in the world. This particular one was perhaps the most exquisitely engraved gilt table clock of the Renaissance. The mysterious dial, Eugen was told, had been crafted

by the master of sixteenth-century German goldsmiths, Wenzel Jamnitzer.

In the early 1530s Jamnitzer had opened his narrow workshop, just a few doors down from Albrecht Dürer's house, in the shadows of the Imperial Castle of Nuremberg. The ground floor centered around an enormous hot kiln. On the next floor were printing presses for etchings. From here Jamnitzer and his sons produced a dazzling array of vases, engravings, jewelry, and artifacts of silver and gold. Soon he was appointed court goldsmith to the German Emperor. Much of Jamnitzer's fame was based on highly inventive objects for the curiosity cabinets of princes, as well as extravagant presentation pieces. On just a few occasions Jamnitzer would focus his talents on decorating a clock; of these barely a handful survive.

The clock Eugen coveted was one of these. If one can visualize the chronometrically perfect components rendered in gilt brass, with a case of gold and bronze covered with intricate high-relief depictions of scenes from the legend of Orpheus in the Underworld, one has an idea of the mechanical mastery and artistic genius of this clock.

After a spirited contest in Spitzer's elaborate Paris mansion, near the Arc de Triomphe, my great-grandfather prevailed, and the Orpheus Clock, originally intended for an Italian Renaissance prince, would soon find its way to the Gutmann home in Berlin.

As time went on, Eugen's collecting interests became increasingly eclectic: Renaissance jeweled pendants, seventeenth-century pocket watches, Italian bronzes, medieval illustrated manuscripts, and Renaissance majolica pottery.

Perhaps the most astonishing pieces in Eugen's collection, and closest to his heart, were the German Renaissance and Mannerist silver-gilt sculptures. Most of these pieces illustrated Eugen's continued fascination with the combination of beauty and function. Johannes Lencker's ewer, featuring a nymph on the back of a mythological fish-man known as a triton, is considered to be one of the greatest pieces ever made by the master sculptors of sixteenth-century Augsburg. Eugen acquired from the late Baron Karl von Rothschild a magnificent

pair of sixteenth-century silver-gilt drinking cups by Hans Petzolt of Nuremberg. Perhaps the most coveted of all was the Jamnitzer *Becher* (chalice), created by Wenzel Jamnitzer's son Abraham and featuring a pedestal of three golden elephants supporting an ornate stem flanked by golden angels and a perfectly white ivory cup topped with a gold crown, out of which blossomed an entire miniature Gothic castle, replete with turrets adorned with silver and pearl. And this was just one of hundreds of exquisite pieces.

I discovered that Eugen's collection was not static, but rather a constantly evolving ensemble. In 1907, finding his collection a bit heavy with sixteenth- and seventeenth-century silver-gilt "wager cups" and silver plate, he sold some of those pieces to his American counterpart, J. P. Morgan, for a reported 1 million marks (roughly 6 million in today's dollars). Later Eugen bought the famous Jamnitzer chalice from the estate of the last Baron von Harsdorf of Nuremberg for roughly the modern-day equivalent of $2 million.

The Gutmann silver and gold collection—in German simply the Silbersammlung Gutmann—became almost legendary in its time. Even the vitrine display cabinets were famous in their own right. During the same trip to Paris when Eugen secured the Orpheus Clock as well as the Reinhold Clock for his collection, he also, quite remarkably, acquired from Fontainebleau a spectacular series of Empire ormolu cabinets that had once belonged to Napoléon.

In 1906, Eugen's friend Wilhelm von Bode, director of the Berlin state museums, publicly exhibited the collection in honor of the Kaiser. Later, the distinguished art historian Otto von Falke wrote that Eugen's collection was "worthy to rank beside the treasure chambers of princes." It also became the object of considerable jealousy. One century and multiple catastrophes later, I would hold some of those silver pieces in my hands and marvel not only at the skill of the men who'd made them, but at the artistic taste and discernment of the man who had so lovingly collected them.

I remember when I first began my search into my family's history, Aunt Lili had warned me that nothing good would ever come from

unlocking the saga of the Silbersammlung Gutmann. She compared it to the mythical Nibelungen gold and said it was cursed. At the time I had no idea what she meant. Now I do.

CONVERSION IN GERMANY

German Jews reacted to prejudice against them in different ways, many of which created deep divisions within the Jewish community, and even between individual families. Most Jews retained their traditional heritage and identity even while practicing German customs. For example, many assimilated Jews celebrated the Sabbath on Sundays, instead of Saturday. In Berlin, most of the city's Jews observed Christmas as a national holiday, complete with tannenbaums in their living rooms. Still others took a different tack, embracing an assertive form of Judaism—Zionism—as an alternative to assimilation. Even so, many German Jews chose to become Christian, at least nominally. Eugen and his children were among this group. In 1898, they officially converted to Lutheranism, just a few years after Bernhard, the patriarch, had passed away. Was the timing out of respect? I have often wondered why.

Significantly, Bernhard left his castle, Schloss Schönfeld, not to Eugen but to Eugen's younger brother Alfred. Bernhard had been unhappy with Eugen's lack of religious observance for some time, whereas Alfred had remained faithful to the Jewish religion. Perhaps this had been the cause of another Gutmann family feud?

Certainly the conversion was not the result of some sudden personal epiphany or crisis of faith on Eugen's part. Eugen had never been religious, at least not since his boyhood days in Dresden. He and Sophie and the children had barely observed the High Holidays, if at all, and only rarely attended Berlin's grand, Moorish-style New Synagogue on the Oranienburger Strasse. In December the house on the Rauchstrasse not only had a Christmas tree, but also a smaller tree decorated with German sausages for the family dogs.

It could be said of Eugen, a relentlessly secular man, that his only true places of worship were the bank, the home, and the opera house—and that was equally true after his conversion. A nonpracticing Jew before, he became an equally nonpracticing Christian afterward. Save for his conversion and the occasional wedding, Eugen was never known to set foot in a church.

If not motivated by faith, was his conversion an attempt by Eugen to improve his social standing and business prospects, or was it a necessary first step toward achieving a royal appointment to the German nobility? At the time of his conversion, Eugen was already wealthy and was clearly respected in Germany. As for aspirations to nobility, that, too, seems unlikely. When he had been offered the title of baron by the Kaiser, Eugen reacted by saying he didn't need to add anything to his name: "*Gutmann* was enough."

So again, why the conversion? A hopeless attempt to break the anti-Semitic curse? I cannot know for certain. It was not discussed within the family. Certainly my father never spoke of it. I can only speculate. Perhaps it was for Eugen simply a public statement of his German identity, a final logical step in his steady assimilation. Maybe he gave up something that he didn't endorse—a separate Jewish culture—in favor of something that he believed in most strongly—a unified and secularized German nation. Or, perhaps in the same way he grew rich by anticipating market forces and trends, Eugen sensed something dark and foreboding within the German nation, some premonition of disaster, and wanted to insulate, if possible, his children and grandchildren from what he thought might be coming.

The Gutmann family conversion persuaded few of Eugen's contemporaries that the Gutmann family was now, suddenly, no longer Jewish. Unlike in earlier eras, when the distinction between Jew and Christian was essentially religious, by the turn of the century Jewishness in Germany and elsewhere had become a question of race, of ethnicity, of blood. It might be possible to change one's religion, but changing one's ancestry was impossible. Thus, those Germans who

chose to hate and despise Jews would continue to hate and despise converted Jews.

It's probably also fair to say that most German Jews, even the most religiously secular among them, regarded conversion as a kind of cultural betrayal and generally did not accept that Jewish converts had ever truly stopped being Jewish. All of which may explain why, curiously, even after becoming Christian, Heinrich Heine remains in both Jewish and secular literature a "Jewish poet," the Nobel Prize–winning chemist Fritz Haber remains a "Jewish chemist," and Eugen Gutmann, to this day, is still a "Jewish banker."

So the Gutmanns would remain Jewish in Gentile eyes, defectors in Jewish eyes, and secular in their own eyes. This situation would cause for subsequent generations, down to my own, no end of misunderstanding and loss of cultural connection and identity—some of it merely awkward, and some of it fatal.

Meanwhile, at home, other uncertainties loomed over Eugen as the new century dawned. His marriage to Sophie, never tranquil, was breaking apart. She had always been a difficult personality, headstrong and increasingly resentful of her duties. Eugen's reputed philandering could not have helped, but it was Sophie who became the subject of a scandalous rumor—an affair with a young tutor in the Gutmann household. Perhaps true, perhaps not, the story rocked the Berlin tabloids. There was even talk of a duel until the tutor fled the country.

It was all simply too much for the family. The couple divorced in 1902 and Sophie moved to Italy, where she married a young Italian count, Cesare Sciamplicotti. She died in 1915 when she was only sixty-three. It is perhaps revealing that after the divorce the three youngest children—Kurt, Max, and Fritz—all still teenagers, stayed home in Berlin with Papa.

After the divorce Eugen married another aspiring opera singer, a much younger German American woman named Mary Stevenson, who unfortunately died a few years later. With admirable vigor for a man of seventy-eight, Eugen then carried on an affair with the cele-

brated opera diva Barbara Kemp. He bought a Baroque manor house, the Schloss Zeesen, on a lake south of the city, where he continued to play host to Berlin society. He vacationed at the elegant Dutch seaside resorts of Scheveningen and Noordwijk, and at the new Hotel Waldhaus in Sils-Maria in Switzerland. As Eugen approached retirement, he could look back on a life that had been, for the most part, well and successfully lived.

EUGEN'S CHILDREN

Not surprisingly, Eugen's children would also have their trials and tribulations. His eldest daughter, Lili, was a great beauty—elegant, refined, and, thanks to her father, wealthy. As she came of age, she was a center of considerable attention from the young banking scions, diplomats, and bemedaled Prussian military officers who socialized at the Gutmann villa.

Among them was a dashing young cavalry major named Baron Adolf von Holzing-Berstett. Lili's 1898 wedding to Adolf was a lavish affair at which Prince Max of Baden, the last Chancellor of the German Empire, accompanied Lili to the altar in a church filled with exotic flowers gifted by Grand Duke Friedrich I of Baden. But their marriage proved unhappy. The union produced no children, and in 1909 the baron, beset by gambling debts, committed suicide. One wonders why he didn't ask Lili or Eugen for the money, but perhaps he had already gone too often to that well. Two years later, my great-aunt Lili would remarry, to an Italian diplomat and aristocrat, Luca Orsini Baroni. Significantly, Luca would later become the Italian ambassador to Germany.

Eugen's other daughter, Toinon, married Hans Schuster-Burckhardt, the son of the chairman of the Swiss Bank Corporation. Hans would become one of Eugen's most trusted aides at the Dresdner Bank. They had three children, but sadly, Hans would die in 1914 of an apparent heart attack. Toinon would later marry Baron Hans Henrik von Essen, the Swedish ambassador to Germany.

My great-aunt Baroness Toinon von Essen, Berlin, 1918.

As for Eugen's sons, they were a source of both pride and frustration. After sickly Walther's early death, Herbert became the heir apparent. He took a degree in international economics at the University of Berlin and then started his climb up the Dresdner hierarchy—first as manager, then assistant director of the bank's London branch, later as member of the Dresdner board and also director of the offshoot Deutsche-Orient Bank. Although dismissed by some as a "pale shadow" of his father, Herbert was a gifted banker who established close relations with other international business and financial leaders. He was also a consummate socialite, forging links with members of the royal court, including Crown Prince Wilhelm, the Kaiser's eldest son, with whom he shared a passion for golf.

Herbert fell in love with the beautiful Daisy von Frankenberg und Ludwigsdorf, a member of an aristocratic Catholic family. While Eugen liked Daisy, he opposed the marriage on the grounds that it was

just as easy to marry a rich girl as a poor one. Nevertheless, Herbert loved Daisy passionately, and the wedding went on.

Kurt, meanwhile, always something of a rebel, turned his back on a career at the Dresdner, studying instead literature and theater at university. He was a talented singer, making his amateur debut as a tenor at the Teatro Carignano in Turin. Unfortunately, in 1912, no doubt with Eugen's grudging financial backing, Kurt wrote, produced, and starred in a play in Hamburg that was widely panned. He married Vera Herzfeld, the daughter of a wealthy Jewish commodities magnate, which at least helped fulfill Eugen's requirement that brides come with the necessary wherewithal. But to Eugen's annoyance, Kurt became deeply involved in liberal politics.

Another son, Max, also preferred the arts to business. As close to openly gay as one could be in those days, Max studied art at the famous Dresden Academy and was a talented painter and pianist. He devoted his time between the salons of Berlin and Rome.

Then there was the youngest, Friedrich, "Fritz," the baby—my grandfather. Fritz was born in 1886, surrounded from birth by fabulous wealth and privilege. The youngest child, he was relentlessly coddled, babied, and fussed over by his older sisters and his remarkably indulgent father. A photo of the seven children, taken when Fritz was about three, shows all five boys dressed in sailor suits—the standard outfit for boys of upper-class families of the day—with Fritz in the middle, being held protectively in the arms of his fourteen-year-old sister, Toinon. Little Fritz, staring directly at the camera, seems quite comfortable being the center of attention.

By all accounts, Fritz was an intelligent, lively boy with a quick wit and subtle sense of humor that followed him into manhood. In the few photographs I have of him, including one by the American avant-garde photographer Man Ray, there is always a hint of a wry smile. Although he was handsome, Fritz was not physically imposing. Slightly shorter than average, and plagued from his earliest days with flat feet, he gamely tried but did not excel amid the "physical culture" craze then sweeping Germany. Still, he had definite leadership qualities—people

simply liked him—and a self-assurance often lacking in the youngest sons of powerful men. He held his father in awe but wasn't close to his mother, a remote woman who left when he was just fifteen.

One wonders what Fritz made of his family's place in the world. Through a child's eyes, the wealth—the servants, the carriages, the opulent home—would have been unexceptional, the natural order of things. But the family's religious and cultural status would have been a bit more complicated and confusing. Just twelve when the family converted, Fritz obviously had no say in the matter. Father's word was final.

Unlike his Jewish friends and cousins, Fritz never studied Hebrew, never had a bar mitzvah. And unlike his Gentile friends, he never attended church on Sunday, never went to Bible class, never took communion. He was different from most of the other boys. Although thoroughly assimilated and at least four generations removed from the Bohemian ghetto, I am sure, on many levels, Fritz still felt his Jewish heritage, but he never identified as Jewish, even though his Jewishness was never far away.

At the Royal Wilhelm Gymnasium, where wealthy Berliners, both Christian and Jewish, sent their sons, one of his classmates was Kurt Hahn, the famous educator. Other alumni included Walther Rathenau, the future Jewish-German foreign minister.

Like all the Gutmann children, Fritz grew up with a keen knowledge of and appreciation for the arts. Given Eugen's passion for the subject, and the magnificent artworks that filled almost every wall and cabinet at 10 Rauchstrasse, he could hardly have avoided it. Fritz also, as I would later discover, had some talent as a painter—this no doubt from Sophie's side—and was something of a poet. His interests lay in the appreciation of the arts, their history and philosophy, and, above all, aesthetics. Later he would wistfully say that he might have been happiest as a theater director or an art dealer. Perhaps things would have turned out very differently if Fritz had followed his own dreams and not those of his father.

Eugen, disappointed that Kurt and Max had not gone into the family business, and perhaps seeing Fritz as something of a last chance, was

eager for his youngest son to join the Dresdner Bank. Years of tutoring and family holidays all over Europe had given Fritz a cosmopolitan outlook and an impressive command of languages: German, French, English, Italian, and even some Dutch. After graduating from the Royal Wilhelm Gymnasium, Fritz skipped university and, at the young age of eighteen, went straight into banking at the Dresdner. Fortunately, he had, if not a love for the world of finance, most certainly an aptitude for it.

When Fritz joined the bank in 1904, the family interconnections were complicated and endless. Herbert, Fritz's brother, and Max, Eugen's brother, were board directors, as were Fritz's brother-in-law (Hans Schuster-Burckhardt, Toinon's husband) and Waldemar Mueller (a brother-in-law of Eugen's brother Alfred). Additionally, Eugen's first cousin Felix Gutmann was the first director of the Berlin branch of the bank. The Dresdner remained very much a family business, and as chairman of the board, Eugen was the Dresdner's guiding force.

I imagine that having all those family members already deeply ensconced in the Dresdner hierarchy must have seemed a bit claustrophobic for Fritz, just as it had been for Eugen many decades earlier at the Bankhaus Bernhard Gutmann in Dresden. But if filial duty denied him a career in the theater or art world, he hoped at least for some degree of autonomy within the family business. In 1910, after a few years at the bank headquarters in Berlin, Fritz was considered sufficiently prepared to be sent to Paris as a member of the board of the Banque J. Allard & Cie., in which the Dresdner had a controlling interest.

But unlike Eugen, who had lived in an era and in a country that, though flawed, had allowed him to flourish and prosper, Fritz was entering an era of upheaval and great uncertainty.

FRITZ AND LOUISE:
MARRIAGE, WAR, AND A NEW LIFE

Fritz Gutmann and Louise von Landau,
Baden Baden, 1913.

One can imagine what it was like to be a handsome, wealthy, well-connected—and single—young man in the Paris and London of the day. In Paris, Fritz took a bright apartment near the rue de Monceau,

close to the fabulous mansions of the great Jewish banking families—the Rothschilds, the Ephrussis, the Camondos, and others—most of whom had business connections, and in some cases distant familial ties, to the Dresdner and the Gutmanns. Fritz was soon quite at home. His duties at J. Allard & Cie. not being particularly onerous, he had plenty of time for a succession of lavish dinners, balls, and dances. The lure of the Parisian art world would also create a lifelong attraction.

My grandfather's favorite activity was to wander down the boulevard Malesherbes to the Madeleine and from there to the Ritz in the place Vendôme. The bar at the Ritz became Fritz's "other office" (oddly, years later he would still be using Ritz stationery for private memos). From there he would venture out into the endlessly enticing world of Paris's art emporiums.

Almost next door to the Ritz was the Seligmann brothers' celebrated gallery at number 23 place Vendôme. When Jacques Seligmann invited my grandfather to the newly converted Palais de Sagan, the guests were stunned by the array of masterpieces. Here, perhaps for the first time, Fritz found himself rubbing shoulders with his father's exalted world. Other art mavens included Edmond de Rothschild, and from across the Atlantic Eugen's old friend John Pierpont Morgan.

However, across the square at 8 place Vendôme, in an upstairs gallery at the beautiful old Hôtel Delpech de Chaunot, Fritz discovered the Renaissance sanctuary founded by Count Trotti. In his art gallery Trotti had assembled a veritable cornucopia of ancient artifacts from his native Ferrara, from Tuscany, and all of northern Italy. In retrospect, this was another clear confirmation of the Gutmann family's passion for all things Italian. Fritz made a mental note that when he had a home of his own (and walls to cover), this would be one of his first destinations. Apart from Fritz's already deep connection to the beauty of the Renaissance, he was also drawn to the charms of *l'impressionnisme*, a quintessentially Parisian sensation, and in particular the works of Edgar Degas.

Fritz did return to Paris many times, but obviously he could not

have foreseen the consequence, decades later, of events that would take place at number 16 place Vendôme.

In 1912, at age twenty-six, Fritz was named assistant director at the London branch of the Dresdner on Old Broad Street (just behind the Bank of England), a post held earlier by his brother Herbert. After *La Belle Époque* of Paris (much like the Gilded Age in New York), London might have seemed more than a bit dull. But for a lover of theater, London outshone even Paris. I can imagine young Fritz in spats, top hat, and tails, catching one of the last hansom cabs from his bachelor flat in Mayfair to see Johnston Forbes-Robertson—said by many to be the greatest Hamlet of all time—perform at the Theatre Royal, Drury Lane, or to catch the beautiful Anna Pavlova in her *Saison Russe* ballet at the new Palace Theatre.

As in Paris, Fritz's family and business connections in England offered a ready-made entrée into London society. His brother Herbert, one of the most gregarious of men, seemed to have befriended almost everybody who was anybody during his time in London. Fritz simply borrowed Herbert's calling card. It was all quite exciting and glamorous—lunches at Claridge's, balls at the Savoy, motoring weekends in the country, cross-Channel trips to Paris.

Hans Schuster, his brother-in-law, introduced Fritz to his longtime friend H. H. Asquith, Britain's Liberal Prime Minister and noted bon vivant. Asquith was something of a Germanophile, although this would cause him trouble later. When Toinon and Hans were in England, Fritz was often invited to play bridge with them at the Asquiths' country retreat in Berkshire. Fritz was also a frequent guest at the German Embassy at Carlton House Terrace, one of London society's most sought-after spots, where the new German ambassador and his beautiful wife hosted a breathtakingly ambitious series of balls and receptions. Fritz was beginning to develop a taste for this glamorous world.

During the summer of 1913, Fritz took a break from his hectic so-

cial life to catch some alpine air at a beautiful new hotel, the Suvretta House. The hotel had just opened its doors to universal acclaim the previous Christmas. Here, overlooking Lake St. Moritz in Switzerland, he found Louise von Landau. It was the first time Louise had been able to convince her mother, Thekla, to take a trip out of Germany since Louise's father had died.

Fritz and Louise had met before, but only briefly, at a party given by Gutmann relatives, the Arnholds, at their villa on the shores of Lake Wannsee, just outside Berlin. On that occasion Louise had, somewhat intimidatingly, been surrounded by more than a few competing suitors. Now in St. Moritz she was surrounded by only the majestic Engadine mountains, and my grandfather no longer felt any reticence. Fritz and Louise were clearly smitten by each other. Within a month he was writing to his father asking his consent for marriage.

LOUISE VON LANDAU

The Baroness Louise von Landau was the granddaughter of Jacob von Landau, whose family was originally from Breslau in Silesia, then part of Prussia, but now part of Poland. As a young man, Jacob had tried his luck running a tobacco factory, even horse-trading, before turning to banking. In 1852 he founded the Bankhaus Jacob Landau, first in Breslau and later in Berlin. The bank specialized in mining and metallurgy projects as well as loaning money to leading members of the nobility. In spite of coming from a long line of rabbis, Jacob deftly adapted to the life of an important behind-the-scenes player in the emerging economy.

One story, given credence by some scholars, has it that during the Franco-Prussian War, Jacob induced "mad" King Ludwig II of Bavaria into agreeing to integrate Bavaria into the new German empire— without which history might have been very different. For his services Jacob was granted a hereditary title of nobility by the Duke of Saxe-Coburg-Gotha.

By the time Jacob died in 1882, the Bankhaus Jacob Landau was

one of the largest private banks in Germany and was instrumental in the founding of the Berlin Edison Company (later the electric giant AEG), which brought electric lighting and tramways to Berlin and throughout Germany. Always a pioneer, Jacob was one of the first to get a telephone—his number was Berlin 14.

During this period, the social transformation of the emerging Jewish bourgeoisie was equally dramatic. As an example, in 1883 one of Jacob's daughters, Margarete von Landau, married Heinrich von Poschinger, a Catholic aristocrat. Poschinger was, among other things, Bismarck's biographer, and through his connections at court Margarete caught the eye of the future Kaiser. Not only would she become the Crown Prince Frederick's diarist, but later biographer and confidante to the short-lived second Kaiser.

Two of Jacob's sons, Hugo and Eugen, followed their father into the world of finance. But Jacob's eldest son and my great-grandfather, Wilhelm von Landau, had other interests. After graduating from the University of Berlin with a doctorate of philosophy, and armed with his share of the family's significant fortune, Wilhelm set out in 1870 on a life of world travel and study in archaeology, ethnology, and botany. He participated in, and helped finance, excavations at the ancient cities of Troy and Hattusa, the Bronze Age capital of the Hittites, both in present-day Turkey. Another excavation site was at the Temple of Eshmun (a Phoenician god), in what is now Lebanon.

Wilhelm became perhaps the world's leading expert on the ancient Phoenician alphabet. He wrote sixteen books, which were published in several languages, including English. These included the dauntingly titled *Travels in Asia, Australia and America, Comprising the Period Between 1879 and 1887*, which was packed full with a seemingly endless stream of soporifically dull facts and statistics, such as the exact length of the bridge between Council Bluffs, Iowa, and Omaha, Nebraska: 2,750 feet. Somehow Wilhelm still managed to convey a sense of joyful curiosity about the world's wonders, large and small.

The only photograph I found of great-grandfather Wilhelm shows a thin, hawk-faced man with a Vandyke beard, puffing on a cigar and

dressed somewhat eccentrically in a well-worn suit and homburg. His eyes seemed fixed on some distant horizon. Amid all of his writings and travels, at the somewhat advanced age of forty-two, Wilhelm found time to get married to his cousin, Thekla, a woman thirteen years his junior. Eventually, in 1892, they had a daughter, Louise—my grandmother.

Louise grew up surrounded by wealth and privilege in a social atmosphere filled with many of the leading lights of Berlin society. The von Landaus lived in a large villa on the Lützowufer, near the Gutmanns in the Tiergarten district.

In addition to her private tutoring in languages and music, Louise was enrolled at a young age in an exclusive private school. One of Louise's childhood classmates was Walter Benjamin, who would later become a preeminent German philosopher, literary critic, and essayist. In one of his most famous works, *Berliner Kindheit um 1900* (*Berlin Childhood around 1900*), Benjamin recalled his infatuation with the young "Louise von Landau . . . a little girl of the nobility [whose] name soon had me under its spell."

By the time Louise was presented to Berlin society, she had developed into a strikingly beautiful young woman—vivacious, intelligent, an accomplished pianist and keen sportswoman. She was one of the most sought-after young debutantes of the day, Jewish or otherwise.

Fritz's father would remark later that after Wilhelm's death in 1908, Louise was, while still relatively wealthy, not fabulously rich because her father had spent much of his share of the family fortune on too many excavations in ancient, dusty places. Meanwhile, around this time, Louise's uncle Eugen von Landau and his adopted sons (the Sobernheim brothers) were busy laying the foundations of the Commerzbank—a future rival of the Dresdner's.

The Gutmanns and the von Landaus moved in the same social circles. At the end of 1912, when Fritz returned to Berlin from London for a family visit, Louise was now twenty and in full bloom. At the Arnholds', over the holidays, Fritz had tried to get close to her, but another suitor, Paul Wallich, always seemed to be in the way. To make

matters worse, Paul was the son of Hermann Wallich, Eugen's archrival at the Deutsche Bank. Fritz kept his cool; always a careful planner, he would bide his time. He knew he would catch Louise alone soon enough. Then the following summer, as luck would have it, St. Moritz offered the perfect opportunity.

Although this was still an era when letters were lovingly kept and filed away in precise bundles wrapped with ribbons inside precious chests, not a single piece of correspondence between Fritz and Louise survived the conflagration that was to come. I can't help but imagine those letters, written carefully in an elegant hand, being tossed brutishly on some burning pyre. The madness of the mid-twentieth century destroyed not only millions of lives but millions upon millions of memories—gone, vanished, never to be recovered. Without those letters I struggle to know my grandparents.

The only letters concerning the impending marriage that do survive are two from Eugen in Berlin to Fritz in London in August 1913. I found the letters in those drab boxes that appeared in Los Angeles all those years later. These two businesslike and yet tender notes were among the few treasures that my father had managed to preserve.

Eugen noted that Louise would be a perfectly lovely bride, and that Fritz could "be sure that I will welcome your wife-to-be with the same love as one of my own children." He continued with this somewhat gruff fatherly advice: "A young man should not marry until he has already acquired some wealth and has, at least, a secure position which gives him the assurance that he has sufficient income to live in accordance with his position and, most importantly, without worries. Love alone is not enough. You also need the necessary 'pocket change' to go along with it." Eugen backed this up by noting that Fritz's annual income as assistant director of the London branch was currently some fifty thousand marks, but would be increased to eighty thousand marks if and when he became director. In other words, the marriage should wait.

Two things are significant in these missives. First, Eugen felt strongly that fifty thousand marks a year was insufficient for a married man to live in the style to which the Gutmanns were accustomed. This

at a time when the average salary for a worker in Germany was barely over a thousand marks a year. Second, Eugen's advice to Fritz is almost word for word the same he had earlier given his older son Herbert when he was contemplating marriage to (the less wealthy) Daisy von Frankenberg und Ludwigsdorf—and the result was exactly the same.

Despite Eugen's reservations, in November 1913, Fritz and Louise were married in a church because Louise had converted as well. The newlyweds departed for their honeymoon in Italy. Soon after, while staying at the new and grand Hotel Excelsior in Rome, Fritz received the following message from Eugen, in terse telegram style: "Yesterday meeting [of the Dresdner board of directors] named [you] director [of the London branch]—2½ percent bonus. Greetings Papa." The old man had come around and come through. In addition to the promotion, the honeymoon was successful on another level as well. By the time they returned to London, Louise was pregnant.

Fritz took a comfortable country home just outside London in Byfleet, Surrey, for his family—complete with butler, maid, and cook—and assumed his new duties as the director of the London branch. Although Louise's "delicate condition" soon precluded her involvement in outside social activities, it was a happy, promising time for a young couple just beginning their lives together.

However, my grandfather had an almost uncanny and tragic knack for being in exactly the wrong place at precisely the wrong time.

In Sarajevo, on June 28, 1914, a nineteen-year-old Yugoslav nationalist named Gavrilo Princip assassinated the Archduke Franz Ferdinand, heir to the Austro-Hungarian throne. Barely five weeks later, following the German invasion of Belgium, at midnight on August 4, 1914, Britain declared war on Germany and the Austro-Hungarian Empire.

Shock and confusion reigned in London—mixed with no small measure of war excitement. Shipping lines to the Continent were canceled; German ships in British harbors were seized. Telegraph and mail communications with Germany were cut off, a blockade of its

ports begun. "Spy fever" raged with German bankers, journalists, and, curiously, waiters and domestics suspected of being advance agents for the Kaiser. A moratorium on all international financial transactions was imposed, and within days British police arrived at 65 Old Broad Street to seize the Dresdner Bank's records and cash reserves—in effect putting the bank into British receivership. Similar police raids were conducted on the London branches of the Deutsche Bank and the Disconto-Gesellschaft.

The quickly enacted Alien Restriction Order required all German and Austro-Hungarian nationals to register with the authorities. Military-age "enemy aliens" were barred from leaving England and traveling even to neutral countries, lest they return home to Germany and swell the ranks of the Kaiser's armies. Soon, even German women were prohibited from leaving.

Some wealthy and well-connected Germans managed to slip out of England in the very first days after war was declared and make it to various neutral countries—Holland, Sweden, and even the United States. Fritz and Louise could perhaps have done the same, but they did not. Fritz, no doubt, felt that Louise's pregnancy made it too dangerous for her to travel. He probably also underestimated—not, as we'll see, for the last time—the hatred and passions that modern war engendered, not just on the front lines but on the home front as well, even in supposedly civilized nations. Whatever the reason, instead of fleeing with the war's first shots, they stayed and the window of opportunity to flee soon closed. Along with some sixty-six thousand other German and Austrian citizens—men, women, and children—Fritz and Louise were stranded in Britain.

Amid all this confusion and misfortune and dawning worldwide catastrophe, on August 24, 1914, in Byfleet, Surrey, my father, Bernhard Friedrich Eugen Gutmann, was born. As a curious consequence, little Bernard (as he would come to be known) was thus under British law a British citizen, which would have a profound impact on his destiny, and mine. Despite their son's dual nationality, Fritz and Louise were, by both law and allegiance, considered enemy aliens. Soon

thereafter, the British government announced that all military-age enemy civilian males would be interned. My grandfather Fritz Gutmann would be one of them.

This was unprecedented. In previous modern-era European wars, civilian citizens of belligerent states caught behind the lines may have been harassed, persecuted, driven out, or even murdered individually, but they had never been rounded up and imprisoned en masse. Germany reciprocated by arresting several thousand British civilians. Meanwhile, with few exceptions, all enemy alien women, children, and old men would be deported, regardless of how long they had lived in Britain, even if they were married to a British citizen.

Fritz managed to avoid the first wave of internments, but for him and Louise, as with almost every other German still in England, life became increasingly difficult. Their movements were restricted by security regulations imposed on all enemy aliens and by a curfew from 9:00 p.m. until 5:00 a.m. Rising anti-German public opinion left the young couple ostracized from their former British friends. Fritz and Louise, with their new baby, found themselves living under a form of house arrest. In time British anti-German attitudes hardened even further, especially after the sinking of the passenger liner *Lusitania* by a German U-boat in May 1915, with great loss of life. During riots in London and other British cities, German-owned shops were attacked and ransacked by mobs. Parliament called for strict enforcement of the alien internment and deportation policies, with no exceptions whatever. The prevailing slogan was "Collar the Huns."

Mercifully, late in May 1915, a deal was worked out between the Germans and the British for the repatriation of noncombatants. Louise and baby Bernard bade Fritz a tearful good-bye and left for Harwich, where a cross-Channel ship, bound for neutral territory, was waiting.

One of the rare family tales that I was able to extricate from my father went something like this: Because Bernard threw a tantrum, my father and my grandmother missed the ship they were scheduled to board, only to discover later that it had been struck by a torpedo or mine and sunk. Mercifully the next ship reached Holland safely. From

there they crossed the border into Germany, then went on to Berlin, where they moved in with Eugen at the family home on 10 Rauch-strasse.

Fritz's incarceration began in a rather civilized manner. A constable knocked on his door in Surrey and politely asked if the gentleman would be so good as to report to the police station in the morning. The following day Fritz went to the station, carrying only the permitted two small suitcases. From there he was transported to the Isle of Man, where some twenty-three thousand German and Austrian male civilian internees—an eclectic mix from every conceivable profession and social stratum—would spend the war behind barbed wire. It would be more than three years before Fritz would see his wife and baby son again.

The Isle of Man is a tiny, sparsely populated, and windswept island set between England and Ireland in the stormy Irish Sea. For most of the past thousand years or so it has been a largely forgotten place—a barren and almost perpetually gloomy bit of rock far removed from the great affairs of the world. In 1914, the British government considered the Isle of Man to be the perfect place to isolate "enemy" civilians unlucky enough to find themselves stranded in Britain at the start of the First World War.

Two internment camps were on the Isle of Man. The government requisitioned Douglas Camp, originally a holiday camp for boys, and surrounded it by twin barriers of ten-foot-high barbed wire. The larger Knockaloe Camp was built from scratch to handle the growing overload of internees. Initially housed in tents with bunks and straw-filled mattresses, the prisoners were later moved into single-story wooden huts. The camp food was predictably execrable; back in England the typical man on the street muttered that it was a pity the English had to feed the bloody Huns at all.

There were some amenities: a camp hospital, a library, an athletic field for exercise, even a camp school where prisoners could lecture

other prisoners ranging on subjects from "Glass Manufacture" to "A Pictorial Journey through North East Siberia."

My grandfather found his own way to survive the tedium and isolation—he devoured every book available. Then, compensating for a missed university life, he indulged his fellow inmates with erudite lectures on theater, literature, and philosophy—everything from Ibsen to Marx to Darwin. Prisoners could receive and send mail—thoroughly censored—and they were allowed to organize concerts and plays. Ironically, Fritz, who had often dreamed of being a theater director, was allowed to stage a number of Shakespearean productions—in German (notably Theodor Fontane's famous translation of *Hamlet*). Many in Germany still maintain that Shakespeare in German is better. Meanwhile, all the women's parts were played by men in female attire, with Fritz appearing, in cameo, usually as an old man. His English was impeccable, but he stubbornly refused to speak it on the grounds that if he was locked up for the crime of being a German, then a German he would be. Like most of his Berlin contemporaries Fritz had started off as a confirmed Anglophile—sadly that died on the Isle of Man.

Hobbies and small crafts were encouraged among the internees. Drawings and other artworks were also popular. One internee named Brelow carved from wood and old bone a beautifully intricate ex libris stamp for Fritz, portraying an art deco sphinxlike figure over the name *F. B. Gutmann*. The ex libris stamp, and a signed and (later) framed copy of the pencil-and-charcoal drawing that served as the prototype, were among Fritz's most precious mementos after the war.

The stamp itself was later lost, but almost unbelievably, some years ago while I was rummaging through an antique-books shop in Rotterdam, I was astonished to see hanging, on the wall above a shelf of dusty, old editions, the framed prototype drawing of the ex libris stamp, signed by the artist and inscribed *Douglas, 1917*. I knew that the drawing must once have been my grandfather's. It seemed quite impossible, almost eerie, that I would stumble by chance upon such a thing, and yet there it was. Feigning indifference, and of course not mentioning my personal connection, I asked the antiques dealer if he knew where this

somewhat unusual item had come from. I already knew the bitter an-
swer, but the shopkeeper only shrugged. With a minimum of haggling,
I bought it for seventy-five euros, which for the shopkeeper was a fair
price. For me, the old framed drawing was priceless.

Despite the grim surroundings on the Isle of Man, one might argue
that Fritz and the other internees were actually lucky. Unlike German
soldiers, the German men who were interned on the Isle of Man could
be reasonably certain, barring some serious medical problem, of surviv-
ing the war.

Still, I imagine that Fritz would have been more than willing to
take his chances. None of Fritz's many letters home survive, but I did
find, in those old boxes, a poem in his wartime notebook (on theater
and philosophy) that he wrote, in German, during his incarceration:

> *The nights are impassable palaces.*
> *Lurking through are the mysterious grins of horror.*
> *Behind doors ghosts are assembling,*
> *not knowing about each other*
> *not knowing about life*
> *or about the burden of the prowling masses,*
> *crowding the earth.*
> *Nor had they ever heard the roaring song of love.*
> *Not to comprehend is the fate of the damned.*
> *Their feelings numbed, they languish in derangement*
> *and die the death of poverty.*
> *Shove them beneath the stubble field!*
> *But the victors grow and ascend through the ether*
> *in the twilight of the universe*
> *and herald the song that the others despise.*

Other accounts of life in the camps speak of the mind-numbing
monotony, the soul-killing isolation. By the end of the war, interna-
tional observers reported that almost every internee suffered to some
degree from a form of clinical depression dubbed barbed-wire dis-

ease. Fritz did not go mad behind the wire, but as the wasted months and years passed by, he was increasingly bitter, angry, and defiant. He waited and waited, feeling his youth slipping away. He dreamed of his wife and child.

The euphoria for war was perhaps greatest in Germany. Pastors, priests, and rabbis alike preached that the war was just and necessary, and of course that God was on Germany's side—a timeless and universal conceit. Strangely, most German Jews saw the war as an opportunity, a chance to prove once and for all their inherent Germanness, and to remove the still-lingering barriers against them in the army and the German civil service. After all, the Kaiser himself had announced in his initial war speech to the Reichstag that there could no longer be distinctions of religion, class, or ethnicity in Germany. "I know only Germans," Wilhelm declared to thunderous approval.

At first, it seemed as if German unity could be realized. The Prussian high command, albeit grudgingly, finally allowed a handful of Jews into the officer corps. Louise's uncle Eugen von Landau became the first Jewish cavalry officer to make it to the rank of major (without converting). Jews also were admitted in greater numbers to the higher ranks of the judiciary and civil service. But eventually, as the casualties at the front mounted—a third of a million Germans dead at Verdun alone—and the deprivations at home grew more severe, the German people's initial enthusiasm for the war, and the sense of national unity that it had engendered, began to sour. Military requirements, coupled with the increasingly effective British naval blockade, made fresh foodstuffs increasingly hard to find. Long queues formed outside shops for bread, milk, sugar, everything. By the end of 1916, turnips and beets were the primary staples of the urban German diet, and some foods, such as fresh meat, were almost impossible to get in the cities, even at wildly inflated black-market prices. There were riots in some German cities.

As in almost every period of economic or social stress in Germany, the latent anti-Semitism that seemed to lurk just below the German

psyche began to reassert itself. Much of the widespread fear and contempt was directed at the *Ostjuden*, the poor and culturally foreign Eastern European Jews who streamed by the tens of thousands into Germany from the Eastern Front and congregated in the cities in appallingly primitive conditions. Many German Jews worried that the newcomers would erase the gains that they had made in assimilation.

Native-born German Jews were not immune to the renewed wave of anti-Semitism. German Jewish bankers and industrialists, it was muttered, were intentionally prolonging the war to boost their profits; Jewish black marketers were getting rich while Christian babies starved. Right-wing members of the Reichstag claimed that young German Jewish men were "draft dodgers," and even if they were conscripted, they always got safe, cushy jobs in the rear, while the "real" Germans did the fighting. In a seemingly self-defeating effort to prove that last calumny, in late 1916 the German high command ordered a survey of the troops—the infamous "Jew census"—to determine how many Jews were serving in the army, and in what capacity. When it was found that a hundred thousand German Jews were in the ranks, and serving in equal proportion in the front lines, the report was officially suppressed.

Meanwhile, another "census" demonstrated even more dramatically the devotion of German Jews to their country—namely twelve thousand Jews died fighting for the fatherland. Among them were Sergeant Erich Waldemar Gutmann, the twenty-five-year-old son of Eugen's brother Alfred, killed in Flanders in 1915 while serving in an infantry regiment, and Lieutenant Hans Gutmann, the thirty-three-year-old only son of Eugen's brother Max, also killed in Belgium in 1916.

Many years later, during a visit to Dresden's New Jewish Cemetery with my wife, May, and our ten-year-old son, James, I found poor Erich's and Hans's names inscribed on a post–World War I monument to the Jewish sons of the city who had died for the *Vaterland*. Along the mossy east wall I discovered the graves and headstones of the *Familie Gutmann*—among them the graves of the Bohemian patriarch, Bernhard, his wife, Marie, and their son Alfred. The stones were inscribed in Hebrew and German and bore Stars of David. Somehow, those Jewish

graves and symbols, and that cenotaph to World War I Jewish war
dead, had survived virtually undisturbed for the last eighty years—from
Nazi rule, then Allied bombing, to Soviet invasion, and, finally, East
German skinheads bearing spray-paint cans. It seemed nothing short
of miraculous—so much so that I wondered if the spirits of those dead
young Jewish soldiers had somehow served as otherworldly guardians
at the gate of the cemetery.

The rabbi who unlocked the seldom-used gate and let us in had
sensed I was Jewish and had given me a yarmulke to wear. I hadn't
had the heart to tell him that my branch of the Gutmanns hadn't been
Jewish since 1898. But seeing those graves, feeling that connection, I
wondered if, for me at least, that was completely true.

By 1916 no German family, no matter how wealthy, could be totally
isolated from the war's effects. True, the residents at 10 Rauchstrasse
were far better off than most. Black-market food prices could be paid,
and what could not be bought could be grown. In the grounds behind
the mansion the lawn was torn up and a vegetable garden planted. As
soon as baby Bernard arrived in Berlin, Eugen even installed a cow on
the estate grounds to provide milk for his grandson, which it faithfully
did until it was stolen for meat by hungry Berliners. Parties and din-
ners were still held at the Tiergarten villa and the Schloss Zeesen, with
a concert here and there, and occasional nights at the opera, but the
grand and glittering affairs of prewar days receded into the past.

Fortunately for Eugen, most of his sons would remain out of harm's
way. Fritz, of course, was isolated on the Isle of Man. Herbert contin-
ued as director of the Deutsche-Orient Bank. His extensive contacts
with Germany's ally the Ottoman Empire made Herbert vital to the
war effort. Kurt, unlike most Germans, had held on to his liberal,
pacifist beliefs even as the war began, beliefs that only grew stronger
as the bloodletting went on. He authored a number of articles and
essays questioning the war. His book *La Vérité est en Marche!* had to be
published in Switzerland to keep a step ahead of the increasingly harsh

German censors, not to mention internal security services. Kurt managed to stay out of jail but created endless headaches for Eugen.

I discovered just recently that Max was not so fortunate. Wrenched from the comfort of Berlin's salons, he found himself by the end of 1914 on the Eastern Front. Max fought valiantly in the frozen swamplands of Lithuania, ending up, improbably, as sergeant major of the Second Dragoon Guards.

Despite successes on the Eastern Front, by autumn of 1918 the German army was exhausted and the people restless. A spirit of revolution and mutiny spread quickly throughout the country. Along with the German high command, the new German Chancellor, Prince Max of Baden—the same Prince Max who had escorted Great-Aunt Lili to the altar when she married the ill-fated baron—urged Kaiser Wilhelm to abdicate. On November 10, the last Kaiser begrudgingly crossed the border into neutral Holland and into sullen exile, never to return again to Germany. The Kaiser, now technically a war criminal, had begun the war by preaching unity throughout the Reich, but now resorted to blaming the Jews for his woes.

The war had been a catastrophe for Germany. When the shooting stopped on November 11, 1918, 2 million German soldiers were dead, along with hundreds of thousands of civilians. After four years of their own staggering losses, the victors were in no mood to be generous to the vanquished. Through the Treaty of Versailles, Germany would be stripped of her colonies, see her national borders shrink, her military dismantled, her merchant fleet seized, and then have part of her territory occupied. Carl Melchior, a partner of Max Warburg's and Germany's financial adviser to the Treaty of Versailles, tried vainly to scale back the staggering war reparations. Years later, Hitler's deputy in the Reichstag would blame Melchior, Rathenau, and Jews in general for Germany's humiliating defeat.

Meanwhile, in the immediate aftermath of the Kaiser's abdication, Germany was near anarchy. Although the moderate Social Democrats were in nominal control of the new German Republic, all was chaos as various left and right factions battled for supremacy. There were gun

battles, strikes, mass demonstrations, assassinations, riots. In Berlin, civilians fired Mausers and machine guns from behind barricades, women cut up dead horses in the street for food, mobs ransacked stores, and disabled soldiers begged on the sides of the roads. For a while there was genuine fear of a Russian-style Bolshevik revolution in Germany, with all that would entail.

The war had been a disaster for the Dresdner Bank as well. Its assets were seized in Britain, France, Russia, the Middle East, the United States, and elsewhere—never to be returned. The bank had lost roughly half of its prewar capital. Wartime inflation, though a mere shadow of what was to come, had further weakened the Dresdner's capital position, and Germany's uncertain political and financial status had choked off access to almost all foreign credit.

However, the Gutmann family had one bit of good news amid all this turmoil: even before the war ended, Fritz had finally managed to escape from the Isle of Man.

Fritz's escape was not some feat of derring-do, but rather the result of an agreement signed in The Hague between the belligerents in 1917. Fritz's brother-in-law, the neutral Swedish diplomat Hans Henrik von Essen, served as a vital go-between. Great Britain agreed to release to the custody of the Netherlands some sixteen hundred German internees, while Germany agreed to send a smaller number of British internees there. Loaded aboard a Dutch paddle steamer marked as a "hospital ship" to avoid German submarine attack, Fritz sailed to Rotterdam. The sixteen hundred men were technically still interned and, therefore, unable to return to Germany. However, for the first time they were allowed to move about more or less freely. Although Fritz seldom if ever spoke of his wartime experiences, other German internees later wrote of the joy of having a good meal in a restaurant, of seeing women and children again, of breathing free air. On the downside, a number of internees initially had trouble dodging cars and trolleys and even climbing stairs, none of which they had seen for nearly four years.

Although initially restricted to the Rotterdam area, Fritz eventually got permission to relocate to the coastal resort of Noordwijk, which for him was almost like going home. As a boy he had spent many a Gutmann family holiday at the fashionable Grand Hotel Huis ter Duin, set amid the sand dunes. Inland, behind the windy dunes, began the vast tulip fields that stretched from Leiden north to Heemstede.

That tradition would continue. In the 1950s my family would often stay in Noordwijk—also in the grand style that my father always insisted on, but could not really afford. Nick and I would play hide-and-seek among the giant wicker chairs on the windy beach, while my father was off to Amsterdam or The Hague on, what was to us, another of his mysterious quests.

With money wired from Berlin, Fritz rented a generous suite of rooms, and after overcoming the usual mountain of Dutch red tape, Louise and three-year-old Bernard finally were able to cross the heavily guarded German-Dutch border and join him. The reunion, like their honeymoon, was successful on multiple levels—Louise was soon pregnant again.

Still not allowed to return to Germany, Fritz waited for the war to end and pondered his future. Given the troubles Fritz foresaw for Germany and the situation at the Dresdner, the prospects did not seem particularly bright or appealing. Instinctively, he sensed that the peace and calm he found in neutral Holland, and its ability to act as a safe haven between opposing forces, would be key.

Fritz was not the same man he had been four years earlier. Some of the changes were what one might expect of a former prisoner of war. He had developed an aversion to confined spaces, a desire to make up for lost time, and a near obsession with food (for the rest of his life Fritz would hate to see food wasted). But some of the changes went deeper. The years in prison had been a leveling experience. On the Isle of Man he had been closely aligned with men of every class and background and had found that he could move easily among them. Like his father, he would be dignified, but approachable; exacting, but at the same time generous. True, he could at times be angry and impa-

tient. But he still maintained his wry sense of humor, only now with a sharper, almost caustic edge. With a comment or even just a look, he could be withering, even to those he loved. Yet, unlike so many others who had been caught up in the war, the years in prison, the memory of being marched through the London streets amid the crowds of jeering, hate-filled faces, had not left him with a lust for revenge. If anything, for the rest of his life he would feel nothing but disdain, even contempt, for nationalism, militarism, the superheated passions of politics and ideology and ethnic hatred—all of which would continue to consume Germany for decades after the war to end all wars.

Perhaps Fritz sensed that Germany offered only chaos, when all he wanted was peace. Whatever the reason, after four years of defiantly being a German, he would, ironically, soon no longer be one.

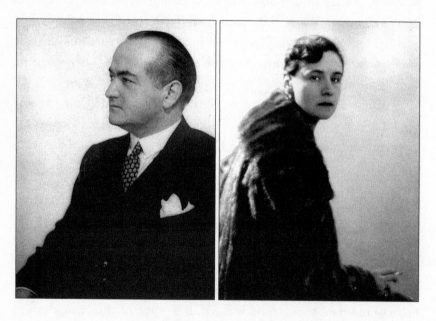

Fritz and Louise by Man Ray, Paris, 1926.

HOLLAND AND BOSBEEK: THE YEARS BETWEEN THE WARS

Bosbeek in 1930.

As Fritz waited for the war to grind to a halt, he had plenty of time to examine his options—and what role the Dresdner Bank might play in it all. His father was still in overall control of the bank, but at age seventy-eight Eugen had increasingly shifted day-to-day operations to his son Herbert and to Henry Nathan, a trusted friend and longtime board

member. Sooner rather than later, the unthinkable, yet inevitable, would happen when Eugen relinquished control. Fritz had always got on well with his brother and Nathan, but he had lost almost four years on the Isle of Man. Now, at age thirty-one, it seemed likely that if he rejoined the Dresdner, he would be relegated to a somewhat minor role in the bank, perhaps indefinitely.

Just four days before Fritz's thirty-second birthday, the war ended.

While celebrating in Amsterdam, Fritz and Louise met a thirty-three-year-old Hamburg-born banker and stockbroker named Ernst Proehl, and his Austrian Jewish wife. The two young couples, who both had small children, quickly took to each other. Proehl, a naturalized Dutch citizen with a seat on the Amsterdam stock exchange, was, like Fritz, intelligent, sophisticated, and urbane. They also shared a passion for art.

Proehl was a shrewd businessman with an eye for opportunity. Both he and Fritz saw that neutral Holland stood to benefit from the financial paralysis that would engulf postwar Germany. He understood also that Fritz's international banking experience and his position in what was still Germany's second-largest bank could be an invaluable asset. Proehl proposed that Fritz remain in Holland and that they go into business together. They were thinking along the same lines. Fritz found it an attractive notion, a chance to achieve independence, to live his own life out from under the shadow of his father and his older brother.

Of no small importance was that Fritz liked Holland. A constitutional monarchy, liberal by tradition, and with a rich artistic and cultural heritage, the Netherlands was a peaceful place. Holland's last war had been back in 1830 against Belgium, and that hadn't really been a war at all. Fritz liked the people and he liked the countryside. After the inner torment of years of incarceration, his soul was soothed by the flat and endlessly serene Dutch landscape. It may have been somewhat dull compared with Paris or London, or even prewar Berlin, but for a man with a young and growing family, Holland suited him perfectly.

Fritz returned to Berlin to greet his father and announce his de-

cision to the family. Happily, Fritz's idea to settle in Holland also appealed to Eugen and the Dresdner. Until Germany could shed its pariah status among foreign investors and get its economic house in order, the Dresdner desperately needed a neutral-based affiliate that could channel foreign credit to the bank—and how fortunate that the affiliate would be headed by someone of unquestioned loyalty and trustworthiness.

So in early 1919 the firm Proehl & Gutmann was registered with the Dutch government and the Amsterdam stock exchange, with offices on the fashionable Gouden Bocht (Golden Bend) stretch of the Herengracht, a canal in Amsterdam. Firma Proehl & Gutmann would specialize in short-term bank acceptances, international lines of credit, and stock issues—much of it in collaboration with the Dresdner Bank.

Fritz's decision to go into business in Holland had been fortuitous. Dozens of other German banks would also open affiliate offices in Amsterdam to escape the postwar chaos and credit restrictions imposed on Germany, but Firma Proehl & Gutmann had been among the first, and it prospered. Later Eugen, as retiring chairman, purchased a controlling share in the firm for the Dresdner in 1920. Technically, Fritz was thus again answerable to the family business, rendering his period of independence brief, but there were compensations. With the buyout, Fritz and Ernst Proehl were suddenly very wealthy men.

Fritz and Louise leased an elegant town house on the Koningslaan, overlooking the Vondelpark, in the heart of the city, and began to live their lives together—for the second time. Fritz's family flourished. Daughter Lili was born on July 17, 1919, this no doubt to the childish annoyance of her five-year-old brother, my father. After the long years of separation, Bernard was just getting to know his father. He had always imagined his father returning with a long beard, like an explorer. Bernard was having to make serious adjustments when, suddenly, there was a new center in Fritz's universe—Lili, bubbly and precocious, Daddy's perfect little angel. In a photograph of Lili that survives, she is age four, dressed in a mink-lined coat and muff, a mirror of the young Louise. As Fritz adored Louise, so he adored little Lili.

Young Bernard had a somewhat more difficult time. Quiet, deliberative, and extremely close to his rather indulgent mother, he suddenly had to deal with a new authority figure when his father returned home. Fritz, though loving and affectionate, could at times also be demanding and impatient. In contrast to his sister, a photograph of Bernard at age nine shows him dressed in the still-obligatory sailor suit, with his arms stubbornly crossed, and his dark eyes staring almost defiantly at the camera. Additionally, Bernard was left-handed, which was then considered something of an affliction—one to be corrected. His being forced to write with his right hand at school no doubt contributed to the slight stutter he developed as a child, which would in times of stress manifest itself throughout his life. However, his being a natural lefty in a right-handed world left him almost completely ambidextrous, often an advantage in what was Bernard's primary passion—sports. Unlike his father, Bernard was a gifted athlete, excelling from a young age in ice-skating. The winter-frozen canals of Holland were an ideal training ground. Soon he added skiing, tennis, ice hockey, and even cricket to his list of achievements, and still later javelin and discus throwing.

Both children were as Dutch as any of their school chums and spoke the language like natives, but the legal reality was more complicated. Lili was by birth a Dutch citizen, as well as, through her parents, a German citizen, while Bernard was still both German and British, and Fritz and Louise remained, technically, Germans. Fritz simplified the situation in 1924 when, after the required five-year residency period, he and Louise—and through them, young Bernard—officially renounced their German citizenship and became naturalized Dutch citizens. For Fritz, always a man of the world, it was an emotionally liberating moment. Germany had begun to feel claustrophobic. He had never felt as German as his father, Eugen, who was German down to his very soul.

Dutch citizenship had various practical advantages, but I suspect that deeper down Fritz desired to further insulate himself and his new family from the bitter, and often violent, upheavals now escalating in Germany. Under the generally well-intentioned, but fatally weak governance of the Weimar Republic, the chaos that had immediately

followed the end of the war continued unabated into the mid-1920s. Strikes, political street fights, assassinations, left-wing revolts in the Ruhr, and right-wing revolts in Berlin and Munich were ripping the country asunder. The Munich revolt included, ominously, an attempted "putsch" by a tiny party called the National Socialist German Workers' Party, led by an obscure ex-corporal.

Perhaps the most grievous blow to the nation was the infamous hyperinflation of the early 1920s—a period of printing-press insanity that at its worst point saw the German currency decline to roughly 4 trillion marks to the dollar. A loaf of bread that had cost one mark before the war now suddenly cost, incredibly, 200 billion marks. The inflation wiped out the savings of millions of Germans. The country devolved into essentially a barter economy, with hausfraus selling their shoes to buy bread and their family heirlooms to buy coal. Inflation was finally brought under control in 1924 with the help of Hjalmar Schacht, a former Dresdner Bank executive.

Schacht was, by then, the Weimar government's commissioner of currency. However, the nation's moral foundations had been badly shaken. Crime, prostitution, divorce, suicide, and corruption all soared. And, as always in Germany during times of crisis, so did anti-Semitism. Mobs in Berlin on at least one occasion ransacked several Jewish-owned shops amid cries of "Kill the Jews!" Fritz could only watch Germany with increasing apprehension from the relative peace of Holland.

The Dresdner Bank, like all German banks, had suffered during the inflation madness, but it survived under the capable direction of the team Eugen left behind. One added burden was the need to take on hundreds of extra bank employees just to handle the huge piles of million-mark and later billion-mark notes then in circulation. Among those new employees, and by all accounts not a particularly good one, was a frustrated writer named Joseph Goebbels. His Jewish girlfriend had helped him get a job as a clerk in the Cologne branch.

Eugen had retired in 1920, taking on the mostly honorary position of chairman emeritus. His seminal role in the bank's history was memorialized with a life-size bronze bust by the noted sculptor Hugo

Lederer. The original was installed in the great banking hall of the Berlin headquarters, with copies placed in every branch office.

Embracing his newfound freedom, Eugen spent less and less time in Berlin. He enjoyed visiting the luxury resorts and spas in the more healthful climes of the Black Forest and the Swiss Alps, and taking the healing waters at Bad Gastein in Austria. Worn down by the war and the shocking collapse of the old Germany he had known and loved, Eugen had grown increasingly frail in his later years. A photo I found shows him with hair and mustache brilliantly white, sitting dignifiedly erect, but with his obviously expensive suit hanging in loose folds over his thinning frame. Still, he retained his sense of humor and love of children and family. My father, then eleven, later remembered how his grandfather had doted on him and little Lili when they had visited him at his hotel in Interlaken—and how the old man, still up to his old tricks, had delighted in cheating them at cards.

Eugen maintained an enormous fortune in relatively inflation-proof real estate, foreign currencies, and securities—as well as the famous silver collection. In his waning years, he gave considerable thought to how to pass that fortune along. Ultimately Eugen decided that rather than dividing it equally among his six children—great fortunes divided tend to be frittered away piecemeal—he would create a family trust to be nurtured and grown, presumably in perpetuity, for the benefit of not only his children, but subsequent generations as well. Suspicious as ever of decisions by committee, he also had to decide which of his sons would administer his financial legacy. (I suppose given the mores of the era, his daughters were not even considered.) Max or Kurt, of course, simply wouldn't do—which left Herbert or Fritz.

Max, a lovable and popular fellow but certainly no businessman, continued to devote his time to the music salons of Rome and Berlin. Included among his many well-known friends were Winifred and Siegfried Wagner, the son of the legendary composer, and Elisabeth Förster-Nietzsche, sister of the famous philosopher. All of this was more than a bit curious given that Winifred Wagner was a well-known anti-Semite and a close personal friend of the leader of the

Munich putsch, Adolf Hitler. Elisabeth Förster-Nietzsche was also a noted anti-Semite, whose late husband had been an early advocate of "pure Aryanism" in Germany. Ironically, anti-Semites in Germany commonly spouted the most vicious diatribes against Jews in general while assuring their actual Jewish friends and associates, "Of course, we don't mean you!" Perhaps an equally insidious and fatal corollary was a tendency among some German Jews, particularly the wealthy and well connected, to respond to such anti-Semitism by deluding themselves with the assertion "Of course, they don't mean us!"

Max even numbered among his many acquaintances the Vatican's ambassador to Berlin, Archbishop Eugenio Pacelli, who would later become Pope Pius XII. The future pope was an inveterate socialite who would host numerous parties at his Tiergarten home. On more than one occasion Max, a frequent guest, would play the piano, flawlessly it was said. The future pope's favorite piece was the "Death of Isolde" (sometimes known as the "End of the World") from Wagner's famous opera *Tristan and Isolde*. This connection to the Vatican, and his sister Lili's closeness to other members of the Italian nobility, would later prove crucial when Max found himself on the run in Italy.

Kurt Gutmann, although charming and affable, was also not an inspired businessman. After the war, Kurt served as an assistant to family friend Walther Rathenau when he became Germany's first Jewish foreign minister. Rathenau's subsequent assassination in Berlin in 1922 by right-wing thugs was a terrible blow for Kurt. Disillusioned, Kurt and his wife, Vera Herzfeld-Gutmann, turned to the film business, of all things. Vera's father, a Berlin entrepreneur and notorious wheeler-dealer, had become known as the Potash King for his near-monopolization of that vital fertilizer. Hugo Herzfeld's spectacular success brought with it the inevitable accusations of "Jewish conspiracy." When Herzfeld died suddenly in 1922 of a heart attack, the Berlin stock market nearly collapsed. Vera and Kurt quickly sold a large share of his holdings and invested, instead, in Universum Film AG (UFA), the famous studio that was home to such stars as Marlene Dietrich, Henny Porten, and actor-directors Fritz Lang and Kurt Gerron. Lang was director of the

expressionist masterpiece *Metropolis*, the most expensive silent movie ever made—which may help explain why the film company was nearly bankrupt by 1927 and the stockholders, including Kurt and Vera, were deeply in the red. Evidently, Kurt was not the sort to whom a family fortune could reasonably be entrusted.

Herbert, as the eldest son, might have seemed an obvious choice as executor of the Gutmann estate. After all, he had been successful as director of the Deutsche-Orient Bank, which, after the disruption of the war, had been able to reopen its branches in the Middle East in 1923. He was a powerful player in the Dresdner hierarchy, and he was a director on the boards of three dozen major German companies. Yet, for all his accomplishments, Herbert was also something of a risk-taker, a man who enjoyed the fast life. Eugen had sometimes shared such traits, but he knew they did not lend themselves to the careful preservation of a family fortune.

Stable and cautious in money matters, Fritz was also the family diplomat. As he neared forty, it was decided that he would become executor of Eugen's estate and director of the Gutmann Family Trust. Incorporated in Amsterdam, the trust developed into a multimillion-dollar financial concern. Fritz also became caretaker of the famous "silver collection," which still included such priceless pieces as the Lencker ewer, Abraham Drentwett's three exceptional globes, in silver and vermeil, supported by Saturn, Atlas, and Hercules, and the enigmatic Orpheus Clock. My grandfather could not have known it then, but those responsibilities would eventually cause Fritz, his children, and even my generation no end of conflict and grief.

Sadly, in 1925 while in Munich, Eugen died of congestive heart failure and general decline at the age of eighty-five. Remembered and honored as one of the great financial figures of his time, his obituary appeared in newspapers from London to New York to Hong Kong. A thousand people attended his funeral in Berlin. The rather large new family tomb, designed by the noted architect Franz Seeck, in the Urnenfriedhof, survives to this day.

Whenever I'm in Berlin, I make it a point to stop by this cemetery

and spend a few moments with my great-grandfather and hope his soul is at peace. As I stand in the shade of the linden and oak trees, I'm always struck by how, as with the Jewish cemetery in Dresden, the Gutmann family tomb somehow escaped both desecration by the Nazis and destruction from bombing during World War II. I can only wish, ironically, that the living had been as fortunate as the dead.

After his father's death, Fritz began clearing up the matters of the estate. Eugen's country retreat, Schloss Zeesen, was leased to Ernst Goldschmidt, another banker and family friend. Meanwhile, perhaps because of Fritz's Dutch connections, the grand Gutmann villa on the Rauchstrasse was sold to the Dutch government, which used it as their embassy until World War II.

Like so many other beautiful homes in the Tiergarten, the Gutmann villa was later blown to flinders by Allied bombs and probably some Soviet artillery. The castle at Zeesen was taken over by a Nazi actor. It survived the war, but was neglected afterward by the East German government; the last I heard it was a boarded-up, empty shell.

As for the silver collection, a few of the lesser pieces were sold off, but the more valuable and exquisite Renaissance and Mannerist silver pieces—which also included the fierce Silver Cat by Hans Utten, the exotic Jamnitzer beaker, and hundreds of other objects—were kept intact as undivided property, owned equally by Eugen's children. Fritz moved the collection to Holland, where he had built a special walk-in safe hidden behind the men's smoking room in his home. It would remain there, safe for the time being.

Perhaps expectedly, as a wealthy man with a growing family, Fritz by 1924 had found the town house on the Koningslaan in Amsterdam, while absolutely delightful and convenient for his work in the city, not quite adequate for the family's lifestyle anymore.

His search for a new home led him to a once-grand, but somewhat neglected, manor house twenty miles outside the city.

The estate of Bosbeek is situated in bucolic parkland by Heem-

stede, near Haarlem and due west of Amsterdam. Bosbeek in English means Forest Brook. Originally it was a seventeenth-century country retreat built for a wealthy Amsterdam merchant seeking refuge from the dreaded "canal fever" that festered in summer along the old canals of Amsterdam. In 1736 the estate was purchased by the mayor of Amsterdam, who commissioned Jacob de Wit, the famous Dutch painter, to completely renovate the manor house. By the late eighteenth century, when Bosbeek was sold to the Hope banking family (of Hope Diamond fame), it had become one of the most sought-after properties in the region. Adrian Elias Hope, who was something of a hoarder, packed the manor house with magnificent Italian Renaissance art treasures before going incurably insane and being confined in a straitjacket. Poor Adrian Hope was locked in a small upstairs bedroom of his grand house, where he died in 1834.

In more recent times, the estate's thirty-room manor house has had a more checkered history. When I first visited as a small boy, the house was being used as a nursing home. Elderly people in hospital gowns shuffled around the once-beautiful grounds. The elegant ornamental ponds were surrounded by wheelchairs. But in the 1920s and '30s, Bosbeek was where Fritz and Louise found a life of almost golden happiness in that all-too-brief time between the twin catastrophes of both World Wars.

The salon at Bosbeek, with the Jacob de Wit
grisaille over the door, 1928.

Fritz and Louise made Huize Bosbeek and its ten acres of woodland, lawns, and surrounding gardens bloom again. Lovingly, they remodeled the main house, taking great pains to restore the original De Wit artworks. Two centuries of grime were removed from the magnificent painted ceiling of the grand salon. The huge ceiling oil canvas, entitled *Bacchus and Ceres in the Clouds*, depicted the Roman god of wine airborne with the goddess of fertility, surrounded by winged putti flying about. Among other distinctive touches brought back to their original splendor was the gilt-framed De Wit grisaille called *Autumn* (a large trompe l'oeil painting resembling a grayscale sculpture), which was placed over the doorway to the stateroom. Fritz and Louise reoriented the interior to look outward to the reflecting pools and newly lush gardens.

In addition to the grand salon were a large formal dining room, a library, and a drawing room for Louise. Behind the gentlemen's smoking room, which was decorated in red velvet, was the custom-built strong room. Fritz placed Eugen's treasures here. Rarely, he would allow the glittering marvels to be viewed by friends or art scholars and, on the most special occasions, by the next generation of Gutmann children. Bernard and Lili's favorite was the Golden Ostrich automaton, which would flap its wings on the hour while, at its feet, a little, gilded monkey beat a drum.

Fritz and Louise's dressing rooms were on the second floor, along with the children's rooms. The butler, cook, governess, and maids— seven in all—were quartered in the spacious attic. The house was decorated in the classic style with Louis XV tables and sofas, gilded-framed mirrors, seventeenth-century Savonnerie carpets, and Aubusson tapestries. The cabinets were filled with eighteenth-century Meissen and Chinese porcelain vases.

Fritz also added a service building near the estate entrance to house the groundsmen and two chauffeurs with, what would become, a small fleet of luxury cars. My grandfather's favorite car was a 1925 Isotta Fraschini coupe, at the time one of the fastest cars in the world. It had a guaranteed top speed of ninety-three miles per hour. Perhaps the grandest automobile was a 1928 Hispano-Suiza Berline de Voyage

touring car. Meanwhile, Louise cut a dashing figure in a 1927 LaSalle convertible. Perhaps curiously, Louise seemed to enjoy the cars most. Fritz, always dignified and perhaps a little staid, was usually driven to and from the bank by the chauffeur, whereas the vivacious and daring Louise would sometimes hop into a convertible and drive alone, at breakneck speed, her scarf flying in the wind, into the city or even on long road trips to Paris or Baden-Baden.

Louise in the 1927 LaSalle convertible.

Fritz and Louise together traveled extensively throughout Europe. During a 1926 visit to Paris, they posed, fashionably, for portraits by Man Ray in his Montparnasse studio. Born Emmanuel Radnitzky in Philadelphia, the avant-garde artist had also become one of the preeminent portrait photographers of the day.

Fritz's portrait shows him in quarter profile, clean-shaven, his dark, glossy hair combed straight back—perhaps not so staid after all. Nearing forty, he had not yet grown stout, but his face is not quite as lean as it once was. As always, there is that suggestion of a smile. Louise is also looking away from the camera, slim and elegant in an ivory crepe-

de-chine dress, with pearl earrings and a single-strand pearl necklace. Her dark hair is cut short in the bobbed fashion of the twenties. At thirty-four she is strikingly beautiful. In another portrait by Man Ray, which I cherish to this day, she is wearing an ankle-length fur coat while nonchalantly smoking a long cigarette. Fritz and Louise were a glamorous couple, leading a glamorous and exciting life. Yet despite the obvious temptations, they remained a loving couple, in marked contrast to Eugen and Sophie's tempestuous relationship.

For young Bernard and Lili, life at Bosbeek had an almost magical quality. The well-manicured, but still rural qualities of the estate provided endless places to play. A photo survives of Bernard and Lili lolling about in the grass with their beloved Scottish terriers. At one point at least ten white Westies wandered about the estate. Lili and Bernard were provided with material luxuries that other children could only dream of. For their birthdays, they each received from a family friend a 1928 Baby Bugatti. These were perfect half-scale, electric-powered versions of Ettore Bugatti's famous Type 35 racing car—an extravagant gift perhaps, given that only some five hundred Baby Bugattis were ever produced.

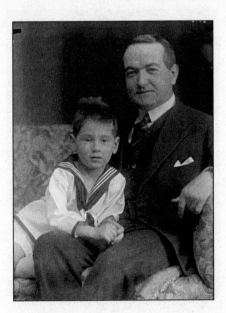

Bernard with Fritz in Amsterdam, 1923.

Lili in Amsterdam, 1923.

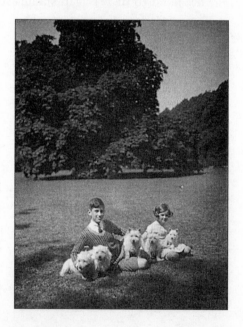

Bernard and Lili at Bosbeek with some of the West Highland terriers.

Lili with Baby Bugatti, around 1928.

In the evening, the guests for dinner would consist of a not-too-surprisingly well-heeled crowd. On a given night the diners might include Wilhelm and Margarethe von Humboldt, the famous conductor Erich Kleiber, some of the Bentincks, the sculptor Georg Kolbe, Fritz's niece Marion von Goldschmidt-Rothschild and her husband, Albert, and on occasion Heinrich Thyssen, a member of the German industrialist family and an avid art collector. The Gutmanns loved fine cuisine, and their chef served the most refined French dishes. However, Fritz cherished one prosaic hangover from his otherwise not-so-happy stay in Britain: he loved kippers. Once a month he had a box of kippers flown in by an airmail carrier. A Berlin society column got hold of this information and decided to paint Fritz as the epitome of self-indulgence—fair comment, perhaps, if it were not for the underlying anti-Semitism.

Fritz and Louise entertained in a style that would also delight any child. Lili remembered that for her tenth birthday her parents hired an entire circus troupe—clowns, lion tamers, trapeze artists, and all—to

perform for several hundred guests under a big top on the Bosbeek grounds. When the famous German rider Carl von Langen and his horse, Draufgänger (Daredevil), won gold medals in dressage at the 1928 Olympics in Amsterdam, Fritz and Louise invited von Langen and the entire German equestrian team, including Draufgänger, to Bosbeek to be feted at a gala celebration ball.

There were, however, certain expectations. The children were rigorously schooled in the arts, history, science, and languages. By the time Bernard went to boarding school at the exclusive Lyceum Alpinum Zuoz in Switzerland, and Lili went to finishing school in Florence, they were already fluent in French, English, Italian, and, of course, German and Dutch.

As children of the twentieth century, unlike their nineteenth-century counterparts, Bernard and Lili were allowed at a certain age to dine with their parents and their guests. It went without saying that the children exhibited the proper manners and were suitably dressed, as their parents always were. My father never saw his father sit down to dinner in anything less than either an impeccably tailored three-piece suit, the pocket handkerchief arranged just so, or more usually a dinner jacket and, for formal occasions, tails.

Although children were still expected to be seen rather than heard, Lili and Bernard thrived with the erudite and stimulating dinner conversation of a constant stream of friends and visitors from around the world. Lili would later describe it as "a very international life."

From the moment they arrived in Holland, Fritz and Louise quickly developed close friendships with other socially prominent couples. Fritz's business partner, Ernst Proehl, and his wife, Ilse, were good friends, as were Franz Koenigs and his wife, Countess Anna von Kalckreuth. Koenigs was another German-born banker, cofounder of the Rhodius-Koenigs bank in Amsterdam, and his wife was the daughter of the famous painter. The Koenigs lived with their five children in a grand villa by the Florapark in Haarlem, not far from Bosbeek. An older couple from Amsterdam, Dr. Otto Lanz and his wife, Anna, were also dear friends. Otto was a wealthy and highly respected Swiss-born

surgeon, known equally for his medical innovations and his magnificent collection of Italian Renaissance art. Another friend was a young Dutch Jewish art dealer, Jacques Goudstikker, whose gallery was conveniently located next door to the Proehl & Gutmann offices on the Herengracht. Goudstikker was a collector in his own right and widely known as Holland's most important dealer of old masters.

The flamboyant and controversial Fritz Mannheimer was another friend. It was he who gave little Lili and Bernard the Baby Bugattis. The German Jewish banker was director of the Amsterdam branch of the powerful Mendelssohn & Co. private bank. He was also a key player in Germany's postwar economic reconstruction.

Mannheimer was known for his ostentatious lifestyle and flashy, rather un-banker-like manner. He draped himself in jewelry and infamously installed a solid-gold bathtub in his palatial Amsterdam home for one of his many mistresses. Also known and widely mocked for his excessive corpulence, when Mannheimer did finally marry at age forty-nine, at a ceremony attended by dignitaries from throughout Europe, his best man was Paul Reynaud, the future Prime Minister of France.

It was a shock to all when Mannheimer collapsed while waddling down the aisle. After he was revived with two injections to his heart, the wedding took place. Just two months later, he died under somewhat suspicious circumstances, leaving behind his monumental art collection.

Fritz and Louise were also close socially to their neighbor Catalina von Pannwitz. Young Bernard and Lili knew her as Aunt Käthe. Catalina was a strikingly beautiful, German-born daughter of an enormously wealthy German Argentinean cattle baron. Her much older husband, Walther von Pannwitz, a prominent and equally wealthy Berlin lawyer, had served as close legal adviser and confidant to Kaiser Wilhelm II. When the Emperor was forced into exile in Holland, the Von Pannwitz family had dutifully followed.

The Kaiser, who had barely escaped being extradited from Holland and tried as a war criminal by the Allies, often left his Dutch estate in

Doorn to visit Von Pannwitz at his Hartekamp estate. After Walther died in 1920 and left the still-beautiful Catalina a widow, Wilhelm's visits became even more frequent. Suggestions of an illicit affair between the former Kaiser and the heiress were rife.

Fritz and Louise also had connections in Holland with members of the former German and future Dutch royal families. Eugen had been a financial counselor to the Kaiser before the war, and brother Herbert remained a friend and benefactor of Crown Prince Wilhelm's family in Berlin. As a result, Fritz often provided financial services and advice for the former Kaiser in Holland and saw him frequently at gala dinners at Hartekamp and occasionally at Bosbeek. All of which seems a bit curious. Wilhelm's anti-Semitism had been apparent even when he'd surrounded himself with his *Kaiserjuden* advisers before the war. During his exile, it had only grown and festered. The deposed monarch was frequently heard blaming "Jewish parasites" for Germany's defeat. He even, infamously, suggested that to "gas" the lot of them would be the best and final solution. Again, it appeared to be another perverse example of "Of course, we don't mean you."

Fritz was not in awe of his former sovereign. In Germany it had been protocol at dinners with the Kaiser for the footmen or butlers to remove a course setting as soon as Wilhelm finished, regardless if the other guests were still eating. The still-haughty former emperor took this etiquette with him into exile. Fritz quite rightly thought this was ridiculous and notoriously made the point at a dinner at Hartekamp by waving off the waiter and loudly declaring, "I'm not done yet!" One can imagine the uncomfortable silence as Fritz finished his soup while the aging Emperor fumed.

Later, Fritz, Louise, and their children were also friends and hosts to Prince Bernhard zur Lippe-Biesterfeld, another deposed and somewhat impecunious German royal who was courting Catalina Pannwitz's beautiful daughter, Ursula (an older friend to Lili). However, Prince Bernhard later married Dutch Crown Princess Juliana and became Prince Bernhard of the Netherlands, a connection that

would have a significant impact on my father during the Second World War.

Almost all of my grandparents' friends were deeply involved in art, often as connoisseurs and scholars, as well as collectors. Many assembled significant collections, each according to his or her individual tastes and expertise. Dr. Lanz specialized in Italian Renaissance works. Ernst Proehl had an extensive collection of old-master paintings, including Lucas Cranach the Elder's life-size, early-sixteenth-century *Venus*, said to be the most sensual and erotic painting of the German Renaissance. Fritz Mannheimer amassed a fabulous collection of Renaissance bronzes, crystal, silver, and gold as well as numerous paintings. Franz Koenigs had what was perhaps the world's greatest single collection of old-master drawings, more than twenty-six hundred of them, as well as paintings and, later, select Impressionist works. (These included Van Gogh's now famous *Portrait of Dr. Gachet*.) And Catalina von Pannwitz's Hartekamp estate was a virtual art museum, combining her late husband's extensive collection of ancient bronzes, Meissen, and other porcelain treasures with her own equally extensive collection of fifteenth- to eighteenth-century European paintings. These art collectors all moved in the same circles, went to the same art auctions, and used the same internationally known art dealers for advice and counsel: Goudstikker and Helmuth Lütjens in Amsterdam, Kurt Bachstitz in The Hague, the Van Diemen Gallery and Paul Cassirer & Co. in Berlin, and Ambroise Vollard and Jacques Seligmann in Paris, among others. Their passion for collecting went far beyond their obvious appreciation of high culture. Relentlessly, they bought, sold, traded, and searched for pieces to embellish their collections.

Fritz moved easily and knowledgeably within this circle. As the legal custodian and, in effect, the artistic curator of the Gutmann silver collection, Fritz was already in possession of an internationally famous collection of objets d'art. Since his arrival in Holland, Fritz had also begun to assemble his own rather magnificent collection of paintings,

a collection that would consume not only his own passions, but also eventually his son's, and now, to this day, mine.

Fritz, drawn by the pull of tangible history, began his art collection with the old masters of Italy. The scope of his taste would soon widen in a somewhat eclectic manner to encompass all of Western Europe. His first acquisition, from Count Trotti in Paris shortly after the end of the First World War, was a large, fifteenth-century Italian Renaissance cassone panel called *The Siege of Veii*, a marvelously detailed and wonderfully colorful depiction of an ancient Roman battle by Florentine painter Biagio d'Antonio. Later he added several paintings by Francesco Guardi, the eighteenth-century Venetian painter known for his architectural fantasies and atmospheric depictions of the Venetian landscape. Prophetically, one of those Guardis, *Paesaggio di Fantasia con Isola della Laguna*, portrayed an area in the lagoon of Venice where Fritz's son, my father, would later drown.

Other early acquisitions included an Italian Baroque pair of gouache capriccios by Marco Ricci, another master of the architectural fantasy. Through a tortuous chain of events, these two works, along with a portrait of a veiled Spanish lady by eighteenth-century French painter Jean Barbault, would one day wind up in our family house in Shepherd Market. I didn't know how important this painting was to my father, yet I remember being fascinated by it when I was a child.

Works by artists of the Northern Renaissance were also one of Fritz's special passions—a passion that would, tragically, later be shared by some of the leading Nazis. Like his friend Ernst Proehl, Fritz acquired several works by Lucas Cranach the Elder, one of the most important German masters. These paintings reflected the various subgenres of that artist's work: the allegorical *Melancholy*, the biblical *Samson and the Lion*, and, Cranach's most common subject, portraiture—in this case *Portrait of Johann Friedrich the Magnanimous, Elector of Saxony*. Normally the electors (or princes) of Saxony were portrayed as stern Protestant patriarchs, but in this atypical portrait the prince

was resplendent in his nuptial finery. A fifteenth-century *Madonna with Child* by Hans Memling, one of the leading masters of the early Netherlandish style, was a particularly exciting acquisition for Fritz, given the beauty and rarity of Memling's work.

The collection of old masters that covered the walls in the Bosbeek estate grew each year. Aunt Lili remembered that her father hardly ever returned from a trip without bringing another artwork home with him. Two were early-seventeenth-century landscapes by Jan van Goyen, one of the most prolific landscape artists of the Dutch Golden Age. In Switzerland, Fritz found a rare portrait by the sixteenth-century German Renaissance artist Hans Baldung Grien, *Portrait of a Young Man*, which bore one of those generic titles that cause researchers endless frustration. Another painting was, in retrospect, an important part of my personal history. It was *Portrait of Isaac Abrahamsz. Massa* by Frans Hals. This was the painting that my father stared at wistfully years later when he brought me to the San Diego Museum of Art. Another was the descriptively titled *Small Portrait of a Young Man with a Red Jerkin* by Giovanni Dosso Dossi, court artist to the dukes of Ferrara, which would one day wind up in Hermann Göring's Carinhall estate.

Interestingly, old masters rarely signed or named their paintings, so the names and even the attributions of paintings vary widely over the years. Fritz's fifteenth-century panel *Adoration of the Magi* was painted by an anonymous German artist known simply, after the artist's most famous work, as "the Master of the St. Bartholomew Altarpiece." One more late-fifteenth-century portrait of an Austrian archduke was by yet another anonymous German artist known cryptically as "the Master of the Mornauer Portrait." Both of these artists, along with Cranach and Memling, would one day stir the Nazi soul.

The early-sixteenth-century head of the Madonna, originally part of a pentaptych altarpiece by Augsburg artist Hans Holbein the Elder, was another exceptional find for Fritz. A fifteenth-century masterpiece, *The Argonauts Leaving Colchis*, was by the sadly short-lived Ercole de' Roberti, who was also from Ferrara. According to Vasari, Ercole's "extraordinary love of wine" led to a sudden demise at the age of forty.

Then there was an eighteenth-century portrait of a young woman by Thomas Gainsborough, best known as the painter of *The Blue Boy*. Two exquisite still lifes were painted in the last days of the eighteenth century by Swiss French artist Jean-Étienne Liotard. A delicate chalk self-portrait by Élisabeth Vigée-Lebrun, the most important female painter of the eighteenth century, was one of the few works by woman artists in Fritz's collection.

Perhaps the most curious of Fritz's old-master acquisitions was a small oil painting barely more than ten by eight inches, *The Temptation of St. Anthony*, by Hieronymus Bosch. On a trip to Madrid in 1926, Fritz bought the Bosch, known as El Bosco, from a private collector. Years later, when I was barely ten, my father sat me in front of the massive *Garden of Earthly Delights*, known aptly as *Between Heaven and Hell*, to contemplate El Bosco's masterpiece in Madrid's Prado. Bosch was the early-sixteenth-century Dutch master famed for his surrealistic, even nightmarish, visions of hell, death, sin, and other religious subjects. His paintings were populated with fantastic animal and human forms in surreal situations that were symbolic of various contemporary social and religious themes. Fritz's *St. Anthony*—one of two paintings by Bosch that featured the hermit Egyptian saint—certainly fit that description, showing a cloaked and hooded Saint Anthony surrounded by, among other odd things, a frog rigged up with sails, an archer shooting an arrow from inside a broken eggshell, and a kneeling, naked man with his head in a bag, his foot in a jar, and what appear to be swallows flying out of a funnel protruding from his backside. The Bosch was a somewhat bold acquisition on Fritz's part, considering that Bosch did not loom nearly as large among art scholars and the general public as he does today. In fact, when *St. Anthony* was displayed on loan from Fritz's collection, alongside 450 other old-master paintings, at the 1939 New York World's Fair, the *New York Times* seemed confused by its inclusion. Describing it as the "queerest painting" in the exhibition, the newspaper primly suggested that it more appropriately belonged with Salvador Dalí's *Dream of Venus* exhibit—which perhaps

it did, given that Dalí and other modern-day surrealists were heavily influenced by Bosch.

Other significant artists that Fritz added to the collection included Fra Bartolommeo, François Boucher, Adriaen Isenbrandt, Hercules Seghers, Luca Signorelli, Adriaen van Ostade, and Paolo Veronese. Eventually his collection of old-master paintings would number well over sixty, which easily placed Fritz among the most important private collectors in Holland. It was all quite impressive—except that at least one member of the Bosbeek household was not always impressed.

Young Lili, schooled in the appreciation of art from the earliest age, spent many hours perusing her father's extensive collection of art books, acquiring a budding connoisseur's eye. She remembered how once an art dealer came to Bosbeek to try to sell Fritz what was purported to be a painting by Raphael, but when he unveiled the work, Lili took one look and declared, *"Das ist kein Raphael!"* ("That is no Raphael!"), which, as it turned out, it wasn't. The embarrassed dealer made a quick exit.

Meanwhile Lili, despite her precocious knowledge of art, found some of Fritz's collection rather dreary, especially the German Renaissance portraits. They were "hideous" and "boring," she said. Many had "dreadful noses." Whenever he brought home yet another painting of some poor German, dead for four centuries, she would complain vociferously in the way that favored daughters could. Lili recalled that her father often told her, "Ah, you do not understand them. They are really quite beautiful." But she remained unconvinced when Fritz explained to her the finer points of composition, perspective, and brushwork. She insisted that the paintings were old and ugly and boring, and she wanted to know why Papi never brought home anything that was new and fresh and exciting. Louise agreed they needed something more contemporary, so starting in 1928, Fritz began to expand his painting collection beyond old masters.

Fritz had long been exposed to modern trends in art, both in Berlin and in Paris. However, the Expressionist movement in Germany was so

angst-ridden, it reminded him why he didn't like to live there anymore. The new, fractured world of cubism was almost as unsettling.

So, during a visit to the Paul Cassirer Gallery in Berlin in 1928, Fritz bought a small (eighteen-by-fifteen-inch) oil called *Le Poirier*, or *The Pear Tree (in Bloom)*. It had been painted around 1871 by one of the earliest and greatest figures of the Impressionist movement, Pierre-Auguste Renoir. For Renoir, a prolific painter best known for his nudes and portraits, it was a less typical piece portraying, as the name simply suggested, a pear tree in the then-rural area of Louveciennes, located west of Paris. Renoir's vibrant use of light and free brush style offered a sensation of movement. This ephemeral, windswept landscape set in springtime seemed to reflect the new optimism of the period immediately after the Franco-Prussian War.

The following year, during a visit to the famous Ambroise Vollard in Paris, Fritz acquired the 1880 pastel *Femme se Chauffant* or *Woman Warming Herself*, by another great and prolific figure of French Impressionism, Edgar Degas. Two years later, through his agent at a Paris auction, Fritz bought yet another Degas, a landscape simply known as *Paysage* and later deceptively reincarnated in English as *Landscape with Smokestacks*.

Both Degas paintings were quite beautiful, with vivid colors and deep luminescence, and, in the case of *Paysage*, somewhat rare because his landscapes were not well-known. Degas himself, on the other hand, was anything but beautiful. Ever since the Dreyfus affair, he had become increasingly withdrawn, until even his best friends viewed him as a cranky misanthrope. First he drove away all his Jewish friends, such as Pissarro, and then even his closest friends, such as Renoir. Fritz knew that Degas had turned into a notoriously outspoken anti-Semite. Nevertheless, Fritz was not the sort to judge art by the beliefs of the artist—and as a German Jew, albeit a converted one, he was more or less inured to such things. No doubt to Lili's and Louise's delight, the Renoir and the two Degas paintings took their places among the underappreciated old masters on the walls at Bosbeek. Mother and daughter agreed that they certainly brightened up the house.

Apart from some sculpture, Fritz made one other foray into Modernism that is worth noting. In 1929, during a trip to Munich, he purchased a startling work by Bavarian Symbolist painter Franz von Stuck, whose work was considered a precursor of Art Nouveau. Painted in 1891 and variously titled *Die Sünde* (*The Sin*) or *Die Sinnlichkeit* (*The Sensuality*), it portrayed a Garden of Eden theme with a seductively posed naked woman embraced within the coils of an exceedingly large and decidedly evil-looking snake.

It seemed an odd acquisition on Fritz's part, even though Stuck's mentor Franz von Lenbach had painted portraits of Fritz's parents as well as Louise's grandmother and aunt.

Artistic significance was always crucial to Fritz, but ultimately he always bought only pieces that he liked. Unfortunately, just as I imagine how *Sensuality* caught Fritz's eye, years later it would also catch the attention of one of the worst Nazis who ever lived.

How much was Fritz's collection of art worth? It's perhaps a crass question, but probably inevitable. It's also difficult to answer, especially almost a century later. Artists and artworks have waxed and waned in popularity—and thus in price—among collectors and dealers over the decades. The value of an individual piece by a given artist also varies widely based on numerous factors: the subject, the period of the artist's life in which it was painted, the strength of its composition and provenance, its physical condition, and, of course, the economy at the time. As always, size matters. For example, at a 2011 auction in London, a forty-seven-by-eighty-inch *veduta* by Francesco Guardi titled *View of the Rialto Bridge* was sold for an astonishing $42 million. A year later, a pair of Venetian *vedute* also painted by Guardi, each measuring just seven by eight inches, were sold for $660,000 at auction.

In today's superheated art market, we are accustomed to seeing tens of millions, even hundreds of millions, dollars spent on paintings. It was all rather different in Fritz's day. Obviously, then as now, the collecting of art masterpieces was a rich man's obsession, but the real

cost of being such a collector then was still considerably less than it is now. For example, *Portrait of a Man with Arms Akimbo* by Rembrandt sold for $33 million in 2009. In 1930, it had sold at auction for roughly $72,000, or the equivalent of just under $1 million today. The Van Gogh *Portrait of Dr. Gachet*, which went for $82 million in 1990, had been sold by Van Gogh's own sister in 1897 for a paltry three hundred French francs (about $1,000 today). In 1938, Fritz's dear friend Franz Koenigs paid about $50,000 for it, which was about $800,000 today. Suffice it to say that the paintings in Fritz's collection were worth many hundreds of thousands of dollars then, and several millions of dollars today.

All things considered, the 1920s were a happy time for Fritz and Louise. They were wealthy, popular, good-looking, still relatively young, blessed with two healthy and intelligent children, surrounded by art and culture and music, and living in a stable and peaceful country. Yet, as the 1930s dawned, Fritz and Louise could not remain immune to the turmoil and tumult of history, any more than they had in 1914. While neither they, nor anyone else, could fully understand or accurately predict just how terrible the implications, they could not help but see that a catastrophe was rising just over the border.

THE EPHEMERAL PEACE

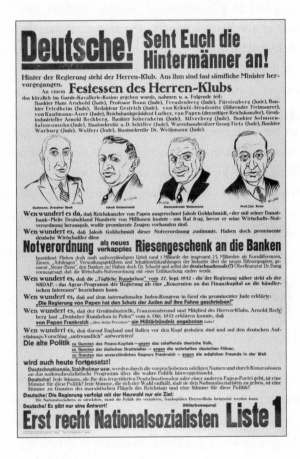

Among the many papers I have uncovered in my research is a faded and yellowed election pamphlet produced by the National Socialist German Workers' Party, better known as the Nazis. It was from a poster designed by Rudolf Hess for the Reichstag elections of November 1932. This depressing document features a screaming headline: "Germans! Look at

the men behind the government!"—adding another nail to the coffin of the fading Weimar Republic. Farther down, the pamphlet rants about "Jewish manipulators against true German leaders." Four caricatures of prominent "German Jews" are rendered in typical Nazi style. All four have big ears, low foreheads, long, hooked noses, beady eyes, and stubbly five o'clock shadows. Each of these cartoonish, unsavory-looking characters is described as a "profiteer," a "Jewish schemer," and one of the "perpetrators" of Germany's misery. The first caricature is identified as "Guttmann, Dresdner Bank"—"Gutmann" is misspelled, but it is clearly my great-uncle Herbert.

Even now it is still chilling to see a member of my family with a Nazi target painted on his back. I imagine some hard-faced Nazi thug, with club in hand, pasting this vicious caricature of my great-uncle all over the streets of Berlin. It also makes me wonder, for perhaps the millionth time, how Herbert and so many other Germans did not, would not, see what was coming. While that is an easy question to ask from the safety of the twenty-first century, with the utter certainty of hindsight, at the time the answer was not quite so simple.

Like Fritz and Louise in Holland, for Herbert and Daisy in Germany the 1920s had been a happy, prosperous, and glamorous time. After the war, Herbert had turned their relatively modest summer home on Bertinistrasse, in the Berlin suburb of Potsdam, into an eighty-room, twenty-thousand-square-foot virtual palace known as Herbertshof. The estate featured, among other luxuries, an underground passageway to the boathouse on the Jungfern Lake, an indoor gym (reportedly Berlin's first), tennis courts, a screening room for first-run films, a Turkish tiled sauna, and a vast collection of Near and Middle Eastern art and antiquities that Herbert had discovered during his many travels in the region.

Later, my father would remember playing hide-and-seek with his cousins in the secret stairs behind the famous "Arabian room" at Herbertshof. This vaulted room had paneling carved by eighteenth-century

Syrian artisans and was filled with various art treasures. From the hide-away, the children delighted in spying on the oh-so-grand houseguests.

Herbert and Daisy entertained on a lavish scale. One Berlin society writer described the social life at Herbertshof this way: "No foreign diplomat, young or old, comes to Berlin without instantly leaving his visiting card at the Gutmanns and subsequently making his social debut at their salon. Every Sunday Herbertshof is open house for lunch. One finds 20–24 invited guests while numerous acquaintances and friends arrive unannounced by car from Berlin in the afternoon. . . . In winter one dances in the beautiful hall or films are shown that one has not yet seen at the cinema. In summer one goes to the pretty private bathing pavilion, swims, rows, rides rubber animals or the large motor boat on the lovely blue waters. . . . At the home of Herbert Gutmann you find the entire diplomatic corps, part of the Foreign Office, most Reichministers and the leading lights of high finance."

Several kings visited Herbert and Daisy at Herbertshof, including King Faisal of Iraq, King Fuad of Egypt, and King Amanullah of Afghanistan, which reflected Herbert's position at the Deutsche-Orient Bank. In 1926 Herbert cohosted with his sister Toinon, wife of the Swedish ambassador, a grand ball in honor of King Gustav V of Sweden, in preparation for which Herbert had the grand salon remodeled to accommodate no fewer than three hundred guests. Herbert and Daisy also remained close to the former German royal family. After Crown Prince Wilhelm followed his father into postwar Dutch exile, his wife, Crown Princess Cecilie, chose to remain in Germany with their six children at her villa Cecilienhof, just down the Jungfern lake-shore from Herbertshof. Herbert took the Crown Princess and her children under his wing, keeping her supplied with funds and helping to resist postwar efforts for the confiscation of the royal family's exten-sive assets, including the Potsdam villa. Years later, one of Cecilie's sons, Prince Louis Ferdinand, heir to the Hohenzollern throne, noted in his memoirs that during this time "the Jewish banker Herbert Gutmann, one of our neighbors in Potsdam, proved most helpful" to the royal family. This was yet another indication that, decades after the Gutmann

family's conversion, they remained in German eyes, even friendly ones, still Jewish.

Herbert's social and professional connections reached into every corner of Berlin society. As a member of the Gesellschaft der Freunde, or Society of Friends, founded in the eighteenth century by the Mendelssohns as a Jewish charity, he was part of Berlin's financial elite. He was also president of the German Golf Association. However, being the founder and president of the exclusive Berlin-Wannsee Golf and Country Club gave Herbert the most pleasure. On the other hand, my great-uncle's membership in the somewhat right-leaning Anglo-German Union would eventually cause Herbert and his eldest son, Luca, unforeseen problems.

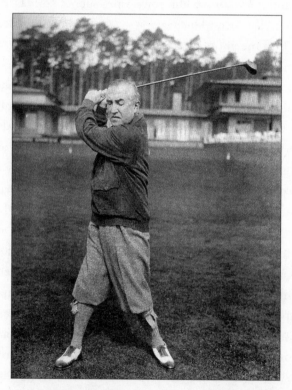

Herbert playing at the Wannsee Golf Club, where he was president. The Wannsee club was nearby the house where the "Final Solution" was hatched and where the "Wannsee Conference"—the official beginning of the Holocaust—took place.

Herbert was also president of the German-Persian Society and a consultant to the Islamic Department of the Kaiser Friedrich Museum in Berlin, a reflection of his artistic tastes and expertise.

In addition to serving as a director of the Dresdner Bank and chairman of the Deutsche-Orient Bank, he was, in the German business style, also on the boards of directors of some fifty other major corporations. Intensely nationalistic, even monarchist in his political leanings, Herbert was associated with a number of prominent, and later sinister, German political figures. Frequent guests at Herbertshof included the ultranationalist future Chancellor General Kurt von Schleicher, and the aforementioned Hjalmar Schacht, erstwhile Dresdner Bank employee and a future finance minister under the Nazis. Franz von Papen, yet another future Chancellor, was also a regular at Herbertshof.

Given such wealth and powerful connections, it was reasonable to ask what a man such as Herbert would have to fear from some boorish, uneducated Austrian ex-corporal and his band of thuggish, low-class henchmen. Herbert's son Luca later remembered a conversation between his mother and one of her guests during one of those grand dinner parties in the early 1930s. Daisy asked, "Who really is this Herr Hitler?" The guest assured her, "Madame, that is nothing for you, someone who lives in luxury and has such a high position, to be worried about."

German Jews tended to dismiss the rising Nazi Party as just another gang of street toughs and hooligans. From both the right and the left, many fringe groups infested the fractured German political landscape. Common also was the German Jews' desire to sweep under the carpet the anti-Semitic tendencies of their acquaintances who might, at one moment, spout the most vicious, Nazi-style drivel about the Jewish "pollution" of German blood and culture—but in the next breath calmly reassure their Jewish friends that nothing would change.

It seems astonishing now, but apparently Herbert and other prominent Jewish families actually believed that the Nazis and their supporters, at least the ones they hosted in their salons and drawing rooms, meant them no harm. For example, Herbert's friends Crown

Prince Wilhelm and the steel magnate Fritz Thyssen were both early supporters of Hitler, but that did not prevent their names from often gracing the guest book at Herbertshof. Worse still, some of Daisy's relatives had got in the habit of living off Herbert's largesse even as they openly admired Hitler. Another frequent guest and business partner of Herbert's was Joachim von Ribbentrop, a relentless social and political climber. Ribbentrop actually counted Herbert as one of his good friends and turned to him when he needed financial help. Later he was deeply involved in the behind-the-scenes scheming that put Hitler in power and ultimately was promoted to foreign minister in the Nazi government. In the end, Ribbentrop was hanged as a war criminal at Nuremberg.

In Holland, Fritz and his children maintained friendships with Prince Bernhard, who, while at university in Berlin in the early 1930s, joined the Nazi Party and the paramilitary Sturmabteilung (SA). He would later claim he had resigned all his Nazi Party affiliations in 1934, but his younger brother, Prince Aschwin, originally also a Gutmann family friend, remained a party member. Ultimately these two brothers would fight on opposite sides during the war.

Fritz felt duty-bound to provide financial advice to Kaiser Wilhelm despite his increasingly anti-Semitic and pro-Nazi leanings. The list of what now appear to be incongruous bedfellows was long, but symptomatic of a German society that had not yet completely unraveled.

As difficult as it may be to believe now, some prominent German Jews, while decrying the Nazi party's crude anti-Semitism, even expressed support for the Nazi platform of a strong, politically stable, and internationally respected Germany. For example, the banker Siegmund Warburg—the distant cousin who would much later turn me down for a banking job I didn't really want—declared in 1930, "The Nazis are doubtless in part dreadfully primitive in human and political terms. On the other hand, one finds among a large part of them valuable, typically German strengths [that] show strong feeling for social and national duties." Like many German Jews, Warburg assumed that Hitler and the Nazis could be controlled, that their vicious and increasingly popu-

lar anti-Semitism was a passing thing. In hindsight that seems prepos-
terously and fatally naive.

German anti-Semitism was not invented by the Nazis; it had waxed
and waned throughout modern history, rising in times of social and
economic stress and subsiding in times of peace and prosperity. German
Jews were thus accustomed to it, so perhaps it can be understood why
the Nazis' anti-Jewish rantings, and the parlor-room anti-Semitism of
their wealthy friends, did not cause Germans such as Herbert or Sieg-
mund Warburg undue alarm at first. They had seen it before and, with a
few isolated exceptions over the previous decades, it had never actually
sparked widespread physical violence against Jews in Germany, or even
any diminution of their civil rights. That it could, and eventually would,
seemed inconceivable as the 1920s ended. Yet, within just a few years,
that is precisely what happened.

In January 1933, Hitler legally became Chancellor of Germany
through a combination of bare-knuckle street violence and clever po-
litical manipulation, aided by the Great Depression, which put millions
of Germans in misery. Less than a month later, the Reichstag "burned
down" and Hitler assumed dictatorial powers under the "Decree of the
Reich President for the Protection of People and State." The opposition
was effectively silenced. Almost immediately, the Nazis' long-promised,
and long-dismissed, persecution of Germany's Jews began in earnest.

Even before the complete Nazi takeover, Herbert became one of
their first victims. In the final years of the Weimar Republic, when
the "German Banking Crisis" hit its peak in July of 1931, the reaction
of Chancellor Heinrich Brüning and his finance minister, Hermann
Dietrich, was not surprising. Despite their apparent differences with
the nascent Nazi Party, the one thing they could all agree on was the
"cosmopolitan Jewish character" of banking. Dietrich, who made no at-
tempt to hide his anti-Semitism, declared to a fellow cabinet member,
"The trading Jew, who has taken so much in interest from us, should
now be really made to cough up." As a result of the crisis, the Reichs-
bank assumed control of the major banks. Dietrich readily began his
purge.

Herbert Gutmann was the first "Jewish" banker to be sacrificed. Next was Jakob Goldschmidt of the Danat Bank, who happened, also, to be second after Herbert on that infamous poster. The Danat, like the Dresdner, was one of the top four German banks. Between 1931 and 1933 about half the directors of all the top four banks would be out of a job.

Suddenly those same industrialists and financiers who had been Herbert's friends now looked to Hitler and the Nazis as bulwarks against Bolshevism. Even those who had attended the lavish parties at Herbertshof decided that they didn't want Herbert on their boards of directors anymore. As he and other Jewish board members were forced out of their positions, hacks sympathetic to the Nazi Party soon replaced them.

Meanwhile, the so-called Aryanization of the Dresdner Bank, and of Germany, continued under the Nazis' 1933 "Law for the Restoration of the Professional Civil Service," which required the dismissal of non-Aryan teachers, professors, judges, and other civil servants—including employees of government-controlled banks such as the Dresdner. Soon all six hundred Jewish employees of the Dresdner (about 5 percent of the total workforce), from board members to branch managers to the lowliest clerks, were dismissed, their pensions canceled or confiscated.

In May 1933, Nazi brownshirts swarmed into the lobby of the Dresdner headquarters and smashed the bronze bust of Eugen to the ground. Eventually the bank founded by Eugen Gutmann was proudly declared by its new masters to be *Judenrein*—that is, "cleansed" of Jews.

Herbert became a marked man. Nazi posters and pamphlets with his image continued to appear, denouncing Herbert and others of his circle as Jewish "schemers" and "parasites." Long after Herbert's loss of office, much to the family's bewilderment, his caricature would often appear in the gutter press and Nazi pamphlets as a prime example of what a Jewish "bloodsucker" looked like. Jakob Goldschmidt also continued to be pilloried.

Friends and acquaintances that Herbert and Daisy had known for years began to turn away. Daisy later recalled going to a concert at

the Berliner Philharmonie and coming face-to-face with the former Dresdner executive Hjalmar Schacht. Now president of the Reichsbank, Schacht, in the company of various high-ranking Nazis, seemed to make a point of snubbing her; Daisy actually wept. In April 1933, Herbert was even kicked out of his beloved Berlin-Wannsee Golf Club, which he had founded and was still president of. The membership voted to no longer allow Jews as members.

Curiously, after dismissing Herbert from the Dresdner board, the bank suddenly discovered that Herbert and other Jewish board members allegedly owed the bank hundreds of thousands of marks. In 1934, beset by debts, both real and invented, Herbert was forced to put his extensive art collection up for sale at the Berlin auction house of Paul Graupe, a Jewish art dealer who had assisted both Herbert and Fritz in acquiring their art collections. Graupe's auction catalog for the *Sammlung Herbert M. Gutmann* listed more than eight hundred pieces for sale—Meissen and Chinese porcelain, Islamic art, ancient Syrian glass, bronzes, tapestries, and sixty-four paintings, including well-known works by Fragonard and *The Coronation of the Virgin* by Peter Paul Rubens. With German law preventing the foreign sale of the artworks, and with the German art market flooded with works from other similar "Jew auctions," the auction was a fire sale. The proceeds barely covered Herbert's alleged debts to the now-Nazified Dresdner Bank. In order to economize, he and Daisy moved out of Herbertshof and into a smaller rented home nearby.

As the Nazi noose tightened, across Germany thousands of other Jewish families, suddenly faced with no jobs and no income, sold their homes and household goods—furniture, silverware, everything—at deflated prices, to try to survive. Other Germans were only too happy to snap up these bargains.

The persecution of Jews intensified. The Nazi government called for a national boycott of Jewish shops and businesses. Brown-shirted storm troopers, from the paramilitary Sturmabteilung (SA), broke windows of Jewish-owned stores and beat up Jews on the streets. On the night of May 10, 1933, forty thousand people, many of them university

students, gathered in the Opernplatz, in the shadow of the Dresdner headquarters, to watch books by Jews and other disfavored writers go up in flames. Such Nazi book burnings spread throughout Germany.

Families considered Jewish began to see their erstwhile Aryan friends and colleagues shun them. Sometimes it was out of Nazi conviction, sometimes for fear of the new Nazi state security police—the Gestapo.

People were also beginning to disappear. Herbert was one of them, at least temporarily. In June 1934, in what became known as "the Night of the Long Knives," the Gestapo and the SS murdered scores of alleged Hitler opponents—including, perversely, the top leadership of their own SA. They also arrested more than a thousand others. Herbert's friend the former Chancellor General von Schleicher and his wife were among the murdered, as was the top assistant to Herbert's political associate Vice Chancellor Franz von Papen. Herbert was arrested by the SS and held under what was euphemistically described as "protective custody" in, ironically, the basement at (recently vacated) Herbertshof, along with nine other suspected opponents of Hitler. Among the nine was a former mayor of Cologne named Konrad Adenauer, who later would become the first Chancellor of West Germany after the war. Kept under armed guard for three days, Herbert feared he would be shot like so many others. Then the SS suddenly left after Herbert's brother-in-law Luca Orsini Baroni intervened at the last minute. Orsini, the former Italian ambassador to Berlin, was now a member of the Italian Senate. With news of Herbert's arrest, he persuaded Benito Mussolini's office to request Herbert's release.

Despite the close call, Herbert and Daisy stayed in Germany, still hoping the Nazis were a passing nightmare.

In 1935 the so-called Nuremberg Laws were enacted, codifying the persecution of Jews that was already taking place. Bearing such grandiose titles as the "Law for the Protection of German Blood and Honor," the new laws prohibited marriage or sexual relations between Jews and non-Jews, prohibited Jews from employing female non-Jews under a certain age, and, most significantly, stripped German Jews of their

citizenship, including the right to vote. The last was something of a grim joke, since by then the only party any German could vote for was the Nazis. "Full Jews" were defined as anyone with three or four Jewish grandparents. People with two Jewish grandparents, such as Herbert's children—and like me—were dubbed *Mischlinge* of the first degree, meaning in English "mongrels" or "half-breeds." They all had to register as such in their schools. Herbert's daughter, Marion, later remembered how, at age twelve, a group of her classmates surrounded her in the playground and started shouting, "Jew! Jew!" Like me when I was a boy in England, Marion had never known that she was Jewish.

As the Nazi nightmare intensified, Herbert and Daisy existed like so many Germans in a strange netherworld between despair and hope. Some of their friends and relatives—including Fritz and Louise—urged them to leave. Others still believed that the Nazis' anti-Jewish persecutions would eventually pass. Former friends or associates, such as Schacht and Von Ribbentrop, when they deigned to speak to Herbert at all, smilingly assured him that there was nothing to worry about: Herbert and other members of wealthy and established German Jewish families would not be harassed. Then the next day the Gestapo would be knocking on Herbert and Daisy's door, checking on them, asking questions. There were odd, almost surreal social interactions. Once, during a visit to her hometown of Baden-Baden, Daisy to her horror found herself at a dinner party seated next to SS officer Sepp Dietrich, the head of Hitler's bodyguard and a future SS general. Not knowing who Daisy was, Dietrich joked about executing prisoners during the Night of the Long Knives—the same purge that almost cost Herbert his life.

Finally it was too much. Herbert and Daisy decided to leave Germany, but it had to be done carefully so as not to arouse the Gestapo's suspicion. During a visit to Fritz and Louise in Holland, Daisy smuggled her valuable family jewelry across the German-Dutch border hidden under her clothes—an almost insanely risky thing to do. Under Nazi currency and assets export laws, such smuggling could bring the death penalty. Herbert and Daisy sent their children to England one

by one, ostensibly on vacation—first Luca, then Fredy, and finally little Marion. In late 1936, under the guise of attending a business meeting in Switzerland, Herbert and Daisy crossed the German border and made their way to England. With the help of Fritz, Herbert rented a suitable flat on London's Park Lane. Back in Germany the Nazis' punitive taxes on Jews and Jewish property took everything he had left, including Herbertshof.

Once safely in England, Herbert continued to receive demands from the German government. Documents, adorned with the Nazi eagle and swastika, ordered payment for various taxes. Again, it seems unbelievable, but Herbert, ever the loyal German, still hoping that Germany could regain its senses, still believing that he might return, filled out the forms and complied. Herbert's "atonement tax" came to thirty-five thousand Reichsmarks.

In reality Herbert, and all others who had fled Germany, were forced to leave behind virtually everything they had owned. The taxes were nothing more than a device for "legally" stripping all Jewish assets.

Nevertheless, while financially ruined and forced, with a heavy heart, into the bitter life of a refugee, Herbert and Daisy were some of the lucky ones. Of half a million Jews living in Germany when Hitler and the Nazis took power, some three hundred thousand managed to get out before the war began and the door slammed irremovably shut. Of the two hundred thousand Jews who would not leave Germany or could not find another country that would accept them, 90 percent would perish.

The repercussions of the Nazification of Germany did not stop at the German border. In December 1933, with the Aryanization of the Dresdner Bank in Germany well under way, a delegation of bank officials, armed with a sheaf of writs and authorizations, arrived at the Proehl & Gutmann offices on the Herengracht in central Amsterdam. They curtly informed Fritz that, under the provisions of the Nazi "Pro-

fessional Civil Service" law, his association with the Dresdner Bank was dissolved. Proehl & Gutmann's assets—accounts, files, office furniture, the paintings on the walls, everything—were being seized. Among the paintings were two Goyas and a spectacular Guardi. It was all quite legal. The last tenuous link between the Gutmann family and the Dresdner Bank had been broken.

Ernst Proehl, as a German-born "Aryan," might have been able to continue an association with the Dresdner, despite that his wife, Ilse, was Jewish. Proehl, who was fiercely anti-Nazi—a stance that would later almost cost him his life—wanted no part of it. Instead he and Fritz formed ostensibly separate but cooperating companies, Firma F. B. Gutmann and Proehl & Co. The former was to handle international credit and trade transactions; the latter was to continue the dealing with German companies that had formed the lion's share of Proehl & Gutmann's business.

Still, times were difficult. The Depression had hit Holland just as it had everyplace else, and business never had time to recover. As director of the Gutmann Family Trust, Fritz was also required to dip into the now-diminished trust capital to help support other members of the family. Herbert, obviously, was in need of funds, especially after he and Daisy fled to London. Kurt, now divorced from Vera, had fled to Paris to escape the Nazis and was, as usual, constantly broke. Max, now residing permanently in Italy, had never had a civilian job and was also a constant drain.

Yet, despite the financial crunch, increasing international tensions, and the loathsome persecution of Jews in Germany, Fritz and his family in Holland, and millions of other families throughout Europe, had an odd sense of normality, of life going on. There were still parties at Bosbeek, trips to Paris, and holidays in the Swiss Alps. The day-to-day business of earning a living and sending children off to school continued for Fritz.

In 1934 my father, Bernard, graduated from the Lyceum Alpinum Zuoz in Switzerland and set off for England to enroll at Cambridge University. At Trinity College he majored in art history, girls, MG con-

vertibles, and sports—not necessarily in that order. Unlike the crushed, taciturn, and damaged man I knew, in those days he was outgoing, gregarious, and fun—not to mention wealthy and well connected. He was a member of the best clubs and captain of the Cambridge Ice Hockey Club, then considered one of the elite university hockey teams in England. When the English national hockey team, which was composed primarily of professional ringers from Canada, went to the 1936 Winter Olympics in Garmisch-Partenkirchen in Bavaria, the outstanding Cambridge team went along to play some exhibition games.

It was the first time Bernard had been back to Germany since the Nazis took over. The 1936 Nazi eagle and swastika stamp on one of the old British passports I found in my father's boxes was from that trip. During the Winter Games the Nazis went to great pains to temporarily downplay their anti-Jewish program, ordering the "No Jews Allowed" signs to be removed from stores and cafés and excising the more strident anti-Jewish rhetoric from newspaper articles. I don't think my father was fooled for a minute; he was well aware of what the Nazis had done to his uncle Herbert and the Jews in Germany. I remember, as a young boy, being told the story about how my father had been tailed by Gestapo agents in Garmisch, tailed in an obvious and surely ominous way. My father, always self-deprecating, seemed to think it funny that they should take such notice of him. Regrettably this story was one of the tiny exceptions to my father's normal rule of silence. Years later, after the war, when we were racing across Germany toward Switzerland without stopping, I wondered if my father remembered, too, as he kept looking in his rearview mirror.

Fritz was well aware of the long reach of the Gestapo and the German intelligence services, even into Holland. Aunt Lili recalls him warning her not to discuss politics while visiting Aunt Käthe at Hartekamp. Although still a teenager, Lili was already an ardent anti-Nazi. Fritz suspected, quite correctly, that Catalina von Pannwitz's butler was a Nazi spy.

Reports on prominent German expatriates, Fritz included, were routinely forwarded to Berlin. The Nazi specter even loomed over the

Netherlands' biggest social event of the decade: the 1937 royal wedding between Crown Princess Juliana and the Gutmanns' young friend Prince Bernhard zur Lippe-Biesterfeld. Prince Bernhard had wooed the heir to the Dutch throne after meeting her at the 1936 Winter Olympics. As a prelude to the wedding the prince had publicly renounced both his Nazi connections and his German citizenship. However, at a gala pre-wedding party in The Hague for twenty-five hundred guests, Fritz and Louise among them, members of Prince Bernhard's family gave the Nazi salute and the band played the Nazi marching anthem, "The Horst Wessel Song." In news photographs of the day everyone is smiling, the happy smiles of people who don't understand what's coming.

Meanwhile, Aunt Lili had met a young man, Franco Bosi, during her finishing school days in Florence. The Bosis were an old Italian family with extensive property holdings in Tuscany. Franco Bosi's mother even owned two of the famous medieval towers in the old walled city of San Gimignano. (Today, the towers attract tourists by the seemingly endless busloads.)

Lili and Franco were engaged to be married in the summer of 1938, which would seem to be not a moment too soon, given that the Fascist government under Mussolini would later that year enact a set of Nuremberg-style laws. The new decrees prohibited marriage between Aryans and non-Aryans. All foreign Jews—with the exception of those over sixty-five years of age or those married to Italian citizens—were ordered to leave the country within four months or be forcibly expelled. Great-Aunt Lili was already married to Luca Orsini and, as a result, immune from these decrees, but Great-Uncle Max, on his own in Rome, was clearly at risk. Fortunately, the Italian people never took anti-Semitism as seriously as their budding German allies. While there was indeed persecution and harassment, initially the country's fifty thousand Jews were mostly left alone. The true atrocities against Italian Jews did not begin until the Germans arrived late in the coming war.

So the wedding went on in Florence, although Fritz and Louise did not attend. I don't know why—Aunt Lili to this day refuses to discuss

the matter—but I sense that Fritz did not completely approve, that he felt his only daughter could have done better. Nevertheless, he was either unable or unwilling to stop the marriage. My father, however, freshly graduated from Cambridge with a bachelor of arts degree, did attend the wedding. He drove, no doubt at breakneck speed, from Bosbeek to Florence in one of Fritz's convertibles. This time he took the long way, through France, avoiding Germany altogether. Then it was back to Bosbeek for a quick visit with his parents before returning to England to enjoy some postgraduate freedom. Meanwhile, he pondered what was no longer such a certain future. He could not have known that it would be eight years before he would see Bosbeek again.

Even as these family activities went on, Europe was inexorably moving toward catastrophe. Just twenty years after the end of the first war, unbelievably, "the lights were going out all over Europe" for a second time.

In 1936, Hitler remilitarized the Rhineland. In 1937, the Nazis started bombing Republican forces in Spain. Then in 1938, Hitler annexed the German-speaking Sudetenland in Czechoslovakia. Only a few months before, the German army had marched into Austria. This "union" or *Anschluss* was greeted with hysterical delight by most Austrians. Hundreds of thousands greeted Hitler's triumphant entry into Vienna with flowers and Nazi salutes. Within days, Vienna's Jews, including our distant Gutmann cousins, were being taunted, humiliated, beaten, arrested, and of course having their property confiscated. Through it all, the Western allies, namely England and France, averted their eyes and did nothing. Life went on blithely, unless you were a Viennese Jew forced by storm troopers to scrub sidewalks and privies, or a Czech antifascist hauled off to a concentration camp.

On November 9, 1938, in Germany, the Nazis used the murder of a minor German diplomat in Paris by a young Polish Jew to unleash a nationwide orgy of violence against Jews. History knows this as Kristallnacht. Thousands of Jewish stores and shops were smashed and looted, at least a hundred Jews were murdered, and tens of thousands were arrested and locked up in Buchenwald, Sachsen-

hausen, and Dachau. Jewish cemeteries were desecrated and over a thousand synagogues burned. While the Dresden synagogue that my great-great-grandfather Bernhard helped to build was destroyed, Bernhard's grave in the Jewish cemetery in Dresden, and Eugen's tomb in Berlin, miraculously survived almost untouched. In the wake of the violence, the Nazis imposed a 1 billion mark "atonement tax" on German Jews to pay for the damage. This was one of the taxes that Herbert, albeit safe in England, had no real choice but to pay.

Kristallnacht marked the turning point for those Jews who remained in Germany. No longer could there be any doubt what the Nazis had in store for them, even if the rest of the world still did not quite believe it. Those who could fled Germany, in the tens of thousands, their passports stamped with a large red *J* for *Jude*. Most were only allowed to take with them a few clothes and ten marks in cash after paying the *Reichsfluchtsteuer*, or Reich flight tax. Their remaining possessions in Germany were confiscated.

Holland had waxed and waned in its acceptance of German Jews, but in the wake of Kristallnacht some seven thousand German Jews were allowed into Holland, joining the twenty-five thousand German Jewish refugees who were already there. Among those was Louise's mother, Thekla, who moved into Bosbeek. Another arrival in Holland was Louise's second cousin Franz Ledermann, a Jewish lawyer from Berlin. While living in Amsterdam, his ten-year-old daughter, Susi, would become best friends with another young German Jewish girl, Anne Frank. Each day after school, Susi and Anne would play hide-and-seek. On weekends the Franks and the Ledermanns would listen to chamber music over tea in the Ledermanns' crowded apartment.

Those immigrants without means or family connections were housed in a refugee camp at Westerbork, their expenses paid by the Dutch Committee for Jewish Interests, to which Fritz and Louise and their friends were substantial contributors.

By mid-1939, it was finally clear to almost everyone that war in Europe was coming. The prospect of Hitler's not respecting Dutch neutrality had become a real possibility. For all of Hitler's promises, for

all of Neville Chamberlain's appeasing talk of "peace for our time," the Nazis would not stop with Austria or Czechoslovakia—which after the Sudeten crisis, Hitler had gone on to swallow almost whole.

Fritz, ever cautious, was all too aware from his World War I experience just how quickly events could overwhelm a country, and a continent. Urgently, he took steps to prepare. He transferred funds to several accounts in Switzerland and some securities to my father in England. A few artworks were sent to New York. A much larger portion of his art collection went, for safekeeping, to the Paris gallery of the art dealer Paul Graupe. After obligingly doing the Nazis' dirty work with the "Jew sales" in Berlin, Graupe had finally fled, himself, from Germany to France to escape the Nazis.

Then, in September 1939, just over two decades after a conflict that had killed some 12 million people, Europe was once again at war. Thanks to a treaty negotiated by Herbert's erstwhile friend Joachim von Ribbentrop, now the Nazi foreign minister, Hitler had nothing to fear from the Soviet Union. Armed with the cynical nonaggression pact he had just signed with Stalin, Hitler invaded Poland unopposed. The Germans unleashed for the first time the lightning style of war known as blitzkrieg and easily gobbled up the western half of Poland, while the Russians took the rest.

England and France, finally awakening, declared war on Germany. As the French army and a British expeditionary force settled down behind France's Maginot Line, the war entered into an uneasy stalemate—the so-called Phony War. In the Netherlands, the government hoped, as in the First World War, that the country could somehow stay out of the conflict. Despite this, Dutch intelligence reported an imminent German invasion. While some attempts were made to bolster defenses, hope seemed to be the Dutch government's primary option. In April 1940, German armies invaded Norway and Denmark, both of which had, like Holland, been neutral in the last war.

Bernard sent telegrams imploring Fritz and Louise to leave Holland and join him in Britain while there was still time. Stubbornly Fritz refused, though he certainly had the means to do so. It's one of those

situations in which I want to shout back across the generations, to ask my grandfather why he stayed. Why didn't he and my grandmother drop everything and flee? But there are no answers. Despite his own experience in the previous war, and despite what had happened to his brother Herbert, Fritz must have thought he could weather the storm. Perhaps he believed that his family would somehow be protected by his wealth and his connections with the Kaiser, with the Dutch royal family, and with the Italian government. Maybe he did not understand that civilization as he had known it, had, at least temporarily, come to an end. Under the Nazis, his native Germany had already descended into barbarism. Or maybe, in what clearly was a Gutmann family genetic trait, he was simply obstinate—a fifty-four-year-old man who was set in his ways, secure in his position, a man who refused to be run out of the home and the life that he had built, even in the face of armies on the march.

Whatever the reason, Fritz and Louise stayed in Holland. And by the time they realized their terrible mistake, it was already too late.

PART II

DEVASTATION

CHAPTER 6

THE WOLVES AT THE DOOR

Berlin SW 11, den 1J. Juni 1942
DER REICHSFÜHRER SS
z.Zt. Führer-Hauptquartier
und
CHEF DER DEUTSCHEN POLIZEI
im Reichsministerium des Innern

Sehr geehrter Herr Botschafter !

Auf Ihr Schreiben vom 31.3.1942 teile ich
Ihnen mit, dass bisher gegen den Juden und niederländischen Staatsangehörigen G u t m a n n, wohnhaft
in Hemstede bei Den Haag, Glipperweg 91, nichts unternommen worden ist. Ich habe Ihrem Wunschen entsprechend, meinen Dienststellen in Den Haag Anweisung geben
lassen, Gutmann in seiner Wohnung zu belassen und
Ihn sowie seine Ehefrau von sicherheitspolizeilichen
Massnahmen allgemeiner Art auszunehmen.
Mit besonderer Hochachtung
verbleibe ich
Ihr
H.Himmler

Heinrich Himmler's letter where he assures the Italian ambassador, "the Jew and Dutch citizen Gutmann" and his wife will be exempt from any Security Police measures.

I try to imagine how Fritz and Louise felt on that day, May 10, 1940.

I can imagine them staring up at the sky over Bosbeek in the early-morning hours, watching with shock and astonishment, and no small measure of terror, as the squadrons of German bombers roared overhead. I see them listening to the low, far-off rumble of bombs falling

and the booming of Dutch antiaircraft artillery. The black, oily smoke from crashed and burning planes loomed over the horizon. In the morning twilight, they could just make out, in the distance, the tiny, eerie, white shapes of German paratroopers floating down. They were landing around Valkenburg airfield, just twenty miles away. Then the frantic phone calls started, the lines suddenly going dead in midsentence. The near-hysterical reports on Dutch radio were full of short-lived bravado. Together Fritz and Louise listened to the news from the Hilversum radio station, following the Germans' advance. I can see their hands trembling as they clasped each other and wondered what this would mean. They must have felt the Germans' approach like a jail door slamming.

However, one aspect of that day, and of the days that followed, I find hard to imagine. Almost every contemporary account notes that the skies over Bosbeek and the rest of western Holland were clear and blue, that it was an unusually beautiful spring morning. I know, rationally, that even under the Nazis there surely were sunny days; I just can't see it. Whenever I think of my grandparents during the Nazi nightmare, I envision them only in the monochromatic shades of World War II newsreels, under clouds of SS black and skies of Wehrmacht gray.

For the Dutch, the struggle against the invading German army was all quite hopeless, a David and Goliath contest in which the giant soon carried the day. For their offensive on the Western Front, the Germans had a modern army and air force with Stuka dive-bombers and hundreds of tanks. The Dutch air force consisted mainly of biplanes, its armored forces comprised exactly thirty-nine armored cars, one tank, which was out of service, and five diminutive tankettes. The Dutch defense certainly showed instances of heroism. The Dutch army actually staged a successful counterattack the next day—the German attack on The Hague ended in failure. To the south, though, the battle of Rotterdam raged. Again German ground troops did not achieve immediate supremacy. Then on the fifth day, Göring unleashed the Luftwaffe.

Almost a hundred bombers flattened central Rotterdam in hours. Soon after, the Dutch forces surrendered. The Battle of the Netherlands was over in five days.

Queen Wilhelmina and the Dutch royal family fled to England with the Crown Jewels packed in a cardboard box. Thousands of panicked Dutch civilians tried to escape by going south to Belgium, including many Dutch Jews and German Jewish refugees who knew all too well what the Nazis were like. Unfortunately, Belgium was also under German attack, so most of them were turned back. Thousands of others fled westward in cars, on bicycles, or on foot, hoping to escape by sea. A few made it, including Fritz and Louise's friends the art dealer Jacques Goudstikker, his wife, Desi, and their infant son. The Goudstikkers had made the heart-wrenching decision to abandon their fairy-tale castle, the art gallery, and their enormous art collection (over twelve hundred pieces). They secured passage on the last ship to leave the port of Ijmuiden, the SS *Bodegraven*. Tragically, Goudstikker went on deck during the night to get some fresh air, but when he tried to get back to his cabin, he opened the wrong door. He fell through an open hatch and broke his neck. Several hundred other refugees climbed aboard fishing boats, or any small vessel, and set out into the North Sea for England. While many were forced back by high seas or sunk by mines or German attacks, some successfully made their escape.

Fritz and Louise could have been among them. Later, during the war, my father's cousin Luca, Herbert's son, met a German Jewish refugee—his name is lost—who had known Fritz in Holland. As the invasion rolled over the country, the man had offered to try to get Fritz and Louise passage with him on a fishing boat to England. Fritz declined, the story went, and told Luca's acquaintance, "Thank you, but no; nothing can happen to us. We are Dutch citizens."

My noble grandfather still thought that the rules of civilized behavior would apply, even with the Nazis. It was a common enough self-delusion in the Netherlands. For every Dutch civilian who tried to flee the Nazi onslaught, thousands of others simply settled down

to wait it out, unwilling or unable to abandon their homes to attempt the dangerous and uncertain path of refugees. Certainly some in the Netherlands despaired, particularly the thirty thousand Jewish refugees from Germany. They had already fled the Nazis once; now they found themselves once more at the mercy of their persecutors. Reports were that suicides in Amsterdam increased threefold immediately after the invasion, mostly among the Jewish refugees.

The writing was on the wall, but most of the Dutch people, Jews and non-Jews alike, simply hoped for the best. At first it seemed those hopes might not be misguided. The brutal measures by the Germans against the civilian population in Poland and other eastern territories contrasted dramatically with the comparatively benign way the Nazi occupation of the Netherlands began. The moment the Germans marched into Poland, thousands of ordinary civilians, both Jews and non-Jews, were executed daily. Polish POWs of Jewish origin were routinely selected and shot on the spot.

Under the Nazi racial policies, the Dutch, along with the Danes and the Norwegians, were considered to be fellow "Nordics," "racially pure Aryans," closely tied by culture and blood to their German occupiers. Hitler thought, wrongly as it turned out, that the Dutch could therefore easily be converted to National Socialism and the Netherlands incorporated into the greater German Reich. Even Dutch Jews were buoyed by the Nazis' initial assurances that Dutch citizens would not be treated badly.

Early in the occupation, the Nazis' true intentions regarding Holland's Jewish population had not yet been revealed. Their promises could still be taken at face value. For the moment, Jews still remained legal citizens. Soon after, German Jews were ordered to leave The Hague and other coastal towns and submit to registration. The illusion of Nazi benevolence did not last long.

Meanwhile, the guns had barely fallen silent over Holland before a swarm of Nazi agents and art dealers descended on the country to plunder the nation's vast treasure trove of art. In theory, they were seeking to "repatriate" art of German origin and liberate "Christian" art

from unworthy Jewish collectors. In practice, they were commissioned to stock the museum Hitler was building in his hometown of Linz and to furnish the private art collections of Hermann Göring and other top Nazis. While pursuing this twisted mind-set, the Nazi art vultures were eager to make a fortune.

On May 15, 1940, immediately following the surrender of Holland, Kajetan Mühlmann arrived in The Hague and established the Dienststelle Mühlmann, which became—under the Nazi Governor Seyss-Inquart—the central agency for all matters concerning Dutch and Belgian art properties.

Mühlmann was an Austrian-born art historian and SS *Gruppenführer*. Earlier, he had served in Poland as Special Commissioner for the Protection of Works of Art in the Occupied Territories—*protection* and *safeguarding* being common Nazi euphemisms for "looting." His stated task was to identify, evaluate, and acquire Holland's premier artworks and collections. Dienststelle Mühlmann shared offices with the Gestapo, which was available to intervene should the owners of any desired artworks raise a fuss.

Mühlmann's chief assistant was Eduard Plietzsch, a German art historian and a specialist in Dutch and Flemish paintings. Before the war, Dr. Plietzsch had handled one of Fritz Gutmann's major art deals and was thoroughly familiar with the best private collections in Holland, Fritz's included.

A report on Dutch collections compiled for Hitler and Göring, authored by Plietzsch and Mühlmann, ominously noted that several "important works by German masters can be found in the possession of Fritz Gutmann: portraits by Cranach, Burgkmair and Baldung . . ."

Soon they were knocking on Fritz's door. However, just a month after the Dutch surrender, the first Nazi agent to arrive, unannounced, at Bosbeek was a beady-eyed art dealer from Berlin named Walter Andreas Hofer. With him was Alois Miedl, another profiteer. They were particularly interested in the Gutmann silver collection. Hofer, with his brother-in-law Kurt Bachstitz in The Hague, had actually been authorized to sell several minor pieces from the collection in the 1920s.

Miedl, who had moved to Holland in 1932 with his Jewish wife, had actually been present for one of the rare prewar showings of the silver collection, normally locked in Bosbeek's strong room.

Miedl and Hofer assured Fritz that, if he wished to leave the country, they would use their influence with their superiors. The two dealers were, in fact, special agents for none other than Hermann Göring. They pointed out that it was unwise to disappoint the *Reichsmarschall*. Frighteningly, it dawned on Fritz that he was Hofer's very first call since his return to Holland. Fritz realized that he had little choice.

However, Fritz was determined, at all costs, to protect the family legacy for which he was custodian. Instead, he agreed, albeit grudgingly, to part with several magnificent sixteenth- and seventeenth-century, silver-gilt pieces from his personal collection, including the Johannes Lencker ewer in the shape of a triton, the *Horse and Rider* by Hans Ludwig Kienle, and a pair of silver-gilt wedding cups by Hans Petzolt. A payment was made that was far below the real value of the art pieces. Additionally, the payment went into a bank account that would soon be frozen. The Nazis always insisted on covering up extortion with a veneer of strict "legality." Hofer assured Fritz that his cooperation would be remembered, and no doubt rewarded. Fritz wanted very much to believe him.

Early on, a few threatened collectors and dealers in Holland did manage to turn the Nazis' hunger for art into some kind of advantage. Fritz and Louise's friend and neighbor Catalina von Pannwitz arranged through Hofer to sell Göring a Rembrandt and four other paintings from her Hartekamp collection in return for an exit visa to Switzerland, which Göring actually delivered as promised. In another case, Dutch Jewish art dealer Nathan Katz used his control over the collection of the late Dr. Otto Lanz to secure exit visas for himself and several other members of his family.

So perhaps Fritz was not naive to believe that he was still in a position to negotiate—that somehow his cooperation could get his family out of Holland. Unfortunately, as time went on and as the Nazi grip

tightened, the true value of Nazi promises would become all too apparent.

Meanwhile, pro-German quislings from the Dutch National Socialist Movement (NSB) were quickly inserted into positions of authority. The civilian bureaucracy and police took no time in implementing the new order. Soon enough, the new masters began the systematic intimidation and persecution of Jews, which would eventually lead to genocide.

In November 1940, Dutch Jews were banned from civil service positions, including teaching. By January 1941, Jews were required to register as such with local police and receive identity papers stamped with a *J*. Soon all public parks, beaches, museums, and trams were off-limits to them. Cafés, stores, and cinemas posted signs saying VOOR JODEN VERBODEN or "Forbidden for Jews."

In March 1942, Jewish businesses were required to have an Aryan administrator. Then on April 29, all Jews were ordered to wear the yellow star, with the word *Jood* across it. In June, Jews had to surrender their bank accounts. Later that same month, the order went out for all Jews to surrender their jewelry and art. One of the last anti-Jewish regulations prohibited the use of public phones. Authorities also disconnected the telephones of all Jewish subscribers. During this bureaucratic nightmare, the Nazis even found time to pass Decree Number 140, which banned Jews from owning pigeons.

Dutch Jews reacted to this tightening noose of restrictions in various ways. Most continued to comply because, like their non-Jewish countrymen, they were accustomed to abiding by the law, no matter how absurd. In many cases the Amsterdam-based Jewish Council actually encouraged compliance, fearing that resistance would prompt still harsher measures.

Jews by the hundreds, and then the thousands, were rounded up and transferred to the Westerbork detention camp. Starting in 1942,

the deportees were "relocated" to the east, supposedly to "labor camps." Their homes were seized and their possessions stolen, down to the last spoon and teacup. What was not kept by Dutch collaborators was shipped to Germany.

A few Jews joined the Resistance, obtaining counterfeit identification documents and staying, the lucky ones at least, one step ahead of the Gestapo and the Nazi-controlled local police. Thousands of others, such as Anne Frank and her family, became *onderduikers*, or literally "underdivers." They went into hiding, usually with the help of sympathetic and brave non-Jewish friends or neighbors. Like the Franks, they spent months, even years, in attics and barns or concealed spaces in homes, trembling with fear when the Nazis and Dutch "Jew hunters" came looking. In her famous diary, Anne described watching from her attic hiding place in Amsterdam as "night after night, green and gray military vehicles cruise the streets. They knock on every door, asking whether any Jews live there. If so, the whole family is taken away. . . . They often go around with lists, knocking only on those doors where they know there's a big haul to be made. They frequently offer a bounty, so much per head."

Twenty-five thousand Jews in Holland went into hiding; of those, some nine thousand, Anne Frank among them, were caught or betrayed. All the same, those who went into hiding stood a better chance of surviving than those who did not. A grim example is that Anne Frank and her family avoided Auschwitz for almost a year longer than her friend (and our cousin) Susi Ledermann and her family.

In Bosbeek, Louise's seventy-eight-year-old mother, Thekla, died of natural causes shortly after the German invasion, compounded, no doubt, by sheer dread. Going into hiding had not been an option. The Gutmann–Von Landaus were too prominent, too well-known, too closely watched. For them, the early days of the German occupation were not a case of police cars racing through the streets and hard men pounding on their doors, but rather a slow shrinking of the world they had known.

As the occupation progressed, Fritz's company, Firma F. B. Gutmann,

was, like all Jewish businesses, "Aryanized" and placed under control of a non-Jewish administrator. Its assets were liquidated at a fraction of their value, of which Fritz never saw a guilder. The Gutmanns' cars were requisitioned by the German army—Jews were prohibited from owning or driving automobiles—and the household staff at Bosbeek began to dwindle. The gardeners and chauffeurs were drafted into labor battalions or went into hiding. The Dutch maids and cooks were prohibited by Nazi decree from working in a "non-Aryan" home. Soon only Piet, the butler, was left. Jews were next forbidden to travel, except to Amsterdam and the ghetto, which left Fritz and Louise confined to Bosbeek in a form of house arrest. Life descended into genteel shabbiness. Fritz's old friend Franz Koenigs recalled going to dinner at Bosbeek at the end of April in 1941. The Gutmanns had secured a rare Dutch delicacy, the last of that season's *kievit* eggs—which Fritz, luckily, had found on the estate. Just one week later, Koenigs was in Cologne, where, in mysterious circumstances, he died under a train in the railway station.

The Gutmanns' friends were disappearing fast. In a letter written in 1942 and smuggled to my aunt in Italy, Fritz described the creeping terror that was enveloping the country, how people they had known had been taken away, held as hostages, or gone into hiding. Others simply vanished.

"Poor Maisels has already become a victim, and if we will ever see him again only the gods know," Fritz wrote to Lili. Rikard Maisels was originally from Vienna and Fritz's business partner and friend. They never did see him again. Maisels perished in Auschwitz soon after Fritz wrote his letter.

From the same smuggled letter: "Reni and Egon [two of Lili's childhood friends] have disappeared without a trace, supposedly they are safe, but I do not know. . . . Your nice professor from Leiden [one of Lili's high school teachers] is being held as a hostage, of whom five have already been shot . . . and so many, many more that had to leave, never to return. It is a horrible misery!"

Yet, for all his despair, Fritz still held out hope.

• • •

From throughout the art world, the rapacious opportunists numbered in the hundreds. Chief among them were representatives of Adolf Hitler and his second-in-command, the corpulent Reichsmarschall Hermann Göring.

Hitler, a failed artist of pre–World War I Vienna, still fancied himself an art connoisseur. His tastes, however, were limited to works consistent with National Socialist ideals. Even Rembrandt was deemed "too Jewish" by many Nazis. Works that did fit into this narrow range included most old masters, usually German, and works considered to be Teutonic. Significantly, much of Fritz's collection fell under these headings. (Hitler also collected kitsch paintings of German peasants and heroic war scenes of the type that might be found on 1930s propaganda posters.)

Following the 1938 annexation of Austria, Hitler made plans to build the self-styled Führermuseum in Linz, where he had grown up as a boy. It was to be a monument to himself and Nazism that would be stocked with thousands of paintings and other objets d'art amassed (by his minions) from museums and private collections throughout Europe. The Special Linz Commission, under the direction of art historian and museum director Hans Posse, was created to acquire works for the planned Führermuseum.

Göring, meanwhile, was a collector of virtually kleptomaniacal proportions. He stocked his palatial hunting lodge Carinhall (and other residences) with more than four thousand artworks, including some fifty paintings by Lucas Cranach the Elder and thirty by Peter Paul Rubens. With typical Göring taste, these were displayed side by side with a few fakes and such lesser masterpieces as a watercolor by one Adolf Hitler, not to mention countless stuffed stag heads. Although Göring publicly toed the Nazi line against "degenerate" art, he also accumulated modern paintings by the hundreds, using them frequently as a kind of currency to trade for more acceptable works.

Julius Böhler, a Munich-based art dealer, often advised Hitler and

Göring on art matters. He was also acquainted with Fritz and had even sold some paintings to him during the 1920s. Now he was also advising the Dienststelle Mühlmann. Holland was not, however, the exclusive domain of this official agency. Numerous freelancers also popped in regularly to snatch up coveted pieces for their Nazi patrons before someone else got them first. Competition among the top Nazi collectors was often fierce, sometimes even pitting Göring and Hitler against each other for possession of a particularly coveted work—although in the end Hitler always won.

Alois Miedl (despite his Jewish wife) had quickly become a major player in the Nazi plunder of the Dutch art market. Through a series of sham transactions, Miedl conveniently assumed control of the Goudstikker estate. Having fled the Nazis, the late Jacques Goudstikker had technically abandoned his collection. Miedl wasted no time in selling much of it to Göring at a substantial profit. Miedl even took over poor Goudstikker's home and, of course, the famed art gallery on the Herengracht, right next door to Fritz's former offices. From there Miedl continued to supply the Nazis with artworks from various collectors, many of them Jewish, who, as Miedl invariably pointed out, had little choice in the matter.

Then there was Karl Haberstock, described by one postwar journalist as "arguably the single most prodigious art plunderer in the history of human civilization." Born in 1878, the son of a farmer, Haberstock—gruff, bewhiskered, and forever clearing his throat—never completely shed his rural image. He had begun his career selling china. Pompous and overbearing, Haberstock was a shameless opportunist who quickly jumped on the Nazi bandwagon, joining the party in 1933. He later sold Hitler his first important artwork, Paris Bordone's rather voluptuous sixteenth-century *Venus and Amor*, which hung in the salon of Hitler's country home in Berchtesgaden. Boasting both a ferocious anti-Semitism and a hatred for "modern" art, Haberstock was a relentless campaigner for the purging of "degenerate" art in Germany—while at the same time appreciating its commercial possibilities. As a member of the Nazis' 1937 Commission for the Exploitation

of Degenerate Art, he was charged with selling on the international market the modern works culled from German museums. In this way Haberstock obtained much-needed foreign currency for the Nazis and no small profit for himself. Later, as the leading agent of the Special Linz Commission, Haberstock would make a fortune trading not only in Nazi-approved artworks, but also in the denigrated works of Van Gogh, Degas, Renoir, and Cézanne that were looted in France, Holland, and other conquered countries.

Mühlmann, Plietzsch, Miedl, Hofer, Böhler, and Haberstock—all names that I had found so eerily sinister when I first saw them in my father's papers. The more I learned about them, the more sinister they became.

One curious aspect of this gang of thieves (and scores of others like them) was that in their minds they were not thieves at all. The Nazis insisted on wrapping even their most despicable acts, all the way down to mass murder, in a strange patina of legality. This policy clearly carried over to their acquisition of art in the occupied territories. In the Nazi view, it was all quite legal to confiscate or force the sale of artworks from terrified Jews, provided the "seller" signed the necessary paperwork in triplicate. That the purchase of such artworks was negotiated, in effect, at gunpoint did not, in the Nazi view, make the resulting deals any less legitimate. Even Reichsmarschall Göring, the most prolific looter of all, insisted to the end of his days that all of his art acquisitions were obtained "legally," all properly bought and paid for from their owners. It was said that, while awaiting trial at Nuremberg, Göring cheerfully shrugged off accusations that he was complicit in the murders of 6 million people, yet grew truly indignant when he was accused of being an art thief.

In March 1941, the German art dealer Karl Haberstock, armed with special authorization documents from both Hitler's Special Linz Commission and from Göring, showed up at Bosbeek's door. Through his extensive sources—the art world was as infested with spies and informers as the military and diplomatic worlds—Haberstock was already familiar with the extent of Fritz's collection. He was even aware

that, before the war, Fritz had sent some of his best paintings to the Paul Graupe gallery in Paris for safekeeping. However, since the collapse of France in 1940, the Germans had begun, almost immediately, to seize, catalog, and haul away artworks by the thousands from Paris. Haberstock, who had a reputation as a hard bargainer even in normal circumstances, presented Fritz with an offer that was a nonnegotiable demand: Sell me the paintings I want, at my price, or they will be confiscated as "enemy property" (by the German authorities in Paris) and you'll wind up with nothing. On the other hand, if you cooperate, perhaps something can be arranged to help you and your wife get out of the country. It was the Nazi way of doing business.

Having no alternative, Fritz signed documents authorizing Haberstock to take possession of eight of his paintings from the Paris warehouse. The eight old masters (all by German or Flemish artists, who appealed to the Nazi taste) consisted of portraits by Hans Baldung Grien, Hans Burgkmair, and Jakob Elsner, along with Lucas Cranach the Elder's *Samson and the Lion*, an altarpiece fragment of a Madonna by Hans Holbein, Madonnas by Adriaen Isenbrandt and Hans Memling, and a landscape by Van Goyen. For good measure, Haberstock walked away with a very different painting that caught his eye, which was still hanging on the wall in Bosbeek. It was *The Sin* by the Symbolist Franz von Stuck, and Haberstock had a particular high-level Nazi buyer in mind for this piece.

At the last minute, Haberstock added to his list two magnificently carved Renaissance shields and a beautiful Chinese carpet, which he had been standing on.

Fritz was sent a payment for 122,000 Dutch guilders to the Rotterdamsch Bank Vereeniging N.V. of Amsterdam. This was the equivalent of $75,000 for all eight of the old masters and four other works of art. The account was placed in receivership by a Nazi-appointed trustee. Ultimately, Fritz got nothing except empty promises.

Haberstock, however, was far from finished. In February 1942, he returned to Bosbeek accompanied by Julius Böhler, agent to both Hitler and Göring. Böhler, in contrast to Haberstock's bluster,

appeared calm and scholarly. Behind the thinning hair and professorial beard a cruel cunning was at play. Haberstock and Böhler didn't just want some of the artworks and antiques that still remained in Bosbeek. They wanted all of them.

As Fritz stood helplessly by—and, I imagine, as Louise sat weeping in her dressing room—Haberstock and Böhler stomped imperiously through every single room in the house like a pair of jackbooted thugs. Starting with the front hall, then the main hall, slowly and meticulously scouring every inch, they finally finished in the breakfast room with the huge red carpet. In total they compiled an exhaustive list of more than two hundred valuable works of art, all to be taken away. The paintings included a Biagio d'Antonio, a Fra Bartolommeo, two François Bouchers, a Francesco Guardi, an Élisabeth Vigée-Lebrun, two Hubert Roberts, and many more important pieces. Among the antiques were Aubusson tapestries, Louis XV and XVI furniture, Meissen porcelain, gilded mirrors, Ming and Qing Chinese vases, bronze sculptures, and so much more. All of it was to be loaded up and driven by truck to Germany.

In return for this huge haul, Böhler and Haberstock transferred—unbelievably, through the now Aryanized Dresdner Bank—the meager sum of 150,000 Dutch guilders, less than $100,000. This time the money went straight to the Deutsche Revisions und Treuhand AG in The Hague (the German Audit and Trustee Company—a notorious Nazi money-laundering facility).

A month later Böhler and Haberstock were back again. This time their purpose was twofold. They had received strict instructions from Göring to secure the Gutmann silver collection, one way or the other. Their secondary purpose was more of a mopping-up operation—they were to inventory the remnants of the estate. After all, the remaining household furniture, china, and silverware were all of the utmost quality. The Nazi dealers, graciously they thought, would allow those items to remain in Bosbeek as long as the residents did. The ominous implication was that Böhler and Haberstock knew, only too well, that Fritz and Louise were not going to be staying much longer.

Once again, Fritz was forced to sign a receipt for the "sale" of the

remains of his collection and household goods, even though, by now, it was quite clear he would never actually receive a cent. However, concerning the Gutmann silver collection (still belonging to all of Eugen's children), there was one stumbling block. Playing the Nazis' own legalistic game, Fritz stubbornly refused to sign over ownership of the "Crown Jewels" of the Gutmann family. Earlier that year, Fritz had transferred legal title for the family trust (which administered the silver collection) to his brother-in-law the Italian senator Luca Orsini. Fritz insisted that he alone could not sell the silver collection.

It seems astonishing, even mad, that at a time when the Nazis were systematically murdering millions, the representatives of Nazism's top warlords would be deterred for even a moment by a mere legalism, especially one wielded by an otherwise powerless man. No doubt the Germans did not wish to have a diplomatic incident with their Italian allies—so, for the moment, they were deterred.

However, Böhler took physical control of the Gutmann silver collection and shipped it, for "safekeeping," to his Munich warehouse. This included the Jamnitzer *Becher*, Bernini's *A Flagellator of Christ*, the Ostrich automaton, and both the Reinhold Clock and the Orpheus Clock. In Munich they would sit until further notice, with the actual ownership of the collection to be settled later.

By the spring of 1942, Fritz and Louise had more than enough reason to despair. The Koenigs girls found Fritz, forlorn, sitting on a bench in his garden, with the yellow star on his suit. The last of the Jewish families in Heemstede had been evacuated to the ghetto in Amsterdam. Fritz and Louise were on their own, isolated at Bosbeek. They were now dependent on the furtive assistance of a few remaining friends. Their once-beautiful home had been stripped of its glory, and Fritz's treasured art collection had been reduced to a series of faded spots on the walls.

They no longer had even a faint belief that their forced cooperation with the Nazi art thieves would afford them any protection. Nothing was left to bargain with, nothing was left to steal. Next, the title to the estate itself was taken from Fritz and Louise by Nazi decree, like all

other Jewish-owned real estate in Holland. On April 12 Bosbeek was officially transferred to the Niederländische Grundstückverwaltung (Netherlands Property Management Office). This puppet organization's various functions included overseeing property "abandoned" by Jews, who had fled or "disappeared." Fritz feared that he and Louise might soon be among those who "disappeared."

"A new calamity is threatening us: the possession and expropriation of our house," Fritz despairingly wrote in a letter smuggled to daughter Lili. "Where we shall go from here, only the gods know! The sword of Damocles is hanging again above our heads!"

For Fritz and Louise, one final source of hope and a potential path to safety remained. Ironically enough, that path led to Fascist Italy.

Fritz on the grounds of Bosbeek, winter 1939.

The Gutmann family had maintained close ties to Italy, and members of the Italian aristocracy, dating back to the late nineteenth century. Eugen had been a founding member and director of the Banca Commerciale Italiana in Milan and later was an honorary consul of the

Italian government in Berlin. Fritz's sister Toinon had lived in Rome since the death in 1923 of her husband, Baron Hans von Essen, the former Swedish ambassador in Berlin. Her daughter, Jacobea, was married to the Italian diplomat Baron Giuseppe Sapuppo. Fritz's other sister, Lili, was married to Luca Orsini Baroni, who, after leaving his post as ambassador in Berlin in August 1932, had been nominated to the Italian Senate by the Italian King. Orsini had extensive ties with the Fascist government and with the Vatican. Fritz's daughter Lili was married to Franco Bosi, now an officer in the Italian army, whose family was from the Tuscan landed gentry. Fritz's brother Max, who had played piano so beautifully for Cardinal Eugenio Pacelli before he became Pope Pius XII, was acquainted with a number of important figures within the Vatican. Even Fritz's mother had Italian ties: after she divorced Eugen, she married again and became Countess Sciamplicotti. Meanwhile, Fritz numbered among his prewar connections Count Galeazzo Ciano, who was Mussolini's son-in-law and Italy's foreign minister.

None of Fritz's family members in Italy were under any illusions about the dangers he and Louise faced under German occupation; almost from the moment the Germans invaded Holland, they had desperately tried to use their connections to get Fritz and Louise safely out of Holland.

Italy had a somewhat odd relationship with its German ally. Despite Italy's membership in the Axis alliance with Germany, Mussolini had initially sat out the conflict with France and England, not declaring war until just before France capitulated in June 1940. Afterward, Mussolini embarked on some rather inept military campaigns in North Africa and Greece, which ended with German troops having to come to the Italians' rescue. Although Hitler had long admired Mussolini, other top Nazis soon came to regard their Italian counterparts with ill-concealed contempt.

The Italians, meanwhile, had never embraced Fascist totalitarianism with the same unquestioning gusto as the Germans. Despite the Italian anti-Jewish laws of 1938, which were only halfheartedly enforced, the

Italians seemed baffled and dismayed by the Germans' rabid persecution and murder of Jews in Germany and the German-occupied territories. In fact, the Italian government went to great lengths to rescue and return to Italy those Italian Jews who found themselves under German control in occupied Europe. While Fritz and Louise were not Italian citizens, their many family connections in Italy made them pretty close to it. So when the two Lilis (Fritz's sister and daughter) and their relatives asked for help in getting Fritz and Louise safe passage from Holland to Italy, members of the Italian government promised to do what they could. Officials in the Vatican also agreed to help.

The Italians were very junior partners to the Germans, and thus while they could ask, they could not demand. The Vatican, meanwhile, maintained an uneasy relationship with the Nazis and Hitler, who had been angered by the pope's protest of their treatment of Catholics—and to a lesser extent, their treatment of the Jews—in Germany and elsewhere. Its influence, too, was somewhat limited.

Still, a number of Italian and Vatican officials took up the case. On orders from Count Ciano, the Italian ambassador in Berlin, Dino Alfieri, gently informed the German foreign office and the office of Reichskommissar Seyss-Inquart in Holland that the safety and security of the Gutmanns was of some importance to the Italian government. An Italian attaché in The Hague, Franco Pietrabissa, was also helpful, personally keeping Fritz and Louise informed of the efforts on their behalf and forwarding occasional messages and letters from Fritz to his daughter Lili in Italy. Pietrabissa even managed, at some personal and professional risk, to smuggle out of Holland, by diplomatic pouch, some of Louise's jewelry. The diplomat was able to deposit the jewels in a bank in Switzerland, later giving Lili the key.

At the Vatican's direction the papal nuncio in Berlin, Monsignor Orsenigo, also took an interest in the Gutmann case. Unfortunately, his zeal may have been somewhat tempered by his being, as one historian put it, "a pro-German, pro-Nazi, anti-Semitic fascist."

As the letters and diplomatic cables flew, by mid-1942 it seemed as if the Italian diplomatic efforts were paying off. In June of that year,

Ambassador Alfieri in Berlin received the following message, a copy of which was later sent to Lili:

"Following your letter of 31.3.42, I notify you that no measures have been carried out against the Jew Gutmann, a Dutch citizen, who resides in Heemstede near The Hague. . . . According to your wishes, I have ordered my office at The Hague to leave Gutmann in his house and to exempt him and his wife from any kind of security police measures."

The letter was signed "H. Himmler."

It is more than a bit chilling to realize that Heinrich Himmler, head of the SS and the Gestapo, architect of the murder of millions, had taken a personal interest in my grandfather and grandmother. Equally chilling to me—and no doubt even more so to Fritz—was the vagueness of Himmler's assurances. What would happen if Fritz and Louise were to set foot outside the Bosbeek estate? Certainly the letter offered no protection against the Nazi art vultures circling around them—by that time most of the more valuable Gutmann possessions had already been taken. However, it did allow Fritz and Louise to remain at Bosbeek while other far less fortunate Dutch Jews were being forcibly herded into the Amsterdam "ghetto," and then into the Westerbork concentration camp. Ironically, the ghetto, or Jewish quarter, was where Jewish refugees had sought refuge from the Spanish Inquisition, at the end of the fifteenth century.

The Himmler letter mentioned, crucially, not one word about the crux of the Italian officials' requests on the Gutmanns' behalf—that is, that they would be allowed to leave Holland and come to Italy. The Italian ambassador in Berlin, Dino Alfieri, seemed to share that concern. In response to an inquiry about the Gutmann case from the Vatican Secretary of State, Cardinal Luigi Maglione, Alfieri wrote, "The case mentioned in your Excellency's letter has become the object of my lively interest in the past few months, and in spite of all the difficulties I've had to overcome, I have managed to receive a written guarantee by the German Chief of Police, Mr. Himmler, that the relatives of his Excellency, Senator Orsini Baroni, residing in Holland, will not be both-

ered. A little while ago I had the opportunity to inform His Excellency, the Nuncio in Berlin, Monsignor Orsenigo, of the above mentioned. He was interested in the fate of his Excellency Orsini's relatives. But even though we have a written guarantee (from an official of high position) it is not certain that all doubt concerning the fate of the family of the relatives of the Senator Orsini has been diffused."

The ambassador's suspicions were well-founded. Despite Himmler's assurances that Fritz and Louise were protected, the Nazis had other plans.

In the early-afternoon hours of May 26, 1943, a black Mercedes touring car sped up the long, elm-shaded driveway of the Bosbeek estate and screeched to a halt in front of the manor house. A young man in an SS uniform got out of the car and strode briskly up the steps, where he knocked, not gently, on the front door.

A certain J. E. Westerbeek, an Amsterdam solicitor of somewhat slippery character whom Fritz had employed for the family trust, was in the house that day to go over some legal matters. Much later, in a letter to Lili, Westerbeek described what happened:

> We heard a car drive up and then an urgent knocking at the door. When Piet, the butler, answered the door, he returned shortly afterward, white as a ghost, with a German in civilian clothes, followed by a uniformed man. He introduced himself as Untersturmführer [Lieutenant] Werner of the SS and in the SS's disagreeable way demanded to know who were Herr Gutmann and Frau Gutmann. He then locked the door, and your parents and I had to stay in the room while he went through the house. You can understand the fearful state we were in, and this increased shortly thereafter, because Werner came back and told us that your parents had to go with him. After repeated entreaties he told us that the journey would be to Berlin. However, they should have no fear, because nothing would happen to them.
>
> He said that on the trip they would be allowed every comfort, and

that after the journey to Berlin, they would continue on "to the south." Your parents would be allowed to take money, jewelry, luggage, etc., and he would take care of the transportation. He said your father was a "special case," referring to your father's Italian relations, and he suggested that Italy was the ultimate destination, although he wasn't really permitted to divulge anything.

Westerbeek said the *Untersturmführer* then told them that Fritz and Louise should pack as many suitcases as they wanted and be ready to leave at 5:00 p.m. He would return with an extra car (for the bags) and take them to The Hague. There Fritz and Louise would board the D train to Berlin, departing at 6:45 p.m. They would have first-class tickets and a sleeping-car compartment. Werner posted an armed soldier at the front door and drove off, leaving Fritz and Louise in an agony of doubt, tempered by hope. It seemed as if this might actually be the beginning of their salvation. But as always there was the question: Could the Nazis be trusted?

Westerbeek took up the story:

After his [Werner's] departure there was a lot of busy packing, and the mood became considerably less anxious. Your mother was still very nervous, but your father seemed to regain his confidence and even found some levity. The whole afternoon was spent packing the suitcases, eventually numbering some fourteen in all, large and small. They packed all manner of clothes, a good supply of linen, toiletries, etc., and some food supplies for the journey.

Shortly after we were ready, Untersturmführer Werner came back [with the two cars]. The doors of the house were locked and the keys taken by him, and then we went full speed from Bosbeek to The Hague. I sat next to your mother in one car, and your father was in the other car with the suitcases. Your father's car went straight to the train station, but we first went to Werner's home so he could pick up his own suitcase. The *Untersturmführer* was to be their escort. We arrived at the station at the last moment, the train was already starting to

move, so I had no opportunity to say good-bye. A pair of waving hands from the train window was the last thing I saw of your parents.

The train moved slowly east on the four-hundred-mile journey to Berlin, the window shades in their compartment pulled down on Werner's order. Returning to the country of their birth filled Fritz and Louise with dread. Frequently delayed by high-priority German military traffic, their train arrived in Berlin the next morning. To their relief, Ambassador Alfieri himself was on hand to greet them at the station. Unfortunately, Alfieri was not alone. With him were two civilian representatives, one from Seyss-Inquart's office and the other from Göring's—their instructions were plain: obtain a release for the Eugen Gutmann Silver Collection. Fritz was unyielding.

With Untersturmführer Werner still accompanying them, Fritz and Louise and their mountains of baggage were boarded onto another train—in a private car, no less. The journey to Italy was to go via Dresden, Prague, and Vienna. After watching them depart, Alfieri's office sent a telegram to Lili Orsini in Pisa advising her of her brother's imminent arrival. Great-Aunt Lili immediately telephoned young Lili in Florence.

Early in the morning on May 28, young Lili rushed with great expectation to the Santa Maria Novella station. Finally the train from Vienna arrived. On tiptoe she scanned the passengers disembarking. She waited until the last solitary traveler got off the train, but Fritz and Louise were nowhere in sight. She thought that perhaps they had missed one of their connections. The next day she came back to the station, and finally the train from the north again arrived. She waited until the last passenger had cleared the platform, and still there was no sign of them. She came back the next day, and the next, and the next, a thin, increasingly forlorn-looking figure, nervously pacing the platform and holding on to the hope that this day's train would finally bring her parents out of the hell they had been living in for the past three years.

As the days, and then nights, went by, and the trains came and went, Fritz and Louise did not arrive.

They never would.

THERESIENSTADT

"Work will make you free." Entrance to the courtyard of the *Kleine Festung* (the small fortress), which led to the Gestapo prison cells.

It was not what was supposed to happen. As they were leaving Berlin, SS Untersturmführer Werner handed them off to another grim-faced SS escort, name unknown. Fritz and Louise, with their mountain of baggage, were escorted to a private car on another train. Their train finally left the Anhalter Station in Berlin about an hour later, southbound for Dresden and then on to Prague and Vienna.

From Vienna they were to connect with the train to Florence.

It is impossible to know exactly what went wrong and on whose orders. Certainly the Italian ambassador and others in his government thought that all was in order. They were unaware that the Nazis had no intention of letting the Gutmanns escape. Perhaps Reichskommissar Seyss-Inquart thought that Fritz would be more cooperative—that he would finally sign over what remained of the Gutmann family fortune. Perhaps Himmler had grown tired of the Italians' weak and sentimental concern about these Jews and decided at the last minute to put them in their place. Most likely, though, it was Hermann Göring, who was never going to allow Fritz Gutmann and the Gutmann silver collection to slip out of his hands.

Whatever the reason—the train suddenly stopped just east of Dresden, in Bautzen, and Fritz and Louise's car was uncoupled on a sidetrack. The train chugged off, leaving their car behind. After the war, in his book *Ghetto Theresienstadt*, Zdenek Lederer described the incident in detail. The SS officer insisted that nothing was out of the ordinary. Next, drowning out Fritz's anxious questions, was the sound of their carriage being hooked to a different train. Louise clutched Fritz's hand as the new locomotive lumbered on through most of the night. At dawn, the shabby transport train rumbled into the little Bohemian town of Bauschowitz. From the platform a harsh metallic voice bellowed, *"Aussteigen!"* The SS officer echoed the command: "You will exit now." Horrified, Fritz and Louise stepped out onto an empty platform. The officer pointed to a black SS car at the side of the station. Fritz and Louise, confused and no doubt terrified, were loaded aboard with as much luggage as the car would hold. They drove two to three kilometers along a narrow, tree-lined road before reaching the gates of the fortress. They had arrived at the Theresienstadt concentration camp.

Their arrival caused some consternation among the inmates. Egon "Gonda" Redlich, a Czech who had arrived in 1942, wrote tersely in his diary, "A man and woman came from Amsterdam, only the two of them. She is elegantly dressed in an expensive fur!" Fritz, too, was impeccably dressed in a well-tailored three-piece suit under his astrakhan coat. Louise, in a long dress and fashionable hat, was indeed wearing a full black-mink coat—no doubt to ward off the late-spring chill. For a

moment, the Baroness Louise Gutmann von Landau stood bewildered in the grimy camp courtyard as inmates gawked at the incongruous vision in furs. Then quickly, the SS escort handed them over personally to the SS camp commandant, Hauptsturmführer Siegfried Seidl.

The method of their arrival, too, was remarkable. Most of the ghetto inmates arrived at the Bauschowitz railway station packed inside "transport" cars with little or no food or water, and no sanitation. Normally, the platform at Bauschowitz thronged with deportees clinging to their bags, while goaded by the rifles of the SS guards and the Czech police. They would then be forced to walk the two to three kilometers, in single file, to the Theresienstadt ghetto. Old and young alike, exhausted from the frightening journey, would clutch their meager belongings—the little that had not already been stripped from them. Fritz and Louise, by contrast, had arrived at the ghetto in a German staff car, with an embarrassing overload of luggage.

The inmates found it incomprehensible that transport train number XXIV/Ez1 had made the journey carrying just two passengers. The next train bringing Jews from Holland would have 305 souls crammed in a few wooden carriages—the one after that carried 870 men, women, and children.

The elaborate ruse of promising Fritz and Louise refuge in Italy was sadly just another case of the Nazis' perverse and cruel tendency to lull their victims, to raise their hopes before sweeping them away. The same twisted logic led them to call gas chambers "shower rooms" and those gassed as receiving *Sonderbehandlung*, or "special treatment." Concentration camps derisively put up signs declaring *"Arbeit macht frei,"* or "Work Makes You Free."

However, Theresienstadt was rather unusual among concentration camps. The ancient town was originally an eighteenth-century walled military garrison, a star-shaped enclosure surrounded by wide earth ramparts and moats. In late 1941, the site was personally selected by the Deputy Reich-Protector of Bohemia and Moravia Reinhard Heydrich, an SS general. Heydrich was also known as the "Butcher of Prague." The Gestapo and the SS converted the *Kleine Festung*, or "Little For-

tress," into their prison. Meanwhile, the walled town was designated a "ghetto" for Jews, starting with those from Prague. As a result, the town's five thousand or so Czech inhabitants were unceremoniously kicked out of their homes. Barbed wire was strung around the walls. Then Jews, by the tens of thousands, were moved in, crammed into overcrowded quarters that were soon teeming with vermin and disease. At its peak, well over sixty thousand Jews were crammed into the ghetto. From there, the next step was transport to the extermination camps farther east that the Nazis were busy building.

Theresienstadt also served another, rather uniquely cynical, Nazi purpose. The Nazi high command had always gone to great lengths to try to conceal from the world and from their allies, and even from the German people (who may, or not, have actually cared), the true nature of the vast network of slave labor and extermination camps. The fiction that millions of Jews deported from Germany and the occupied countries were being sent to "resettlement" camps in the east became increasingly difficult to sustain. What was needed was a "model" concentration camp, a kind of showpiece that could demonstrate to the world that the tales of mass extermination and deadly hard labor were only so much enemy propaganda.

On the orders of Göring, SS-Obergruppenführer Reinhard Heydrich convened the Wannsee Conference, in January 1942. Before the war, Wannsee had been a pleasant suburb of Berlin. The conference was held at a grand villa in close proximity to the golf club founded by Herbert. (The SS villa was also directly across the lake from the Arnhold Villa, which had been the home of Gutmann cousin Hans Arnhold. Hans and his family, fortunately, had fled to New York in 1939.) Here Heydrich, and his assistant Adolf Eichmann, along with other high-ranking SS officers and members of the Nazi government, established the blueprint for the "Final Solution" to the so-called Jewish Question in Europe. Over a buffet luncheon lasting barely an hour and a half, they agreed on an event of unparalleled evil in the history of mankind: the annihilation of an entire people. Even Hitler was heard to describe Heydrich as "the man with the iron heart."

At that infamous meeting, Heydrich also announced that The-

resienstadt, while still being used as a way station for death camp transports, would concurrently be maintained as a "privileged ghetto" for certain Jews. Those Jews who were most likely to elicit sympathy from their fellow Germans, such as the elderly and decorated World War I veterans, were to be sent to the Theresienstadt ghetto. Certain prominent and well-known Jews from Germany and throughout the occupied territories would also be selected.

Unlike in other concentration camps, Theresienstadt inmates wore civilian clothes, albeit graced with the yellow Jewish star, and men and women prisoners would not be so rigidly segregated. Internal ghetto affairs and operations were to be managed, within limits, by a council of Jewish elders. Despite the appalling circumstances, schools for children and cultural events, such as music concerts and theatrical productions, would periodically be tolerated.

Fritz and Louise even found friends and acquaintances that they had known before the war. The elderly playwright Elsa Bernstein-Porges was one. Her animated reminiscences about prewar theater in Berlin and Vienna were a welcome diversion. Another friend, a Dutch cartoonist, Jo Spier, even introduced a few, but extremely rare, hints at humor. As a popular satirist for *De Telegraaf,* his parody of Hitler had landed Spier (who was also Jewish) in the Westerbork camp. In April 1942, he was transferred, with his wife and three children, to Theresienstadt, where he survived by illustrating whatever the German commanders ordered.

At times, Theresienstadt almost appeared to be a functioning Jewish town. Astonishingly, the subterfuge actually worked. The first name the Nazis gave the camp was Theresienbad, or "Spa Theresien." Some unsuspecting elderly Jews in Germany actually paid for an apartment in the "spa" camp. In 1944, the Nazis even allowed a Danish and Swedish Red Cross delegation to visit Theresienstadt, guiding them through carefully rehearsed interviews with temporarily well-fed ghetto inmates and conducting them on a "Potemkin village" tour of faux ghetto restaurants, parks, and sports fields. The "Boy's School" had a sign: "Closed During the Holidays." The ghetto "bank" even printed ersatz currency bearing the likeness of Moses. The Red Cross was unaware

that, just before their arrival, the Nazis had sent seventy-five hundred inmates to their deaths. The three transports to Auschwitz-Birkenau included most of the sick and all the orphans. The Germans needed to relieve the unsightly overcrowding.

The Nazis were pleased with the results and ordered a documentary film to be made by ghetto inmates, depicting similar staged scenes. The notorious propaganda film was officially entitled *A Documentary Film of the Jewish Resettlement*, but became better known as *Theresienstadt: Hitler's Gift to the Jews*. Colonel Karl Rahm of the SS chose the talented actor and director Kurt Gerron to make the film. Gerron, who was a distant relative of the Gutmanns', even sang "Mack the Knife," which he had originally made famous in Berlin. In October 1944, immediately after the film was completed, Gerron and the jazz band, euphemistically named the Ghetto Swingers, were shipped off to Auschwitz. Gerron was gassed on October 28, 1944.

Despite all the Nazi lies, the numbers tell the true story of Theresienstadt. More than 35,000 Jews died within the ghetto walls of starvation, disease, overwork, or brutality at the hands of the SS guards and their Czech Kapos. Another 88,000 died after being transported from Theresienstadt to the death camps at Auschwitz and elsewhere. In all, of 140,000 Jews sent to Theresienstadt, barely 17,000 were alive at the end of the war.

The inmate population of the camp was, by Nazi design, divided into classes. The majority lived in crowded barracks, basements, and casemates within the earthen walls, with as many as fifty people occupying a space designed for three. They worked at various menial tasks such as hoeing in the fields, cleaning latrines, or laboring in the mines outside the town. They existed in constant terror of being included in the next transport east—a fear that for most of them would tragically come true. Those who did hard labor received better rations, which meant that the elderly got the least. Above them in status were the technicians and skilled workers, who received slightly better living quarters. Those who kept the ghetto operating—engineers, electricians, architects, members of the "ghetto" government and their families— were temporarily protected from the dreaded transports.

Then there were the *Prominenten* (prominent figures), also known as the "special cases." Just one or two hundred were classified this way. Most of them were Jews who, because of their status, could not just simply disappear. Their immediate murders might excite protest in the outside world, and some were still politically useful to the Nazis. Among these were the Danish chief rabbi, a German ex–minister of the interior, a Czech minister of justice, the mayor of Le Havre in France, and the Dutch ambassador to the League of Nations.

Also among the Theresienstadt *Prominenten* were well-known musicians, artists, and academics, as well as members of the ghetto council of elders. Dr. Leo Baeck, an internationally renowned rabbi and former leader of the Reich Association of German Jews, was a Theresienstadt "special case," as were Franz Kafka's sister, Ottilie, and Sigmund Freud's sister, Esther. Others included Ellie von Bleichröder, the granddaughter of Bismarck's personal banker, and businessman Arthur von Weinberg, founder of I.G. Farben (which had regrettably developed the poison gas Zyklon B). There was even an Olympic gold medalist.

Fritz and Louise were assigned to this group of concentration-camp *Prominenten*. Fritz was number I/34 and Louise I/35. They were given a one-room billet, at No. 8 on the Neue Gasse, just a few doors down from the ghetto café. Their quarters were generous by ghetto standards, and they could also expect somewhat better food rations. Most important, being on the *Prominenten* A-list was supposed to exempt them from transport to the east—or at least until the Nazis changed their minds.

Nonetheless *Prominenten* privileges were only relative. Theresienstadt remained a concentration camp, with all that that implied. Like any other prisoners, the *Prominenten* were often cursed at and reviled by their SS guards as "filthy Jews" or "Jewish scum." At the Nazis' whim they could be, and often were, subject to physical abuse. *Prominenten* who had outlived their usefulness, eventually including almost all of the council of elders, were regularly taken away and hanged, shot, or sent off to extermination camps. Prominent status was at best a temporary pass, not a guaranteed ticket to survival.

Fritz and Louise were subject to the same treatment. Their luggage and all they had brought with them—cash, jewelry, clothing, and food—were taken away by the guards as soon as they arrived. The few clothes they were left all carried the yellow Jewish star. Technically, as *Prominenten* Fritz and Louise were supposed to be exempt from work. However, Fritz, who had a heart condition and was now fifty-seven years old, helped shovel coal. He also volunteered to dig for potatoes in the fields, while Louise, now fifty-one, distributed bread rations and taught English in the ghetto children's school.

A Czech survivor, the writer Anna Aurednícková, later reported that their sensational arrival had caused some understandable resentment. On top of which their *Prominenten* status created inevitable jealousies. Despite all this, Fritz and Louise were well liked, even respected, by the other prisoners. They were said to be dignified but amiable and generous—willing to share their meager rations with others in need.

Fritz was even, to the extent possible in a Nazi concentration camp, defiant. A quarter century earlier, when he had been imprisoned by the British for the crime of being German, he had refused to speak English. Now, imprisoned by the Germans for the crime of being Jewish, he refused to speak German. Accordingly, Fritz and Louise spoke only English to each other and French, Dutch, Italian, or English, even a little Czech, to everybody else. Fritz encouraged his fellow inmates to do the same.

There was no comparison between a British internment camp on the Isle of Man and a Nazi concentration camp. Nevertheless, Fritz had learned from his first time being locked behind barbed wire the importance of not giving up hope. As the months went by, even as the world beyond the ghetto walls grew ever more distant, he was said to have remained optimistic, certain that someday, perhaps even soon, the locked gates would fly open and they would all be free.

Louise, on the other hand, was perhaps more perceptive. The Baroness Louise Gutmann von Landau, it was reported, was often seen weeping.

• • •

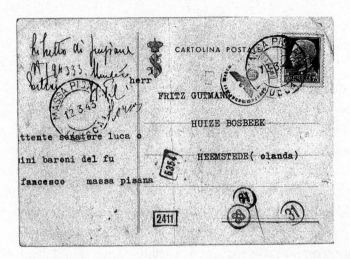

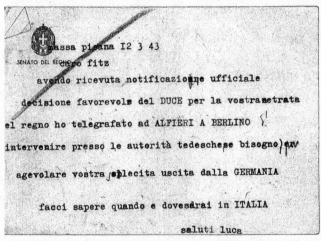

*avendo ricevuta notificazione ufficiale decisione favorevole del DUCE per la vostra
entrata del regno. ho telegrafato ad ALFIERI A BERLINO intervenire presso le
autorità tedesche e bisogno agevolare vostra lecita uscita dalla GERMANIA.
facci sapere quando e dove sarai in ITALIA
saluti luca*

I have received official notification of the favorable decision from Il Duce for
your entry into the kingdom [of Italy]. I telegraphed [Ambassador] Alfieri in
Berlin to intervene with the German authorities and that he should facilitate
your lawful exit from Germany.
Let us know when and where you will be in Italy.
Greetings, Luca [Orsini]

While Fritz hoped and Louise languished behind the ghetto walls, their family in Italy tried desperately first to find them, then to save them. For young Lili, after waiting in vain for days at the Florence train station, an age seemed to pass.

Then in early July, more than a month after Fritz and Louise had seemingly disappeared, the papal nuncio in Berlin, Archbishop Orsenigo, notified Rome that the Gutmanns had finally been located. Despite the Nazi assurances of their safe passage to Italy, the archbishop reported, "The couple Gutmann was in actuality brought to Theresienstadt in May." With a curious mixture of gullibility and skepticism, the archbishop added, "The place has a relatively good reputation, and some say it is actually controlled by the international Red Cross. I find this doubtful."

Lili and her mother-in-law traveled to Rome to appeal for help and met with Nicolò de Cesare, Mussolini's personal secretary. Lili's uncle, Senator Orsini, got the Foreign Minister Count Ciano involved, and once again the letters and diplomatic cables flew. Brother Max, still living in Italy, also appealed to his contacts in the Vatican for help.

At the Vatican's urging, Orsenigo pursued the case, requesting from the German Foreign Ministry permission to travel to Theresienstadt to visit the Gutmanns and perhaps even secure their release. But Orsenigo reported in a subsequent message, "Concerning . . . a possible visit to the Internee Camp for Non-Aryans, Theresienstadt, in Bohemia . . . I was categorically told, 'That is not possible.'"

Even if it had been possible, Orsenigo was more interested in preserving the Vatican-Nazi status quo. The last thing the papal nuncio really wanted was to stir up trouble over the Nazis' "model" concentration camp. The idea that the Gutmanns, or any other prisoners, might actually be released—and then talk—was something Orsenigo's German friends would never tolerate.

No inmate, no matter how prominent, was ever released to freedom from Theresienstadt until just a few months before the end of the war. Ultimately the Nazis realized it was hopeless to try hiding the secrets of Theresienstadt. In February 1945, the war all but lost, Himmler, Eichmann, and a few other SS leaders agreed to release twelve hundred

of the remaining emaciated prisoners to Switzerland. In exchange they received 5 million Swiss francs. A million Swiss francs would go a long way in South America.

However, in 1943 the Nazis apparently didn't care if any of the Italian authorities were angry or resentful at being double-crossed in the Gutmann affair. Even as the Italians pressed their case, Italy's fortunes and influence with its Nazi allies were steadily waning.

By mid-1943 Mussolini's Axis alliance with Hitler had become a disaster for Italy, with hundreds of thousands of Italian soldiers killed or captured in the Balkans, on the Russian front, and in North Africa. Among those interned was young Lili's husband, Franco Bosi, a major in the Italian army, who spent the rest of the war in a British POW camp in Egypt.

In late July 1943, after the Allied invasion of Sicily, and just weeks after Lili had appealed to the Mussolini government for help, Mussolini was deposed. Count Ciano, the Gutmann family friend, as part of the Fascist Grand Council, had voted for the removal from office of his own father-in-law, Mussolini.

Just a month later the Italian government surrendered to the Allies—an act of treachery in the German view. As British and American troops landed in southern Italy, the German Wehrmacht occupied Rome and all the regions not already under Allied control. Mussolini, after being freed by the Germans, set up a puppet government in northern Italy. With the help of the Germans, Mussolini was able to have Ciano shot for treason.

The country was divided and in chaos. Luca Orsini was forced to retire to his villa, outside Lucca, and keep a low profile. The Gutmann family's leverage with the Italian government suddenly evaporated. Their contacts could hardly concern themselves with the fate of one poor couple locked away in far-off Bohemia. Even if the Italians had still wanted to help, their influence with the Germans had dropped to virtually zero. The Vatican, too, now found itself surrounded by German troops, and while it remained neutral ground, its influence with the Nazis, never great, was reduced even further.

As the Nazis and the Gestapo took over in Rome and northern Italy, young Lili and Fritz's brother Max found themselves running for their lives. Italy's fifty thousand Jews had remained mostly unmolested in the early years of the war. Lili had been quite free to travel about and even seek out government officials for help. Max, too, had lived quite openly in Rome at the Hotel Excelsior on the Via Veneto. As a result of the loose enforcement of the Fascist Laws for the Defense of the Race, the Gutmanns had effectively been exempt from the gradual segregation of Italian Jews from the rest of society.

The German occupation changed all that. In October 1943, the Nazis began rounding up Jews throughout occupied Italy—they were herded into police transit camps before transport to the extermination camps of Poland. Except by the standards set in other Nazi-occupied countries, the roundup in Italy was less than completely successful. Largely due to the lack of cooperation by the Italians, only eight thousand Jews were deported. Meanwhile, the other forty-two thousand Italian Jews managed to go underground and survive thanks to non-Jewish friends and relatives. Max and Lili were among the fortunate majority.

To Max's horror, the German Army High Command took over the Hotel Excelsior as their headquarters. Amazingly, he escaped detection in the hotel for a while before going underground. He survived by selling pieces from his prized and valuable stamp collection. Next, Sophie's widowed husband, Count Sciamplicotti, sheltered Max, until it became too dangerous. Eventually Max sought and was granted refuge in the Vatican.

Young Lili, meanwhile, was preparing to flee Florence and hide in the countryside. Just a few days before she was scheduled to leave, she received a tawdry brown postcard with two Adolf Hitler stamps. Dated October 5, 1943, it had the preprinted message "I gratefully acknowledge receipt of your package, letter to follow." Fritz had been allowed to just sign his name and add, by hand, their billet address: Number 8, Neue Gasse, Theresienstadt, Bohemia.

With her three small children, Lili hid in one of her mother-in-

law's medieval towers in San Gimignano. When the German Gestapo and the pro-Nazi local police began searching the town for Jews, Lili and her children spent days hiding in a hunter's shack, in the woods of her in-laws' country estate in Massa Marittima, before sneaking back to San Gimignano. Lili and the children remained hidden in the tower for more than a year, in virtual solitary confinement, until Allied forces arrived in the spring of 1945. Strangely, during all this, Great-Aunt Lili Orsini continued to live comfortably and somehow undisturbed in her sumptuous villa (which had once belonged to Napoléon's sister).

Fritz and Louise were, I imagine, at least vaguely aware of events in Italy. Despite the camp administration's best efforts, news had a way of seeping into the ghetto. While the collapse of Mussolini and the Italian Fascists was a positive development in the war against the Nazi terror, for Fritz and Louise, personally, it was a near-catastrophe. One of the primary reasons the Nazis had been keeping them alive had just been eliminated. Only the Vatican connection remained as a source of help from the Italian front, but it was at best slim.

I imagine my grandfather out in the potato fields looking to the horizon and trying to imagine escape. His prospects were next to nil. Anyway, Fritz realized that he could never leave Louise. Back to earth, he tried to think of the best way to smuggle an extra potato or two into the camp—which in itself was extremely risky. If one was caught, the punishment was usually a severe beating by one of the Kapos, sometimes with clubs, even whips.

Among the tiny handful who did actually escape, one notable hero has to be mentioned. After attempting to escape from Theresienstadt, Siegfried Lederer was transported to Auschwitz in December 1943. Not only did he escape from Auschwitz, but he then broke back into Theresienstadt to warn the ghetto elders what awaited them in Auschwitz-Birkenau.

The reality was stark: all escapees from the camp were easily

rounded up, thanks to a network of Gestapo informants and collab-
orators in the surrounding region. Meanwhile, the Little Fortress was
considered virtually "escape-proof." Punishment was usually by firing
squad. On occasion, though, reminiscent of a more ancient barbarism,
the unfortunate ones were stoned to death by the guards.

Against this bleak reality, Fritz had perhaps only one possible card
left to play in the deadly game of survival at Theresienstadt.

The perverted Nazi compulsion to wrap even their most heinous
crimes in a cloak of technical legality extended to the Theresienstadt
concentration camp. German Jewish inmates arriving at the camp
often were required to sign papers "voluntarily" committing them-
selves for life to what was described as the Theresienstadt "old people's
home." Meticulous inventories of the possessions stolen from them—
described as "donations" to the Reich—had to be signed, in triplicate.
While shipping thousands of people east to certain death, SS guards
might spend days writing reports to prove that a prominent prisoner
executed in cold blood had been "shot while trying to escape." It was a
kind of small madness within the greater madness.

The Nazis' apparent obsession with the Gutmann silver collection
was now thrown into the insane mix. Even though the silver collec-
tion (including the Orpheus Clock) had earlier been removed from
Bosbeek and sent for "safekeeping" to the Munich warehouse of Julius
Böhler, the collection's legal ownership still hung in the balance. Böhler
was eager for a resolution. Even before Fritz's actual arrest, Böhler had
already offered the entire silver collection to Helmuth von Hummel
at the *Führerhaus* in Munich. SS Hauptsturmführer von Hummel was
also Martin Bormann's special adviser and comptroller of all of Hitler's
private funds.

Meanwhile, on Fritz's earlier advice, Senator Orsini had retained
a Munich lawyer, who, in late 1943, started negotiations to try to
move the collection to Italy. Böhler and Haberstock countered with a
request to get the collection classified as Jewish. Technically, though,

all the shares appeared to be in Senator Orsini's name. By using this device Fritz had avoided having the family trust (and the collection) Aryanized. One half-baked idea was to divide the Eugen Gutmann Silbersammlung along ethnic lines. Böhler and Haberstock would keep all the silver and gold considered German or "Nordic," and all works of "Latin" origin could go to Italy. Next, however, the Sicherheitspolizei (State Security Police) declared the whole collection a "national treasure," effectively prohibiting any change in ownership or location. Things had reached stalemate.

Even Dr. Hermann Voss at the Führermuseum appeared stymied. The collection, which had been earmarked for Hitler's Linz museum, would stay under lock and key in Julius Böhler's warehouse. It seems astonishing, but the Nazis, and particularly the curators of the Führermuseum, were quite fussy about these things. After the war it would be found that almost 90 percent of the artworks destined for the Führermuseum were accompanied by documents showing that they had been "legally" sold to Hitler—even if it was over the original owner's dead body.

The Nazis seemed determined to finally wrap up the "Gutmann Affair." With Fritz and Louise safely locked away in Theresienstadt, all they needed was for Fritz to revoke the transfer of the family shares to Senator Orsini.

At least twice during his months in the camp, Fritz was summoned for interrogation at the dreaded SS headquarters. The three-story brick building had once served as the Terezin city hall. Now it was the headquarters for the German security services. The second interrogation was by SS major Karl Rahm. The Austrian-born Rahm had worked for Adolf Eichmann's benignly named Central Office for Jewish Emigration in Vienna and Holland. A mercurial figure, he alternated between bouts of murderous sadism and curious incidents of consideration for some of his Jewish prisoners. Those incidents evidently were not sufficient to prevent him from being executed later as a war criminal.

The interrogations in the commandant's headquarters, presided over by Rahm, were aggressive without descending into outright tor-

ture. Fritz was manhandled, threatened, screamed at, and ordered again and again to sign documents transferring to the Reich the legal owner-ship of the Gutmann Silbersammlung. Again and again, Fritz refused.

Was it honor, naiveté, faith, stubbornness, or bravery? I cannot say. Some in the camp wondered, "Why didn't you just sign it! Why did you risk your life for that damned silver collection? After all, what difference does it make? They have already taken it. Why suffer over some stupid, pointless Nazi compulsion with legality?" Therein perhaps was the answer. Fritz must have realized that, given the Nazi mind-set, his signature on those Reich documents, or rather the lack of it, was the only leverage he possessed. Once the Nazis got what they wanted, they would have no more use for him. If he signed those documents, he would surely be signing his own death warrant, and of course Louise's. So he refused and he suffered.

His refusal to knuckle under to the Nazis became the subject of considerable talk among Theresienstadt inmates. Such defiance was rare, if not unique. In ghetto lore he became "the baron who refused to sign over his fortune to the Nazis." To others the stance seemed both courageous and dangerously foolish.

Then, amazingly, it appeared that Fritz's tenacity had paid off, that the Nazis had improbably given up. The news, according to survivor Zdenek Lederer, was that the Gutmann family's connections in the Vatican had finally come through. On April 13, 1944, after over ten months in the Theresienstadt ghetto, Fritz and Louise were ordered to report to the commandant's office with their remaining luggage. Lederer commented on how the couple seemed impeccably dressed, almost as when they'd arrived. They were quickly piled into a German staff car and driven out the front gate of the walled ghetto. Komman-dant Rahm told the head of the ghetto council of elders, Paul Eppstein, that the Gutmanns were bound for Rome.

The news prompted considerable comment, and no small amount of envy, in the camp. Willy Mahler, a young Jewish Czech who would later be transported to Auschwitz, kept a diary of his time in Theresienstadt that was posthumously discovered. His entry that day noted, "Baron [sic]

Gutmann and his wife were released from the ghetto today, probably due to some foreign orders." Another camp diarist, a Dane named Ralph Oppenhejm, who survived the war, wrote of the Gutmanns, "Released! Oh, what one wouldn't give to be in their position."

Perhaps for a few moments Fritz and Louise believed it, too. Despite all the lies the Nazis had told them in the past, perhaps they truly believed that this time they were going to be free, that the hell of Theresienstadt was being left behind.

Those moments of hope and belief were cruelly brief. Everyone knew that just outside the Theresienstadt main gate the road reached an intersection. The road that went to the right led to the outside world, while the road that went straight led to only one destination— the Little Fortress prison. Which direction the staff car took after it drove out of the ghetto's main gate would announce their fate.

The staff car drove out the main gate—and went straight. Inside the prison courtyard, the car came to a screeching halt under the sign *"Arbeit macht frei."*

As bad as the Theresienstadt ghetto was, for the Jews imprisoned in the walled city, the Little Fortress was an object of abject terror, feared even more than transport to the east. Norbert Troller, a Czech architect imprisoned in Theresienstadt and later in the Little Fortress, described it this way: "In the ghetto the horrible rumors about the Little Fortress were only described in a whisper. No one who wore a Jewish star had escaped alive from there. . . . [The fortress] was a hellish place, but conceived in a place none of us could have imagined in our wildest nightmares. In short, it was worse than we thought hell would be like. . . . Entering the main gate, crossing a bridge over the foul-smelling moat, one felt and smelled decay, death, hopelessness, despair, and damnation. Everything was built to crush you, to leave you no hope, to convey to you your nothingness, prepare you for annihilation. You are lost!"

The Little Fortress's reputation was deserved. Operating separately from the Theresienstadt ghetto, it was run by SS troops, Gestapo agents, and pro-Nazi (usually Czech) guards—the sadistic Kapos. It was primarily used to imprison Czech political prisoners

in the thousands, but also more ominously as punishment for "Jewish troublemakers," usually from the ghetto next door. Although not technically a death camp—there were no gas chambers—nonetheless prisoners were sent there to die, by starvation or abuse or outright execution. Prisoners dressed in scraps of old uniforms were crowded by the hundreds into underground casemate cells awash in filth, while prisoners being held for Gestapo interrogation were thrown into dungeonlike solitary cells, hardly bigger than coffins. Club-wielding guards mercilessly beat prisoners to death for the smallest offense or no offense at all. Public hangings and death by firing squad took place against a bloodred brick wall. In a single day, over 250 Czech patriots were shot to death at the execution site between the ramparts. Presiding over this horror, striding about in riding breeches and sporting a Hitler-style mustache, was the Little Fortress SS commandant, Hauptsturmführer Heinrich Jöckel, a notorious sadist and Jew-hater. Jöckel, who routinely beat prisoners to death with his own hands, actually lived in the Little Fortress with his wife and two teenage daughters. Even the daughters would torment the prisoners with their vicious German shepherds. (After the war Jöckel was hanged as a war criminal.)

Fritz and Louise were now delivered into this hell on earth. Later, Sturmbannführer Rahm would acknowledge to Paul Eppstein the Gutmanns' true fate. Louise's close friend Hedwig Eppstein then spread the shocking news back to the ghetto. Those who had envied the Gutmanns' were suddenly full of pity. The diarist Ralph Oppenhejm noted, with horror and remorse, that the Gutmanns "were not sent to Italy. Instead they are locked up in the Little Fortress. . . . The husband is . . . seriously ill after the treatment they had put him under. And I was so jealous!"

Unlike in the ghetto, in the Little Fortress there was no *Prominenten* A-list, no special treatment. Every prisoner was damned, and Jews damned most of all. Fritz and Louise would immediately have

been separated. There would have been no chance to say good-bye to each other. Louise was locked in cell No. 8, the stifling women's cell. Fritz went into solitary confinement. His dank cell was No. 2, off the first courtyard and reserved for Jews.

Most of the Nazis' meticulous records from the Little Fortress were destroyed near the end of the war, for obvious reasons. However, Fritz and Louise were evidently admitted into the Little Fortress under the R.U. designation—namely *Rückkehr Unerwünschte*, or "Return Unwanted."

The interrogations in the ghetto would have bore little resemblance to the beatings Fritz suffered in the Little Fortress. They would have been almost indescribably worse. From what I have been able to deduce, Fritz survived two weeks in cell No. 2 of the Little Fortress.

According to Joan Dubova (a survivor of both Theresienstadt and Auschwitz), Fritz Gutmann was dragged from his cell in the late afternoon at the very end of April 1944. The Kapos pulled and pushed him all the way to the foot of the bastion. There Dubova, on her way back from work duty, saw my grandfather beaten to death with clubs by the Kapos below the ramparts of the Little Fortress.

A different version I found was even more gruesome, however. Poor Fritz was garroted with a wire by the Kapo called Spielmann.

Spielmann, reputedly, then took Fritz's favorite gold cuff links, which had miraculously survived up to this moment. In another of Fritz's pockets was a visa for Italy, signed by Mussolini himself.

The story goes on that Spielmann later fell out of favor with his SS masters and was sent to Auschwitz. There he met a few of his former victims from the Little Fortress. They clubbed him to death in stages; the torture lasted a week.

Did Fritz, beaten beyond bearing, refuse one more time to sign over ownership of the Silbersammlung? I cannot know for certain, but clearly, after denying the SS *Kommandant* at least twice already, he had crossed a line. Nazi law was adamant on Jewish insubordination.

If he had given them what they wanted, might he have been among those emaciated inmates who were still in Theresienstadt when the Red Army, finally, arrived on May 8, 1945?

I do know that after examining hundreds of Nazi-era documents concerning the Gutmann silver collection (documents bearing the signatures of lawyers, German officials, and Nazi dealers), nowhere could I find Fritz's authority to sell. So perhaps, despite his suffering, my grandfather defied the Nazis and Hitler right up to the end.

Fritz's final resting place is also beyond my grasp. Does he rest anonymously under that shockingly green grass by the red walls? Does he lie undiscovered in an unmarked grave under one of the earthen ramparts that surround the Little Fortress? Or in a mass grave? Was his body taken to cell No. 18, which led to the crematorium the Nazis built after they ran out of burial space at Theresienstadt, and then rendered like so many others into ashes—ashes that later on SS orders were dumped by the ton into the Ohre River? We searched all these places looking for a clue.

My eleven-year-old, James, ran with a stubborn determination through the entire Terezin Memorial Cemetery looking for *Gutmann*, any Gutmann. Aisle after aisle, he scrutinized the individual graves, all 2,386 of them. Finally, exhausted, he returned just shaking his head silently.

The scant remains of thousands more, from the Little Fortress, the Theresienstadt Ghetto, and the outside labor camp have been gathered in a mass grave marked by a pile of boulders. Out of the gray pile rises an enormous Star of David, made from steel girders. In all, the remains of some ten thousand victims lie within the Terezin Cemetery.

Today the town features an occasional shop and café for the benefit of the local residents, and a museum dedicated to the town's dark history. As I walked about, the clean, quiet, well-kept streets seemed eerily deserted. Even though today some three thousand Czechs apparently live within the walled city, I barely saw a soul. The walled community of Terezin has the feel of a ghost town—literally, a town of ghosts.

On the other side of the river, connected by a narrow bridge, and also enclosed by moats and battlements, is the smaller companion to the garrison town, the *Kleine Festung*, the once-dreaded Little Fortress. Although initially designed as a bulwark against foreign invasion, the Little Fortress was never called upon to actually repel an invader. No soldiers of any nation ever won any glory there. Instead, for most of its existence the Little Fortress served as a prison, a dungeon, a final destination of the damned. The people who died there—and there were thousands of them—included Gavrilo Princip, the assassin who had the dubious distinction of starting World War I. He died in the cell right next to my grandfather's. Ironically, also, SS Sturmbannführer Karl Rahm was captured after World War II and sent back to the *Kleine Festung*, where he was held until he was executed in 1947.

These days, just outside the fortress, stands a dismal gift shop. It is hard to imagine what trinkets they sell. Improbably, they also offered microwave pizza. We shuddered and moved on. The Little Fortress stood empty, apart from small knots of solemn tourists who had come to see the dark prison cells, the worn set of gallows, and the cemetery. The well-manicured grass is intensely, curiously green. The *Kleine Festung* is a place of tunnels and underground bunkers filled with the dank odors of earth and stone and seeping wet. Eschewing the guided tours, I found myself in front of Gate No. 17. No. 18 was the mortuary cell, but No. 17 was the entrance to a long tunnel. The tunnel goes through the old fortifications of the *Kleine Festung* for a quarter of a mile. The long, dark, cold tunnel is almost unbearably claustrophobic, winding endlessly with no end in sight. The sense of dread is overwhelming. I realized my wife, my son, and I were all crying. Finally there is light, but the relief is short-lived. It is the firing range, the gallows, the killing field.

Usually the Gestapo and the Kapos took their victims the short route from the cells to the execution site just outside the walls. The gate they took was known as the Gate of Death. However, the long tunnel also leads to the same place of horror. Taking the long tunnel would

have added an immeasurable level of sadism to the Kapos' routine brutality.

I can't help wondering if my grandfather took these same steps, the last he ever would, on that day in April 1944, as the Kapos poked and prodded and dragged him. He finally reached the light only to meet his end.

My grandfather, the cultured and dignified man with the wry smile, who stares back at me from the old photographs, the man who loved art and music and beautiful things, died broken and shattered in this forlorn ditch.

The scant details of Louise's fate are almost unbearably cryptic. Postwar accounts state that two excruciating months after Fritz's murder, the Baroness Louise Gutmann von Landau was taken from the Fortress on July 2 and loaded aboard a cattle wagon. With her were just nine other souls. The destination was the extermination camp of Auschwitz.

Compared to the three previous transports, which included over seventy-five hundred condemned, this time the SS ordered a special transport for just ten unwanted prisoners from the Little Fortress.

Immediately on arrival in Auschwitz, my grandmother, the beautiful, elegant woman of the Man Ray portraits, the vivacious, fun-loving woman who tore across Europe, scarf flying, in her LaSalle convertible, was ordered into the "left line." She had been spared slave labor. This gentle woman was instantly herded into a gas chamber and murdered. Her ashes, like those of over a million others, were next dispersed by noxious black smoke from the chimneys of the overworked crematoriums.

Between March and November of 1944 the German killing machine was at the height of efficiency and the depths of depravity. During these few short months, while the Allies were advancing (and flying overhead), the Nazis disposed of nearly six hundred thousand Jewish lives in Auschwitz-Birkenau alone.

One sad, final irony: I discovered that much of Auschwitz was built

on land originally owned by the Laurahütte mining company. The Laurahütte had been founded in happier days by Louise's grandfather Jacob von Landau. On the board of directors, just before the Nazi takeover, had been Louise's uncle Eugen von Landau. Fritz's brother Herbert was another director.

It was necessary to summon a special courage to retrace the final steps of Fritz and Louise. Unfortunately, I have read much about the complex of Nazi slave-labor and extermination camps known collectively as Auschwitz—the railhead selections, the medical experiments, the starvation, the hangings and shootings, the unspeakable barbarities committed against humanity. The living and the dead were treated like so much industrial waste. Beyond nausea and beyond belief, the mind attempts to grasp the enormity of it, but then recoils.

Nevertheless, on another European trip I resolved to go to Auschwitz, to see the place where my grandmother died. At the train station in Warsaw, I stood on the platform for the train to Kraków. A poster even offered tours of Oświęcim—Polish for "Auschwitz"—just a short ride from Kraków. I tried to prepare myself for what lay ahead: the preserved remains of the death camp, the barbed wire and the gallows, the gas chambers and the crematoriums. I imagined the farm fields and birch forests where my grandmother's ashes might have scattered. I tried to get some sense of her last days and hours.

But when the train to Kraków came and the passengers, ordinary Poles and a few tourists, climbed aboard, I stood on the platform unwilling, unable, to move. I stood there, unused ticket in hand, and watched as the train pulled slowly away.

I simply could not do it. I could not bear to see the place where my grandmother was murdered. I could not take the train to Auschwitz.

CHAPTER 8

BERNARD

Bernard graduating Trinity College,
Cambridge, in 1937.

After his last visit to Bosbeek in the summer of 1938, my father, Bernard, then twenty-four, had returned to London to enjoy what was left of his youthful freedom. He understood that taking his art history degree at Cambridge had been all very fine, a properly broadening experience for a young gentleman, but making art a career was never a

serious consideration. Sooner or later, just as Eugen had with Fritz, his father would insist that Bernard settle down in the ubiquitous family world of banking.

In the meantime, he was determined to enjoy himself—not a difficult objective for a good-looking, socially connected, and quite wealthy young man in prewar London. With a few well-heeled friends, Bernard rented a seventeenth-century house in fashionable Mayfair, on the corner of Charles Street and Waverton Street—probably the last original timber-fronted house in all of London. As the storm clouds gathered over Europe, the house on Charles Street soon developed quite a local reputation; it was said that all one had to tell any Mayfair cabdriver was "Take me to the party house!" and the driver would know exactly where to go.

The lull before the storm was short-lived. Britain's declaration of war against Germany, after the invasion of Poland in September 1939, left my father in a somewhat unusual position. Although still a Dutch citizen by law, he was concurrently by birth a British citizen. Nevertheless, the Gutmann family was strongly associated with the new enemy, Germany, and Bernard also had close family ties, through his sister and his aunts, with Britain's soon-to-be enemy Italy. Certainly he was well aware of the persecutions his parents and other ethnic Germans, even those with British citizenship, had encountered in England at the outbreak of the First World War. He understood, too, that wartime passions could often override legalities, or even common sense.

His concerns were not misplaced. In the first days of the Second World War, around six hundred "enemy aliens" in Great Britain were interned. By May 1940 more than six thousand had been rounded up, some once again in camps on the Isle of Man, others shipped off to Canada and even Australia. Astonishingly, many of them were German and Austrian Jews who had recently fled persecution from Hitler, only to be considered potential allies of the Nazis by some mindless bureaucrat. Among them was Bernard's cousin Luca, Herbert's son, then living with Herbert and Daisy in their Park Lane apartment in London. Apparently Herbert's and Luca's association with the Anglo-German

Union, whose members also included a number of prominent British Fascists, made them both suspect. Herbert, then suffering with throat cancer—his love of cigars had finally taken its toll—was allowed to remain free, perhaps because of his illness. A few years later, in 1942, the cancer would finally take his life. But Luca was arrested and shipped off to an internment camp in Canada, along with more than two thousand other German and Austrian refugees who had aroused suspicion. It was all quite absurd, given that Herbert had come within an inch of being executed by the Nazis, and Luca had been living in England for years without any suspicious activities—not to mention that they were, in Nazi eyes, Jews or at least half-Jews. But then, in war common sense is often the first casualty.

Even before the war began, my father began to anglicize himself. First he changed his name, by deed poll, from the official Bernhard Eugen Gutmann to the English translation, Bernard Eugene Goodman. Then, in January 1939, he enlisted as a private in the British army.

Bernard was placed with the Gloucestershire Regiment, one of those venerable British units that traced its origins back to the seventeenth century. Given his athletic ability and adventurous spirit, he volunteered for training as a commando. Meanwhile, his regiment, as part of the British Expeditionary Force, was fighting a valiant rearguard action before evacuating from Dunkirk in the spring of 1940. Tragically, this was the same German offensive that trapped Fritz and Louise in Holland.

My father had been eager to fight the Nazis. In January 1941, while on a training mission near the South Coast, he and some of his chums cadged weekend passes into town and checked into a hotel in Portsmouth. That night more than a hundred German bombers attacked the city. Being young and foolish, and feeling indestructible, my father stood on the second-floor balcony to watch the fireworks, instead of fleeing to an air-raid shelter. A German bomb landed close enough to blow him and the balcony across the street and onto the

rubble below, breaking his back, several other bones, and cleaving off a portion of his right heel. His injuries would cause him pain for the rest of his life.

Bernard spent six months in a military hospital, much of it encased in a body cast and in traction for his spinal injuries. It was not at all certain that he would ever walk again. He had hoped to remain in service, but it was impossible. His army discharge noted that he was "permanently unfit for any form of military service."

I think my father regretted that he had never been, through no fault of his own, in direct combat against the Nazis. So many of his friends had served with distinction, some even at the cost of their lives. Perhaps best known among them were the three MacRobert brothers, who had been Bernard's best friends at Cambridge. Alasdair, Roderic, and Iain were the sons of Sir Alexander MacRobert, a Scottish millionaire, and Lady Rachel MacRobert. Alasdair died in a prewar flying accident while serving with the Royal Air Force, and Roderic and Iain both died heroically in action in 1941, while also serving with the RAF. In what became one of the fabled stories of World War II Britain, their grieving mother, Lady MacRobert, subsequently donated twenty-five thousand pounds sterling for the purchase of a Stirling bomber aircraft, which was named *MacRobert's Reply* and sent into battle against the Germans. The RAF continued to name airplanes after the MacRobert brothers well into the 1960s. I remember as a boy my father telling me that he had been friends with the famous brothers, which I found incredibly exciting. The concept of MacRobert's "revenge" seemed to give him particular satisfaction. But then, as usual, he slipped back into his thoughts; the memory of their young deaths seemed to return him to some silent, lonely place. I wonder now if, given his frustrations in life, he secretly wished that he had joined them.

After being invalided out of the army and with the war still on, Bernard looked about for something purposeful to do. His strength gradually returned. Through his connection with Prince Bernhard of

the Netherlands, the former Bosbeek guest who was now commander of the Free Dutch Forces in England, Bernard took a job with the free Dutch Red Cross. (This was not to be confused with the official Netherlands Red Cross, operating under German control in The Hague, which would collaborate with the Nazis in deliberately suppressing reports of the persecution of Dutch Jews.)

Bernard also returned to the house at 27a Charles Street in Mayfair, which, despite the war or perhaps because of it, remained a magnet for a steady stream of now-uniformed young men and attractive young women. Most seemed aware that life could be very short and must be enjoyed at all costs. The raucous parties in the distinctive wooden house took on an air of defiance.

Among the guests at one of those affairs was Irene Doreen Rosy Amy Simpson, later known as Dee, a vivacious, twenty-five-year-old recent graduate of the Royal Academy of Dramatic Art. She had just started working as a stage manager in a London theater. With a friend, she had been invited to the Charles Street house by a regular visitor there, Count Manfred von Czernin. He was a Berlin-born RAF ace whose English mother was a friend of the Simpson family's and, co-incidentally, whose brother had been a classmate of Bernard's at Zuoz, in Switzerland. I do not know what Dee and Bernard's first words together were, or whether it was a case of love at first sight across a crowded room. When I was young, I never thought to ask, and when I grew older, it was too late. But Dee obviously saw something in the handsome young man with the dark, sorrowful eyes, because in September 1943 they were married at a church in Mayfair.

Bernard and Dee, hopeful, around the time of D-Day, 1944.

During most of this time Bernard knew almost nothing about his family and what was happening across the Channel. Communication was impossible with his sister Lili, Uncle Max, or other members of the family in Italy. Bernard did discover, however, that his brother-in-law, Lili's husband, Franco Bosi, was a POW of the British in North Africa. Through his Red Cross connections, Bernard was able to send Franco packages of spaghetti and other essentials. Years later Bernard was still joking about how an Englishman was sending pasta to the Italians. He sent similar "care packages" to his cousin Luca, who remained locked up in an internment camp in Canada until 1943.

The last word from Uncle Kurt was that he was living in Paris, a refugee from the Nazis, but there, too, the German occupation then severed all connections. As for his parents in Holland, Bernard could only wonder and agonize over how they were faring under Nazi control.

Not until August 1943 did the *Knickerbocker Weekly*, a New York–based free Dutch newspaper, publish a small item headlined "Banker Fritz Gutmann Arrested in Berlin." The article said that "the former German banker Fritz Gutmann and his wife had been arrested by the Nazis in Berlin—although the Nazi authorities would give permission [to the couple] to travel to their daughter, living in Florence, providing they relinquish their entire possessions in return." It was certainly ominous.

Given the general lack of knowledge in Britain about the true nature and extent of the Holocaust, Bernard might have been spared the full significance of what it meant when Jews were "arrested" by the Germans. Still, my father was overcome with a sense of foreboding. Much later, through International Red Cross contacts, he learned that Fritz and Louise had been taken to Theresienstadt. I doubt that he was reassured by its reputation as the "model" concentration camp.

Bernard must have followed with mounting despair the news in April 1945 when British and American army units first reached the concentration camps at Bergen-Belsen and Buchenwald, giving the world the first documented revelations into the horrors they found there—hundreds of thousands already dead, along with thousands more almost dead. As the word spread of even worse sights at the extermination camps farther east—at Auschwitz and Sobibór and Treblinka—the sheer scale of the Nazi system of industrialized murder slowly began to sink in.

In the waning days of the war, Bernard had heard the radio reports, seen the newsreels, wondering all the while if his parents had been among those piles of emaciated corpses shown stacked up in ditches. He could not bear to look, yet he could not stop.

On May 7, 1945, the Germans surrendered unconditionally. The fighting in and around Theresienstadt still continued for a day or two, however. Obersturmführer Karl Rahm finally fled just as the Red Army moved in. Eventually the International Red Cross took control of Theresienstadt, and as at other camps, they began compiling lists of survivors. It was far easier to make lists of the survivors than of the

dead. The lists of survivors were much shorter. In England Bernard sent out inquiries, monitored reports, and pored over the bulletins. Fritz's and Louise's names were not on them. There was no news— nothing.

Not many Jews were coming back. Out of a total Dutch Jewish population of about 155,000 in 1940, around 15,000 had fled just before the advancing German armies. Then from 25,000 to 30,000 had gone into hiding—nearly 10,000 of whom still perished. The vast majority of Dutch Jews, however, about 107,000, were deported from the Netherlands by the Nazis. Of those, only 5,200 survived.

Shortly after the end of the war, my brother Nicholas was born on November 18, 1945. Two days later the Nuremberg Trials began. Göring, Alfred Rosenberg, Seyss-Inquart, Ribbentrop, and many more war criminals would be sentenced to death. Some, however, such as Hjalmar Schacht and Franz von Papen, would be acquitted.

Then, on November 27, 1945, Pa finally received word from the Dutch Embassy that the restrictions on civilian travel to the Netherlands were being lifted. On that freezing November night, Bernard rushed to the Liverpool Street station, where he caught the night ferry to the Hook of Holland. As the wind whipped off the North Sea, my father set foot in the old country for the first time in over seven years. A lot had changed. He was not even Bernhard Gutmann anymore; now he was Bernard Goodman.

As soon as my father arrived in Amsterdam, he checked into the Schiller Hotel on the Rembrandtplein, along the Herengracht (canal). He had always liked the enormous hotel, famous for its Art Nouveau style, and just a block or so from his father's offices. In the dimly lit lobby, he must have been the only one out of uniform. Still, when Bernard saw the entrance to the hotel's Café Schiller, fond memories briefly came back as he remembered the tea and cakes—a treat as a schoolboy with his parents, a lifetime ago.

The next morning the Dutch Red Cross put my father in touch

with a survivors' organization. They gave him the number of Jo Spier. Pa remembered that, before the war, a famous artist and cartoonist had that same name. A few days later a very thin Jo Spier appeared at the Schiller Hotel. In 1943 he had witnessed the arrival of Fritz and Louise at Theresienstadt. A member of the ghetto *Prominenten*, Spier had known Fritz and Louise well. So it was Spier who finally told my father the story of his parents' last days—the interrogations of Fritz, his refusal to give in, the staged "release" of the Gutmanns that ended in the Little Fortress, Fritz's death by beating, and finally Louise's deportation to Auschwitz.

After my father had read the one brief news story about his parents' arrest in the *Knickerbocker Weekly*, and the ordeal of two and a half years of uncertainty and anxiety, he learned for the first time the true fate of Fritz and Louise. Somehow the gaunt artist was able to comfort my father (to a certain extent) with what he had to say. Bernard's worst fears had been confirmed. The waiting was over.

I suppose that ever since the reports about the Nazi concentration camps had started to filter in, my father had suspected the truth. The hard facts had already begun to change him. The resulting scars left him with what today we recognize as "survivor's guilt." His inability to persuade his parents to flee Holland when there was still time, and that he had remained safely in England while his parents were under the Nazi heel, had haunted him—a broken back and shattered bones notwithstanding. The unattempted fantasy of an impossible rescue had left him with an unwarranted, but painful, sense of failure. The rest of England might be celebrating, but Bernard was slipping further into despair.

Then to compound his gloom, what Jo Spier had to tell my father next about his own reception in Holland, after returning from the camp, was almost as shocking, if that were possible. Despite the liberation from Nazism, anti-Semitism had clearly not disappeared in the Netherlands, and the few Jewish survivors, Spier explained, were becoming increasingly dejected.

As the pitiable remains of the Dutch Jewish community had begun to straggle back to Holland, a small few returned to find that their homes and property had been protected by sympathetic Dutch neighbors, who greeted them warmly. Others, the vast majority, returned to find everything they had once owned gone. Many *bewariers*, or "Aryan guardians," to whom Jews had entrusted their possessions had long since sold everything or used them for their personal needs. Some so-called guardians openly complained, "Why did my Jew have to be the one to come back?" Their former friends and neighbors appeared openly hostile and suspicious, in some cases even blaming the Jews for causing the war and all of its accompanying misery. The *Vrije Katheder* newspaper, in July 1945, quoted some as grumbling, "It was a pity so many came back alive."

Jews coming home from the camps were greeted at the Dutch border by delousing stations and a onetime government stipend of twenty-five guilders. In another example of Dutch insensitivity, for several months after the war a number of stateless Jews were locked up in the same camps alongside Nazis and their supporters.

The Dutch government's official attitude was that Dutch Jews, as a group, represented no special case; apparently they had suffered no more than other Dutch citizens killed in the fighting or conscripted for labor in Germany. When Jews started looking for their lost property, statements began to appear in the Dutch press using anti-Semitic stereotypes, such as "Jews were money hungry." Some Dutch officials stated that the Jewish community should seek "recognition . . . not money." In other words the simple act of a Dutch Jew seeking restoration of his birthright had become, somehow, antisocial and even unpatriotic.

It quickly became apparent that legal restitution to the Jews would be in actual conflict with the postwar economic policies of the new Dutch government. The official position seemed to claim that any large-scale restoration of Jewish property would hinder postwar recovery. The new Prime Minister, Wim Schermerhorn, even went so far

as to explain to Dutch Zionists that "they could not expect him, as a socialist, to help restore money to Jewish capitalists."

On a typically cold and bleak December day in 1945, my father finally came home to Bosbeek. Unlike millions of other homes across Europe, the Bosbeek estate had escaped complete physical destruction. It had not been reduced to rubble by bombs or burned to the ground by incendiaries. The actual fighting had largely passed it by. Nevertheless, the home, the life that my father had once known there, had been destroyed by the war—completely, utterly, and forever.

The gardens, untended, had gone to thorn and thistle, the lawns to weeds. The ornamental ponds lay empty save for a few inches of murky rainwater. Many of the once-stately elms and oaks were now only ragged stumps, victims of widespread "wood rustling" for fuel during the Hunger Winter of 1944–45, when thousands of Dutch civilians shivered and died of starvation. If any of the Scottish terriers that had once roamed the grounds had survived the early years of the occupation, they could not have survived the Hunger Winter, when stray dogs were widely hunted for food.

What still remained in the manor house after Fritz and Louise's arrest had been shipped to Germany. The items that the Germans had not bothered to take were sent to Gustav Cramer, the collaborator art dealer in The Hague. Böhler would, of course, get his cut. Anything else remaining had been divided among the Dutch quislings who had assisted the Nazi looters. Westerbeek, the once-trusted employee, had been the main beneficiary.

In a house once filled with beautiful art, the only piece that remained, remarkably, was the De Wit plafond painting in the ceiling over the grand salon. To Bernard's horror, *Bacchus and Ceres in the Clouds*, the spectacular giant painting, was now pockmarked with bullet holes—German bullet holes. My father assumed it must have been too difficult to remove, and the greedy Nazi dealers had apparently felt the same way.

The plafond painting in the salon at Bosbeek, by Jacob de Wit (1751).

I would discover, years later, that Westerbeek had actually been able to remove the plafond painting, which was in fact a giant canvas. Westerbeek, obviously with help, had gouged the nearly nineteen-by-twelve-foot canvas from its frame in the ceiling. Undeterred, he also pried the large De Wit trompe l'oeil grisaille out of the wall, over the salon doorway, where it had been since 1751. The scavengers then stashed the two precious artworks in the dust of the cellar, along with everything else they could not readily carry out. Westerbeek next offered the ceiling painting to Hermann Göring's agent, Dr. Göpel, for fifty thousand Dutch guilders (or about $25,000 at the time). Before Westerbeek could complete the deal, however, the entire Bosbeek es-

tate was commandeered by the Nationalsozialistische Volkswohlfahrt (a branch of the Nazi Party). Almost immediately, a senior official from the NSV noticed the missing De Wit ceiling painting, and Westerbeek was ordered to return that painting to its rightful place. But the mundane household furnishings—kitchen tables, pots and pans, everyday appliances, the bedding, and my grandparents' remaining clothes—were all stripped as if by locusts.

Meanwhile, emptied of its treasures large and small, Bosbeek manor house had not remained unoccupied. As the war had neared its end, the house had been taken over by some German soldiers. The parquet floors had been scuffed and scarred by countless jackboots—the beautiful paneling and the great ceiling painting punctured with bullet holes. Even after the liberation in the spring of 1945, some German soldiers, now POWs, had been ordered by the Allies to stay behind and remove mines and tank traps that had been planted in and near the grounds. After the last Germans finally left that summer, the Dutch Ministry of Justice took over and turned Bosbeek into a reform school for the children of recently arrested Nazi collaborators. Of those, there was no shortage.

Some two hundred thousand Dutch men and women were rounded up in the reckoning that came with the peace, charged with varying degrees of collaboration with the Nazis. Dutch girls who had taken German boyfriends had their heads shaved; some of the more grievous offenders were hanged. However, most of the rest were given prison sentences or simply interned. In the meantime, their children, temporary orphans, were housed by the thousands in government buildings and empty estates, including over two hundred children who were crammed into makeshift barracks-style dormitories in the once grand suites of Bosbeek.

It was these children who stared suspiciously as my father approached over the trampled lawns, his dejected gaze fixed on his parents' ransacked home. They were merely children, eight and ten or fourteen years old, and not responsible for the sins of their parents. Nevertheless, after being raised on Nazi propaganda, as their parents

embraced the Nazi hatred, the seeds had already been planted in these children's minds. When my father asked one of the boys if he knew who used to live here before the war, the boy shrugged and waved a dismissive hand: "Just some rich Jews."

Just some rich Jews. It was not the last time my father would encounter that sort of justification for what had happened to his parents and countless others. As my father would soon discover, whether from horror or guilt or shame, the world seemed all too eager to forget about what the Nazis had done—not only the lives they had robbed, but the belongings they had stolen as well.

Back in Amsterdam, numb with cold and frozen with dread, Bernard found the offices of the Council for the Restitution of Legal Rights. After waiting in line for hours, he was finally ushered into a drab office where an even more drab official stated bluntly, "We need a death certificate." Bernard pointed out, incredulously, that they did not give death certificates in the camps. The official continued indifferently, "It will take several years before the state can presume death occurred." Before my father could assume control of what might be left of the family estate, he would have to prove that his parents were no longer alive.

Returning to the hotel, Bernard began calling everybody he thought could help. The Red Cross again seemed the most practical. They gave my father the address of a Theresienstadt survivor named Zdenek Lederer. Lederer apparently was in touch with a few other survivors now living back in Prague, and he was compiling their stories. (Ultimately he would publish the definitive *Ghetto Theresienstadt*, in 1952.) Bernard decided that the only way to cut through the Dutch red tape was to travel to Prague himself. There, he felt sure, he would find the grim evidence he needed.

As the final days of 1945 approached, government offices across an exhausted Europe began to close. Pa returned home to London to celebrate Nick's first Christmas. It was a rather subdued affair. By New Year's Eve, he was back on the ferry, this time to Ostend, then Brussels, and the overnight train to Prague. On the first day of 1946, Ber-

nard found himself traveling, albeit reluctantly and with considerable anxiety, across Germany for the first time in eight years. As the dim light began to fade from his second-class compartment, he gloomily watched the devastation unfold. When the train pulled into the Cologne station, there seemed to be barely one other building standing, except for the famous Gothic cathedral. The great twin spires loomed eerily over an otherwise flattened city.

In Prague, a gaunt Lederer took Bernard to visit an even more emaciated Czech woman named Joan Dubova, who had narrowly avoided the gas chambers of Auschwitz. Reluctantly, she began to talk. Not only did she confirm Jo Spier's account of what had happened to Fritz and Louise, she had actually witnessed my grandfather being beaten to death at the foot of the *Kleine Festung*. After some convincing, she agreed to retell her story before a notary on Vaklavska Street, in a section of Prague built in the fifteenth century, now known, rather oddly, as New Town (or *Nové Město*). On January 4, 1946, an affidavit was issued. This significant step, however, only heightened Bernard's growing sense of gloom. Nevertheless he returned to Amsterdam more determined than ever, only to be informed by the Dutch authorities that they did not recognize foreign notaries. Undeterred, my father contacted the notary in Prague and asked him to take the affidavit to the Ministry of Foreign Affairs. Finally, three months later, on April 16, 1946, the Czechoslovak government issued an official death certificate for Fritz Gutmann.

In the interim, however, in true Kafkaesque style, the Dutch authorities had already appointed an accountant as official administrator of the Fritz Gutmann estate. This was the same accountant who had been administering the Gutmann Family Trust since the occupation, with disastrous results. Meanwhile, it would take another five months before my father could obtain a legal Dutch death certificate. As soon as he received this, he filed suit against the Dutch State to be recognized as his father's legal heir. Unfortunately, it would then take more than another year before Bernard was officially declared, in October 1947, heir and administrator of the Fritz Gutmann estate.

My father might have complained, but only to my mother or his sister, Lili. In Holland, Bernard could count on Franz Koenigs's daughters, Nela and her sisters, for some sympathy, but not many others. Along with the Proehls, the family of the late Franz Koenigs was all that was left of the entire social world the Gutmanns had known in the Netherlands.

In the meantime, my father had much to preoccupy himself with. Ever since that dismal day in December 1945 he could not get out of his head the haunting image of the ghostly white walls of his beloved Bosbeek. When Bernard had last seen the family home in 1938, it had been filled with color, with the wonderful artworks his father had so lovingly collected over the years—the two Degas, the Renoir, the Cranachs, the Memling, the Guardis and the Gainsborough, the Bosch and the Botticelli. When he returned to Bosbeek on that cold day in December, not one of them remained. The paintings, the furniture, the china, the silver, the carpets, the cars, even the dogs—everything was gone. Even the door to the safe room, which had once protected the Orpheus Clock and the other family treasures, had disappeared. Pa knew nothing of Haberstock and Böhler, of Mühlmann and Miedl, of the Führermuseum and Göring's Carinhall. Bernard knew only that the Nazis had come and then they had gone, and with them the paintings and other artworks had vanished.

Amid the destruction left by World War II, mere possessions, even valuable paintings, meant relatively little. Millions were dead, including Bernard's parents; millions more were displaced and scattered to the winds as refugees and stateless people, including many of his own family members. Europe lay in ruins, its cities damaged or destroyed, its communications and transportation networks in chaos, many of its people starving. In the midst of all that, a few pretty canvases were perhaps insignificant.

Yet, as the months passed and the terrible finality of his parents' deaths sank in, for my father those missing artworks took on an importance beyond their artistic or material worth. They were the last link to the happy days of his youth, the sole remaining connection to the life he had once known, and they were his murdered parents' last legacy.

He understood that, given their value, it was highly unlikely the Nazis
would have destroyed any of them. He knew that at least some of those
stolen paintings had to be out there, somewhere.

The only clue Bernard had was a letter from Lili, who was still
in Italy waiting for legal travel documents. Lili had relayed to her
brother the contents of the note that Fritz had smuggled out to her,
on Hotel Ritz of Paris stationery. In the note he stated clearly that he
had managed to send several pieces from his collection to Paris in the
care of Arthur Goldschmidt and the Paul Graupe gallery on the place
Vendôme. So Bernard decided his quest would begin in Paris.

In those same years, as the ashes of the war were settling, the scale of
the Holocaust was becoming apparent. Fritz and Louise were not the
only members of the extended Gutmann–Von Landau family to perish
under the Nazis. Other innocents from our decimated extended fam-
ily included Alice Gutmann, Ludwig Bloch, Egon Bloch, Stephanie
Heller, Arthur Misch, Bettie Meyer, Vally Manheimer, Fritz Wallach,
Gertrud Huldschinsky, Emma von Landau, Maurice Poznanski, Curt
Sobernheim, Ellen Citroen, Franz Ledermann, Ilse Ledermann, and
the fifteen-year-old Susi Ledermann.

Thankfully, though, most of Bernard's immediate family had sur-
vived, but were scattered across Europe and America. Uncle Max,
remarkably, managed to hide in Rome until the liberation. Uncle Kurt
had left Paris when the Germans occupied the city in 1940, fleeing
south toward the Franco-Spanish border. There he was caught and im-
prisoned by the Vichy French authorities while trying to cross the Pyr-
enees. Somehow he escaped and returned to Paris, deciding it would
be safer to hide in the big city rather than in the French countryside.
He worked as a window cleaner, then as a cook, and successfully kept
ahead of the Gestapo until liberation came. Kurt's daughter, Ursula,
meanwhile, had managed to make her way to New York.

During all this time, the two aristocratic aunts, Lili Orsini and

Toinon von Essen, had remained comfortably in their villas in Italy—
Lili in the Villa Principessa outside Lucca, and Toinon in the Villa
Mercadente in Rome. Seemingly, neither had been bothered by any
anti-Semitic restrictions. Toinon's daughter Jacobea, who married
Baron Sapuppo, had successfully brushed off any suggestion of Jewish
heritage. On the other hand, Toinon's older daughter, Marion, was not
able to keep such a low profile. Married to the head of the German
Rothschilds, Marion had to flee to Switzerland in 1938, along with
her husband, Albert von Goldschmidt-Rothschild, and their four
children (including the twins, Mathilde and Nadine). With great re-
gret, Albert was forced to abandon the ancestral home of Grüneburg
outside Frankfurt, along with literally a trainload of precious artworks.
Not satisfied, the Germans relentlessly pressured the Swiss to cancel
his visa. The day after Christmas in 1941, Albert took his own life by
jumping from the window of his hotel, overlooking the beautiful lake
at Lausanne.

In England, after Herbert's premature death, Daisy and Marion
Gutmann (first cousin of Marion von Goldschmidt-Rothschild) had
waited out the war, until Luca's eventual release from the British in-
ternment camp in Canada. Herbert's second son, Fredy Gutmann, was
another who successfully made his way to New York; there he changed
his name to Fred Gann and joined the US army. His knowledge of
German became of great use when he was promoted to lieutenant
during the invasion of Germany.

Back in Italy, young Lili had remained hidden in the San Gimig-
nano tower with her children until July 1944, when Free French forces
had liberated the town. (Lili was stunned to find the French forces
led by a glamorous woman lieutenant perched on top of a tank. She
discovered it was the famous writer Ève Curie, daughter of Marie
Curie.)

At the end of the war, Lili was officially a resident of a former
enemy country. As a result, she could not return to the Netherlands
until her Dutch citizenship was reinstated. In 1946, after eight years,

Bernard and Lili were tearfully reunited in Amsterdam. It was a miracle that either of them was still alive. They clung to each other for a long time, and then they started talking. There was so much to tell.

Lili described dodging the Fascists and the Gestapo only to be nearly shot by ungrateful Communist partisans. She had been smuggling supplies to the Resistance, on a horse-drawn buggy, when the partisans accused her of withholding vital food.

Meanwhile, Bernard told of a near miss: while still recovering in the hospital, another bomb hit his local pub, the Red Lion, at the end of Charles Street, exactly opposite his house. Even in March, just before the end of the war, a V-2 flying rocket-bomb landed nearby in Hyde Park, killing several people.

The war stories were accompanied by a certain bravado. But when Bernard explained what had happened to Bosbeek, the gloom set in. The subject, inevitably, turned to Theresienstadt. Eventually Bernard and Lili just sat in silence together.

PART III

RESTORATION

CHAPTER 9

OUT OF THE ASHES

The new generation: Simon and Nick, with Bernard, visiting Bosbeek in 1952. In the background is a rare statue the Nazis had not removed.

Before the war, the many descendants of Eugen had come to rely on Fritz for financial support. Now with Fritz gone, it would fall to my father to handle not only his parents' estate, but also what remained of the Eugen Gutmann Family Trust—a task that, given the disruptions of the war and the ponderous pace of bureaucracies, would take many

years. But first the Dutch State had to confirm Bernard as the executor of his father's estate and of the family trust. With the final hearings in Dutch court still several months away, at best, Bernard headed for Paris.

Pa found a room above Le Berkeley restaurant, on the avenue Matignon. Le Berkeley had been a favorite of Fritz's in the thirties, when he would tour the great art galleries, such as Bernheim-Jeune, just a few doors down. A helpful man at the British Embassy directed Bernard the next day to the Commission de Récupération Artistique (Commission on Art Recovery). The new commission's offices had been set up initially in the Jeu de Paume. Symbolically this would be where the Allies would start returning all recovered French artworks.

Bernard was ushered into the offices of the former *Résistance* leader Albert Henraux, now director of the CRA. "Ah, Monsieur Gutmann! We have been waiting for you." Unfortunately Henraux didn't have good news for my father. As best he could, the director began to explain what had happened to the Graupe Gallery and the collections entrusted to its care. In 1941, Hitler's art agent, Karl Haberstock, had arrived at the gallery with orders to collect from the Gutmann collection eight major paintings (including the Memling, one of the Cranachs, and the Holbein). Then, when Paul Graupe fled to Switzerland, and his associate, Arthur Goldschmidt, to the south of France, what had been left in the gallery had been seized by a branch of the Nazi Party known as the Einsatzstab Reichsleiter Rosenberg (or ERR), including the Pietà statue and the Veronese, I would later discover. Meanwhile, the other Gutmann artworks had been put in storage on the boulevard Raspail and filed under the pseudonym "Muir." The strategy was that a Scottish name such as Muir might go undetected by the Nazis, whereas they would certainly pursue anything listed under a typically Jewish name, such as Gutmann. Henraux believed these artworks included the three Impressionist paintings. Ultimately, they would suffer the same fate as the other works when the ERR discovered them in 1942.

Henraux next handed Bernard an envelope containing three negatives. He explained that they had been taken in late 1942 by Henraux's colleague Rose Valland (now Captain Valland). During the years of German occupation, Valland was the only remaining French official at the Jeu de Paume Museum, which had become the depot for the art that the Germans were looting. Undercover for all of that time, and at great personal risk, she was working for the French Resistance. She was indeed a remarkable woman. At night, Valland secretly cataloged and photographed as many artworks as possible before they were shipped to Germany—including, as we discovered, some of my grandparents' paintings. Amazingly, Valland was barely noticed by the Germans. They were not even aware she was fluent in German.

A shiver ran up my father's spine when he realized he was in the very same building at that moment.

Henraux explained that so far none of the Gutmann paintings seemed to be among those the Allies had already found. However, Rose Valland was, at present, in Munich, at the new Central Collecting Point, busily looking for any pieces taken in France by the Nazis. Henraux, or Valland herself, would contact my father as soon as they had found something. Henraux pointed out it was early days yet—they had "thousands" of artworks to sift through.

The scale of the Nazi art looting of Europe in World War II beggars the imagination. Hundreds of thousands of pieces—paintings, sculptures, antiquities—were stolen outright or "purchased" under duress and usually transported back to Germany, not only by top Nazis such as Hitler and Göring but by all levels of Nazi officials and military men. From France alone, thirty complete train convoys packed full with masterworks (approximately 140 wagons with over twelve hundred crates) left Paris for Germany between the end of 1940 and July 1944. As the war neared its end, the bombing of Germany increased and the Allies closed in from the west and the east. Out of fear of detection and no doubt to safeguard these valuables (along with Ger-

man gold reserves), the Nazis hid the priceless treasures in more than a thousand repositories across Germany and Austria—in castles and cathedrals, in cellars and warehouses, in underground bunkers and huge salt mines.

What they hoped to accomplish with this subterfuge is uncertain. Perhaps they thought the Allies would not find these vast troves of art and gold. Perhaps some of the top Nazis, Göring in particular, thought that after the war they would actually be allowed to keep the thousands of artworks they had "legitimately" collected from the occupied territories. Whatever the Nazi thinking, it was delusional. As the Russians swept through eastern Germany, the Red Army's "trophy brigades" swept up countless artworks and unabashedly shipped them back to Russia—works not only stolen by the Germans during the invasion of the Soviet Union, but artworks stolen by the Nazis from other European countries as well. Hundreds of thousands of artworks disappeared, seemingly forever, behind what would soon be known as the Iron Curtain—a small measure of restitution, the Russians felt, for the terrible destruction they had suffered in the war.

To this day, the Russians still refuse to return stolen artworks or even, in some cases, acknowledge that they had even taken them. The Western Allies, to their credit, took a more humanitarian approach at the end of the war. Alarmed by reports of the Nazis' cultural rape of Europe, in 1943 the American government initiated a joint Allied military unit called the Monuments, Fine Arts, and Archives (MFAA) group, a collection of museum professionals, art historians, art dealers, and other experts in uniform. The task of the so-called Monuments Men was to protect significant cultural structures such as cathedrals and museums from wartime destruction, and to recover and return to their rightful owners the artworks the Nazis had stolen. As Allied armies uncovered stashes of looted art, Monuments Men rushed to secure the artworks and to begin the process of repatriating them. At the same time, the American Office of Strategic Services (OSS), forerunner of the CIA, set up an Art Looting Investigation Unit, charged with tracking down the art vultures who had orchestrated the thefts—men

such as Mühlmann, Hofer, Haberstock, Böhler, Wendland, and scores of others.

The Monuments Men, whose story, until recently, had rarely been told, performed their work admirably, with dedication and courage. The task they faced, however, was overwhelming, especially for a unit that at its height numbered less than four hundred men and women. Perhaps it was inevitable that thousands of stolen artworks that had escaped destruction in the war would remain undiscovered.

Nevertheless, pieces of Fritz's stolen art collection started turning up. In the vast underground Austrian salt mine at Altaussee, the Monuments Men found more than ten thousand paintings and artworks. Alongside Michelangelo's *Bruges Madonna*, Van Eyck's *Adoration of the Mystic Lamb* (known as the Ghent Altarpiece), and Jan Vermeer's *The Astronomer*, which had been Hitler's most cherished painting, were several paintings that had been stolen from the collection of F. B. E. Gutmann. Among this vast horde, slated for the Führermuseum in Linz, were at least one Cranach, two Liotards, one Van Goyen, the Jakob Elsner, the Nicholas Maes, and the Isenbrandt, all from Fritz's collection. Then in bunkers and on a freight train, hidden in an abandoned railway tunnel near Berchtesgaden, Allied soldiers found thousands of artworks from Göring's collection. Among these looted pieces were many from the collections of Fritz's friends Franz Koenigs and Jacques Goudstikker, as well as the fourteenth-century Pietà sculpture that Fritz had sent to Paris in 1939, and several pieces from the Gutmann silver collection. However, the Dosso Dossi portrait, which had been taken from the Wacker-Bondy storage on the boulevard Raspail for Göring's private collection, was nowhere to be seen.

Meanwhile, the bulk of the Gutmann silver collection, which had been sent to Munich, was found near Lake Starnberg. Böhler's business partner, Hans Sauermann, had hidden it all, including the Reinhold Clock and the Orpheus Clock, in the cellar of his home. An October 1945 report on the find by a US army lieutenant urged that "this property should be placed under [military] control immediately as an

attempt was to be made to loot this property"—a warning that, as we'll see, came a little bit too late.

Eventually, many pieces from the Fritz and Eugen Gutmann collections would be found by the Monuments Men, and not just paintings and silver works but even fragile, little Meissen teacups. A large amount of Gutmann Meissen porcelain and antique French furniture was found in the cellars of Mad Ludwig's castle Neuschwanstein, perched on a rugged hill in the Bavarian Alps. Much of the French Rothschild collection was also there, in conveniently marked crates. Still more Gutmann antiques were found in the enormous Baroque monastery of St. Florian, in Upper Austria.

Those and the tens of thousands of other artworks recovered by the Allies were initially sent to various "collecting points," the largest being the Munich Central Collecting Point, housed in the former Nazi Party headquarters. They would be cataloged and their owners identified, if possible. (Identification proved in many cases to be easy, since the Nazis kept meticulous records of their thefts—perhaps because, as we have seen, they did not regard them as thefts at all.) Ultimately the Monuments Men would process as many as 5 million cultural artifacts through the collecting points.

However, for logistical reasons, the Allies had decided that instead of returning stolen artworks directly to individual owners (many of whom had perished in the war), they would instead be returned to the governments of the countries from which they had been taken. Sadly the Monuments Men unit was disbanded in June 1946. No doubt it was assumed the new governments, in the former occupied territories, would work as tirelessly to ensure that the stolen art was returned to its legitimate owners. That was unfortunately an extremely optimistic assumption.

Tens of thousands of pieces of looted art recovered by Allied armies were turned over to the Dutch Stichting Nederlandsch Kunstbezit (Dutch Art Collections Foundation, or SNK), including most of the recovered pieces identified as coming from the Gutmann collection. The SNK did not, however, go out of its way to track down and

notify the owners of the returned artworks—or more likely, in the case of stolen Jewish-owned art, their surviving heirs. Instead, the owners or heirs had to file official claims with the SNK, specifically stating what pieces had been taken from their families and requesting their return.

That may sound simple enough, but it was not, particularly with paintings. One could not simply request the return of, for example, a "Tavern scene by Van Ostade" or a "Seascape by Van de Velde" and expect the SNK to hand it over. Dozens of paintings could fit those general descriptions. Instead, claimants had to describe their stolen painting in detail, including if possible the canvas measurements—an important identifying point in paintings—and provide documentation of prior ownership.

Under ordinary circumstances that might have been reasonable. But how could a claimant provide documentation of ownership when, often, those documents had been dispersed, destroyed, or taken by the very people who stole the painting in the first place? Even when those documents still existed, claimants often could not access them because the captured Nazi records of looted artworks had been classified and sealed by the Allied armies, as had the Allies' own records of recovered looted art—and they would remain classified for decades. It was a perfect example of what would later be known as a "catch-22."

In Amsterdam, Bernard and Lili tried their utmost to comply with the new rules and regulations. They compiled list after list, initially from memory, of as many, as possible, of the paintings and other artworks that had disappeared from Bosbeek. Delving into art catalogs, exhibition catalogs, and auction catalogs, they did their best to document the painting and silver collection. They sought the testimony of eminent art historians, such as Bernard Berenson and Max Friedländer. Eventually they filed hundreds and hundreds of claims with the Dutch government.

Meanwhile, thanks to the painstaking work of the Monuments of-

ficers, many of these works were now in the possession of the SNK in Amsterdam. We now know that over nine hundred pieces from both the Fritz Gutmann and Eugen Gutmann collections were turned over to the Dutch authorities from the Munich Collecting Point alone, mostly in 1946. Among these artworks were the paintings by Hans Memling, Hans Holbein, and *Samson and the Lion* by Lucas Cranach, as well as over two hundred pieces from the Gutmann silver collection found near Lake Starnberg. Bernard and Lili formally requested the artworks' return.

But there was another catch. If the Nazis had simply confiscated all of Fritz's artworks outright, it might, ironically, have been easier to secure their return. Instead, as we have seen, the Nazis had disguised their art thefts with a cloak of legality and bogus money transfers. Under Dutch law, ownership of any artworks, or other property, sold by Dutch citizens to the Nazis during the occupation was technically transferred to the Dutch government, on the grounds that the Dutch government-in-exile had declared such sales illegal during the war. After the war Nazi dealers, such as Haberstock, obstinately claimed their transactions had been legitimate, blithely ignoring the severe circumstances Jewish collectors suffered. But even more startling was that postwar Dutch officials seemed to agree with this revisionist Nazi scenario. Technically only involuntary sales were eligible for restitution under the new 1945 rules, and the Dutch authorities were insisting that Fritz Gutmann had willingly sold his artworks to the Nazis and had been paid for the sale—this despite the fact that the money "paid" to Fritz by Haberstock, Böhler, and other Nazis had been deposited in Nazi-controlled accounts. Meanwhile, the little money that had actually been paid into the Gutmann Trust account (the only account left open by the Germans) was withdrawn by a Nazi-appointed *Treuhänder* (trustee) named R. Leuchtmann, on August 18, 1944, just as the German army was retreating before the advancing Allies.

The SNK was adamant that only artworks that had not been involved in any "sale" would be returned. Bernard and Lili felt they had

no alternative: they would have to take the Stichting Nederlandsch Kunstbezit to court.

Fortunately, at the same time, Rose Valland had been busy reclaiming several other pieces from the Gutmann collection. The confiscations by the ERR had been classified as outright theft, so the bureaucrats had no gray area to hide behind. Bernard went back to Paris eager, this time, to meet the heroine of the Resistance he had heard so much about. Instead he was greeted by a hard-smoking, drab, bespectacled woman, almost fifty, in a frumpy uniform. Although a little taken aback, he was grateful for the opportunity to thank Captain Valland personally. The first two paintings to come back were the Luca Signorelli and the little Barbault (originally thought to be by Goya). Thanks to Valland's indefatigable efforts in Germany, Bernard and Lili welcomed the first successful recovery of any of Fritz's artworks.

Rose Valland, later, also recovered one of the Van Goyen landscapes and five magnificent Louis XV armchairs. Unfortunately, because the Van Goyen had been part of the first "sale" to Haberstock, Valland felt obliged to send it to Holland and let the Dutch government sort out the legalities.

Then in October 1947 there was actually some progress on the legal front. The Dutch government had finally declared my father the official heir to Fritz's estate. However, the ownership of the Bosbeek property was still in question. Its legal ownership had been seized by the Nazis in August 1942, while Fritz and Louise were still living there, and assigned to the Nazis' "Dutch property management office." Later, while Fritz and Louise were imprisoned in Theresienstadt, it had been "sold" to the German National Socialist Volkswohlfahrt (NSV), a Nazi "social welfare" organization.

By mid-1948 the authorities conceded that they might be prepared to void the Nazi sale of Bosbeek. Bernard was ecstatic for just a brief moment before the other shoe inevitably fell. There was of course a catch. If the state restored the Gutmann family's title retroactively back to 1942, then the Gutmann family would concurrently be liable for all

back taxes and unpaid mortgages. Bernard's heart sank. What choice did he have? After talking it through with the family lawyer, he decided they had to go back to court.

Meanwhile, as the proceedings were getting under way, at the beginning of 1948 the Dutch authorities finally removed all the Nazi children from Bosbeek. That same month I was born.

Then there was more good news. Among the papers that were turned over from what remained of Fritz's last business, Firma F. B. Gutmann, was a storage receipt. Apparently at least one of Fritz's former employees had remained loyal. Bernard was profoundly moved when he entered Fritz's previously undiscovered Amsterdam Storage facility (belonging to the De Gruyter's Shipping Co.) only to find over a hundred pieces originally from Bosbeek and Fritz's office on the Herengracht. Among this unexpected windfall were six minor (but beautiful) paintings, a mahogany dining table with armchairs, Persian rugs, Japanese porcelain, and a complete silver service. (My father happily brought many of these things back to London. I remember fondly, as a child, the lovely Dutch seascape hanging in the hall near the entrance to my bedroom.)

Other documents (from Firma F. B. Gutmann) listed stocks in England and the United States that the Nazi trustee had not been able to touch. Bernard was relieved to find some real liquid assets. The family's tireless lawyer, Albert Gomperts, who had also fled to London during the war, had not been paid in over a year. Also poor Uncle Max had been sending urgent cables from Italy hoping for some funds— the wonderful stamp collection had run out a long time ago. Bernard cabled him finally saying if he could come to Holland, there would be something for him.

Max had been effectively stateless since before the war, when his German citizenship (like that of so many others) had been canceled. When he received my father's cable in early 1948, Max was in a quandary—his papers were still not fully in order. He decided the safest plan would be to fly to Belgium and then slip across the Dutch border. On December 6 he boarded a Douglas C-47 in Milan bound for

Brussels. The small plane crashed during takeoff in a dense fog, killing all aboard. Bernard had been waiting for him in Amsterdam when he got the news; both he and Lili were devastated. Just a few weeks earlier, another uncle, Luca Orsini, had also died after a long illness.

Not until 1950 did the Dutch authorities officially determine what should have been obvious: that the seizure and sale of the Bosbeek estate had been forced by the Nazis, and therefore illegal, and that Bernard and Lili were the rightful heirs. Sadly, there was no legal way to avoid the unconscionable penalties that came attached with this modicum of justice. The title to the estate came burdened with much dubious debt, such as wartime tax bills and mortgages, along with various liens and other legal encumbrances. Bernard, with Gomperts Sr. and Jr., had argued quite reasonably, but vainly, that when a sale has taken place (albeit in wartime), then all previous liens must be settled at the same time. Furthermore they reasoned, at least on moral grounds, that Dutch Jewish citizens who had been barred, by the state, from working or accessing their assets should not be liable for any wartime dues, especially to the state. Not surprisingly the Ministry of Justice did not see things so clearly.

This new Kafkaesque ruling ensured that my family would only own Bosbeek, once again, for a regrettably short time. At the end of 1950 Bosbeek had to be sold to the sitting tenant. The new owners, the Catholic Congregation of the Sisters of Providence, turned the manor house into an insane asylum and later a retirement home for elderly nuns.

Meanwhile, the courts had now also confirmed Bernard as executor of the Gutmann Family Trust. This ruling had taken until almost five years after the end of the war. Again this seemed more like a Pyrrhic victory. During all this time the 220 pieces from the Eugen Gutmann silver collection, so carefully recovered by the Monuments officers at the end of 1945, had been languishing in a Dutch government warehouse. Since their arrival in Amsterdam in August 1946, the SNK had been biding their time. Then only months before my father was granted control of the Gutmann Family Trust, the SNK decided to release the

family treasures to a court-appointed trustee. This so-called trustee quickly sold between sixty and seventy pieces from the collection before my father was able to get rid of him. On paper the functionary was merely paying expenses, his no doubt, but others also dating back to the Nazi occupation.

What followed was perhaps even sadder. The remaining 150 pieces of silver had triggered a backstabbing battle among Eugen's qualifying heirs. Suddenly my father found himself at odds with his own cousins. It was one thing to fight against a callous bureaucracy or an avaricious museum, but Bernard had no stomach for fighting against what little was left of his own family. Reluctantly he yielded to his cousins. The remaining undivided artworks from the Eugen Gutmann collection were sent to New York in the early 1950s. There they would be sold, piece by piece, by a well-known antiques dealer who specialized in Fabergé eggs. To say the results were disappointing doesn't begin to describe my father's and my aunt's reactions. The famous Jamnitzer *Becher* or goblet, which had made some of the worst Nazis salivate, had been valued, despite depressed 1945 values, at fifty thousand Reichsmarks, or at least $20,000, at the end of the war. When it was finally sold in New York, ten years later, the family received exactly $5,273.78. The superb little statue entitled *A Flagellator of Christ*, made by Alessandro Algardi around 1630, was sold for the astonishing price of $78.95 (after commission). Originally thought to be by the great Bernini, the silver statue now stands proudly on display in the National Gallery in Washington.

The meager proceeds were then divided among Eugen Gutmann's feuding heirs—including Bernard and Lili, their two aunts, and Uncle Herbert's children. Divided so many ways, the sums were derisively inconsequential. Bernard sank into a deep gloom as he reflected on the enormous lengths to which his father had gone to protect the Silbersammlung Gutmann. If only poor Fritz had a grave, he would surely be turning in it.

After another two years, Bernard's next battle with the Dutch State came to a conclusion. The court ruled, in 1952, that even though the

purchase agreements for Fritz's "sales" to Böhler and Haberstock had not been concluded under direct coercion, they had still been concluded "under the influence of . . . exceptional circumstances" and were therefore eligible for "restitution."

Yet again there was a twist. The heirs were allocated the right to restitution on condition that the sales prices "received" during the war be handed over to the state. In a nutshell, if Bernard and Lili wanted their family heritage returned, they would have to buy it back from the Dutch government.

It is more than merely astonishing. The facts were plain: Bosbeek had been stripped bare, the bank accounts had been emptied, and then Fritz and Louise had been murdered.

Even though Fritz's sale of the artworks to the Nazis had been made under obvious duress, and even though neither Fritz nor his estate ultimately benefited from money the Nazis supposedly "paid" for the artworks, Dutch officials insisted that Bernard and Lili "repay" the government money that they had never received. Furthermore, the Dutch government insisted on "repayment" even though it had never expended any of its own money for these artworks.

Bernard and Lili were not the only heirs of Dutch Holocaust victims to be treated this way. Throughout the postwar years the Dutch government, as well as other Western European governments, displayed a fundamental disregard for the special circumstances in which Jews found themselves during the German occupation. In the name of democracy, the new Dutch State claimed it could not make special laws just for Jews. As a result it made no distinction between a Dutch citizen's sale of property to the Germans and a Dutch Jewish citizen's coerced sale during the occupation. Jews knew that if they refused to sell their property (at hugely discounted prices), it would be taken anyway. Like Fritz, they sold their possessions not for gain, but out of desperation.

Following the court ruling it took the Ministry of Finance another year to assemble the artworks from the Fritz Gutmann collection and price them for sale. Ultimately the ministry only offered my father

and aunt about five hundred out of the seven hundred or so pieces the Monuments Men had returned to Amsterdam, although my father was not aware of the discrepancy. So, at the beginning of 1954, after years of negotiation and litigation, Bernard and Lili raised what capital they could to buy back as much of Fritz's collection as was being offered. This amounted to sixteen major paintings, including the Memling, the Isenbrandt, the Holbein, the Cranach *Samson and the Lion*, one Guardi, and the Fra Bartolommeo, along with nearly 170 antiques and artifacts.

But as with the Bosbeek estate, now that Bernard and Lili owned the art pieces, they could not afford to keep most of them. My father was able to bring home, among others, several pieces of Chinese porcelain, some silver, and the pair of Hubert Robert Roman fantasy paintings, which I remember so vividly in our house in Shepherd Market. Meanwhile, Lili took back to Italy a portrait by Gainsborough, three bronzes, and a Franz von Lenbach family portrait that the Dutch authorities decided not to charge us for. The rest was put on the art market in Amsterdam to pay the legal bills. Unfortunately, in a deeply depressed art market, the results were not impressive. For example, the Hans Memling *Madonna with Child*, a work that might today be worth a million dollars or more, went for around $4,000—even though, ten years before, Haberstock had offered it to Hitler for over one hundred thousand Reichsmarks (or $40,000).

Unbeknown to Bernard and Lili, the SNK kept countless pieces from Fritz's art collection, along with some of the silver collection that belonged to Fritz personally, without bothering to tell them that it had them. The Dutch government had, in effect, stolen the artworks that had been stolen by the Nazis. That secret would remain uncovered for the next forty years.

Much later, in his brief 1991 memoir of the Gutmann family (which Eva sent me just before he died), my father would sum up the postwar struggle over the Gutmann estate and the recovered artworks this way: "The entire affair lasted years, and very little came out of it. Only the lawyers made money."

• • •

Sadly, as so often happens in such matters, the drawn-out liquidation of the estate and the Eugen Gutmann trust, and the troubled sale of the artworks and silver pieces, caused further disruptions and divisions among the Gutmann family, pitting nephew against aunt, cousin against cousin, even brother against sister. Perhaps Lili was right to compare the silver collection to the Nibelungen gold—maybe it was cursed. There were accusations, recriminations, complaints by one party or the other that he or she had somehow been shortchanged in the division of the various estates' insufficient remains. Angry words were followed by years, decades, of angry silence. Even my father and Lili, once so close, did not speak to each other for years and years following a dispute after some of Louise's jewelry was discovered in Switzerland. Not until the late 1960s, while I was traveling through Italy as a student, was I able to help bring about a full reconciliation between my dear father and aunt.

The burden of all this family turmoil fell most heavily on Bernard. The role of family executor is seldom enviable, especially when one has to explain to the other heirs that their expectations are unrealistic. In the usual nature of family feuds, the divisions persisted long after the precise reasons for them had been forgotten, even into my own generation. It was why, as a boy, I had never met my aunt or many of my cousins. I had barely been aware they existed, even though several lived just a few miles away in London. My mother had relatives, but otherwise my family consisted of my parents and my brother. This, I'm sure, was one of the reasons why, for much of his life, my father was so lonely.

Perhaps he would have got over it if the matter of his father's art collection and other assets had all been firmly wrapped up, if there hadn't been so many loose ends, so many questions unanswered. But my father knew at least thirty paintings were still missing, that he remembered—paintings that had never been found by the Allies after the war or, if they had been found, were never returned.

Rose Valland continued, valiantly, to look for the two Degas pastels, the Renoir, and the portraits by Dosso Dossi and Baldung Grien. But even she had given up on the Botticelli. The two fantasy landscapes by Guardi, last seen in Switzerland, had slipped out of the Allies' jurisdiction. Others such as the Adriaen van Ostade, the Hercules Seghers, a second Jan van Goyen, the strange Franz von Stuck called *The Sin*, and so many others had just disappeared. Last seen in Munich in 1943 was the wonderful Renaissance cassone panel (originally attributed to Uccello) that had been Fritz's first acquisition.

The idea that paintings stolen from his murdered father's prized collection were hanging on someone else's wall, perhaps even in the home of some ex-Nazi, ate away at Bernard, tormented him, and eventually obsessed him.

At this point my father's secret life must have begun, the secret life that had so mystified me when I was a boy—the unexplained trips, the constant correspondence to and from foreign governments and overseas lawyers, and the mounting sense of frustration and inner rage.

He traveled relentlessly through Europe, to Holland, Belgium, and France, to Spain and Italy, to Germany, Austria, and Switzerland. Endlessly he would search museums and galleries, attend auctions, and search those records that hadn't been sealed and classified, looking for any hints of his father's missing art treasures.

In my early childhood, my family sometimes all went to Europe together. However, my parents would often leave my brother and me alone with our nanny, by a beach in Holland or in Italy by Lake Como. I remember having fun, but sometimes Nick and I were lonely. On occasion, my mother would come back first and we would all wait for Pa together. When we were old enough to start school, my mother took a job in London, and my father continued his journeys alone.

When at home, Bernard would lock himself away in his study and write letters by the hundreds. Letters to the French Service de Protection des Oeuvres d'Art, to the German Bundesamt für Äussere Restitutionen, to the Interpol section of Scotland Yard, to solicitors and art dealers and museum curators, letters pleading for help, letters de-

manding action, letters that, as the years went by, became increasingly indignant and frustrated.

"Bear in mind that we are not refugees being dictated to by what might be for all I know ex-Nazis," he angrily wrote in a letter refer-encing a claim against the German government. In another letter to Paris concerning a report that two of his father's missing Guardis had been sighted in Switzerland, he impatiently declared, "It is not clear to me whether . . . you have started a new inquiry at Geneva as I have repeatedly requested. I have a feeling that you may not have entirely understood my previous letters."

In the end, it all came to almost nothing. In 1967, after years of negotiations, Bernard and Lili agreed, very reluctantly with their law-yers, to a restitution settlement with the West German government that paid them a paltry $7,500 each for four stolen and still-missing paintings that had disappeared somewhere in Germany during the war. Officially they were being paid 50 percent of the 1945 values. Appar-ently, if my father wanted the other half that was due, he would have to go behind the Iron Curtain and get Communist East Germany to pay the rest. For the West German officials, twenty years after the end of the war, it was a convenient resolution for what to them was essentially a nuisance lawsuit. For Bernard and Lili, the settlement barely covered the legal fees.

For all his travels, all his letters, and all his years of searching, my father never found another of his father's missing paintings. As the decades went by, as the war and the Holocaust receded in time, gov-ernment officials, and others, were less and less interested in recovering a few stolen paintings. Most of Germany had become part of the new alliance, and now the authorities were focused on a different enemy, the Soviet bloc. Officials would say what happened was all quite regretta-ble, most unfortunate, but there was nothing they could do about it—it was time to move on.

Increasingly, my father's letters went unanswered. But he could never let it go. Others might forget, but for my father that was never an option. Despite substantial successes immediately after the war—

my father and aunt recovered far more than most other comparable families—the failure of the last three decades to redeem his family's lost legacy had irrevocably changed him. Slowly, bit by bit, the once cheerful, gregarious, fun-loving young man from Cambridge, the loving young father who had lifted me on his shoulders to see the King's funeral procession, turned into the silent, withdrawn, broken man I came to know.

As his marriage to my mother slowly fell away, their breakup came not with shouts or angry words, but more by silences that grew ever longer. After their divorce my father took a bachelor flat in Chelsea, a rather cramped place with well-worn carpets and bookcases stacked with art books and museum catalogs, where he just slipped into obscurity. Each time I visited, he seemed to have barely moved from his armchair.

My father's otherwise almost nonexistent social calendar had one annual highlight. Each year the "old boys" from his school in Zuoz, the Lyceum Alpinum, would gather for a reunion in the Engadine valley, by St. Moritz, high in the Swiss Alps. My father never failed to attend. Surrounded by his old school friends, once the sons of bankers and industrialists and counts and barons, now bankers and industrialists and counts and barons in their own right, he seemed able for the moment to put aside the tragedies and disillusionment of the last forty years, to immerse himself in happier memories. His dinner jacket and tails still dated from that period. If his wealthy friends noticed that his collars were a bit frayed, his suits a bit worn, they were too nice to say anything about it. One quirk also set my father somewhat apart from the other Zuoz alumni—his utter refusal to speak the common language of the school, which was German. If anyone addressed him in German, he would respond in English—not because he had forgotten the language of his youth, but because he detested the country it came from. This stand made what happened next all the more surprising. At a school-reunion dinner in 1978, my father, then sixty-four, met and quietly fell in love with a younger woman named Eva Schultze-Dumbsky. What was even more star-

tling was that Eva was German and had been born in Germany just as Hitler was taking power. After the Zuoz school went coed in the 1950s, she had been among the first females to graduate. The dinner was held at the fashionable Badrutt's Palace Hotel in St. Moritz— coincidentally one of Fritz's favorites that summer in 1913, when he had fallen in love with Louise. The result was that not only did my father start speaking German again, but in the early eighties he left London and moved to Eva's hometown of Tübingen, in southwestern Germany.

At the time, Nick and I were stunned. When I had the opportunity to ask my father what it was like living in Germany, he just shrugged and said it was fine. I think, after all that had happened, he liked being called sir again in German and being treated with the deference he was originally accustomed to. Obviously Nick and I were pleased that Pa had found some measure of happiness in his later years.

Yet, despite this apparent accommodation with the past, my father never abandoned his search for the missing paintings. He continued to study art catalogs and auction listings, to haunt museums and art galleries, to write his letters, albeit much less frequently. As Eva later told us, when the Berlin Wall finally came down in 1989, followed in short order by the lifting of the Iron Curtain throughout Eastern Europe, he had happily slapped the breakfast table and announced, *"Das ist die Wende!"* "This is the turning point!" Ever since its creation, East Germany had consistently refused to restitute property seized by the Nazis. Suddenly East Germany no longer existed. In October of 1990, German reunification became a reality. Bernard quickly summoned the courage to resume his long-dormant correspondence with the Federal German authorities. Convinced now that the paintings had disappeared into East Germany or the Soviet Union, he hoped that finally, after four decades of searching, he would at last be able to track them down.

But it was not to be. In 1994, during a trip to Venice, my father and Eva spent the night of his eightieth birthday in happy celebration at the famous Harry's Bar, a familiar haunt from his younger

days. The next day he went swimming at the Lido and sank without a sound.

My father had never been able to express his pain. Like the ghost of an unfulfilled spirit, I believe, part of this pain was passed on. Then two months later, in Los Angeles, those dusty old boxes arrived at our doorstep.

SEARCHING FOR DEGAS

From the old negative taken by Rose Valland and found in Bernard's boxes.

My father wasn't able to leave my brother or me much, or so it seemed. There was no great inheritance. When those musty boxes arrived, I wasn't sure if they were a gift or a burden.

My brother and I didn't know where to begin. So Nick cleared the biggest table he had, and we started to make delicate piles based on any common reference we could detect. Neither of us had any clue where this real-life puzzle might lead. Pa had to have had a reason to keep all

this so carefully, decade after decade, country after country, and home after home. Whatever our motivation—filial duty, tender respect—we were determined to find out the answers.

What emerged before us was a rare glimpse into the withdrawn world of our departed father. From the time we were children, we had always assumed those endless trips to Europe were for his career in the travel business. Only now did we realize that our father's unspectacular career had a hidden, ulterior purpose.

We had always taken for granted that what had been lost during the war years had somehow all been accounted for. With each letter, it became more and more clear that little had truly been settled. Our father had never given up his silent struggle to recover his parents' lost art treasures, right up to the moment of his sudden death.

Nick and I were beginning to grasp, with a sense of both foreboding and exhilaration, that hidden among these brittle pages were the secrets that Pa had never been able to articulate. Reaching across time, our past, perhaps mercifully out of reach up till this point, was about to become tangible.

Suddenly, I was grateful for all the times my father had dragged me through those musty museums as a little boy. It was all coming back to me—the familiar names, the familiar artists. Thanks to this gift that had lain dormant for so many years, I felt strangely confident about the task that was unfolding in front of me.

Waves of forgotten memories swept over me while reading names and addresses from a distant childhood, comforted by my father's headed notepaper, still real after so many years. Brittle stamps, barely hanging on with ancient glue, recalled boyhood heroes such as Churchill and De Gaulle, alongside the likes of Hitler and Mussolini. One pattern quickly became clear. Almost every one of my father's yellowing letters had the same theme—paintings and art once cherished and then swallowed up in the Nazi whirlwind.

In particular, Pa had focused most of his attention on the paintings

that had been sent to the Paul Graupe gallery in the place Vendôme. In the spring of 1939 and with war imminent, Fritz had sent around twenty-five major paintings from Bosbeek to Paris for safekeeping, along with several sculptures and some very valuable furniture.

Almost all the Paris documents and inventories that we found in our father's papers listing the old masters included three missing Impressionist works: a Renoir landscape and two works by Degas.

Between all the carefully kept envelopes, one stood out. Curiously, it had nothing written on it. Inside were simply three carefully preserved photo-slide negatives. When held up to the light, we could see the ghostlike images of three almost forgotten paintings. One, even to my amateur eye, looked very much like a Degas. Nick quickly had the negatives printed. The excitement was palpable. We had plenty of clues, but here were our first real images.

The photos, we would discover, were of a Renoir called *Le Poirier*, a Degas called *Femme se Chauffant*, and another painting by Edgar Degas entitled simply *Paysage*. The photos had apparently been taken by Rose Valland. According to Aunt Lili, the paintings had once hung in the drawing room at Bosbeek, but during the war had disappeared from a warehouse in Paris.

Nick and I were both deeply moved by what we were learning about our father and the quest that had consumed him. Both of us felt that we now had a belated opportunity to decipher our father's secrets and even ultimately our family's history—a family we never knew we had. A half century after the war, we decided to take up where our father had left off. The first step: Nick would look for the Renoir and I would look for the two Degas.

I was not a lost-art sleuth. For the previous twenty-five years or so, I had been an executive in the music industry. I had never done this sort of thing before. I didn't even know whether it could be done, but I was determined to try.

Today, tracking down a particular artwork, particularly one by a fa-

mous artist, can sometimes be a simple, lucky matter of punching a few keys on a computer. Back in 1995, I was still grappling with the DOS system on UCLA's computers. Museums did not yet routinely display their inventories on the Internet. Auction houses were extremely circumspect, and art galleries had always been downright secretive. Nor could one easily track a painting by its title. Titles were often merely descriptive and subject to change. For example, the same painting might be variously titled *Portrait of a Young Man*, *Portrait of a Young Man in a Red Hat*, or simply *Portrait of a Man*. To complicate matters, over the decades the same artwork would often be attributed (at various times) to completely different artists.

It was September 1995, exactly fifty years after the end of World War II. For months I had been haunting libraries, combing through art books and old exhibition and auction catalogs looking for a painting to match the old photographs. Most of September I had been navigating the various libraries on the UCLA campus, not far from my home. This was my third visit to what is now the Charles E. Young Library. On my previous visit, they had kindly ordered for me some hard-to-get volumes from the larger University of California collection and the books had just arrived from Berkeley. I was excited. Finding an unoccupied Formica-covered table in the Arts Research Library, I quickly established my territory by spreading my reference books around the entire communal desk. A little self-conscious, and easily twice the age of the average student, I felt I needed some boundaries.

Before I knew it, students were packing up for the day. The library would soon close, but I still needed to go through one catalog. I didn't want to risk its not being there the next time I came back to UCLA. With one eye on Rose Valland's photo of the *Paysage*, I opened Richard Kendall's *Degas Landscapes*. The Kendall book had recently been published to coincide with an exhibition at New York's Metropolitan Museum of Art.

Quickly leafing through the book, almost instinctively, halfway through it hit me. There it was! As if it jumped off the page, the impact was like a blow to the chest. What had eluded my family for over half

a century was staring me in the face: *Landscape with Smokestacks, 1890, monotype and pastel, 28x40 cm.*

I grabbed Rose Valland's photograph, my heart pounding. Degas had painted many landscapes. Trying to be methodical, I compared the slightest details to the reproduction in the book, scanning from side to side and then from the top to bottom—same rolling hills, same smudge of dark smoke in the distance, and down in the bottom left corner, Degas's same autograph. It was identical! I'd found it!

The green and blue hues of Edgar Degas's Norman hills, dotted with wild yellow flowers, were breathtaking. I had no idea the little painting could be so beautiful, so full of color. I laughed quietly at my own lack of imagination—for months I had been looking at the old, wartime, black-and-white photograph. Still in shock, I ascertained that the painting had been loaned to the Metropolitan Museum in New York for an exhibition at the beginning of 1994, . . . just a year before. Trembling slightly, I dimly realized that by turning that particular page of that particular book, my whole life was about to change. Now reaching out from the past, a past almost lost forever, I had the distinct feeling that my father, Bernard, and my grandfather Fritz were cheering me on.

I read the inscription again. *Plate No. 130 Landscape with Smokestacks, 1890, monotype and pastel, 28x40 cm.* Followed by the names Mr. and Mrs. Daniel Searle. Who were these people? And how did an American word such as *Smokestacks* get in there? Was the title change mere clumsiness or was it an attempt to obscure the painting's identity?

The sudden announcement of the closing of the library jolted me from my reverie. My mind was still racing when I emerged into the brisk early-autumn evening descending over the Westwood campus. Not until I was halfway down Westwood Boulevard did I notice a pay phone. I got through to Nick. He was stunned. I must have gone over my news about three times. The next day, I called Lili in Florence. Her voice went up an octave or two in astonishment. My news brought with it the first real hope that she had felt in decades about her parents' lost treasures. We were elated by the possibility of recovering one of Fritz and Louise's stolen artworks.

A few months earlier, Nick and I had wheedled our way into a private lecture that was given by Lynn Nicholas at the old Getty Villa in Malibu. The topic had been "Nazi looting," and Lynn Nicholas's seminal book, *The Rape of Europa*, was the first of its kind. After the lecture we introduced ourselves to her. Our grandfather Fritz was even mentioned in her book. Lynn recommended we contact Willi Korte, an art detective, and Tom Kline, a lawyer. Both were based in Washington, DC, and Tom Kline, we discovered, was the foremost art-recovery lawyer in the United States. He had been the first American lawyer to pioneer the field of art restitution when the Orthodox Church of Cyprus hired him to help recover four famous mosaics. Later, in 1990, Tom had secured his reputation in a groundbreaking restitution case in which American GIs had looted German artifacts from the medieval church in Quedlinburg. Even at the time it seemed more than a little ironic that Germans were trying to reclaim looted art while there had been no cases involving Jewish looted art in more than several decades.

Later, one of the many questions the press would ask us was "How many other families are there who might make a claim?" I had no idea. "Maybe a hundred?" Eventually I would come to realize, with a certain pride, that we were just the beginning. Countless families who had feared all was lost up till this point would soon start reviving their claims.

The day after I found the Degas, Nick called Tom Kline to tell him what had happened. We had two big questions for him. How did our grandparents' Degas, last seen in Nazi hands in wartime Paris, somehow wind up a half century later in the private collection of a Chicago billionaire? And two, what could we do about it?

Daniel Searle, we would discover, was a gaunt, heavy-smoking man with a dark gray suit for every day of the week. Behind his somber desk he had hung a large portrait of himself. The humorless face in the portrait seemed to mirror exactly the man sitting beneath it. Nevertheless, Daniel Searle was at the pinnacle of Midwestern society. He was a trustee of the Art Institute of Chicago and sat on the board of countless companies and charities. Meanwhile, the Searle Freedom Trust

funded a veritable who's who of right-wing organizations. Donald Rumsfeld was a protégé. The Searle fortune was assured in 1965 when G. D. Searle & Co. developed aspartame, the controversial sugar substitute. Twenty years later, Daniel Searle sold the family pharmaceutical firm to Monsanto for $2.7 billion.

Under Tom's guidance, we assembled every available document that mentioned the Degas *Paysage*, now forever known as *Landscape with Smokestacks*. By December, all of us were confident that we had put together a solid case.

Tom wrote the first official letter to Daniel Searle, which must have arrived just before the holidays. In a nutshell, we were asking for our painting back. Searle's attorneys responded curtly by denying that it was even the same painting. Fortunately, we were able to establish that there was indeed only one such landscape. Then Searle's legal team claimed my grandfather had never owned the pastel. Their lawyer demanded, "What's this painting got to do with these people? Who are the Goodmans or the Gutmanns anyway?" It quickly became apparent, legally at least, that we would have to answer these questions.

Curiously, in the provenance records that I had uncovered at UCLA, and from the many *catalogues raisonnés* and monographs on Degas, there was no mention of Fritz Gutmann. The leading Degas expert (P. A. Lemoisne) merely listed the prewar owner as the Lütjens Collection, Holland. Eventually we were able to demonstrate, beyond a shadow of doubt, that Helmuth Lütjens was actually the art dealer who had bid for the *Paysage* on behalf of Fritz Gutmann at an auction in Paris in 1932.

Less than two months later we received startling news. Searle's lawyer, Ralph Lerner, who was well respected in the art world, had decided to drop the case. He didn't seem to have the heart for it; perhaps his being Jewish had something to do with it. In any event, we were thrilled.

Unfortunately, our euphoria did not last long. Searle was not giving up. Instead he switched his defense to the Chicago office of the same law firm. The new legal team took a more aggressive position.

They now claimed my grandfather must have sold the Degas *Paysage*. I began to realize that so much more than just the provenance of one painting was being revealed, and in a not-so-roundabout way. Perhaps I had a hard-nosed lawyer from Chicago to thank for the journey on which I was embarking. Pandora's box had been opened.

Slowly, we started to trace the journey of Degas's *Paysage* through the decades. In a 1968 American study on Degas monotypes, a doctoral candidate named Eugenia Parry Janis had listed the next person in the provenance, after my grandfather's agent, as Hans Wendland, Paris. The activities of Hans Wendland were now critical to our case. Willi Korte, the art detective, would help expose the truth about him, and as a result, we would uncover the painting's grim history.

The Degas had been sent to Arthur Goldschmidt in Paris for safekeeping in April 1939, via the shipping company De Gruyter. However, those to whom the painting had been entrusted were also of Jewish origin. Soon they also had to flee the Germans. Not long after it had been stored, on the boulevard Raspail, it would be confiscated as "abandoned Jewish property" by the ERR. At this point the *Paysage* seemed to disappear.

The landscape, along with several others of Fritz's artworks, was taken to the Jeu de Paume Museum, just off the place de la Concorde, where Rose Valland was working. The Germans had converted the famous museum into their private storage for thousands of looted artworks. As many as twenty thousand pieces went through the historic gallery in less than four years. Hermann Göring, personally, made several trips to the Jeu de Paume, where he raked through the stolen art. Vast selections were shipped back to his private country residence at Carinhall. Well-known Nazi art dealers, such as Hofer and Haberstock, also scoured the ERR's loot, which was displayed in the museum. Masterpieces by the trainload were sent back to Hitler and the other top Nazis.

As a rule, the Nazis did not want Impressionist or other "modern" artworks, which they considered degenerate—and here the dealer

Hans Adolf Wendland came into the equation. Wendland had devised a plan for "degenerate" art to be smuggled into neutral Switzerland—sometimes in German diplomatic pouches—and sold or traded there for old masters. As part of this scheme, he had conveniently forged a special relationship with Theodor Fischer, the owner of the Fischer Gallery and Auction House in Lucerne.

Many of the Swiss were eager collaborators, not only in the looted-art trade, but later in providing safe harbor for Nazi gold and other assets. The Swiss banks had no compunction expropriating, at the urging of their German neighbors, the "abandoned" assets of Jews, murdered or otherwise. When my father and Lili tried to retrieve Swiss bank accounts opened by Fritz in the early 1920s, the Swiss Banking Association said they had no records. (Roughly sixty years after the end of the war, I would have more luck.)

Meanwhile, since the 1920s Wendland had been the primary German art dealer based in Switzerland. During this time he formed a close working relationship with Fritz's nemesis Karl Haberstock, which, curiously, ended abruptly in 1927 over a quarrel involving Haberstock's wife. From 1933 on, Wendland also established a base in Paris. As soon as the Germans took over the French capital, Hans Wendland quickly became the most notorious player in the Nazi stolen-degenerate-art trade. In Paris his friend Bruno Lohse was now second-in-command of the ERR looting machine. Wendland also made a point of being available to facilitate several of Göring's acquisitions.

After the war Hans Wendland was arrested by the US armed forces in Italy and transferred in 1946 to an internment camp in Germany—in Wannsee of all places. In that same villa, Wendland was grilled by the American OSS Monuments officers. We found a detailed interrogation report in the US Archives in Washington, DC.

Ironically, Wendland's wartime Paris headquarters were in the Ritz Hotel, where Fritz had also based himself, albeit in happier times. Around the same time, Fritz's brother Kurt was working incognito downstairs in one of the hotel's kitchens. Kurt, no doubt, had no idea

that his brother's treasures were hanging in the balance. Even if he had known, I suppose Kurt wouldn't have lasted long if he had started poisoning Germans in the hotel.

From his perch at the Ritz, Wendland could observe the Paul Graupe gallery just across the place Vendôme. As the Germans consolidated their grip throughout the French capital, Graupe and his associate, Arthur Goldschmidt, were frantically hiding their collections, including Fritz's many artworks. Unfortunately, their hiding place on the boulevard Raspail was no secret to Wendland. By coincidence or not, Wendland had rented his own space in the same storage facility, which gave him easy access. Before long he led the ERR straight to the Gutmann treasures. It was customary for the ERR to reward Wendland (and his ilk) with some of the pieces of art they didn't want, such as the *Paysage*.

In the 1942 raid, the ERR also took from the Gutmann collection a painting of an enigmatic Spanish lady by Jean Barbault (but once attributed to Goya), and an impressive fifteenth-century *Baptism of Christ* by the great Tuscan Luca Signorelli. Both canvases were earmarked for the Führermuseum. On this same inventory, a small Renaissance portrait by Dosso Dossi was stamped with an ominous *H.G.* This meant that it had been selected by Hermann Göring himself. The other Degas, *Femme se Chauffant*, also appeared in the 1942 haul at the Jeu de Paume. It had been designated, dismissively, as "modern" and marked down for exchange. However, the Degas *Paysage* didn't even appear in the final ERR accounting at the Jeu de Paume. It had already made its way to Switzerland, where it appeared next in the Hans Wendland collection in Versoix outside Geneva—as if nothing untoward had ever taken place. Wendland never mentioned the Gutmann Degas during his lengthy interrogations with US Monuments officers in September 1946, even though he mentioned Paul Graupe, in a different context, and two other Degas paintings.

Daniel Searle's lawyers tried to insinuate that Hans Wendland had somehow bought *Paysage*. But no tangible evidence was offered to this effect. On the contrary, according to the US Monuments interrogators

Major Otto Wittmann Jr. and Lieutenant Bernard Taper, Wendland admitted "to claiming pictures as his own which in fact did not belong to him, in his *rescues* of Jewish-owned art in France." Furthermore the OSS issued a red-flag list of several hundred people who had participated in the art trade under the Nazis. Wendland was described as "probably the most important individual engaged in quasi-official looted art transactions in France, Germany, and Switzerland in World War II."

Following the German defeat, the likes of Haberstock, Hofer, and Böhler were eager to show the Allies documents that demonstrated their "aboveboard" professional practices. They were careful to show only papers that demonstrated their "ownership." From their point of view, they were within the law. Wendland, on the other hand, wouldn't even admit to being an art dealer—he insisted he was merely a "consultant."

After the war, Paul Graupe and his son never claimed they had sold the *Paysage*. Arthur Goldschmidt, Paul Graupe's partner, in a 1945 statement to a Gutmann family lawyer, declared that he personally had put both Degas pastels in storage on the boulevard Raspail, just before he fled Paris and the Nazis.

Unfortunately, Wendland was soon released from the last "denazification" camp where he had been held. On his return to Switzerland at the beginning of 1948, Wendland then sold the Gutmann Degas to his brother-in-law, Hans Fankhauser. Fankhauser was a Swiss citizen and, as such, immune from Allied arrest or detention. Just a few years later, in 1951, Fankhauser would sell the painting to Emile Wolf, a wealthy collector who lived in New York.

Searle's lawyers claimed that Wolf must have acquired "good title" to the painting in Switzerland. However, Wendland himself had pointed out on several occasions that even though he was a resident in Switzerland, he was forbidden to sell art on the Swiss market (a privilege reserved for Swiss citizens) because he was a German citizen. Therefore, his brother-in-law, Hans Fankhauser, did not have "good title" to give.

What Emile Wolf knew or did not know is hard to say. All we

know is that the Degas was not seen again until 1965, when a painting with the designation *"Degas Landscape 11.5 x 16.5 in.* lent by Evelyne Wolf-Walborsky" was displayed for over ten weeks in the short-lived Finch College Museum of Art in New York. (Evelyne Wolf-Walborsky was Emile Wolf's daughter.)

In 1968, the Degas was on public view again for seven weeks as part of an exhibition at Harvard's Fogg Museum in Cambridge, Massachusetts. The exhibition catalog, which was never published in Europe, was prepared by the doctoral student Eugenia Janis. But the painting now had a different title. Janis, perhaps with Wolf's encouragement, had created a new name for the Degas—*Landscape with Smokestacks.* Later, this title was even translated back into French as *Paysage avec fumée de cheminées.* Edgar Degas would not have recognized this greatly expanded title, which wasn't even grammatically very good French.

In 1987, Emile Wolf sold the Degas to Daniel Searle for $850,000. Searle's simple concern, at the time, had been whether this was a "good" Degas. His advisers, including the Art Institute of Chicago, confirmed the artistic importance of the landscape and its significance in art history. The provenance, true to fashion, was never a real consideration.

Through the seventies and eighties Bernard and Lili continued looking for the missing art. They hired an arts specialist in Munich; Lili went on German television in 1987 and displayed pictures of both the missing Degas paintings. As soon as the Berlin Wall came down in 1989, marking the end of the Iron Curtain, Lili, at age seventy, made a trip to Russia. Unfortunately, she found nothing.

My father, quite reasonably, had always thought of the United States as "the Allies." In the years after the war, it would never have occurred to him to look for Nazi loot in the United States, especially in the museum of an exclusive Manhattan college for women or on the venerable campus of Harvard.

Based on the brief public showing of the painting in New York and Cambridge, Massachusetts, Searle's legal team came up with yet

another line of defense. They asserted that my father and aunt had not looked hard enough for the Degas and so had no rights. They argued that we should have, somehow, been aware when the Degas was loaned to an exhibition in New England. In legal terms, they asserted that my family had not been "duly diligent." This came as a surprise to Nick and me when we thought of our father's years of searching museums and galleries.

In fact, in 1967, just the year before the Harvard exhibition, West German and French authorities had concluded that the Degas, along with three other paintings from the Gutmann collection, could not be traced. As a result, the West German government paid Bernard and Lili a nominal compensation for the four artworks, almost twenty-two years after the end of the war. Rose Valland had backed my family throughout this lengthy process. Additionally, during all this time Interpol had not come up with any clues, either, even though my father had alerted them to the loss of the art within months of the war's end. The German consensus was that the paintings must have ended up behind the Iron Curtain.

Today we know better. In the years after the war, the gray market in Europe was awash with thousands of artworks of dubious provenance, or no provenance at all. Many American dealers and collectors could not resist the bargain prices. With next to no questions asked, hundreds, if not thousands, of paintings and other art pieces would make their way across the Atlantic.

Searle's team claimed innocence. They asserted that no one had ever heard of these Nazi art traders. Ignorance had become a defense. We discovered a glaring disconnect in the art world. The benefits of the gray market in art were such that the art world had almost completely overlooked the realities of war and, most specifically, the Holocaust.

By July of 1996, after seven months of patient argument, we realized we had hit a brick wall. Daniel Searle did not want to give the painting back. A billionaire, he could afford a battery of lawyers, and his lawyers were telling him he didn't have to budge. He said we'd have to sue him—and so we did.

We filed our lawsuit in New York on July 19, 1996. As soon as the writ became public, the phone started ringing off the hook. Apparently we were making history. Our suit against Searle would be the first major Nazi looting case to be tried in the United States. Newspapers from Los Angeles to London and from Jerusalem to Japan were lining up. Just the day after the story broke, Nick received a call from CBS. Morley Safer from *60 Minutes* wanted to interview us.

The producers of *60 Minutes* decided that the Getty Villa in Malibu would serve as a dramatic setting for the segment. They chose to film the interview in a room with a charming still-life painting by Jean-Étienne Liotard, titled *The Tea Set*. By coincidence, this painting had once also belonged to my grandfather and had been stolen from the Gutmann possessions in Paris. Unlike the Degas, though, it had become part of Hitler's Linz collection. After the war, it had been recovered by the US army from Hitler's secret storage, deep in the salt mines of Altaussee in Austria. Following its restitution, my father and aunt had sold this particular Liotard in Switzerland—reluctantly, but at least legally. After that *The Tea Set* had passed, ironically, through the hands of Theodor Fischer before being acquired by the Getty in the 1980s.

The Tea Set was a much-studied eighteenth-century oddity with its teacups and china in uncustomary disarray. My brother and I, along with the *60 Minutes* producers, agreed it was a fitting metaphor for the family's scattered collection.

CBS decided to entitle the segment "The Search." The little Degas pastel over monotype, now known as *Landscape with Smokestacks*, was about to become famous. Nick and I also had to become accustomed, rather quickly, to the sudden media attention.

When we arrived at the Getty, our hosts unveiled for us, with great pride, their latest acquisition: a beautiful still life by another famous Impressionist, Paul Cézanne. Then, as the CBS cameras followed us around, we walked through the splendid Roman garden of the Getty Villa. Morley Safer encouraged us to describe what life had been like for our family before the Nazi cataclysm. He likened the Gutmanns to Jewish grandees. I tried to emphasize the contrast between the world

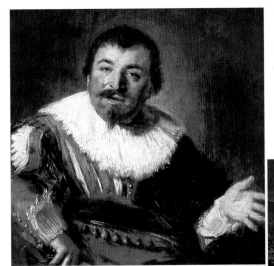

1

Frans Hals, *Portrait of Isaac Abrahamsz. Massa*

2

Hieronymus Bosch,
The Temptation of St. Anthony

3

Jean-Étienne Liotard, *The Tea Set*

4

Edgar Degas, *Paysage* (*Landscape with Smokestacks*)

5

Pierre-Auguste Renoir,
Le Poirier (*The Pear Tree*)

6

Sandro Botticelli,
Portrait of a Young Man with Red Cap

7

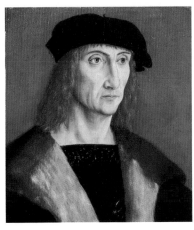

Jakob Elsner,
Portrait of a Man (red background)

8

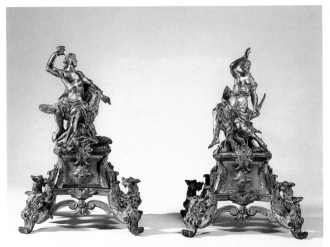

French 1710,
pair of Louis XIV
ormulu chenets

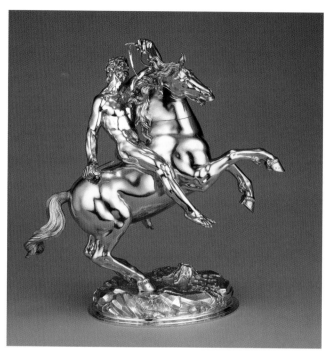

Hans Ludwig Kienle,
Horse & Rider,
silver-gilt cup

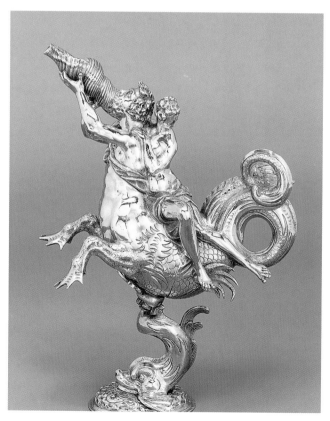

Johannes Lencker,
Triton and Nymph,
silver-gilt ewer

11

12

ABOVE: Flemish, sixteenth century, Grammont *feuilles-de-choux* tapestry

RIGHT: Picchi Workshop, maiolica albarello jar

13

Kangxi, eighteenth century, garniture of five vases

14

Franz von Stuck,
Sensuality

15

Hans Baldung Grien,
Portrait of a Young Man
(green background)

Francesco Guardi, *Paesaggio di Fantasia con Isola della Laguna*

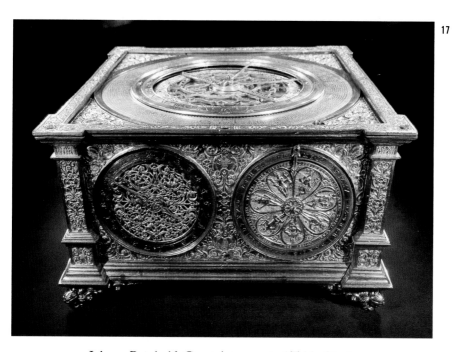

Johann Reinhold, Great Astronomical Table Clock

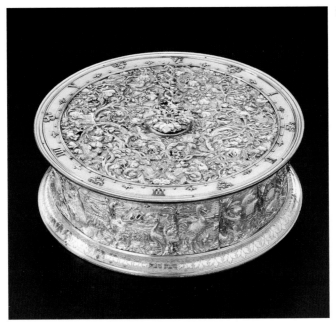

Jamnitzer, Wenzel, and Family, Orpheus Clock

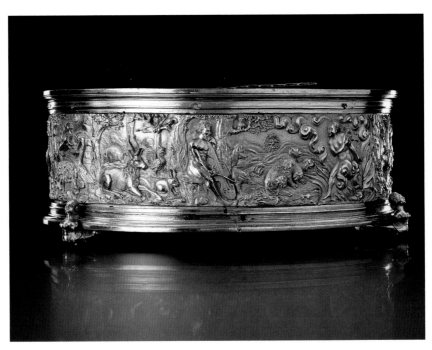

Jamnitzer, Wenzel, and Family, Orpheus Clock (side)

into which my father had been born and his drastically diminished circumstances at the time of his passing. The segment continued with Nick and me sitting in a grand room surrounded by Louis XV furniture with the Liotard behind us. Next Safer asked me, "Why do you want it [the Degas] back?"

I nearly stuttered, realizing it wasn't a rhetorical question. There was so much to say. "It's about honor," I began. "So much was lost. . . . We can't bring back the dead. . . . This is all that's left."

We were fighting for our birthright and for justice finally, but Safer realized many would not be sympathetic. Skillfully he induced my brother and me to argue our case. "The Search" aired on January 19, 1997, then twice more after that. It would win an Emmy for *60 Minutes* and CBS.

Many other journalists would ask the almost identical question. Another persistent query was "Why now?" Patiently, I would point out that we were only doing what we were doing because very little had been settled after the war. Inwardly I wanted to scream, "If your grandparents had been murdered and all their possessions stolen—what would you do?" Finally I hit on a simple phrase that explained so much: "It's unfinished business." The British documentary *Making a Killing* would open with me quoting that phrase as the camera surveyed the courthouse where the landmark case for the Degas landscape was destined to reach its climax.

Perhaps we were lucky to be consumed by the media during all this time. Since we had filed suit against Daniel Searle, the legal process had barely ground forward. Searle's team, headed by Howard Trienens, seemed content to drag out the "discovery" process as long as possible. The longer it took, the greater the expenses for my family. Even the judge seemed frustrated by the lack of progress. He actually ordered a conference between my brother, me, Aunt Lili, and Daniel Searle. Alas, nothing substantial came of it. Searle's position had become increasingly narrow and unyielding. Egged on by his legal team, Searle completely disregarded the realities of the Holocaust era. Anne Webber, in her powerful film about the Gutmann saga, *Making a Killing*, pointed

out, "There's no allowance being made for the unique circumstances of these thefts."

During a TV interview, obviously inflamed, Searle went so far as to call my family's claim "extortion." No doubt the buttoned-down industrialist's image had been somewhat tarnished by all the bad press. To make things worse, Mrs. Searle had, apparently, become the subject of gossip at their country club. One Chicago newspaper even ran an editorial with the headline "Shame, Shame, Shame." The article continued, "Shame on Daniel Searle."

Ironically, just a year before and immediately after we filed suit, Daniel Searle had personally called Nick. He introduced himself bluntly: "I'm the guy you're trying to sue." To Nick's astonishment, Searle then made an offer of $150,000. Obviously he thought we could be induced to go away. Nick politely pointed out that if the painting had been worth $850,000 in 1987, then $150,000 in 1996 could hardly be considered a reasonable offer. Still my family was heartened that Searle seemed disposed to negotiate. At the end of August, Nick wrote back suggesting a more equitable solution. We offered to split the ownership of the painting. Reluctantly, my family had come to the realization that a truly just resolution was probably out of our reach. Given the intransigence of the opposition, along with the complexities of the law, it became apparent that some compromise would be inevitable. The legal realities were beginning to take their toll. Unfortunately, rather than accept graciously or even make a realistic counteroffer, Searle merely suggested we could all get a nice tax write-off. Clearly it hadn't occurred to the Chicago billionaire that not everybody was in his same tax bracket.

The trial would be held in the Superior Court of Illinois. In September of 1997, Nick and I flew to Chicago, where we met Lili. Over several days we would all give our depositions to Searle's battery of lawyers. Lili seemed particularly anxious. Her doctors had warned her against the long flight from Italy, considering her recent heart condition.

Throughout this ordeal, Searle's attorneys seemed determined to

put words in our mouths. I was supposed to have found *Paysage* the very first day I started looking. The implication was that since it had been so "easy" for me, if my father had indeed been searching for the Degas, he would have found it decades earlier. Then they tried to twist Lili's statements to imply that Fritz had been bankrupt in 1939, that his business had failed, and he was desperate to liquidate his entire collection.

The truth was that Firma F. B. Gutmann did not close until 1942 (two years into the occupation of the Netherlands), and then only on orders of the Nazis. Meanwhile, the Gutmann Trust actually survived the war and, against all odds, emerged with considerable assets.

The case seemed to hinge largely on the interpretation of the word *consignment*. Searle's lawyers insisted that the term implied "intent to sell." This might have been the usual American/English understanding. However, in French, *consigner* simply designated a shipment entrusted for deposit. Unfortunately these linguistic subtleties seemed to be lost on the hard-nosed Midwesterners we were up against.

Even though Searle's side conceded that the Gutmann collection was looted by the Nazis, they obstinately claimed there was no "proof" that this particular work had been stolen. The fact that there was not one document indicating a sale of the Degas did not seem to deter Searle or his team. Neither did the fact that Hans Wendland never claimed, after he was arrested, that he had purchased *Paysage*.

We countered that not only did Fritz's agent, Paul Graupe, not sell the Degas, he didn't sell any of the other paintings or artworks from the so-called consignment to Paris—not one. Every piece of the Paris "consignment" had, one way or another, been taken by the Nazis.

Lili, Nick, and I were proud of how much we had been able to piece together after so much time had passed. Inevitably, though, after half a century or more, it was virtually impossible to fill in all the gaps of provenance. We were learning that the burden of proof lay with the victims. My family became increasingly aware of how hard it was to disprove a negative. The insinuation that Fritz had sold the Degas per-

sisted. The more Howard Trienens repeated the allegation, the more stubborn Daniel Searle became.

Oftentimes I wondered whether this legal stonewalling wasn't just a ploy to push up our expenses and force us to back down. When I arrived in Chicago for the depositions, somebody actually warned me, "Nobody ever sues Daniel Searle!"

The legal back and forth dragged on. On July 30, 1998, just days before the trial was to begin, we were advised that Searle's request for a motion to dismiss had been denied by the court. Clearly, too much evidence was on our side. Judge Lindberg ruled that the case must proceed to trial. Tom Kline and his Chicago associate, Barry Rosen, had done an exemplary job. This would be the first Nazi looting case to be successfully brought to trial in the United States.

After the elation subsided, Nick and I realized that we had a few tough decisions to make. Our hardworking legal team had already cost us a few hundred thousand dollars. Meanwhile, after the depositions Searle had actually complained to us that he had already spent more on the case than he had spent on the painting. We assumed that to be around a million dollars—evidently Trienens's legal posturing had not been cost-effective.

The trial would obviously drag out again everything that we had already gone over. Our costs were about to double. Regardless, I was confident that we would win. Right was on our side and so was public opinion. However, a greater consideration came into play. Lili had hated the depositions. She was filled with trepidation when she learned that she would have to return to Chicago and undergo another harsh grilling as the star witness. Nick and I feared that Lili's weak heart might not endure such a public ordeal. Moreover, the thought of her being forced to relive from the witness stand what had happened to her parents was too much to bear.

On August 7, Nick called Daniel Searle again and reoffered the fifty-fifty arrangement. This time Searle accepted. While it was clearly a victory, a vindication, after nearly three years of battle (and almost sixty years after my family lost possession of the Degas), I felt de-

flated. We had taken the prudent course, but in my heart I wanted to go to trial. At least the *Chicago Jewish Star* pointed out how "the final settlement shows just how skewed and crass Searle's insinuation of extortion was."

Nick was justly proud of an honorable conclusion. The press started to call it a "Solomonic solution." The settlement was somewhat complicated, though. Our friend Hector Feliciano (author of *The Lost Museum*) had helped broker the deal with the Art Institute of Chicago, which would become the third party in the agreement. At first the museum didn't want to get involved in what appeared to be a legal morass. However, Hector skillfully reminded James Wood, then director of the Art Institute, how much they had always wanted the Degas landscape. Before my family came along, the museum had assumed Searle would bequeath it to them. Now they had an opportunity to acquire *Paysage*, effectively at half price, since Searle would donate his half. The deal was set. My family would receive payment from the Art Institute for our half of the appraised value; Daniel Searle would donate his half of the painting to the museum in return for a tax deduction.

Clearly, Searle had not wanted to take his chances in court. Another factor that might have loomed large for Searle was the power of the press. Anne Webber's *Making a Killing* had received strong reviews in the United Kingdom and Europe. This compelling detective story about my family's fifty-year quest to recover our missing art collection was set against a background of murder, greed, and corruption. The Seattle Jewish Film Festival would later write, "*Making a Killing* is not only a beautifully-shot documentary, it has become a powerful tool in the arsenal of those fighting to address the 'unfinished business of the Holocaust.'"

Meanwhile, PBS affiliates had just started to run the US version on TV. It was scheduled to air in Chicago on August 10, but Searle had already viewed an advance copy. According to Anne Webber, now chair of the European Commission on Looted Art, Searle was beginning to have a change of heart after seeing himself in the documentary. Not surprisingly, his cold, offhand bluster had not come across sympathetically.

Before the ceremonies and unveiling of the Degas, which would be organized by the Art Institute, we had one more important piece of business to attend to—the appraisals. The agreement was that two established art institutions would give their estimates for the Degas and that a median price would establish the painting's current value. The first appraiser had to come from a list supplied by the Art Institute, from which we chose the art dealer Richard Feigen. The second appraiser had to be from either Christie's or Sotheby's. We chose Christie's because we had just begun a new legal dispute with Sotheby's concerning another painting. During the endless legal delays we had not been idle. We had been busy pursuing our Renoir, *Le Poirier*.

During the Degas case, we hadn't given too much notice to the reaction from the art world. Public opinion had been almost universally supportive of my family, but now it became apparent that the art trade thought differently. Before the court ruling in our favor, and the subsequent settlement, the art world had viewed us as upstarts. From art dealers, museum directors, gallery owners, auction houses, and, of course, wealthy collectors came the same indignant questions: Who were these people who suddenly appeared out of nowhere and claimed a valuable painting? Wasn't it over half a century ago? Aren't there statutes of limitations? Entirely overlooking the Holocaust and Nazi plunder, their main concern seemed to be that the art market might be "disrupted." When we prevailed, a lot of hand wringing went on. What will it mean for us? Are there Nazi looted pieces in our collections as well? Will we have to return artworks for which we paid hundreds of thousands, even millions, of dollars? Will we be exposed in the press as purveyors or possessors of art stolen from Holocaust victims?

I could not feel much sympathy for them, and then, suddenly, it became quite clear that the art trade felt no sympathy for us, either.

In November 1998, the Christie's appraisal came in at $300,000—a staggering $550,000 less than Daniel Searle had paid for the landscape. Next Richard Feigen, a Chicago native, came in with $575,000 (33 percent below the purchase price of eleven years before).

Was it possible that the art establishment wanted to punish us for helping to expose its witting or unwitting role in the scandal of Holocaust art?

Nick and I decided action was required. We requested a meeting at Christie's. Meanwhile, I busily prepared a dossier of Degas sale and auction prices. At Christie's West Coast headquarters in Beverly Hills, we were introduced to Marc Porter, the newly appointed international managing director. Porter appeared friendly, even slightly apologetic. We asked about the disparity between Feigen's already low estimate and Christie's rock-bottom evaluation. To reinforce our position, I presented a lengthy list of other Degas pastels that had fared comparatively better on the open market. Porter seemed sympathetic and assured us that Christie's would do what they could.

A month later, Christie's increased their appraisal from $300,000 to $400,000. Ultimately the art experts set the average value of the Degas at $487,500—just over half of what Searle had paid a decade earlier. Our portion barely covered our legal fees, but it had never been just about the money. It was still a significant victory and, it would turn out, an important turning point in the history of the art world since the end of World War II.

At the end of 1998, the (American) Association of Art Museum Directors called on all museums to check their collections for Nazi-era artworks. The Art Institute of Chicago agreed to a systematic provenance search on all the institute's works from the Holocaust era. In October they invited my whole family to an inaugural luncheon before the unveiling of the Degas landscape. Lili had no appetite for such events; the endless compromises had been a bitter experience for her (and certainly did not justify another round-trip from Italy to the States). However, Nick, his daughter Cheyenne, my wife, May, and our son, James, were all there for the emotional occasion.

When *Paysage* finally went on display at the Art Institute of Chicago—after a world war and more than half a century—it would at long last be publicly credited "From the Collection of Friedrich and Louise Gutmann."

Nick and Simon with the Degas landscape, Chicago, 1998.

CHAPTER 11

RENOIR AND BOTTICELLI

Dear Madam,

 We have carefully examined the photographs of the paintings
which you left with us, and judging from the information which
you gave us we have come to the following conclusions as to
their probable market value:

 Francesco Guardi - Venetian Capricci, a pair,
 c. 12½in. by 18in. - £15,000 (Fifteen Thousand Pounds)

 Dosso Dossi - Portrait of a Man, presumably on panel,
 c. 8in. by 11in:

 As we have no photograph of this painting, it is very
difficult to assess an approximate value, but taking into
account that it was bought by Goering, who was quite well
advised as to the quality of pictures he included in his
collection, we must presume that it was authentic and
should therefore value it at £7000(Seven Thousand Pounds).

 The small Renoir oil painting would, in our opinion, be
worth about £10,000 (Ten Thousand Pounds) to judge from the
photograph.

 The Degas pastel entitled "Femme se Chauffant" in so far
as we can judge from the photograph would be worth about
£18,000 (Eighteen Thousand Pounds), and the other Degas pastel
of a landscape would be worth about £3500 (Three Thousand
Five Hundred Pounds).

 We return the photographs herewith.

Mrs. Bernard Goodman, Yours faithfully,
42, Cottesmore Court,
London, W.8.
 Sotheby & Co

Sotheby's letter to my mother about the Renoir
and other paintings.

Two months after I had found the Degas, Nick went to the old Getty
Villa to meet with David Jaffe, the curator of nineteenth-century paint-
ings at the museum. He outlined our search to Jaffe and showed him
the other two Impressionist photographs that Rose Valland had taken
during the war. Jaffe was sympathetic to our cause as his family had also

been targeted by the Germans. For the next two weeks, Jaffe rummaged through countless catalogs. The image of the Renoir seemed to ring a bell. Suddenly he was on the phone: "I've found your Renoir." We were ecstatic, although it turned out what Jaffe had discovered was where the painting had been in the late sixties.

Renoir's *Le Poirier* (*The Pear Tree*) had been auctioned at Parke-Bernet (a subsidiary of Sotheby's) in New York, in 1969. The catalog stated that the painting was the "property of the estate of the late Lucienne Fribourg and property of the Fribourg Foundation Inc." The scant provenance consisted of just one line, "Provenance: Durand-Ruel Gallery, New York," and even that one line was incorrect. In fact, Fritz Gutmann had bought the Renoir in October 1928 from Paul Cassirer, who had in turn bought it from the Galerie Durand-Ruel in Paris— not New York.

We discovered the Fribourg Foundation had been founded in 1953 by Jules and Lucienne Fribourg, who had, coincidentally, fled Paris in 1940. Jules Fribourg was from a long line of famous grain merchants, and when his family reached Lisbon, they were lucky enough to be picked up by one of their own freighters. After a brief detour to the Dominican Republic, they arrived safely in New York in August 1940.

Jules Fribourg had died toward the end of the war, but we were able to trace his son, Michel, who was still living in New York. Tom Kline wrote a polite letter inquiring about the origins of the painting. The chilling response we received from the Fribourgs' attorneys, like the sound of a door slamming, seemed to set the tone for what was to follow: "We regret to inform you that we are not in a position to respond to your inquiries."

The ability of the ultrarich to insulate themselves from the rest of us left Nick and me with a sinking feeling. We seemed to be undertaking not just one David-and-Goliath battle but two at the same time: first Daniel Searle and now Michel Fribourg. Fortunately, we soon realized that, even if the Fribourgs never revealed where they had got the Renoir from, we could still discover where our painting had gone after the sale in New York.

Tom Kline's next letter was to Sotheby's, asking for the name of the person who had bought the painting. Their response was also to be expected. Not surprisingly Sotheby's resisted vigorously, saying it had a duty of confidentiality to its clients. The venerable auction house did, however, seem to offer a possible compromise solution. They indicated that they might be prepared to provide such information if we could show evidence of my family's due diligence in our efforts to trace the Renoir, and other pieces from the Gutmann collection, stolen during World War II.

The established art world seemed to hold outsiders, such as my family, accountable to a completely different set of standards from themselves. However, not only could we prove our due diligence, but we would demonstrate the 251-year-old auction house's complete lack of the same. One of the many letters in those bottomless boxes from our dear late father had been from Sotheby's in 1964, addressed to our mother. The letter gave my parents estimates for several of our stolen paintings, which at the time we were claiming compensation for from the West German government. The Renoir was one of those paintings, and their estimate was based on a copy of Rose Valland's photo, which they must have kept in their files. All this had taken place less than five years before they would actually sell the painting to somebody else, in 1969.

Nonetheless, we assembled a hefty portfolio that included my father and Lili's reporting the loss to Interpol and the Dutch, French, and West German authorities. As part of the documentation to support our case, we sent Sotheby's a memo that was dated April 7, 1964, written by Rose Valland. Her memo confirmed that Renoir's painting *Poirier en Fleurs* had been stored by Paul Graupe *chez Madame Wacker-Bondy*; it had formed part of the Fritz Gutmann collection, and it had been seized in Paris by the ERR at the beginning of the war.

As recently as the eighties Lili had been interviewed on German television about our search for the Renoir, and the rest of the collection. One of the last things Bernard had done was to try to revive our claim for it with the German authorities after German unification in 1991.

We felt more than confident that we had presented a compelling case. But to our disappointment, no quid pro quo was forthcoming. The matter was batted back and forth for virtually a year. Sotheby's seemed to be playing a legal cat-and-mouse game with us. By the beginning of 1997 we had lost our patience more than once. On February 24, Tom Kline filed in New York State court a petition "to compel the production of documents and the examination of Sotheby's. Prior to instituting suit to recover personal property." The judge accepted our petition and issued a directive to Sotheby's to provide the identity of the 1969 purchaser of *Le Poirier*. That should have been enough, but still the auction house refused to comply. Tom was never one to lose his cool, but he was coming close. Left with no alternative, we took Sotheby's to court for a second time. The judge, too, was losing his patience. He threatened their attorney with contempt of court and suggested he might like to spend the weekend in jail while he considered the consequences. Finally Sotheby's complied, although to our dismay all we got for our troubles was a post office box number in the British Virgin Islands.

After more legal work and a lot more sleuthing, on the last day of May 1997, we were finally given a real name: Dolores Brunilda Núñez Fábrega de Baeza. She had been married at least three times and was part of the moneyed Cuban diaspora. Before the revolution there had been Havana casinos and considerable wealth. Her father was one of the last Prime Ministers before Castro took over. After the communist takeover he settled in Panama, where his wife had come from an equally wealthy and powerful family.

Brunilda Núñez de Baeza and Rafael Navarro, her then husband, had bought *Le Poirier* at Parke-Bernet in New York in April 1969, presumably as an investment. Following their acquisition, the lovely landscape became a pawn to be shuffled between various trust companies. It bounced, on paper at least, from the Bahamas to Liechtenstein and back again. Ultimately our Renoir ended up as an asset of a trust company called the Mallard Corporation, in the British Virgin Islands. While the deed to the *Poirier* had flitted from one exotic tax haven to

another, the actual painting had been in storage in Zurich with the Union Bank of Switzerland for the first ten years following Núñez de Baeza's purchase. After that the ephemeral landscape, with its sunlit tones of yellow, orange, green, and deep red set against a bright blue sky, had languished for eighteen years in a drab, industrial neighborhood near Waterloo Station in London. It was hard to imagine a more depressing location for such a beautiful painting than the old brick warehouse on Glasshouse Walk. At least for a couple of years in Paris, while at the Wacker-Bondy storage, the *Poirier* had been next door to the Café des Arts, an old Montparnasse haunt where even Renoir might have had a drink. From there I could not be certain where the Nazis had taken our painting. Most likely it had ended up in the Galerie Fischer repository in Lucerne, Switzerland, where so much art tagged as "modern" by the ERR was ultimately laundered. Thinking about Fritz and Louise's orphaned collection, I began to wonder whether art could have a memory. Could *Le Poirier*, once so lovingly displayed in Louise's warm living room, feel the pain of neglect as it withered in some warehouse?

Throughout the summer of '97, while the legal teams were preparing their briefs, Nick had been busy lobbying. He spoke on panels; he met with influential British politicians and then flew to Washington, DC, to meet with the lawyer of Brunilda Núñez de Baeza and the Mallard Corporation. In a singular show of bad faith and arrogance, the lawyer never arrived. Eventually Nick reached him in his London office, which the lawyer had never left. Instead he made an offer to Nick on the phone. The incredibly low offer was almost insulting, but it was an offer. Nick, Tom, and I felt we could build on it.

While I was fielding calls from the press, the *New York Post* and the *Daily Mail* in London among others, Nick must have done a dozen interviews. He was a firm believer in the power of the press. Like Daniel Searle and so many other ultrawealthy, Núñez de Baeza shunned publicity. We were hoping a little pressure would result in some concessions, and we were right. They raised their offer by 5 percent.

We were up against the reality that under English law Núñez de

Baeza and the Mallard Corporation would most likely be recognized as the lawful owners. The prospect of actually getting the Renoir back was virtually nonexistent. The best we could do was restrict the possessor's ability to resell the painting. Another problem was that lawyers cannot be hired in the UK on contingency, as can be done in the United States, and most British lawyers wanted to be paid up front. We kept negotiating while Nick stepped up the political pressure. The international "London Conference on Nazi Gold" had just been scheduled for the end of the year, and other looted assets, including artworks, would feature prominently.

The Mallard Corporation retaliated by summoning me to court in London. Their writ was that the various transfers of *Le Poirier* had given them good title under Bahamian law and that my family was impeding their rights. Fortunately, thanks to some clerical error, they had omitted to serve Nick or Lili with a similar summons. Their mistake allowed us to press one more time for an out-of-court settlement. Nick, to everybody's surprise, managed to push them up another 5 percent. Realistically, we were pretty sure this was as far as we could go.

Under the terms of the agreement the Renoir would go back to auction. I had tried to get Christie's involved, but after a month their specialist still hadn't ventured from the comfort of St. James's across the river to the unlovely Glasshouse Walk. As a result Núñez de Baeza's choice prevailed. It was Sotheby's.

Nick and I felt we had done our best in dealing with another intransigent ultrarich adversary, but what happened next took us completely by surprise.

We had agreed to a barely reasonable percentage of the proceeds based on Sotheby's estimates. To make matters worse, the estimates had already been lowered a couple of times because, not surprisingly, our lovely *Poirier* had suffered from years of neglect. The auction began at Sotheby's in London on a miserable day in October; the room was not well attended. Nick and I were in LA, but Bernard's dear partner, Eva, was there to witness the sleight of hand.

When the *Poirier*'s lot came up, the auctioneer gave a cursory and

unenthusiastic introduction, in a barely audible tone. There was no flourish and certainly no attempt to coax the room with an imaginary chandelier bid. Before Eva could catch her breath, the auctioneer hammered his podium with a dismissive "pass." It was over in a flash before any potential bidder even had time to react. It had all happened so fast, Eva could not believe her eyes.

Sotheby's seemed to have taught us another bitter lesson. We had little alternative when Brunilda Núñez de Baeza's lawyer bought our share based on the reserve price used for auction.

In 2005 I noticed the Renoir reappear at Sotheby's in Bond Street. Without much hesitation, it comfortably reached over our original reserve price. Five years after that, in 2010, the lovely *Poirier* resurfaced yet again at Sotheby's, in New York instead. This time it sold for four times our original reserve price. Our poor, neglected Renoir had at last found the recognition it deserved. Equally satisfying was that Sotheby's had finally got the provenance right.

In the midst of all the tumult from the Degas and the Renoir, after the airing of "The Search" on *60 Minutes*, Nick and I were fielding calls left and right. One call was different, however. Christine Koenigs, the granddaughter of Fritz's old friend Franz Koenigs, had been in New York checking the January sales at the big auction houses. She had hoped for some vital evidence in her valiant, yet quixotic, battle for the dispersed Koenigs collection. Instead, as she relayed with some excitement, she had just discovered Fritz's missing Botticelli. Nick and I were dumbfounded.

The Sotheby's *Important Old Masters Paintings* catalog for January 30, 1997, left no doubt. Lot 74 was by Sandro Botticelli and entitled *Portrait of a Young Man in a Red Cap*. It was euphemistically listed as the "Property of a European Collector." However in the provenance, for all to see, was listed Fritz Gutmann. The utter brazenness of the auction house took us aback. We had become accustomed to the Gutmann name disappearing, conveniently, from so many of our paintings'

histories. What was indeed remarkable about Sotheby's audacity in this instance was that our lawyer, Tom Kline, had only a year before supplied their legal department with a partial list of our family's missing paintings. The list clearly included the Botticelli. Among the documentation that Tom included was a 1955 memo, yet again by Rose Valland, in which the Botticelli portrait was described, along with several other Gutmann paintings, as being looted by the Nazis. Furthermore, Tom had not sent this list to Sotheby's on a whim. Our list, which included the *Portrait of a Young Man in a Red Cap*, had been compiled following a request in February 1996 by Sotheby's very own legal department, concerning the Gutmann family history.

Sotheby's had made every effort to ascertain that the portrait was indeed by Botticelli before putting it up for auction. Everett Fahy, the Metropolitan Museum of Art's principal authority on European paintings at the time, had attested that the painting, from 1484, had indeed been painted by Sandro Botticelli. In contrast, concerning the true provenance of the painting, Sotheby's had clearly never even consulted its own records on the Gutmann losses. As the true story languished in its files, the auction house had no compunction printing in their catalog that after F. B. Gutmann, but with no date, the painting had been "acquired by Dr. R. Wetzlar, Naarden, Holland." This was despite the fact that the literature, which Sotheby's made a point of quoting in their catalog, actually still listed Fritz Gutmann as the last owner. The auction catalog also listed the last time the Botticelli portrait had been exhibited—at the Stedelijk Museum, Amsterdam, in 1934. Again, if they had checked, they would have discovered that *Portrait of a Young Man in a Red Cap* had been loaned by Fritz Gutmann of Heemstede.

We did not have much time. Christine's call had come just two days before the auction was to begin. Following several more frantic calls, Tom Kline, as fast as he could, sent the auction house a cease-and-desist notice. Unfortunately, the painting had already been sold by the time Sotheby's claimed they had received our lawyer's letter. The auction house was naturally defensive, even evasive, but they realized

they could not ignore this action. Reason was on our side; we had first alerted the auction house about our claim for the Botticelli nearly a year before this particular auction. Within a few days Tom prevailed. Reluctantly Sotheby's agreed to hold the painting, since it had not yet been delivered, and freeze any funds received. The upshot was that the auction house would retain possession until a settlement could be reached.

Before long their legal department regrouped. Sotheby's changed tack and went on the offensive. Through some legal hocus-pocus they attempted to position themselves as the aggrieved party. They threatened to sue, claiming we were "interfering with their business" by stopping a sale. Heavens forbid that we should interrupt "business as usual" in the art world. Apparently, the consignor of the *Portrait of a Young Man in a Red Cap* was also threatening a lawsuit.

Just before the situation spun out of control, the press came to our support again. Walter Robinson, in the *Boston Globe*, wrote, "For Sotheby's, the Botticelli sale is all the more awkward: Its wartime owner, Friedrich Gutmann of Holland, was beaten to death by the Nazis. His wife, Louise, was killed at Auschwitz. New York's spring auction season opens next week, and the tainted sales are likely to increase longstanding concerns about the ease with which stolen art moves through the unregulated international art market."

This was a damning editorial indeed, but in the interim, thanks to our hardworking researcher in Holland, Helen Hofhuis, we had unearthed some telling evidence. Nick was even able to talk to the widow of the man who had supposedly bought the painting from Fritz. Nick then passed the contact information on to Walter Robinson. The *Boston Globe* continued the story:

The Botticelli, for example, is listed in the Sotheby's catalog as being sold by Gutmann to Dr. R. Wetzlar of Holland. Yet Wetzlar's relatives said in interviews this week that Wetzlar bought the painting in about 1955—a decade after Lili Gutmann and her late brother Bernard reported it stolen. Wetzlar, in fact, bought the painting not from Gut-

mann but from a family that had wartime ties to an art dealer who did substantial business with Nazis, including Göring, who trafficked in looted art. Wetzlar's stepdaughter, who asked that her name not be used, said her stepfather knew the painting had once been owned by Gutmann, was suspicious, and demanded proof that the seller owned it. So, she said, the seller produced a woman who introduced herself as Lili Gutmann, and Wetzlar bought the Botticelli. But the stepdaughter conceded that the seller may have produced an impostor. Wetzlar's stepson's wife, Beatrice Blans, said she now believes Wetzlar was duped. After Wetzlar's death, the painting was sold to an Italian woman.

Meanwhile, Tom was able to smooth the ruffled legal feathers of the intransigent old auction house. Rather than unpleasant and costly litigation, he suggested a negotiation would be more productive. For once they agreed, and the next thing we heard was that the consignor, an Italian collector, was on his way to New York. Nick jumped on the next plane.

The next morning Tom met him in the lobby before going to the lawyer's office at Sotheby's headquarters on York Avenue. Nick confided in me he was feeling extremely anxious. In the conference room he expected to meet Rena Neville, the auction house's acting general counsel. Instead they were received by a bulldog of a lawyer who barked aggressively until it was time to adjourn for lunch. Nick was relieved to get out of the room. Over a quick sandwich, Nick and Tom agreed they needed a new strategy. Tom outlined a scenario that might work if only they could get the Italian collector on his own. After lunch Tom suggested to Sotheby's counsel that they discuss the legal technicalities in a different room. As soon as Nick was alone with the Italian, he tried to appeal to him as one European to another: "We would save a lot of time and money if we could just avoid all these American lawyers." The collector seemed to be receptive. Nick continued, "I'm sure we can come to a gentleman's agreement." It was a small world; the Italian actually knew one of our cousins in Florence. Nick and the collector were

quickly developing a bond, but Nick knew he had no time to waste. That bulldog lawyer could storm in at any moment. "Why don't we just split the profits?" Nick offered with a European shrug. They agreed and shook on it. When Sotheby's lawyer returned, he was furious, but a deal had been agreed.

In reality the auction house had been keen to avoid any public embarrassment about the sale of another Gutmann painting. Despite its lapses with the Botticelli, Sotheby's managed to keep its commission, estimated at more than $100,000. The terms of the settlement were confidential. However, the Italian collector recouped his initial outlay from when he had bought the painting in Geneva in 1985 and made a reasonable profit on the new sale. Meanwhile, my family had avoided defending two lawsuits that would have been stacked against us. If Swiss law were applied, because of the painting's Geneva sale, good title would almost certainly have been granted to the Italian collector. We were also relieved we could pay all our expenses, including Tom Kline's, and still have funds left over for what we had begun to call our "war chest."

Nick never did get to see our *Portrait of a Young Man in a Red Cap*, which had been secured somewhere in Sotheby's Manhattan vaults. Fortunately, today Botticelli's *Young Man* is now beautifully restored and on view at the Denver Art Museum.

We had now found and settled, for better or for worse, three paintings from our family's shattered collection. The effort to reclaim these works was not only an attempt to recover a vestige of our rich family heritage, but also our way of proving that, despite the Nazis' having so nearly destroyed our history, they had ultimately failed.

Meanwhile, the way the art world conducted its business was being shaken to its foundations. Many said that my family was a catalyst, if not a leader, in creating an awareness about Holocaust-looted art in American museums, and beyond. By the spring of 1998 the scale of the problem was becoming apparent when another notable case hit the

headlines. Our friends the Paul Rosenberg family had just discovered that their looted *Odalisque*, by Henri Matisse, had been in the Seattle Art Museum since the early 1990s.

At the end of 1998 our case about the Degas helped prompt a conference, convened by the State Department, which would involve forty-four nations. Nick and I were invited to attend the "Washington Conference on Holocaust-Era Assets," or so we thought. At the last minute it must have been decided having actual claimants present might be too disruptive. The politicians felt safer, no doubt, confining the event to diplomats only. Nevertheless I was invited to speak on a panel at the National Archives, not far from the State Department. I found myself at loggerheads with a charming, but intractable, director of the New York Museum of Modern Art over the concept of "statute of limitations"; the room seemed to be on my side, and the press was digesting every word. The next day I gave a more personal interview about our quest at CNN's Washington headquarters, which was followed by a luncheon hosted by the B'nai B'rith Klutznick National Jewish Museum. Everybody involved was excited about what we sensed were historical developments.

The State Department conference ultimately adopted standards for resolving issues of Nazi-confiscated art that became known as the Washington Principles. The first principle was "art that had been confiscated by the Nazis and not subsequently restituted should be identified"—as obvious as this sounded, it was an important first step. Then the conference urged that these findings should be publicized. Another important recommendation was the establishment of a centralized registry that would (attempt to) link all databases of Holocaust-era lost art. The conferees also made a point of encouraging alternative strategies for resolving disputes and avoiding litigation.

The basis for the Washington Principles was a set of guidelines that had been established earlier in 1998 by the Association of Art Museum Directors at a meeting hosted by one of the more progressive museums, the Worcester Art Museum in Massachusetts. Just a few years later, this museum invited Nick to give a talk on the Jan van Goyen that

had been looted from our family for Adolf Hitler's museum and later recovered in the mines at Altaussee by none other than Lieutenant Commander George Stout of the Monuments Men, who back in civilian life after the war became director of the Worcester Art Museum. The leader of the Monuments Men had returned the painting to Paris, where Rose Valland had returned it to my family. The sale in the 1950s to the Worcester, via an art dealer, had been totally legitimate, much to the museum's relief. And to the museum's credit, they had contacted my family even before they knew the Van Goyen's full history.

In June 1999 the Seattle Art Museum settled the first lawsuit over Holocaust-related art against a museum in the United States when they returned the exotic *Odalisque* by Matisse to the Paul Rosenberg family.

The Washington Principles would not only set new guidelines for US museums and institutions, but perhaps more important they would bring about the creation of "restitution committees" in Austria, France, and the Netherlands.

Even the two great tradition-bound auction houses began to thaw. Apparently while our Renoir debacle was still under way in 1997, Sotheby's discreetly introduced an in-house restitution department headed by a specialist in art law, Lucian Simmons. Lucian has since become a worthy colleague. Then a few years later Monica Dugot became director of restitution for Christie's. I was heartened by the choice; Monica had been a crucial support for my Swiss bank claims while she had been deputy director of the New York State Banking Department's Holocaust Claims Processing Office.

After half a century of business as usual, the art world was finally coming to terms with history.

RETURN TO HOLLAND

Mevrouw Gutmann neemt plaats

Lili finds her mother's old Duchesse chair.

Celebrations all across the Netherlands followed the engagement, in 2001, of Crown Prince Willem-Alexander to his Argentinean fiancée. The Governor of Utrecht was getting ready to greet the royal couple in the Paushuize, which had been built in sixteenth century for the only Dutch pope. Standing proudly, surrounded by fine examples of the provincial art collection, he was fielding questions from the national and

local press. Out of the blue the reporter from VPRO asked, "Do you know who that painting used to belong to?"

Shuchen Tan, a veteran video reporter, thrust her microphone at the dumbfounded official. The Governor looked at the painting behind him, hoping for clues, and stuttered something about its belonging to the state.

Shuchen persevered. "How did the state get it? And who did it belong to before?"

The Governor admitted he had no idea.

"The previous owner was murdered in Auschwitz," the reporter clarified.

The Governor began to panic. "I hope you are not recording this."

"Of course I am," she replied.

Later when the Governor had grasped the implications of the situation, he declared that he did not want any tainted art in his government buildings. He thought an official inquiry should be initiated. The charming painting in question was *Ducks at a Pond* by a talented, but little-known, early-nineteenth-century artist named Angela Schuszler. It was one of a pair, the other simply called *Chickens*, and both had lived happily upstairs at Bosbeek, in the hallway on the way to the bedrooms—that was, until February 11, 1942, when Julius Böhler had included the two paintings as Item 37 in his first comprehensive inventory of Fritz and Louise's house.

In July of that same year, Böhler and Haberstock sold the pair, along with a huge amount of my grandparents' antique furniture, to Dr. Heinrich Glasmeier, director general of the Third Reich Radio Corporation, who was decorating his new offices at the time. Apparently he had a huge budget and was buying looted artworks from at least three countries, much to Böhler and Haberstock's delight and profit. Glasmeier had just taken over the enormous Baroque monastery of St. Florian, not far from Hitler's hometown of Linz, to create the "Great German and European Radio." At the instigation of his boss, Joseph Goebbels, the Gestapo had expelled the monks from the monastery

in 1941. For the next few years Glasmeier lived in the lap of luxury, and then in 1945, just weeks after hosting a huge gala for the Führer's birthday, he fled before the advancing US army and disappeared, never to be seen again.

The two Schuszler paintings, among others, and large amounts of Fritz's furniture and antiques, were eventually returned to the Netherlands in early 1947. However, not until 1954 did the Dutch authorities offer the two paintings to my father and aunt—and then only at a price. Sadly Bernard and Lili had already spent every last penny at their disposal to buy back as much as they could from the Netherlands government. As a result the *Ducks* and the *Chickens* were absorbed into the Dutch National Collection, along with many Gutmann antiques and works of art. Some of these works the authorities never even bothered to offer.

The postwar governments of countries once occupied by the Germans were afraid that once restitution started, there would be no end. My father, like so many survivors, was officially shunned after the war because the authorities knew if they followed the problem to its ultimate conclusion, almost the entire population would be involved. Not only had many art dealers, curators, and directors of major Dutch museums actively collaborated with the Germans, but virtually the entire population of the Netherlands, just like that of Germany, had been complicit in the systematic robbing of the Jews. From my grandfather's Botticelli and Hispano-Suiza sedan down to the brooms and brushes in the kitchen—Jewish clothes, books, furniture, apartments, jewelry, shops, cars, businesses, bicycles, everything, including the pots and pans, had been divided among a willing population. By allowing entire countries to be accessories to the greatest crime in history, the Nazis knew that everybody would also have to be part of the greatest cover-up.

It would take five decades before the Dutch government would finally admit that its postwar treatment of Jewish survivors was, in the

words of one official, "extremely cold and unjust." Even this reluctant concession had only come about as the result of enormous international pressure.

From my family's perspective, it all began around the end of 1996. Our researcher, Helen Hofhuis, had just discovered the original Dutch customs receipt for the Renoir. During her research, she kept coming across references to the *Collectie* (Collection) Gutmann. At first she thought it was a historical reference; only gradually did she realize the collection in question referred to the present day.

When we asked Lili, she exclaimed, "Yes, yes! They [the Dutch] probably have hundreds of our things!" Nick tried to narrow it down a bit, so he asked Helen to start looking for one of the more recognizable works in Holland. The *Portrait of a Man* by Jakob Elsner seemed a good place to start. Originally attributed simply to a Nuremberg master and dated around 1490, it was exactly what Lili was referring to when she talked about all the "ugly old men" in Fritz's Renaissance portrait gallery. It was also exactly the kind of painting the top Nazis had been looking for.

When the Monuments Men found the portrait in the mines of Altaussee in May 1945, they gave it the identifying marks *Hitler nr. 1623* (referring to the inventory of the Führermuseum). After being processed through the Munich Collecting Point, the Elsner was sent back to Amsterdam at the end of April 1946. As with the pair of Schuszler paintings, it would then take almost nine years before the SNK (Netherlands Art Property Foundation) would offer the portrait back to my family. As usual, the catch was that my father and aunt would have to pay the Dutch State fourteen thousand Dutch guilders, and Bernard and Lili had already exhausted their limited budget. As I would discover years later, the SNK had been somewhat disingenuous in their offer. In 1948 they had already placed the Jakob Elsner on permanent loan to the Rijksmuseum Twenthe, in Enschede.

In the late 1990s it was still not clear with whom in the Netherlands we might lodge a claim or even an inquiry; the only possibility was to petition the Secretary of State for Education, Culture and

Science. That no works of art lost during the German occupation had been returned since the 1950s did not bode well for any such new claim. Meanwhile, thanks to a class-action suit, supported by the World Jewish Congress, against the Swiss banks, attitudes were changing. Following pressure from Israel Singer and Elan Steinberg (Secretary General and Chief Executive, respectively, of the WJC), the Dutch agreed to initiate serious discussions concerning World War II assets. After a breakthrough vote in the parliament in The Hague, in October 1997 a special committee was established to investigate art confiscated during the German occupation.

The head of the special committee was Rudi Ekkart, a respected art historian, and in April 1998 he issued his initial recommendations. One of the major results was the establishment of the Herkomst Gezocht (Origins Unknown) agency. Its assignment was to investigate who originally owned the works currently in the Dutch Art Property Collection (NK). Technically the NK consisted of thousands of artworks recovered from Germany after World War II and still in the custody of the Dutch State. It was not long before Origins Unknown's Evelien Campfens would alert Helen to the discovery of a lovely Meissen teacup, a tiny step in the right direction. Soon their initial report included a couple of paintings, several pieces of Chinese porcelain, and a set of Meissen plates from our collection. When the agency's following report came out in October 1999, even more pieces from Fritz and Louise's home were listed—all still in the "custody" of the Dutch State.

Nick and I were growing impatient. As each month went by and the inventory from our family's collection grew longer and longer, we seemed no nearer to a resolution. At the end of 1999 we filed an official claim with the help and encouragement of Anne Webber, who had decided to make Holocaust restitution her life's work after directing the documentary *Making a Killing*.

Origins Unknown was now also featuring countless artworks that had belonged before the war to others, including the Koenigs, Lanz, Mannheimer, and Goudstikker families. The Goudstikker collection was another case in point. Jacques Goudstikker had fled the Nazi

occupation with little except his famous Black Book, which was the inventory of his gallery. When his surviving wife, Desi, returned to the Netherlands after the war, the Dutch State offered back only some of the Goudstikker paintings, and then only on condition the poor widow compensate the government.

Nick had several meetings with Christine Koenigs and Marei von Saher, heiress to the Goudstikker estate, trying to plot a common strategy. They decided to get in touch with the World Jewish Congress, which was more than receptive. The WJC was fresh from its success in forcing the Swiss banks to establish a fund (ultimately $1.25 billion) to compensate families, such as the Gutmanns, for the loss of so-called dormant accounts during the Holocaust era. Israel Singer called the Netherlands' Prime Minister, Wim Kok. The Prime Minister was not only extremely stubborn, but, like so many of his predecessors, seemed to have a blind spot about what had happened during and after the war. In a notorious example of how far Wim Kok was missing the point, he actually went on Israeli radio and asserted, "The Dutch have never been responsible for the misbehavior of the Germans in the Netherlands during the war." I think the images left by Anne Frank's diary of good Dutch folk trying to hide poor Jews had become widely accepted. In reality, about a third of all the Jews hiding in the Netherlands were betrayed to the Germans—not to mention the twenty-five thousand or so Dutchmen who volunteered for the Waffen-SS.

Moreover, the current issue was what the Dutch had done after the war. Eventually the Prime Minister conceded, "The restitution of legal rights in the impoverished postwar Netherlands was basically correct from a legal and formal point of view, but at the same time . . . reports identify and criticize a number of shortcomings: the length of the process, the cumbersome and inflexible procedures, and above all the chill reception and lack of understanding that awaited those returning from the camps." The Dutch authorities, despite some reactionary elements, were finally coming to grips with their behavior at the end of the Holocaust era. The more progressive felt an outright apology to the Jewish people was long overdue.

History was on our side, for once, when Rudi Ekkart issued his recommendations in April 2001. "The Committee recommends that sales of works of art by Jewish private persons in the Netherlands from 10 May 1940 onwards be treated as forced sales." And: "The Committee recommends that a work of art be restituted if the title thereto has been proved with a high degree of probability."

Nick and I were elated, but Lili, with her long years of dealing with the Dutch, soon brought us back to earth. Her cynicism proved justified as we watched Ekkart's recommendations get kicked around like a political football for half a year. I was also bothered by the sanctimonious tone of the Dutch authorities, as if they might be doing us a favor. They were attempting to gain the moral high ground by claiming everything they had done had been entirely lawful (not unlike the Germans after the war).

Meanwhile, Shuchen Tan flew out to Los Angeles to continue her report of the Gutmann saga. Nick shared rather indignantly that the Dutch authorities were still holding on to (among other things) our grandmother's dinner service—quite possibly the one used for Lili's very last dinner with her parents. The press was on our side, again, but what about the politicians? Finally parliament was swayed, and on November 16 (my mother's birthday) the Ekkart Committee was officially given some teeth. Evelien Campfens and Origins Unknown could finally do their work.

At the end of March 2002, almost fifty-seven years after the liberation of the Netherlands, the new committee authorized its first restitution. It was for just one painting, by the sixteenth-century Flemish artist Joachim Beuckelaer, and it was to be returned to the heirs of the Berl family, originally from Vienna. On the same day the committee advised the State Secretary for Education, Culture and Science to return approximately 255 artworks and antiques to the heirs of Fritz Gutmann.

In April we received the confirmation from the ministry in The

Hague. We could hardly believe it. Secretary of State Rick van der Ploeg had authorized the return of all 255 pieces claimed. This time elation was in order. Nick, Lili, and I were all frantically calling each other. Nick and I were also e-mailing each other constantly, but communications with our dear aunt remained more old-fashioned—by telephone or by mail. She could still hammer out a good letter on her faithful typewriter.

We agreed to meet in Amsterdam in September; meanwhile there was much to organize. The Dutch also had a lot to take care of. The most important thing, now that they had agreed to give back everything (from this claim at least), was to actually find all the artworks and antiques—no small feat as it turned out. Some of our antiques were already in the repository at the Netherlands Institute for Cultural Heritage (ICN) in Rijswijk, just outside The Hague. The ICN, as we learned, administered a collection of over one hundred thousand pieces, half of which were in their enormous facility; the rest were scattered throughout various Dutch museums, government ministries, and even foreign embassies. The Gutmann *Collectie* was similarly dispersed.

The pair of Angela Schuszler paintings had to be recalled from the Paushuize in Utrecht. *Chicken with Hens* by Aelbert Cuyp, formerly in the dining room at Bosbeek, was coming back from the Dutch Embassy in Stockholm. The museum in Enschede returned the Jakob Elsner portrait. Gradually they started to assemble our collection in a huge room at the ICN that had been reserved just for our family. Over the next months items came from far and wide: tapestries from Maastricht, an Etruscan terra-cotta mask from Leiden, Meissen bowls and dishes from the museum in Zwolle, and an Italian Renaissance table and Chantilly vases from the Rijksmuseum in Amsterdam. An eighteenth-century, gilded Italian sofa had been exhibited, until recently, at the royal palace Het Loo in Apeldoorn, and an exquisite Dutch tulipwood parquetry commode, circa 1780, had been in The Hague. A Louis XV desk was on its way back from the New World, where it had once decorated the Dutch Embassy in Buenos Aires. The François Boucher *Pastoral Scene* was taken down from the wall of the Consulate General's

suite in Toronto. Meanwhile, the beautiful floral dinner service that Nick had complained about was being returned from the Netherlands' Embassy in Moscow, where the *corps diplomatique* had used it to entertain since the sixties. Apparently Nikita Khrushchev had been served dinner from our hand-painted 1750 Meissen plates.

As our room in Rijswijk was filling up nicely, according to reports it became evident the Rijksmuseum was not completely cooperating. It appeared to be dragging its feet over some pieces it clearly did not want to give up. About twenty pieces were involved. The most significant were three silver-gilt sculptures that Fritz had acquired from his father's collection. Nick and I agreed we would lend the twenty pieces back to the museum temporarily, provided they first delivered them to Rijswijk. Apparently they wanted to make us an offer, which seemed rather premature. We just wanted to get everything back and see it all together before we made any big decisions.

May and I arrived in Amsterdam in mid-September. The Dutch government had agreed to cover the airfares for the three principal heirs, so I felt in a generous mood when we checked in at my favorite hotel on the Prinsengracht (Prince's Canal). Despite all that had happened, Amsterdam had always felt like a home away from home. The next day we met with Nick and drove together to Bosbeek, just outside Heemstede. Lili and my cousin Lorenzo must have arrived at the same time. The nuns who lived there had left the door open and were making themselves scarce. Shuchen Tan was also there to record the emotional homecoming.

Lili opened the door and invited us all in, the way it might once have been, if only. The house was still strangely bare and empty. The sparse modern furniture seemed random and hardly present. I had vague memories of Bosbeek from when I was very young, with my father, but I had never been with Lili in the house where she grew up. With a loud-echoing voice she began to describe what used to be. Pointing to a blank wall: "To the right of the marble fireplace was the Liotard *Tea Set or Service*, underneath it was the Goya-like *Spanish Lady*." Then swinging farther to the right: "On this wall was a huge

Gobelin tapestry, you could see children playing under a tree." Through double doors, on either side of which had been a bronze Louis XV clock and a gilded Louis XV barometer, we entered the great room. May and I caught our breath simultaneously as we were struck by Jacob de Wit's magnificent painted ceiling. With colors vibrant and beautifully restored by the state, it was surrounded by a newly gilded frame, all of which contrasted depressingly with the sanatorium's functional furnishings. Lili pointed to more barren walls where there had once been Louis XIV silk damask paneling in between floor-to-ceiling Louis XV mirrors. Over the doors we could still see where the trompe l'oeil wall painting, also by Jacob de Wit, had been pried out of the wall. Two large open cabinets, once brimming with Qing dynasty Chinese vases, were now ignored and unused. Later one of the nuns explained that they preferred to use the modern annex, built in the 1990s. Upstairs Lili showed us the deserted bedrooms. Louise, from her dressing room, had the best views over the ornamental hedges and garden sculptures. Grandmother Thekla von Landau's room seemed particularly modest. Lili expressed relief that she had died just before the vicious anti-Semitic laws had taken hold. Lili pointed out the window toward Thekla's grave, thankfully unmolested, across the lawn and under a lovely willow. Off in a wing almost to itself was my father's old room. A rare smile came over Lili's face as she recalled how Bernard would drive the older generation mad playing his American jazz records as loud as he could. The unlikely image of my father as a carefree young man brought a tear to my eye.

My aunt had remained inscrutable and distant throughout, her guard coming down, only for a moment, when confronted with some modern aberration. She would gesture and say almost angrily, "This is all wrong!" As we drove away, I think we all took comfort from the final view of Bosbeek, its exterior intact, looking much as it always had, surrounded by the well-maintained lawns. The void inside was still a difficult image to shake.

By contrast, when we arrived at Rijswijk, the ICN building appeared like any other sprawling complex in a modern business park.

Only when we got through security and had each been issued a laminated badge did it dawn on us we were surrounded by approximately fifty thousand artworks. The director, Rik Vos, and the head of collections, Evert Rodrigo, escorted us down corridor after corridor, passing room after room stuffed with paintings, drawings, sculptures, and every conceivable other art form. There were far too many paintings to display; most were ranged tightly in gallery racks. As we descended several floors, Nick likened the complex to a giant bunker. Finally we arrived at our room. A throng was already there to greet us, and somebody was taking pictures with a flash. As I got to the door, a very tall man extended his hand and introduced himself as the State Secretary for Education, Culture and Science. He muttered something that sounded like an apology, and I replied that I wished he had been there fifty years earlier.

Our room was the size of a warehouse, windowless, its walls all brick, and definitely bunkerlike. Yet the ICN had gone to a lot of trouble. Rik Vos and Evert Rodrigo took turns showing each of us around. The first thing I noticed was an enormous chocolate-brown carpet on the ground. The beautiful Savonerrie carpet had once been in the dining room at Bosbeek. When May and I entered the cavernous room, the tables and chairs were all neatly arranged, and the shelves laden with sculptures and vases. Paintings were on the walls. Many tables were decked with bronzes and porcelain. Farther in the room, one wall was covered with two large tapestries depicting an array of exotic animals. Under each were giltwood console tables, and on each of these was perched one of a pair of spectacular ormolu chenets, which must originally have stood on each side of the marble fireplace in the drawing room at Bosbeek. On the opposite wall hung a brilliant Dutch mirror that had exuberant gilded feathers sprouting from its top; made around 1720, it must have been nearly six feet tall. Then I came across a little desk, or bureau, with intricate parquetry. When I pulled out the writing compartment, I suddenly imagined Louise composing a letter. Not far away I found Lili lost in thought in front of a Louis XV beechwood duchesse, an eighteenth-century daybed. I went up to my

aunt and realized she must be thinking of Louise as well. I was stunned to see that, although a little threadbare, the floral yellow silk upholstery had survived all this time.

"It's ours again," I said in disbelief.

Lili rejoined, "I think I'm going to sit in it."

I took her arm and carefully eased her onto her mother's cushions. It was a sublime moment. Suddenly I noticed several people watching us, and then there were those camera flashes again. A Dutch newspaper ran the story "Mrs. Gutmann Takes Her Seat."

On another table we found an odd assortment of ancient wineglasses. Nearby were large amounts of Meissen plates and bowls. A delightful teapot attracted May, and I found myself drawn to a pair of four-legged, floral sauceboats. Visions of dinner at Bosbeek soon crossed my mind.

That a sturdy bronze, fifteenth-century mortar and pestle, with German coat of arms, had survived was not so surprising, but close by were two ancient cushions still in remarkable condition. Embroidered on both was their year of creation—1689. They seemed to epitomize to what lengths the Nazis had gone to preserve everything of value—except human life. In contrast, next to the cushions were some shards and fragments of china and porcelain. May and I wondered how long these broken bits had been preserved and who had broken them. Was it the Dutch or, even longer ago, the Germans?

Then on the back wall I glimpsed three of the most prized objects from Fritz's personal collection. They had been part of that very first forced sale to Hermann Göring's agents. I was a little shocked to see them in the open, just standing on a table, even though we were in one of the most secure buildings in the Netherlands.

At first I was taken by the clean lines and simplicity of the *Horse and Rider* sculpted by Hans Kienle in 1630. The heroic rider was naked and in pure silver, in contrast to the smooth golden horse, dramatically rearing on its hind legs. The next magnificent piece was a silver-gilt ewer in the shape of a triton blowing a shell, while on his back sat a seminaked nymph. Art historians described it as Johannes Lencker's

Baroque masterpiece. The third piece, dating from 1596, consisted of the silver-gilt double cups by Hans Petzolt of Nuremberg. These towering Renaissance cups had once been the pride and possessions of my family, until 1940, when Göring's agents pried them from my grandfather's hands. Originally Eugen had acquired the Petzolt cups from the estate of Karl von Rothschild, who had died in 1886.

After the US army had retrieved the golden cups from Göring's alpine hideaway in Berchtesgaden at the end of 1945, they had been shipped to the new government of the Netherlands a year later. Nick and I were shocked to discover that the Petzolt cups had been transferred, in 1960, to the Rijksmuseum in Amsterdam, without my family's ever being notified.

By now Nick and Lili had joined me, and we stood in wonder together. Lili was also visibly stunned to see the three silver-gilt works of art seemingly unprotected. When she was a child, Fritz had usually kept the great silver pieces safely under lock and key in the safe room, only to be brought out on special occasions. With the exception of the automatons (the Jamnitzer scales with the bronze lizard, the ormolu lady strumming her golden lute, and, Lili's favorite, the Ostrich with its flapping wings and drum-beating monkey), the children were never allowed to touch any of the masterpieces in the Silbersammlung Gutmann. Lili had recently turned eighty-three, but from somewhere she must have heard her father's admonishing tone. She stood back with a certain reserve, but Nick and I felt no such restraint. We were both instinctively drawn to the Rothschild cups. I lifted the top half of the double cup, and Nick grasped the bottom cup. To our surprise at the bottom of each were silver medallions, one of a man and the other of a woman, both sporting sixteenth-century ruff collars. They must have been wedding cups. Nick gallantly handed his to May so that she and I could symbolically toast each other and our family's success.

We would have much to decide when we returned to Rijswijk the next day. None of us lived the way the Gutmanns had before the war; those days seemed to be gone forever. When we looked at all the Meissen, Lili reminded us how Fritz and Louise once used to enter-

tain. That night back in Amsterdam, with much to celebrate, we also had quite a large dinner, albeit not in the style of Bosbeek. Lili chose a favorite Indonesian restaurant, on the other side of the Vondelpark, where we could sample the endless dishes of a truly authentic *rijsttafel*. It was quite a gathering: Christine Koenigs joined us, and our cousin Nadine von Goldschmidt-Rothschild came all the way from Frankfurt with her nephew Jean-Paul. With a lot of laughter we shared the exotic food. Our family seemed to have found a new sense of optimism.

The following morning Nick, Lili, and I started to make lists of what we most wanted to keep. It was difficult to be so practical, but we did our best. Nick decided on the Cuyp painting, two lovely bronzes, some Kangxi platters, one of the marble-top console tables, and some Meissen, including a set of teacups. More surprisingly, though, he also chose an enormous Italian Renaissance table. He was overjoyed when we discovered that the ICN would even cover the shipping. Nick gallantly suggested we send the first little teacup that had started this round of discovery to Eva, as a symbolic thank-you for those old boxes and our dear father's papers.

Lili wanted the least, for reasons I think I understand. Most important to her was a De Wit pen-and-ink drawing that her father had found in the twenties. Remarkably, it was the original sketch for the enormous ceiling painting in Bosbeek, which De Wit had later installed. She also kept a lovely Italian gilt mirror. Then she gave Lorenzo the two Angela Schuszler paintings, which made him happy. His brother, Enrico, chose a huge seventeenth-century walnut candlestick lamp and several Chinese pieces, while his sister, Luisa, kept a beautiful bronze statue of Mercury.

Ultimately May and I decided on a delightful small painting of French lovers in a park, by Henri-Victor Devéria, and several pieces of Chinese porcelain, including a set of Kangxi Immortals. Nick and I each decided to keep one of the ancient cushions. Then May and I settled on an enchanting French, early-seventeenth-century, bronze group of a mother and child, one of the marble-topped consoles, and a Parisian barometer from before the Revolution. Also, I had to have

some Meissen to commemorate our family's roots in Saxony. But perhaps most dear to my heart was my grandfather Fritz's shaving stand. We had recovered the little mahogany stand from the basement of the Rijksmuseum in Amsterdam, where it had been since 1960. Years later, I would discover that Julius Böhler had personally kept this sturdy, little piece of furniture as a stand for a flowerpot.

It was a miracle that so much had come back after all these years, yet I could not help thinking that all these things from my family had only been part of the first inventory Böhler had taken of Bosbeek. I would later deduce that there were still several pieces missing from the Gutmann Silver Collection, including the fierce silver cat, known as the *Tetzelkatze*, and the enigmatic Orpheus Clock. Also, a second Bosbeek inventory had consisted of well over another four hundred pieces. In that contract, Böhler's cynicism knew no bounds. He had inserted a provision that allowed my grandparents to continue enjoying the use of their own furniture "as long as they were residents at Bosbeek." After Fritz and Louise had been taken away that day in May 1943 in a black SS limousine, the vultures had descended on Bosbeek, and those last four hundred pieces had, I feared, been strewn to the wind.

The next afternoon we met with Rik Vos of the ICN at their lawyer's offices on the Keizersgracht, just two bridges down from where Firma F. B. Gutmann had been, until the Nazis closed it in 1942. It seemed like a sensitive touch by the ICN to pick Mr. Maarten Meijer, one of the few remaining Jewish lawyers in Amsterdam. The meeting was to establish the official line of inheritance for Fritz and Louise's estate. I hoped it would be a foregone conclusion, since Nick and I were the only two children of their only son, and Lili was their only other child. Nevertheless I had to supply birth certificates and many other legal documents. The process, perhaps a little tedious, resulted in my being issued a certificate of inheritance that was then authorized and stamped by the government of the Netherlands. In the complex world of restitution, it is crucial to be able to prove you are who you say you

are. Now when I say I am Fritz Gutmann's grandson and Eugen Gutmann's great-grandson, I can prove it. This certificate has since been worth its weight in gold, on many occasions, in negotiations with the Swiss, French, and German authorities.

With the legalities taken care of and our personal lists complete, the next big decision to make was to whom to entrust the rest of the collection. Not long ago, the big auction houses had treated us with barely concealed contempt. Nick and I were still smarting from our treatment over the Renoir. Now Christie's and Sotheby's had come courting. How times had changed in just four short years. Clearly the Washington Principles had made a great impression, but also I suspected the prospect of priceless works of art coming on the market, through restitution, had proved irresistible to the auction houses. Unique works, once under lock and key in the world's great museums, could now reenter the art market.

Based on our recent experiences, Christie's was the obvious choice. I instinctively felt we could do business with Sheri Farber, Christie's vice president in charge of estates. It proved to be a good decision. That evening to cement our new relationship, Sheri and Jop Ubbens, chairman of Christie's Amsterdam (and another extremely tall Dutchman), took us to a lovely restaurant called La Rive overlooking the Amstel River. One of the important concessions they offered us was a "single-owner" sale. The auction would be devoted exclusively to the Gutmann Collection, and as a result we would get our own catalog. The thought of a Gutmann catalog's always being there as a form of commemoration appealed to us enormously. After a few more concessions, Jop threw in tickets for the Concertgebouw concert hall, the following evening. We all laughed. It was an unashamed move, but it was also a clincher.

Early in 2003, the director and the keeper of the Rijksmuseum, on their way back from a trip to the Far East, flew to Los Angeles to talk with Nick and me. On a bright, late-January morning they arrived at my house. They were making every effort to keep at least three of twenty

artworks we had lent back to them. Due to budget restrictions, they had to concentrate on what they considered essential, and apparently the three silver-gilt works by Petzolt, Lencker, and Kienle were essential.

Thanks to expert reports from Anthony Phillips, head of silver at Christie's in London, Nick and I had a good idea what they might fetch on the open market. We also had an initial report from Sotheby's. After a little back-and-forth, the director delivered their absolute best offer. Nick and I knew this was coming, yet we were still, inwardly at least, quite stunned. We requested a brief time-out. In the hallway we looked at each other openmouthed: nobody had ever offered us that kind of money before. Without having to say much at all, we knew we were agreed. I think we both felt a deep-rooted responsibility to get the best results for our family. Back in the living room Nick informed the director, perhaps a little bluntly, "I'm afraid it's not enough." The two heads of the Rijksmuseum were clearly crestfallen; they had come a long way. I pointed out that as much as our family appreciated their generous offer, we were convinced the value of the three unique pieces was greater. As they were leaving, Nick added that we hoped to see them at the auction. Money aside, I felt that something was wrong in just letting the museum keep these precious works. I kept thinking of my father in Amsterdam, during those nightmare years after the war, and how the authorities had kept so much from him.

There would be not just one auction, but two. The first would be in Amsterdam on May 13 for everything except the three silver pieces. The catalog would be entitled *Property from the Gutmann Collection*, and the cover illustration was to be one of the Louis XIV ormolu chenets. The second auction was scheduled for exactly a month later in London. The three Renaissance silver-gilt pieces would be the highlight of the London auction, entitled "Important Silver Including Three Magnificent Renaissance Silver-Gilt Works of Art from the Collection of Fritz and Eugen Gutmann." The Lencker ewer would adorn the cover of the catalog.

The night before the Amsterdam sale, Jop Ubbens organized a grand dinner, surprisingly right in the auction room. Immediately I noticed, just behind the auctioneer's stand, two familiar photos: extremely large copies of Man Ray's portraits of Fritz and Louise. They made me feel straight at home. It was a good omen. At dinner were a large contingent of Christie's executives from across Europe; they seemed to be taking this first restitution sale seriously. A contingent also came from the new Dresdner Bank, now based in Frankfurt, to pay their respects. Lili always enjoyed the attention they showered on her, albeit so late in life.

The auction room was already packed when Nick and I arrived the following morning. We could hardly contain our excitement. Jop Ubbens was our auctioneer. May and I were spellbound by his command of the room. Things were going well. Early on, an armorial plaque by Andrea della Robbia started a bidding war. It was thrilling to watch. Next the Jakob Elsner sold extremely well. Equally successful were the two exotic Flemish tapestries that followed. Most surprising, the sturdy bronze mortar and pestle started a frenzied bidding contest. Eventually it went for something staggering—twenty-five times its low estimate. Jop was more animated than the conductor at the Concertgebouw. Then the woman sitting right in front of me became determined to win the huge Savonerrie carpet. Every time she asked her husband, sitting right next to her, for more money to bid with, May and I unashamedly egged him on. I'm not sure if she realized who we were when she thanked us afterward. Then we watched as a beautiful, richly painted canvas by Michele Rocca, entitled *Rinaldo and Armida*, went for nearly four times the low estimate. During all the excitement my son, James, managed to fall sound asleep. People nearby seemed genuinely charmed by his snoring. In another touching moment a nice lady from Heemstede bought a Delft dish as a memento of Bosbeek in its better days. Lili appeared moved by this gesture; otherwise she remained stoic throughout. It must have been difficult to say good-bye to all these wonderful things one more time. Nevertheless, the auction was a great success.

A month later in London, I arrived with my family at Christie's in

St. James's for an elegant dinner in the Directors' Boardroom, arranged by Anthony Phillips. Nick was already there, as was Sheri Farber. Out of the blue, seven-year-old James politely asked for some chocolate. He cut such a dashing figure, in his brocade waistcoat and silk bow tie, that two pretty interns immediately rushed off to find some. Christie's silver specialist Harry Williams-Bulkeley calculated that James must have been the youngest person to have ever had dinner in the boardroom in the 180 years since Christie's moved from Pall Mall to St. James's. I was moved by the lengths to which the venerable old firm had gone to accommodate my family. A lot had changed since that day less than five years before when Nick and I had gone to Marc Porter's office in Beverly Hills to complain about the Degas evaluations.

Over dinner the conversation inevitably turned to Eugen's original collection. Anthony Phillips asserted that the collection was of exceptional quality and depth. He went so far as to say he thought there was no better example of late-nineteenth-century taste and that Fritz's three pieces being offered the next day were of the greatest artistic importance. His exuberance reached a pinnacle when he began to describe the Lencker ewer: "It is a sublime work."

The next day our anticipation was extremely high. We had taken a big gamble turning down the Rijksmuseum and their money. Lili, as a result, had started to find all these financial shenanigans, including the negotiations with Christie's, a little distressing. She had decided to stay home in Florence. Nick and I devised a plan to make sure she would not suffer regardless of the final results. In case we had miscalculated, she would still receive her share of what the museum had originally offered—even if it came out of our own pockets.

Christie's had saved the Gutmann silver until last. By now several old friends were in the room. After a slow start and well over a hundred lots, the silver-gilt ewer by Johannes Lencker came up for bidding. Slowly it reached a point near the reserve price, then the bidding stopped for what seemed an age. We could hardly breathe. Suddenly the bidding resumed, this time much faster. Quickly it went

over what the Rijksmuseum had offered and then kept going, hitting
some kind of a record. James was definitely not asleep this time. Next
came the Petzolt cups. They, too, quickly reached their reserve, then
the low estimate, then passed the high estimate. Nick and I looked at
each other in triumph and relief. By the time the beautiful *Horse and
Rider* by Hans Ludwig Kienle came up, I had started to breathe nor-
mally again. Whatever happened, we had been vindicated. The Kienle
finished the auction in great style, also comfortably surpassing its high
estimate.

We soon discovered that the winning bidder for the Lencker ewer
had in fact been a proxy for the Rijksmuseum. With enormous satisfac-
tion, we realized the museum had just paid more for the ewer than they
had originally offered us for all three of our silver-gilt masterworks.

The Petzolt cups found a good home at the Detroit Institute
of Arts (now sadly beleaguered), and the Kienle also made its way
across the Atlantic. Just a few months later May and I were in Chi-
cago when we were invited for lunch at the Art Institute by Ghenete
Zelleke, the curator of European decorative arts. Ghenete was jus-
tifiably proud of the Art Institute's new acquisition and enthusias-
tically showed me some of the results of her exhaustive analysis of
the sculpture. During that same visit, Suzanne McCullagh, curator
of prints and drawings, came by to say hello. Suzanne was also a
lifelong friend of Daniel Searle's daughter, and, rather significantly,
she wanted to show me the institute's new provenance and research
department. She proudly ushered me into the large new wing, where
I saw bright-eyed university graduates studying delicate drawings.
The scale of the department and its state-of-the-art facilities were
impressive. Then she took us to a room to greet an old friend. More
than five years had passed since May and I had last seen the Degas
Landscape with Smokestacks, and James had only been a baby when he
had first seen our *Paysage*. As I again mused over its beautiful colors, I
began to reflect on how much all our lives had changed since that day
in September 1995 when I first found it.

May and Simon toasting the family's success with the Petzolt cups.

CHAPTER 13

SIN AND *SENSUALITY*

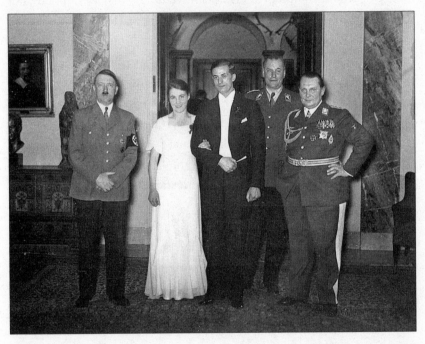

Karl Brandt (the wartime owner of *Sensuality*) and Anni Rehborn at their
wedding, in 1934, with Hitler and Göring as guests of honor.

After the excitement of our auctions began to subside, a nagging feeling
seemed to take its place. By returning so many pieces to us, the Dutch
government had surely done a decent thing—albeit more than a half
century late. But I could not help wondering how they had decided
exactly what to return. How good a job had they done? After all, if they
found so many Meissen cups and saucers, where were the teapots or
coffeepots?

I decided to construct, to the best of my ability, a master list of the entire family collection based on every inventory and catalog I could find. My task would be to identify and reference every item that had eventually been recovered or compensated for and every piece that had disappeared. (I've been working on this for years and am still not finished.) I incorporated all the prewar documents that had survived and, most important, the meticulous Nazi inventories that were finally becoming available. The Allies, in their wisdom, had sealed all Nazi-looting documents as classified after the war. Now that fifty years had elapsed, the national archives of the United States, Britain, France, the Netherlands, and Germany were opening their vaults for the first time. To this day, many vital documents still elude us. However, to my everlasting astonishment, I now have in my possession copies of Fritz's first forced sale to Göring's agent Haberstock, the first Nazi inventory of Bosbeek, their secondary inventory of the estate, the Nazi inventory of the Gutmann Silver Collection, the ERR confiscations from Fritz's storage in Paris, and so much more.

After a year or two of painstaking work, I began to recognize several pieces from the Gutmann collection that were still in the Dutch National Collection. Most were listed under the euphemistic heading "Origins Unknown," meaning no known provenance. I began filing claims.

At the same time, I filed a petition for the return of the money my father and aunt had been forced to pay to the Dutch State in 1954. The Ministry of Finance in The Hague had insisted on being "compensated" before it would release over seventy antiques and seventeen paintings belonging to our family. Unfortunately, these new claims would keep me tied up in red tape for several years to come. It soon became apparent that the thaw in restitution practices we had enjoyed in 2002 was often the exception rather than the rule. That being said, several other restitutions began to take place in Holland, most notably for a sizable part of the Goudstikker Collection. However, Christine Koenigs, and others less fortunate, continued to be rebuffed.

Undaunted, I turned my attention elsewhere. During an extended

European trip, I put aside a week to make a long-overdue visit to the German Federal Archives in Koblenz, on the Rhine. Each morning I would drive along the scenic river, with medieval castles perched above, from the fabled Lorelei rock to the ancient city of Koblenz. The dichotomy between this idealized view of Germany and the cloaked reality that I would discover in the national archives was startling. On my arrival, across an empty, cavernous hall, I was greeted by a most deferential curator. She seemed to know who I was, which I found a little unsettling. After a busy morning, copying furiously from several enormous index files, I was ready with my most wanted list. It included all the usual suspects: Haberstock, Böhler, Mühlmann, Miedl, and Plietzsch. When I read the name Göring to the archivist, the already-quiet reading room suddenly became several decibels quieter. After a long pause, he explained to me that I was asking for a lot. However, the next day, when I came back, they had two enormous shelves tagged with the name Gutmann. I did not know where to begin.

My photocopying bill ran into the hundreds of dollars. To this day, I have not fully processed this gold mine of information. One of the first gems I uncovered was the actual first forced-sale contract between poor Fritz and Karl Haberstock. Most of the paintings that had been itemized were no surprise to me. They were some of the greatest from Fritz's collection, and they had been intended for none other than the Führer. They included the Cranach *Samson and the Lion*, the three different *Madonna and Child* paintings by Memling, Isenbrandt, and Holbein, the Northern Renaissance portraits of men by Elsner, Burgkmair, and Baldung Grien, and the Van Goyen *Landscape with Two Horsecarts*. The ninth item consisted of two carved, seventeenth-century Spanish shields, which had apparently originated from the Oppenheim collection. This, in itself, was an invaluable clue, since the Oppenheim family had several well-illustrated catalogs, dating from the turn of the old century. The last item, however, had me baffled: *Die Sünde von H. Stuck*.

I had seen the word *Stuck* on some earlier inventories. In German

the word simply meant "stucco," so I assumed it was a typo for *Stück*, which was "a piece," as in a piece of furniture. However, the title *Die Sünde* clearly had no other meaning except "the sin." Obviously, this had to be a piece of art. Also, considering that all the other items in this forced sale were major works of art, Haberstock, at least, must have valued highly this mysterious piece.

Soon enough I would discover a German Symbolist painter in the late nineteenth century called Franz Stuck. *H. Stuck* simply meant "Herr Stuck." Later he was made a knight and became Franz von Stuck. He was a protégé of Franz von Lenbach, who had painted portraits of both Eugen and Sophie. I felt I was onto something; but my enthusiasm was soon dampened when I learned that Stuck had made at least a dozen paintings (as well as engravings) all called *The Sin*. If you factored into that series those paintings also called *The Sensuality* or *The Vice*, there must have been over twenty. What was even more perplexing, though, was the subject matter. All the paintings in the series depicted a very pale young woman, half naked, entwined with an overtly phallic snake.

I had trouble imagining my grandfather even buying such a painting, let alone hanging it on his walls between a *Madonna and Child* and some turgid sixteenth-century nobleman. The next thing, obviously, was to call my aunt. Did she remember anything by Franz von Stuck? After a long silence came a strange, short laugh. "How did you know?" she exclaimed. Then, while I relayed my discovery, the details began to come back to her.

Lili must have been about ten, at the time, when Fritz came back from the auctions in Munich. Under his arm was this strange painting. Perhaps the repercussions from the crash on Wall Street, just a few months earlier, had unhinged my grandfather—bankers in Germany were reeling from the aftershocks. The world was changing fast and so, perhaps, was Fritz. Clearly he felt he had to try something new. However, when he bravely unveiled his new acquisition to the family, there were screams. Louise quickly banished Franz von Stuck's sinister image upstairs, out of sight and out of mind. After the initial shock, all this

must have been a source of considerable merriment among the guests at Bosbeek before the war.

Then I discovered the deposition Karl Haberstock had made to Allied officers, a year after the war. He claimed he could not return the Stuck because he had sold it to a certain Dr. Brandt, resident in the Schloss Bellevue, Berlin. Well, Schloss Bellevue is now the official residence of the President of Germany, but during the war it was a guesthouse for high-ranking Nazis. After considerably more digging, I discovered the true identity of this Dr. Brandt. In trying to uncover what happened to my family, I have had to delve far deeper into the Holocaust than I ever thought I had the courage for. This was one of those moments.

Dr. Karl Brandt was no ordinary doctor. In 1934 he became Hitler's personal physician, but it was his medical "experiments" that would earn him the titles of *SS-Gruppenführer* and *SS-Brigadeführer*. Starting in 1933, he began the state-sponsored eugenics program to rid the Reich of the "genetically disordered" and the "racially deficient." By 1939, Brandt was head of the Aktion T4 Euthanasia Program, through which over seventy thousand people would be killed in its extermination centers.

Hitler quickly took the doctor under his wing. The Führer was the guest of honor when Karl Brandt married Anni Rehborn, a renowned athlete and medal-winning swimmer. With her siblings, Anni had become akin to an "Aryan" pinup. Hitler even remarked, "This face could originate from one of the temple friezes of Olympia." The tall, ambitious physician and his athletic bride seemed to epitomize the new Germanic ideal. Before long, Karl and Anni Brandt were invited into the Führer's closest inner circle.

The Brandts were soon regulars at the Berghof, Hitler's weekend mountain retreat on what had been the Austrian border. Anni's closest friends became Margarete Speer (wife of Albert Speer, later minister of armaments and war production) and Eva Braun, Hitler's longtime companion. The popular couple even built their own, albeit much smaller, chalet in the shadow of the Führer's favorite retreat. When

their son was born, they named him Karl-Adolf. To this day several home movies, filmed by Eva Braun, survive, showing the close-knit group playing with their children or dogs and cavorting by the shores of the nearby lake, Chiemsee. For the briefest of moments, they appeared like normal, happy people. Then I realized I was still looking at Hitler, Speer, Bormann, Ribbentrop, Heydrich, Himmler, and Karl Brandt.

As the tide turned in the war, by mid-1944 the Berghof estate was largely abandoned. The Brandts were back in Berlin, at their apartment in the Schloss Bellevue, along with their admired art collection. The Franz von Stuck hung alongside other German works by Hans Thoma and Karl Friedrich Lessing. However, as the Allied bombing of Berlin intensified, Brandt stored most of his art treasures in the safety of the *Führerbunker*. By 1945, with the Red Army no longer far away, Hitler also spent most of his time in the bunker. Then on April 30, 1945, as the Battle for Berlin raged above him, Hitler and Eva Braun committed suicide.

Karl Brandt tried to escape but was arrested by British soldiers in northern Germany on May 23. He was transferred to a maximum-security prison camp euphemistically called Camp Ashcan. This was no ordinary camp. The Allies had selected this former hotel in the middle of Luxembourg to house and interrogate eighty-six of the most prominent surviving Nazi leaders. Here Generalmajor Karl Brandt of the Waffen-SS found himself reunited with some of the Führer's cabinet and inner circle, such as Ribbentrop and Hermann Göring. There was Himmler's precursor, Wilhelm Frick, and some of the most brutal military commanders the war had known, such as Keitel, Kesselring, Jodl, and Von Rundstedt. Others included Seyss-Inquart and Hans Frank, the murderous Governors of the Netherlands and Poland. The vile propagandist Julius Streicher was another inmate.

On August 10, the inmates were transferred to Nuremberg. The trials would begin three months later. Most of those mentioned above would be sentenced to death.

However, Karl Brandt was singled out for special treatment. Along

with some of the other most notorious "medical" practitioners, Dr. Brandt became the primary defendant in what was known as the Doctors' Trial. Officially it was entitled *United States of America v. Karl Brandt, et al.* During the exhaustive preparations for trial, the prosecutors took time out to question the accused about his art collection. Most of it, he claimed, he had stored in the bunker under the Reich's Chancellery. He mentioned Karl Haberstock a few times during the deposition, but he only mentioned the Stuck painting once, and then he was rather evasive. The American interrogators assumed that if any of Brandt's artworks had survived the battle for the bunker, after Hitler's suicide, then the victorious Soviet troops would have carried them away. However, Brandt seemed to imply that a Dr. and Frau Schönemann might have managed to smuggle some pieces to Munich, in the American zone.

Earlier, in the waning days of the Third Reich, Brandt had also sneaked his wife, Anni, and young Karl-Adolf behind American lines, in the state of Thuringia, and from there to safety. In doing so, Brandt had almost got himself killed. When Hitler learned that his once-trusted aide had lost faith in the war effort, he accused him of high treason. Brandt was arrested by his own SS and sentenced to death. However, in the chaos of the final days of the war, the sentence was never carried out.

Now Karl Brandt stood accused of war crimes and crimes against humanity. To be specific: performing medical experiments on prisoners of war and civilians, in the course of which Brandt, and the other defendants, committed murder, torture, atrocities, and other inhuman acts. He was also accused of planning and performing the mass murder of prisoners of war and civilians. The trial lasted over eight months, at the end of which SS-Gruppenführer Prof. Dr. Karl Brandt, Hitler's *Reichskommissar* for Medical and Health Care, was found guilty and sentenced to death.

At the scaffold, Brandt refused the peace and absolution proffered by a nearby priest. Instead he accused the United States and Britain of hypocrisy. "Justice has never been here. What dictates is power. And

this power wants victims. . . . I am such a victim." He was hanged on
June 2, 1948, at the Landsberg Prison, between Munich and Augsburg.
The *Stars and Stripes* newspaper reported the next day that the con-
victed had "paid an eye for 10,000 eyes, a tooth for 10,000 teeth. In a
chilling rain they died unfrightened."

By the winter of 2008 I had become rather dispirited. I had studied
and studied everything I could about Stuck's femmes fatales and their
lascivious snakes. For the life of me, I could not deduce which one Fritz
might have owned. Lili had, not surprisingly, pointed out the obvious:
they all looked the same to her. She did, amazingly, remember the
approximate size. Apparently it had to be one of the smaller versions.
Also I could eliminate those in the series that had solid provenances
dating back from well before the war. Working from the Franz von
Stuck *catalogue raisonné*, I was able to whittle down my list to just
four or five *Sins* or *Sensualities*. I had sent a slew of e-mails and letters
requesting better provenance histories, including several to Germany.
Interestingly, two of the most famous in the series *Sin* or *Die Sünde*
had the least solid provenances and were now in the National Gallery
in Berlin and the Franz von Stuck Museum in Munich. The Berlin
painting had appeared on the Berlin art market in 1940 and then, from
what I could tell, was found languishing in a German government
warehouse in Berlin after the war. Subsequently it had been donated in
the 1960s to the Nationalgalerie. The Villa Stuck version, in Munich,
had been donated to the newly refurbished Stuck Museum in 1965 by
a benefactor. Where it had been before that was unclear.

I decided nobody would get back to me until after the New Year,
so I put myself to bed feeling the flu coming on. But then in the last
mail just before Christmas came a heavy package for which I had been
waiting over a year. May dropped it at the foot of the bed. Inside I
discovered a hefty tome dedicated to none other than Fritz's neme-
sis—Karl Haberstock. It was entitled (translating from the German)
Controversial Art Dealer and Patron of the Arts. I was a little stunned by

the choice of words. I even checked my German dictionary to make sure *controversial* was really the word the authors intended. The book had been commissioned in 2000 by the city of Augsburg, Haberstock's hometown. An American historian had voiced various misgivings about the Karl and Magdalene Haberstock Bequest, which the city of Augsburg had gratefully received in the 1980s. From what I could tell, the collection consisted of artworks Haberstock had not been forced to return after the war. The introductory essays certainly covered much of Haberstock's Nazi-era activities, albeit in a strangely neutral, if not obsequious, tone.

The first illustration in the catalog was of a bronze bust of Augsburg's honored son and citizen. Not until the end of 1999 was the actual bust of Haberstock removed from the entrance to the Schaezlerpalais, which, to this day, still houses the Haberstock bequest. Just a few miles away you can still stroll along Karl-Haberstock-Street if you so wish.

In the catalog, first came the glossy color photos of paintings formerly belonging to Jewish collectors such as Édouard Jonas of Paris, Otto Weissenberger of Dresden, and even our very distant cousins the Gutmanns of Vienna. Then came the antiques, furniture, and china Frau Haberstock had so generously donated. Glancing at these I felt a certain shiver. Maybe it was the flu, but among the china I felt convinced I was looking at my grandmother's coffee cups. I wondered whether it was possible to inherit memory. The china, clearly, would need a lot more research. I forced myself to press on. Besides, the next section was indeed remarkable. It documented Haberstock's purchase and sale ledgers from 1933 until the end of 1944. I quickly found all the forced sales Fritz had been subjected to. The editor, Horst Kessler, had done an outstanding job. Then in the sales section for November 1942 I found—"To Professor Dr. Karl Brandt, Berlin—Franz von Stuck *Die Sünde*." And finally at the end of the book—they had saved the best until last—was a photo archive of almost all the paintings and sculptures that Haberstock had acquired or sold during the Nazi era. On page 308 was what I had been looking for. They were only

tiny photos, but at last I knew what our Franz von Stuck *Die Sünde* looked like.

From Karl Haberstock's wartime photo file.

The next step was relatively easy. When I had first started looking for this painting, I had made copies of all the relevant pages from the Stuck *catalogue raisonné*, which I'd found in the Getty Research Institute library, concerning the *Sins* and *Sensualities* most likely to be ours. There, in my files, was what I needed; I just hadn't known it before. Catalog number 58/149 matched perfectly Haberstock's tiny wartime photo. It was entitled *Die Sinnlichkeit*, or *The Sensuality*, after all, and dated around 1891.

The Franz von Stuck *catalogue raisonné* had been published in 1973 and listed, where possible, the most up-to-date owners. It appeared Fritz's lost painting had been acquired by the Piccadilly Gallery of

London in 1970. I was stunned. When I used to live in London, I had walked past the gallery many times. It had been just around the corner from my mother's old office.

Furiously, I began searching for somebody to contact at the Piccadilly Gallery. However, to my dismay, I discovered that the gallery had closed just the year before, in 2007. To make matters worse, Godfrey Pilkington, the owner and the man who had apparently found the painting in Munich, had just died in August of that year. But all was not lost. I was able to get a message through to Pilkington's surviving partner. Eventually a kindly English lady wrote back to me, a little confused, saying that she thought the painting I was inquiring about might have gone to Poland. However, by this time I knew better.

The original Piccadilly Gallery catalog, which I had recently unearthed, entitled *Franz von Stuck, 1863–1928* and compiled by Pilkington, had included a striking color photo of our *Sensuality*. Erich Lessing's iconic photo of *Sensuality* had since become a popular poster. Next I found the image reproduced in a book called *Femme Fatale: Images of Evil and Fascinating Women.* In the acknowledgments, toward the back of the book, was what I had been looking for for nearly two years—the actual name of the current owner and his location.

For legal reasons I cannot reveal the name of the collector. However, his location was the most startling thing. He was here, in Los Angeles, and the painting, remarkably, was less than two miles from my house.

Throughout January I worked with our lawyer, Tom Kline, on our initial claim. I was rather anxious as the collector was a lawyer of some renown. We requested a verification of the painting's provenance as the first step toward establishing the rightful ownership. The response we got was fairly friendly, but also rather vague. The collector, not surprisingly, was quite shocked by the possibility his *Sensuality* could be Nazi loot. Eventually he seemed to suggest some kind of settlement might be appropriate. I responded that any settlement would most likely involve compromise, which I believed detracted from the main issue. The Haberstock documentation I had found made it quite clear our Stuck

had been lost during the Holocaust. Our case was extremely strong. The point was, we wanted the painting back.

The collector, we discovered, had not paid for the painting. He had received it as a gift about thirty-five years before. Then, when we learned he was Jewish, our hopes increased that he might be prepared to do the right thing. However, as we pressed our claim, the collector decided to seek the counsel of Randy Schoenberg, an expert lawyer in restitution matters. Randy had hit the headlines just a few years before with the spectacular restitution of the famous Gustav Klimt paintings from Austria. I had always considered Randy as something of an ally. If he were to become opposing counsel, this would put us all in a rather awkward situation.

The lawyers inevitably talked about statutes of limitation. The collector, meanwhile, began wondering whether our painting and his painting were even the same. The confusion with the title changing from *Sin* to *Sensuality* had apparently left significant doubts. Then to complicate matters he wanted to involve his insurance company. The idea that any insurance might indemnify somebody for being in possession of Nazi loot seemed to me far-fetched. Fortunately, around this time, Randy took the collector to the Getty Research Institute library to check all the Franz von Stuck catalogs. One catalog, which I had also recently come across, they both found particularly convincing. In 1903, the Galerie Henneberg had exhibited in Munich a Franz von Stuck they called *Die Sünde*, or *The Sin*; however, the illustration matched exactly the painting in the collector's home, now called *Die Sinnlichkeit*, or *The Sensuality*. This seemed to settle the problems with the painting's title.

Nobody could find any fault with our claim. Perhaps the real issue was emotional. Just as my family had formed a deep bond with the art Fritz and Eugen had lovingly collected, we were now faced with an obviously decent man who had also developed a strong connection with the painting that had hung in his living room for thirty-five years. So, despite there being no specific objection to our demand, they continued to ask for more information. I did my best to fill in any blanks in the painting's history.

Regrettably the legal back-and-forth continued for another three months with no tangible results. Nick and I felt we had to change the dynamic. Left with few alternatives, we decided to file a legal complaint as a precursor to an actual trial. As it turned out, the mere mention of issuing a complaint was all that had been needed to break the deadlock. The collector said he was considering a voluntary return of the Von Stuck to our family. At last we had the breakthrough I had hoped for. To complicate matters, though, the collector also wanted to buy the *Sinnlichkeit* from us, whereas my family, simply, wanted the painting returned. This development would inevitably result in the collector holding on to the painting while I arranged for an expert appraisal. In early May 2009, James Hastie, Christie's vice president of nineteenth-century painting, arrived in Los Angeles for a few days.

After months of awkward communications, we were all finally to meet at the collector's Tudor-revival home, just a few canyons over from mine. It was quite a crowd: the tall collector and his elegant wife, my brother and me, Randy Schoenberg, a colleague of Tom Kline's representing my family, and at least two other people, possibly from the collector's insurance company. James Hastie arrived for the appraisal.

Randy and our host were most welcoming. The collector, in his deep, gruff voice, directed us to the Franz von Stuck, apparently waiting for our inspection. The tension of the last few months seemed to slip away. For Nick and me it was a strange and emotional event. With a sense of awe we connected for the first time with the *Sinnlichkeit*, which had been lost for nearly seventy years. Yet we also experienced an unusual sense of familiarity. This was, after all, the painting our grandfather had collected, and it used to live in the same house our father grew up in. Then, as I touched the frame, a shiver went through me as I thought of all those other people who had also admired this unusual work.

As much as I had studied the *Sinnlichkeit* over the previous years, there was no substitute for experiencing the actual painting. The collector and I shared a moment as we marveled over the glowing gold backdrop. The snake's eyes and fangs were truly menacing and in stark

contrast to the inscrutable acquiescence of the woman. The overall effect was oddly hypnotic, and the collector frankly admitted he had been under her spell for some time now.

We parted on friendly terms, and I agreed we would talk more as soon as the Christie's evaluations were ready. While we waited, I sent the collector a copy of the English documentary about my family's quest, *Making a Killing*. The film would have a dramatic effect on him. He later shared how the image of my grandmother Louise, and the fate that befell her, made a haunting impression. The painting, which he had loved for all these past years, suddenly came with a terrible history.

When the estimates for *Sensuality* finally came in, the collector decided we should deal with each other directly. I liked that we were developing an understanding. It seemed appropriate that we should settle this in a gentlemanly manner, without the other lawyers. Besides, Randy preferred to take a backseat. At the end of July I invited the collector over to my house for coffee. I welcomed the opportunity to show him some of my grandparents' treasures from Holland that I had been fortunate enough to keep. The Kangxi porcelain figures of the Immortals watched over us from above the fireplace. The discussion was extremely pleasant but eventually it came down to numbers. The number being offered us was fair, but just not what I thought the ultimate value might be. Moreover, numbers aside, it didn't feel right to say good-bye to the *Sensuality* so soon after I had found it. Nevertheless we were obliged to think it over. I promised to call my aunt in Florence and then get back to him, once we had made up our minds.

However, before I could formulate our response to the collector, a dramatic development occurred. While I had been pressing Christie's for the estimate, James Hastie had asked the Villa Stuck Museum in Munich for their opinion. Now, finally, we had their opinion, and it wasn't very good. They claimed there were problems not only with the style and the paint, but also with the signature and the frame. At first I was taken aback; then it occurred to me the Villa must have overlooked the strange history of the painting and how it had been handled since 1940. James Hastie and I agreed that significant mitigating circum-

stances went a long way toward addressing the museum's misgivings. However, Christie's felt it had to put its appraisal on hold until we could present the Villa Stuck with our evidence and arguments.

Despite this setback, I couldn't help feeling there was a silver lining here. I called the collector to tell him about the German experts' opinion and that, at least for the moment, we could not count on Christie's (or anybody's) evaluation of the painting. The collector thanked me for my honesty and then explained that, under the circumstances, he wasn't prepared to write a six-figure check. I sympathized and then pressed my demand. The only equitable solution was the return of our painting.

The collector seemed to go through much soul-searching. I think the image of my grandmother continued to haunt him. It had also become harder and harder for him to disassociate the painting, which he had once loved, from the specters of Karl Brandt and Adolf Hitler. In contrast he began to focus on his young son, who was just beginning preparations for his bar mitzvah. It must have seemed like an opportune time to show his son what a true mitzvah was.

After much deliberation it was agreed. The transfer documents were drawn up. The collector was relinquishing all ownership of the painting. The only proviso was that I give him thirty days' advance notice if I chose to sell *Sensuality*.

On a sunny day in mid-September, I drove the mile along Sunset Boulevard to the canyon that led to the collector's home. On my arrival, the collector and his son, who was the same age as my son, James, greeted me warmly. Then just the two of us sat down to go over the written agreement. All seemed to be in order and we both signed.

What followed was one of the most remarkable moments I had experienced on this extraordinary journey since my father's boxes arrived fifteen years earlier. The collector got up and walked over to the wall of his living room to unhook *Sensuality*. He asked me to help him, and together we walked the painting out of his house. With great care, he helped me load the Franz von Stuck into the trunk of my old Jag. Almost tearfully, we shook hands and said good-bye.

As I drove off down the hill, a wave of emotions and thoughts began to overwhelm me: gratitude, vindication, faith in humanity, justice . . . I started talking to Fritz and Louise and Bernard as if they were in the car with me. When I got home, it was a poignant moment, indeed, as we hung the long-lost painting in our living room. I put it near a Louis XV console and a Louis XVI barometer, also originally from Bosbeek, which I had recovered just a few years before. May and I mused over the incongruity of this lascivious lady and her snake becoming the object of a mitzvah. James was speechless. May invited a photographer friend over to commemorate the event. She must have taken at least a hundred photos.

Gradually, reality regained the upper hand. The painting did not just belong to me but to the whole family. However, before we could establish a fair value, I would have to do battle with the experts in Munich. It struck me as more than just a cruel irony that the fate of my brief victory lay in the hands of Germans. For the moment, though, I could savor this most striking painting and marvel about my family's unusual legacy.

Ultimately, I had to send the *Sinnlichkeit* to Munich for tests and evaluations. I attached my most reasoned defense of the authenticity of the lascivious lady, along with all supporting documents that seemed relevant. The original outer frame, I pointed out, had obviously been lost at the end of the war. I always had an image of Anni Brandt smuggling the canvas through American lines in 1945. Later, the last two letters of the signature, I argued, could easily have been smudged during a not-so-professional cleaning in the fifties. Without a doubt, the composition clearly resembled the most early etchings in the series. In addition to this, we had the photo from the 1903 catalog, which had been taken while Stuck was still alive in Munich. All of which left the color technique as the last, and most significant, stumbling block. The Stuck Commission deliberated on and off through the winter.

The commission's report finally arrived the beginning of March. It was peppered with words such as "difficult" and "interesting." I reread it several times and was still not sure what they were really saying.

The only way I could sum up their opinion was to say that they were being conclusively inconclusive. Like so many experts, they seemed to be more comfortable sitting on the fence rather than committing themselves. However, they did, at least, come up with one new piece of information. On the back of the painting's stretcher bar had been a hitherto indecipherable ink stamp. They had managed to identify one of the words as *Malverfahren*, which meant "painting technique or process." From there I was able to fill in the blanks. The stamp, in fact, referred to Baron Alfons von Pereira's paint process patented in 1891, which was also the same year Franz von Stuck had painted the *Sinnlichkeit*. Pereira had introduced the unusual technique, in Munich, at the *Glaspalast* exhibition of 1890, and Stuck had exhibited there just the year before.

I concluded that it was probably futile to expect more from the commission. Instead I decided to share this new information with Christie's. After all, the Villa Stuck seemed to be inviting us to make up our own minds, and the discovery of the stamp on the stretcher bar clearly placed the painting at the right place, and at the right time. James Hastie seemed to agree with me.

We set the auction date for December. That way I still had the satisfaction of keeping the painting for several months; after the auction each member of the family would get his or her rightful share. In the meantime, we had near-perfect copies made using the Iris-print method. Next, I called the honorable collector to give him fair warning in case he wanted to bid for *Sensuality*. He seemed to have moved on. He had found a new painting to fit in with his cherished Art Nouveau collection.

The auction in London was a great success. Our Stuck had caused quite a stir. Ultimately she went for far more than had been expected. The market had spoken and my battle for the lady's honor had been vindicated.

PORTRAIT OF A YOUNG MAN

It was not until I found this image in a 1938
catalog that I knew what I was looking for.

I was just packing my bag after a very successful morning at the library
when the fire alarm went off. Somehow I sensed it was not just a drill.
I grabbed my things and made haste for the exit. When I got to the
terrace of the Getty Research Institute, the staff and other researchers
were just standing, transfixed. The small mountain opposite was com-
pletely engulfed in flames. It was already a hot day in July, and the flames
seemed to be coming in our direction. Somebody barked orders to head

for the trams, which would take us down the hill to the parking lots. To my horror, probably over a thousand visitors from the museum were trying to do the same thing. I squeezed myself into one of the last cars, next to a bewildered German tourist. When we got out, she started asking me about public transport. As the fire trucks whizzed by, I knew that no buses would be arriving soon. I offered her a ride since her family was not scheduled to pick her up for hours. I wanted to talk, and I hadn't had a chance to call anybody since the alarm went off.

The excitement of the fire aside, I had something of great importance I needed to share—and in some way this unsuspecting German seemed more than appropriate. For the next twenty minutes I delivered an impassioned rant about Nazi looting. I was animated because, just half an hour earlier, I had tracked down a painting that had disappeared under the very nose of Adolf Hitler's agent.

After finding the Franz von Stuck, one painting still remained missing from the first forced sale between my grandfather and Karl Haberstock: *Portrait of a Young Man, with a Green Background*, dated 1509, by the German Renaissance artist Hans Baldung Grien. Baldung was considered the heir and most gifted student of Germany's greatest artist, Albrecht Dürer. Ever since the war it had eluded many, but now I knew where it was, or at least where it had been.

After combing through every monograph and catalog I could find on Baldung Grien, I had finally found in the Getty archives a rare volume published in 1983 by a German academic, Gert von der Osten. Almost all the other books on Baldung Grien focused on his woodcuts and altarpieces, perhaps because not many of his paintings have survived until this day. However, Osten's small book, his last, entitled *Paintings and Documents*, was only published in Germany. He had done research in Princeton, New Jersey, in the 1950s, which explained why he, and no other art historian, had located our missing Baldung Grien. While at the Institute for Advanced Study at Princeton, Osten had seen the painting in neighboring New Brunswick, at the art gallery of rival Rutgers University.

My father had always believed that most of the artworks he couldn't

trace must have gone behind the Iron Curtain. Now I had found yet another painting right here in the United States.

My first task was to contact Rutgers and make sure the painting was still there. The registrar from their museum, now renamed the Zimmerli Art Museum, replied fairly promptly. As she pointed out, the Zimmerli had over sixty thousand pieces in its permanent collection and the cataloging was far from complete. Fortunately she was soon able to confirm that the Hans Baldung Grien portrait was indeed there. What's more, their images matched the illustration that I had found a couple of years earlier in a 1938 catalog, dating back to when Fritz had loaned the painting to an exhibition in Rotterdam.

I decided to call the museum director myself. To my relief the new director, Suzanne Delehanty, was extremely civil and not at all adversarial. Not surprisingly, she was more than a little taken aback as I explained the strong likelihood that the Zimmerli possessed an artwork stolen during the Holocaust. She welcomed my suggestion that I put together a portfolio of all the relevant documents and detail the history and provenance of the Baldung Grien.

May and I had wanted to make a trip to New York for a while, so I decided to go to Rutgers in person and present my case. While assembling all the crucial evidence in my files that would prove my family's loss of the painting, I began to complete the puzzle of the Hans Baldung Grien, which had eluded even Hitler.

Fritz had sent the painting to Paris in the spring of 1939, along with the two Degas pastels and so many other pieces from his collection. The assumption was that the French Maginot Line of defense would hold in case of war. Fritz had, no doubt, also assumed that in an emergency his treasures would be nearer to neutral Switzerland or the relative safety of Italy. I had often wondered how life would have been so different for us all if my grandfather had sent his artworks to England for safekeeping, instead. But after his treatment by the British during the previous war, Fritz did not trust perfidious Albion. The prospect of the British authorities suddenly declaring my family's assets as enemy property was a real concern.

By the beginning of 1941, Reichskommissar Seyss-Inquart had successfully liquidated about half the Jewish-owned businesses in the Netherlands. Most of the rest were being Aryanized. The objective of stripping the Jews of Holland, step by step, of all their worldly goods was well under way. Next came the special identity cards; when Fritz and Louise received theirs, on the left was a large, ominous capital *J*. When Karl Haberstock came calling at Bosbeek in early March, Fritz was feeling particularly vulnerable. Orsini's attempts from Italy to secure an exit visa for his brother-in-law and sister-in-law, Fritz and Louise, had so far failed miserably. When Haberstock offered to "intercede" on my grandparents' behalf, Fritz was more than receptive. It was clear who Haberstock's superiors were. The price, however, was some of the greatest paintings from the collection.

As previously noted, in return for the promise of just 122,000 Dutch guilders (perhaps $75,000 at the time), Fritz agreed to sign over eight of his finest old masters and the Franz von Stuck. Haberstock immediately took possession of the Stuck, then known as *Die Sünde*, along with two Spanish Renaissance shields and a magnificent carpet. The other eight paintings, including the Hans Baldung Grien, however, were already in storage in Paris; for these Fritz signed an authorization to release.

I discovered that two months later Haberstock paid my grandfather barely a quarter of the agreed amount, and that paltry sum was transferred into a frozen account. Meanwhile, Haberstock had immediately sold the Baldung Grien, along with the Cranach, the Elsner, and the Isenbrandt, directly to the Führer's office—all for a handsome profit. Hitler's chief curator for the Führermuseum, Hans Posse, made it clear that the Führer coveted the Baldung Grien above all and had paid the most for it. Later the Van Goyen and the Holbein were also purchased for the intended Führermuseum at Linz.

Haberstock set off for Paris to arrange for the shipment of the eight masterpieces to Berlin. Seven, including the Baldung, would go straight to the Reich Chancellery. The Memling that Haberstock offered to both Hitler and Göring, with a price tag of well over one hundred thousand Reichsmarks (more than a million dollars today). However, when

Haberstock got to Paris, the paintings were under lock and key, and the dealers to whom Fritz had entrusted his paintings had fled at the beginning of the Nazi occupation. Paul Graupe had made it across the border to Switzerland, and Arthur Goldschmidt was, for the moment, in the relative safety of the south of France. Unoccupied Vichy France was not particularly safe for Jews, either, but fortunately for Goldschmidt, the sunny Côte d'Azur was being run by the Italians. From German-occupied France, Arthur Goldschmidt had been able to smuggle out several artworks and was open for business at the Martinez Hotel in Cannes. Haberstock soon got wind of this and made the trip south. The word was that Goldschmidt had both an important Brouwer and an Ostade for sale as well. Haberstock bought both and quickly resold them as soon as he returned to Berlin—again to Hitler and for a great profit. He also secured from Goldschmidt the authorization for the release of the eight paintings from Fritz's storage in Paris. Haberstock quickly forwarded the authorization back to Hugo Engel in Paris, who ran errands for both Haberstock and Hans Wendland.

What happened next is unclear. Evidently Hugo Engel presented the collection order to Mme. Wacker-Bondy, the owner of the storage facility. They must have prepared the shipments for Berlin. But when the crates were unpacked at Hitler's headquarters, on the Wilhelmplatz in Berlin, instead of seven paintings there were only six, causing considerable consternation. The Hans Baldung Grien *Portrait of a Young Man, with a Green Background* was missing. The Führer had been expecting the arrival of the handsome young man. So far the Führermuseum did not have any works by Baldung, despite his being one of the foremost German artists of the Renaissance. Hitler would be furious.

What followed was a flurry of official letters from Hitler's chief counsel at the Reich Chancellery, Dr. Killy. I must have counted over a dozen at the German Federal Archives in Koblenz. Dr. Killy was blatantly indignant, and the normally smug and pompous Karl Haberstock was groveling indeed. He immediately offered a full refund, which placated Hitler's irate lawyer somewhat. However, the Reich Chancellery was still demanding the location of the painting.

For the next few months accusations flew. Fritz, even while under house arrest in Holland, was accused of some mysterious sleight of hand. Next the focus switched to Paul Graupe; had he spirited the Baldung away before leaving for Switzerland? In that case, one would have assumed Mme. Wacker-Bondy or Hugo Engel would have noticed a discrepancy when preparing the shipment to Berlin. Perhaps Arthur Goldschmidt had taken the painting with him when he escaped to the south of France, but had somehow forgotten to mention it when Karl Haberstock arrived to get authorization for the eight paintings.

By the time Haberstock's angry letter arrived at Goldschmidt's last known address in Cannes, Goldschmidt had already moved again— several times. After leaving Cannes, Goldschmidt reappeared briefly in Bilbao, Spain, before sailing across the Atlantic to Cuba, in early September 1941. There he seemed to resume his art dealing with little hindrance. I found a declassified American intelligence report that chronicled the wily dealer's attempt to sell a Rubens in Havana in early 1944 while he waited for an entry visa for the United States.

When it seemed clear the Baldung wasn't going to resurface anytime soon, Haberstock actually secured a refund out of Fritz's frozen account.

As the war was ending in April of 1945, American forces moved into Aschbach, a small town in northern Bavaria. Aschbach had once had a thriving Jewish community, but by 1942 the last Jew had been deported. Overlooking the small town was an old castle or manor house belonging to Baron von Poellnitz. The Americans quickly arrested the baron when they discovered he had been the local Nazi Party leader. What they next found was more surprising. Tucked away throughout the pretty castle was effectively an enormous art warehouse. The American troops quickly put the other residents of the small *Schloss* under arrest and called the Monuments Men. When the Monuments officers discovered the true identities of two of the residents, the story started to take shape. Their names were Haberstock and Gurlitt. For several

months Karl and Magdalene Haberstock, along with crates of their ill-gotten gains, had been hiding in the castle. Hildebrand Gurlitt and his wife, Helene, had also taken refuge in the castle after their home in Dresden had been destroyed by Allied bombers. With them was their daughter, Renate, and their teenage son, the now notorious Cornelius Gurlitt, who had over fourteen hundred pieces of art hidden in his Munich apartment until it was discovered in March 2012.

Baron von Poellnitz had been stationed in Paris during the occupation as a Luftwaffe officer. In his spare time he liked to help arrange deals (as their unofficial representative) for both Gurlitt and Haberstock, even though the two men were technically competitors. The three would meet to compare notes on their next victims at the Ritz Bar in the place Vendôme—their office away from home.

By the end of the war, the baron's castle also contained a huge proportion of the paintings from the Bamberg Museum and the Kassel Museum, as well as the private stashes of such infamous Nazi commanders as General Fütterer and Field Marshal von Kleist. Captain Posey, the Monuments officer in charge, quickly declared the estate "off-limits." The estimated value of the art treasures in the *Schloss* was a cool $100 million.

According to Allied reports under the heading "Questionable Collections," "one large room on the first floor contained paintings, tapestries, rugs, furniture and other art objects—belonging to Mr. Haberstock—art collector." In another room were more "Haberstock" paintings, trunks, and valuable books. Upstairs, in one room alone, Gurlitt had stashed over thirty-four crates. Remarkably, considering the quantities involved, Hildebrand Gurlitt attempted to convince the Monuments officers that he was merely a *Mischling* trying to survive, an innocent art dealer, a victim no less. His defense that he had a Jewish grandmother named Elizabeth Lewald, a sister of a famous *Salonnière*, Fanny Lewald, was apparently taken into serious consideration. However, that he had obviously been allowed to continue dealing in art in Germany and France throughout the war ought to have created a very different impression. Most of the artworks belonging to Gurlitt

were taken into custody, at least temporarily, and sent to the Wiesbaden collecting point, which was primarily for works considered to be German owned.

By the time Germany officially surrendered, even more of Haberstock's hoard had been found in yet another castle not far from Augsburg, this time belonging to Prince von Thurn und Taxis. Most of these art pieces, unfortunately, were also categorized as "German" and accordingly were sent to Wiesbaden. Among the countless pieces salted away in the Thurn und Taxis castle, I discovered, were the two exquisitely carved Spanish Renaissance coats of arms (from the same first Gutmann-Haberstock transaction). At least one of the shields from Wiesbaden was ultimately returned to Holland. Sadly, to this day, the Dutch authorities have yet to locate either of them. Meanwhile, the majority of Karl Haberstock's enormous hoard from the Aschbach castle was shipped to the larger Munich Collecting Point, where it would be sorted for repatriation to whichever country the artworks had originated from.

Today it might seem odd, but at the time Hildebrand Gurlitt was treated remarkably leniently. Ultimately he was deemed to have been a victim of Nazi persecution. He claimed that the majority of his paintings had been destroyed in the bombing of Dresden, and the rest of his artworks actually confiscated by the Allies were returned to him by 1950. Gurlitt resumed dealing in art up till his death in a car crash in 1956.

On the other hand, Karl Haberstock was, correctly, described in the Monuments officers' daily reports of May 18, 1945, as "the most notorious art collector in Europe. He was Hitler's private art collector and for years drained France, Holland, Belgium, and even Switzerland and Italy of art treasures by unlawful, ruthless and even brutal methods. His name is infamous among all honest collectors in Europe. Mr. Haberstock was unable to furnish an inventory of his art collection at the castle."

By the late summer of 1945, Karl Haberstock was officially under arrest. He was moved to Austria, where he found himself in a cell with

his old cohorts Bruno Lohse and Walter Andreas Hofer. Appropriately, the Art Looting Intelligence Unit of the OSS had chosen Bad Aussee in Austria as the place to imprison Haberstock. It was just a mile down the mountain from the salt mines at Altaussee, where Hitler's erstwhile Linz Collection had been hidden. For thirty-six days Haberstock was interrogated by the ALIU.

In contrast to his usual cutthroat tactics and bossy demeanor, Haberstock now attempted to present himself more contritely. Hoping to ingratiate himself with his interrogators, he even suggested he could help at the Collecting Point in Munich. Famous for his lack of scruples, Haberstock was now spilling the beans on his onetime Nazi bosses. Then stretching his interrogators' credulity, the longtime Nazi Party member and vociferous anti-Semite claimed to have helped Jewish "colleagues" escape. He did, however, secure the release of noted art historian Max Friedländer from arrest in the Netherlands, but only because Haberstock needed Friedländer's advice on acquisitions for Göring and the Führer. Haberstock, although the most important dealer of Nazi Germany, was really of peasant stock and had only a limited education. He certainly had no formal art degree; in fact, he held those with such training in contempt.

At Bad Aussee, Haberstock chronicled his dealings with the Führermuseum, giving Lieutenant Commander Theodore Rousseau full details, including those concerning several of Fritz's paintings. My grandfather's agents, he claimed, had never delivered the Baldung Grien, and spluttering in his usual manner, he insisted he had no knowledge of its whereabouts.

Haberstock was next moved to Nuremberg, where he gave testimony against many of the other figures involved in Nazi art looting, including Field Marshal Göring. In an interview with Benjamin Ferencz, the chief prosecutor at the trials, Haberstock lightheartedly bragged how he would "purchase" priceless paintings in Paris. The payments would be by check payable to the Banque de France, but then, through a sleight of hand, the Reich Ministry would add the same amount to the French war debt. Thus the price of the paintings would miracu-

lously be amortized by the war debt; the check would be canceled, and Haberstock would have completed yet another "legal" transaction.

After that, Haberstock was briefly interned in the Hersbruck Camp for war criminals, before being released, only to be arrested again in the summer of 1947. Following a successful appeal, he voluntarily enrolled in a denazification program. Here again Haberstock was not merely being altruistic; he knew full well that if officially certified as having been cleansed of his Nazi past, he would be allowed to deal in art again. He now claimed he was not the main supplier for the Führermuseum. Instead he shifted the blame onto his old competitor Hildebrand Gurlitt. But Gurlitt had already been declared a free man, so technically nobody was to blame.

The looting of all the possessions of the Jews, especially their money and their art, was intrinsically linked to their annihilation. This was barely understood in the years immediately after the war. Accordingly, art looting was considered a bloodless crime.

Like so many others, Haberstock convinced local authorities that he had only been a Nazi "fellow traveler," and he was soon rehabilitated. Emboldened, he even asked for the return of about fifty paintings from the Munich Collecting Point. Haberstock then went so far as to accuse US personnel of stealing several of his books. I wondered if that included the books he had stolen from my grandfather.

By 1950, Karl Haberstock was back in business dealing in art from his Munich apartment, overlooking the Englischer Garten. In the same building was his old cellmate, Walter Andreas Hofer. Visitors started referring to the building, a little tongue in cheek, as the *Braunes Haus*, after the Nazi Party headquarters that had been destroyed at the end of the war. Meanwhile, just down the road from the original *Braunes Haus*, on the Briennerstrasse, the third generation of the Böhler family was enjoying uninterrupted business at the Julius Böhler Gallery.

Back in Paris, in the years after the war, Bernard and Lili had elicited the help of the indomitable Rose Valland to track down our elusive

Baldung Grien. Bernard also reported the loss to Interpol, while inquiries were sent to everybody who had been associated with the portrait. Mme. Wacker-Bondy insisted that the Baldung had been handed over with the other paintings to Haberstock's agent Hugo Engel, or to his son Herbert Engel. Not long after, Hugo Engel had fled Paris for Switzerland. However, Herbert Engel had continued dealing with the Germans until the Allied liberation of Paris, when he also fled to Switzerland. The Engels fell into that unfortunate category of Jewish art dealers who had cooperated with the Nazis throughout the occupation, presumably to gain protection. But from the safety of Switzerland, Herbert Engel continued to offer his services to Haberstock. Not surprisingly, neither Engel senior nor junior responded to Rose Valland's demand for information. Meanwhile, Paul Graupe, who had by then relocated from Switzerland to New York and was back in the art world, asserted that Haberstock must still be responsible. Graupe's son, now called Tommy Grange, insisted Engel was in charge of shipping the Baldung to Berlin, but he didn't clarify which Engel.

Next my father's American lawyer was able to track down Graupe's partner, Arthur Goldschmidt, who had also survived the war and, after a spell in Havana, was now also dealing art in New York. Unfortunately, Goldschmidt's responses to our questions only seemed to complicate things further. He maintained that the last he knew was that a certain Mr. Meyer from 10 rue Antoine de la Forge, Paris 17e, was going to deliver the paintings, including the Baldung, to Karl Haberstock. I discovered that 10 rue Antoine de la Forge was an apartment building where Edith Piaf, no less, was living at the time. And that Mr. Meyer was in fact August Liebmann Mayer, a well-known art expert, who had fled Munich soon after the Nazis came to power. He had survived in Paris, at least for a while, by making himself useful to the likes of Bruno Lohse, Hans Wendland, and Karl Haberstock. Eventually the ERR confiscated whatever paintings Mayer had in his possession. However, I was not able to find any record of our Baldung Grien in the ERR records. Alas, the clues about Mayer had led to another dead end. The unfortunate and penniless art expert would not be able to answer

any of Valland's questions. Mayer had been arrested, I discovered, with several other Jews, while trying to seek the safety of Monaco. After a spell in the Drancy Internment Camp, August Mayer had been transported to Auschwitz in March 1944, where he was murdered on arrival.

Somebody was lying, but who? Rose Valland saw no alternative but to demand, if not the return of the Baldung, at least compensation from the new West German government. The diplomatic back-and-forth between the French and German authorities would last for years. Meanwhile, Bernard contacted the now-aging art historian Max Friedländer, who before the war had known Fritz's collection well. Friedländer, who was the great authority on the Northern Renaissance, had survived the war, fairly comfortably, and was still living in Amsterdam. He replied that he had not seen the portrait since before the war, but that he would keep a lookout for it. Bernard never heard from him again, and then in 1958 Friedländer died. Meanwhile, a now elderly and fading Haberstock—he had lost all his teeth, apparently—continued to deny any responsibility. By 1956 Karl Haberstock, my grandfather's nemesis, was dead also.

During this period Aunt Lili caught wind of some rumors that the painting had resurfaced on the art market. Several names were bandied about, but nothing of substance ever emerged. Ultimately, and despite Rose Valland's earnest efforts, the West Germans successfully rejected all claims concerning the Hans Baldung Grien. The case had dragged on, amazingly, for fifteen years. Not until November 1960 did a reluctant Rose Valland officially give up her search for the painting.

Bernard and Lili, of course, had never given up, and I think I carried a good share of that determination with me that day, in July 2009, when I pulled the Gert von der Osten book off the shelf of the Getty library. Finally there were some answers to the Baldung enigma.

The Osten *catalogue raisonné* documented that in 1924 Fritz Gutmann bought the Baldung from Alfred Strölin, a famous publisher in Lausanne, Switzerland. Fritz is listed as the only owner of the painting

from 1924 until after the war. There was no mention of Paul Graupe, Arthur Goldschmidt, or Karl Haberstock. The next entry and the most revealing, however cryptic, stated that the painting was in the hands of a "London dealer" between 1948 and 1950. By this time I had my suspicions, just as Lili had over fifty years before, but there was nothing I could prove and certainly nothing I could put in writing. According to Osten, the Baldung then made it across the Atlantic, where it appeared, in 1953, in the possession of the dealers Rosenberg and Stiebel of New York. Shortly after that, the painting was acquired by a certain Rudolf Heinemann, who ultimately gifted the Hans Baldung Grien in 1959 to the then Rutgers University Art Gallery, now called the Zimmerli Art Museum.

It did not take me long to remember who Rudolf Heinemann was. He was the same German art historian who had cataloged Heinrich Thyssen's painting collection at the Villa Favorita, in Lugano, Switzerland, in 1941. Among those paintings were at least two that Thyssen had bought from my grandfather in the early thirties, including the beautiful Ercole de' Roberti called *The Argonauts Leaving Colchis*. In the Villa Favorita as well were several silver-gilt cups and objets d'art from the Eugen Gutmann collection that Heinemann had also helped catalog; so it stood to reason he was perfectly familiar with the Gutmann collection. My suspicions were confirmed when I discovered that Heinemann had collaborated with Max Friedländer in 1949 on another Thyssen catalog. Friedländer was the same art historian who had written a glowing review of the *Portrait of a Young Man* just a year before Fritz had bought it. My father had, no doubt, thought it perfectly reasonable to seek help from such an expert considering his familiarity with the painting.

While the French and West German governments were still actively looking for our Baldung Grien, Rudolf Heinemann had discreetly donated the portrait to the low-profile Rutgers University Art Gallery. It seemed an unusual choice, especially as Heinemann, who was an enormously fat man and walked with two canes, had never had any children, let alone one that attended Rutgers. No doubt the

Munich transplant, who now lived in New York, must have received a reasonable tax deduction. Though, I imagine, the greatest benefit to the distinguished art dealer, assuming he had deduced most of the sordid story, was knowing he was no longer responsible for the painting that had even eluded Hitler.

In hindsight, I suppose my father was naive in his hope that Friedländer might divulge some crucial information. As a matter of principle, almost no art scholar will ever divulge the whereabouts of a "private collection"—apparently even a Jewish art scholar, and apparently even after the Holocaust. Heinemann, on the other hand, before he could consider doing the right thing, would have had to admit, first, that he had done the wrong thing.

I arrived at the New Brunswick train station in New Jersey on a chilly October morning in 2009. The Rutgers campus lay before me, but signs to the Zimmerli Museum were few and far between. Eventually I found the museum more by instinct. The registrar came out to greet me before I was introduced to Suzanne Delehanty, the elegant new director. My reception was pleasantly deferential and they listened intently as I outlined the bizarre story of the painting. While we continued the discourse over a working lunch off campus, orders were given to pull the Hans Baldung Grien portrait out of storage. On our return, a solicitous Delehanty directed me to a large and virtually barren room and suggested I might like to spend some time alone with the portrait. To my consternation, the painting was lying on one side on the ground, leaning against the wall, and protected by a mover's blanket. I'd forgotten it was Columbus Day, and apparently no staff were on hand to find an easel. I crossed the empty room to greet Baldung's *Young Man*. He looked remarkably fresh and rosy cheeked, with his hat still at a rakish angle, especially when I noticed, above the artist's monogram, the date he was created: 1509. The *Young Man* was exactly five hundred years old.

I could only marvel at the power of art to survive, as I touched, tentatively, the ancient frame. Although closer inspection showed a

fair amount of damage to the paintwork of the sitter's black coat, the colors had, fortunately, remained as vibrant as they must have been in Baldung's lifetime, especially the green background for which the artist had been famous, and from which he derived his moniker "Grien." The intricate black-on-white lacing of the *Young Man*'s snug-fitting jacket was a particular visual delight. It was a rare privilege to commune so privately with such a striking work of art. It was also, most movingly, an opportunity to bond with the grandfather I never knew, at least through the things he treasured.

I joined the others with a renewed sense of family pride. Before leaving them with my carefully researched portfolio, I thanked Suzanne Delehanty and all at the Zimmerli for their graciousness and consideration. They promised to get back to me as soon as they had time to translate and evaluate the many documents I had uncovered. Ultimately, the board of trustees of Rutgers University would have to make the final decision.

Several months passed without any significant progress. I feared that what had begun as such a promising case was inexorably turning into another protracted affair. The legal department at Rutgers had, for the first time most likely, just been thrust into the dark world of art looting and Holocaust restitution. It was clearly going to take some time before they emerged into the light again. By the end of March 2010, I decided we could all use a little bit of help.

The Holocaust Claims Processing Office, a division of the New York Banking Department, had been established in 1997 to help, free of charge, with recovering lost assets from Swiss bank accounts. Most recently, they had been helping me track down a painting by Hercules Seghers, a Dutch artist who had a great influence on Rembrandt. So when Rebecca Friedman, one of their investigative attorneys, offered to help, I was more than receptive. Soon Rebecca established a relationship with Rutgers's counsel, and progress slowly returned. The university was eager to establish a value for the Baldung. I tried to point out that, high or low, the value should not affect my family's rightful ownership. Not surprisingly, though, if the Zimmerli was going to do the

right thing, as they kept reassuring me, they clearly wanted to know what they would be giving up. By the end of April they let it be known that they had found no documentation whatsoever that would indicate our claim was not legitimate. The next step for the university was to decide whether they wanted to keep the painting and, if so, how much they might be prepared to compensate my family for it. However, Rutgers's counsel warned that, given that they were a public university, the process could be slow.

Meanwhile, the Dutch were still dragging out my claim for a fifteenth-century Pietà sculpture, along with a dozen antiques from the Gutmann collection, that had been in the system for about five years.

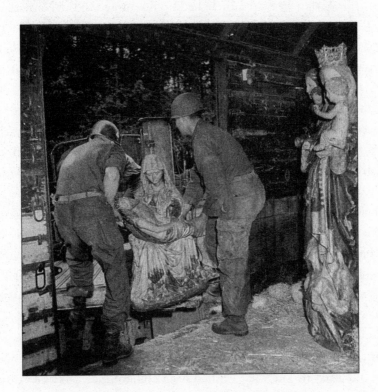

US soldiers removing the Pietà from Göring's train
outside Berchtesgaden, in 1945.

The Pietà was one of the pieces I had found in the Dutch archives, euphemistically filed under the heading "Origins Unknown." Leafing through page after page of supposedly "ownerless" artworks, I had eventually come across this tragic image. As soon as I saw their photo of the sculpture, I knew I had seen it somewhere else. Then it came to me. An almost identical image was in the back of one of the portfolios that Nick had been given in Paris in 1996 by the successors of Rose Valland at the French Foreign Ministry. These portfolios consisted of all the documentation that they could find concerning the portion of the Gutmann collection that had been in Paris at the beginning of the war. Ultimately American soldiers had found the Pietà in a freight car outside Berchtesgaden in 1945. (German soldiers had not had time to salt away all of Hermann Göring's loot before the arrival of the US army.) In March 1947, the Pietà had been returned to the Netherlands on the same train as the three marvelous silver-gilt works that had been in the Rijksmuseum and finally returned to us in 2002. While the Dutch and French restitution authorities argued over whether it was even the same statue, I felt I needed a break.

Two months earlier I'd learned that I required a serious medical procedure. I elected to undergo surgery and, all things being well, recuperate in Italy. The operation was a success, and May, my children, and my friends had helped me find great courage. My recovery on the tranquil shores of Lake Garda provided a welcome and long-overdue opportunity to reflect on the remarkable events of the last few years. From there we traveled down to Florence to visit my dear aunt. We drove out to the country, to a favorite restaurant of hers overlooking the beautiful Medici villa at Artimino. There was so much to tell her. Apart from the Baldung, the Franz von Stuck, the Pietà, and the antiques in Holland, I was also on the trail of our paintings by Hercules Seghers and Biagio d'Antonio, as well as one of the Jacob de Wits and three, no less, by Francesco Guardi. The third Guardi she was having trouble remembering. She marveled at what we had been able to trace, possessions that she thought had been lost forever. I attempted to explain the modern resources at my fingertips: the Getty Research Institute and the US

war archives, which I could now access from my computer at home. But every mention of the Internet she would try to brush away with a dismissive sweep of her hand. "*Basta!* You and your Internet." Then when I tried to describe searching for her grandfather Eugen Gutmann in Google Books, she laughed derisively. "Google came up with twelve thousand five hundred possibilities!" I persisted. The results were substantial: largely thanks to the digital revolution, I was finally piecing together the lost fragments of our family puzzle.

Immediately on my return to LA, I received a letter from the Dutch Ministry of Culture informing me that they had authorized the return of six more pieces: two beautiful Meissen dishes, three Persian prayer rugs, and a wonderful albarello jar made in 1560 in Castel Durante, which was painted with the story of Daniel and the Dragon. A fourth prayer rug had been deemed so threadbare that the Dutch authorities had destroyed it in the fifties. The letter also promised an imminent decision on five exquisite powder-blue Chinese vases (still in the Rijksmuseum in Amsterdam) and the large Pietà sculpture (in the Catharijneconvent Museum in Utrecht). Despite my medical close call, 2010 was turning into a very good year.

By mid-October, Rutgers's legal team had concluded their due diligence, and the verdict was clear. The Hans Baldung Grien would be returned by the end of the year, or as soon as all the legal transfers could be completed. Rutgers and the Zimmerli had behaved in an exemplary fashion, and their honorable decision was indeed an important milestone in our family's history. Lili and Nick were deeply moved when I called them. I was also grateful for the relative speed of the whole affair. It had been almost exactly a year since I'd first set foot in Suzanne Delehanty's office.

In contrast, after a four-year wait, in early December a second settlement from the Swiss banks was finally awarded to my family. Back in 2006, after our first award from the Claims Resolution Tribunal, we became part of an appeal action. Like many other families, our first

settlement from the Swiss banks had seemed unrealistic—they claimed they did not know the original value in the accounts.

A few days later the Dutch authorities announced they were returning the five beautiful Kangxi vases from the Rijksmuseum. I was overwhelmed by these successive victories. It was hard to believe how much the world had changed since the prolonged heartbreak that followed the war. Two days after that, the Franz von Stuck beat all expectations at Christie's in London.

After a happy year-end holiday back home in California, May, James, and I returned in January to a freezing New Jersey. The wind ripped right through us as we stepped onto the icy platform at the New Brunswick station. Even our thickest coats did not seem to offer any protection. Instead we were comforted by the prospect of a warm reception at the museum. This time there was quite a throng, including some press and photographers. Suzanne Delehanty made the cheerful introductions. Soon I was deep in conversation with Dr. Philip Furmanski, the Rutgers executive vice president. When he explained that his parents had escaped Poland at the beginning of the Holocaust, I realized how he must have been an invaluable ally when the university had made its decision. In stark contrast to the first time I had seen the Baldung in that forlorn room, Suzanne now ushered us past a well-stocked refreshments table into a plush, red room. This was a particularly touching and sensitive gesture: Suzanne had made a clear point of remembering what I'd told her about my grandfather. He had hung the Baldung Grien, along with most of his other Renaissance portraits, in his red-walled gentlemen's smoking room. And there was the *Portrait of a Young Man, with a Green Background* comfortably resting on a professional-looking easel with a red wall behind it.

I found myself actually holding on to the easel as I began to address all those attending the ceremony. I wanted to express my gratitude for the humanity with which Rutgers and the Zimmerli had treated my family. Getting back the painting had reaffirmed my faith in justice. I felt it was also important to stress how many other museums and institutions had only paid lip service to the Washington Principles,

but most had balked when it came to restituting artworks from their own collections. Even museums with more art in storage than on display often resorted to technical legal-defense tactics when confronted with a request to return a looted item. Suzanne Delehanty then added, "The Zimmerli clearly wanted to do the right thing. What happened in the Holocaust was one of the black moments in human history. You want to do anything you can to correct, in some small way, this historic wrong."

As is often the case, after such elation comes a moment of sadness. The time had come, regrettably, for us to say good-bye to the five-hundred-year-old *Young Man*. The Gutmanns, or what was left of us, were no longer the wealthy family we once were. Bernhard Gutmann's Schloss Schönfeld, his fairy-tale moated castle high on a hill overlooking Dresden, seemed like a dream from a distant past. Today's reality dictated that the only way to divide an heirloom among the heirs was through a sale. Lili would soon be turning ninety-two and I did not want to delay. We returned to Los Angeles and the Baldung Grien went to join the other old masters at Christie's in New York. The *Young Man* did us proud.

LIFTING THE CURSE: THE ORPHEUS CLOCK

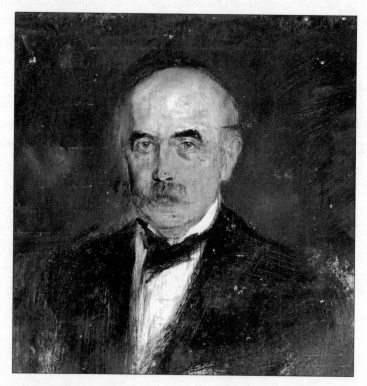

Portrait of Eugen Gutmann by Franz von Lenbach,
now hanging in my office.

For a long time I had avoided my great-grandfather Eugen's collection.
Some said it was what had really killed my grandfather. After all, if it
had not been for Fritz's determination to preserve the Silbersammlung
he might well have bargained his way out of Nazi-occupied Europe. Lili
thought the silver had been cursed. Certainly, the pieces from Eugen's

collection that were recovered after the war had torn apart what was left of the family. Sixty years later, I found myself still at loggerheads with estranged and invisible cousins. The curse had traveled across generations.

In May 2011 the portrait of Eugen by Franz von Lenbach, the one that nobody had ever seen before, arrived from Cologne. It differed dramatically from the Lenbach owned by the Dresdner Bank, and it certainly was not as famous as that other portrait of Eugen by Germany's most distinguished Impressionist, Max Liebermann. My great-grandfather had often been compared to Bismarck: stern, authoritarian, and very Prussian. My painting was quite different: gone was any sense of austerity or aloofness. The man in my portrait loved music and collected beautiful things. Somehow he felt more like family.

I hung the new Eugen over the end of my desk. He seemed to watch over me as I worked, sometimes even with a benign smile. Oddly, the sense of foreboding about the silver collection and the old family trust began to lift. I realized it was time to try to make better sense of my neglected files on Eugen's collection.

I knew exactly what had been taken by Julius Böhler in 1942, all 225 items, and I also knew what had been restored to the Gutmann Family Trust in 1949. Several discrepancies between the 1942 list and the 1949 list were clear. Many precious works such as the Orpheus Clock had slipped through the cracks. If I could discover exactly which pieces from the Silbersammlung the Allies had recovered in 1945, I would have a much better grasp of the situation.

A good place to start was in the Ardelia Hall Collection, now part of the US war archives. Ardelia Hall was a Monuments Officer, and an unsung heroine, who almost single-handedly made sure the files dealing with war-related looting and recovery remained intact. Today they are kept at the National Archives in Washington and Maryland and named in her honor.

In stark contrast to the endless traveling my father was compelled to undertake, today we are blessed with the ability to travel much farther with just a few strokes on a keyboard. From the comfort of my

home I am able to search the vast, and ever-growing, National Archives records relating to Holocaust-era assets. Regrettably, these records were sealed from the public for more than fifty years. Only in recent years has the arduous task of digitizing these records begun. Every time I go back to search for something about my family's collection, it seems as if there is more and more to review.

I was sure I had performed this particular search before, but this time I suddenly came across a remarkable letter, written on October 26, 1945, by a young American lieutenant, William E. Frye. Under the heading "Subject: Property of Jewish Refugees," the lieutenant warned the US director of military government for Bavaria that a collection belonging to Countess Lili Orsini (my great-aunt) and just recently discovered on the shores of Lake Starnberg was going to be stolen again. "I notified the CO at Starnberg by telephone this date that this property should be placed under control immediately as an attempt was to be made to loot this property by the former custodian Herr Böhler, Briennerstrasse, Munich."

It appeared that the collection had remained intact from 1942 right up until the end of the war. Fritz's subterfuge of placing the Eugen Gutmann Silver Collection in the name of his brother-in-law Luca Orsini had worked against all odds. The German lawyer whom Luca and Great-Aunt Lili had hired had been remarkably effective. When a preservation order was issued and the collection declared a "national treasure" in 1943, the Nazi dealers had clearly taken note. Even though the Germans had no compunction in violating other people's laws, their own laws were evidently sacrosanct.

A short while later I received dramatic evidence of this Nazi quirk. I had been using my brother's copy of Eugen's one-hundred-year-old catalog by Otto von Falke, *Die Kunstsammlung Eugen Gutmann*, published in Berlin in 1912. This sumptuous, oversize book itemized 326 amazing artworks with elaborate detail, and fortunately almost every one was accompanied by an ancient, but still clear, photograph. Both Nick and I were worried about my constantly referencing this family

heirloom and the resultant wear and tear. For years I had looked for another copy (only a few hundred had ever been printed), and in early 2012 I found one. It was incredibly expensive but I had to have it. When I opened the book for the first time, I was stunned to find inside a letter dated March 30, 1943. The letter had been signed "Heil Hitler" by none other than Julius Böhler.

This original letter was addressed to the Führerhaus in Munich and marked for the attention of Dr. von Hummel. It read simply, "On behalf of Herr Karl Haberstock, we hereby send you the enclosed catalog of Eugen Gutmann's collection. Heil Hitler! Julius Böhler." Hauptsturmführer Baron Helmut von Hummel was chief secretary of the Nazi Party Chancellery, and as one of his many duties he was in charge of collecting gold, coins, and armory for the Führer (his immediate boss, Martin Bormann, was head of the Linz Commission). By some mysterious process I was now holding the copy of my family's catalog that had once belonged to the man who had stripped our family home. I shuddered, then I shuddered again when it occurred to me that none other than Adolf Hitler had probably held this book. Based on correspondence between Böhler and Haberstock that I had found in the German Koblenz archives, they had intended Eugen's catalog to become a shopping list for the Führer.

Yet, subsequently, the Nazi dealers must have decided, however reluctantly, to respect the preservation order (declaring the collection a "national treasure" not to be touched). As a result the remaining 225 pieces from the Eugen Gutmann Silbersammlung languished for the rest of the war in Böhler's premises on the Briennerstrasse, just a few doors down from Nazi Party headquarters, and, no doubt, the equally frustrated Baron von Hummel. Just as the war was ending, Böhler decided to move the collection from his more visible headquarters in Munich to his associate Hans Sauermann's storage facility by Lake Starnberg. It was here that the young American lieutenant Frye was hoping to secure the Silbersammlung. Somehow he had got wind that Sauermann and Böhler, after having sat on my family's treasures

for over three years, were not prepared to just hand them over to the Allies.

Close to the lieutenant's letter in the archives, under the heading "Orsini," I found a copy of the original list of 225 artworks that the Germans had removed from Bosbeek. At first glance it appeared to be just another copy of the same inventory, except that this version had the heading "Restituted." In front of me was the crucial document I had been searching for. I realized that I must be looking at a copy of the inventory that was used when the Silbersammlung was being checked into the Munich Collecting Point. Next to each item number that Böhler had originally assigned was now a check mark. Soon it became apparent that two eighteenth-century gold rings were missing; unfortunately these were among the few items that did not have illustrations in the Otto von Falke catalog, and as a result they would prove next to impossible to trace. On the next page, however, my intuition seemed to pay off: Eugen must have been looking over me.

Item number 103 was a "Round gilt-bronze Table Clock, South German, second half of the 16th century." This was the long-lost Orpheus Clock. My heart started to race. It was clearly not checked, so it must not have been turned over to the lieutenant or his superior officer. Which meant that Böhler and Sauermann had kept it. This time I had a photo and a very elaborate description by Von Falke. Now I knew exactly what to look for. I tried to contain my excitement. Only three lines farther down the inventory, item number 106 was also unchecked. It was another clock: "Square Table Clock, of gilded-bronze, South German, second half of the 16th century." This was the remarkable astronomical clock by Johann Reinhold.

I quickly saved copies of the lieutenant's letter and the newly discovered "Restituted" inventory, while I made a supreme effort to complete the exercise on hand. My mind was already racing ahead toward the hunt for the Orpheus Clock. I quickly ascertained that four lines below the clocks, item number 110 also seemed to be missing. This was a majolica bowl made in 1537 by the Casa Pirota workshop of Faenza.

The notations on a few other items were also not clear, but I would have to come back to them another time.

I decided to concentrate my investigation on the Orpheus Clock. According to Von Falke's description, I was certain that this piece was unique. It only had a six-hour dial (sometimes used in Italy at the end of the Renaissance), which meant it had to be reset at midnight, sunrise, midday, and sunset. Also most unusual, it only had one hand. When I first looked at Von Falke's sepia-toned photograph, though still quite clear, I could not see the hand at all because the dial face was such a maze of golden leaves, vines, tendrils, and grapes, which in turn hid golden birds and lizards. It was both hugely confusing and yet strangely symmetrical. Then I finally caught sight of the hand, which was concealed in the shape of a long, undulating serpent, its gilded head facing the center of the dial and its tapering tail indicating, oh so subtly, the time. What a marvel.

The artist, reputedly, was Wenzel Jamnitzer of Nuremberg, the master of the *Kunstkammer*. The theme of Orpheus in the underworld had been utilized by some of his competitors in the silversmith and goldsmith workshops of Nuremberg and Augsburg, but clearly Jamnitzer would not be outdone.

Few artworks in my great-grandfather's extraordinary catalog warranted two illustrations, but this "round clock" was one of them—and fortunately so, because the other photograph contained a clue that led me to discover its whereabouts. This side view depicted a frieze that told the tale of Orpheus and Eurydice. You could see a bearded Orpheus playing his lyre as he attempted to induce the gods of the underworld to release Eurydice, his beloved. Eurydice is seen rushing to escape Hades, her long, golden locks billowing behind her. The rest of the frieze consisted of vividly embossed animals: horses, bears, elephants, and some mystical creatures—all apparently entranced by Orpheus's mournful music. During the Renaissance, Orpheus was often used as a metaphor for the triumph of art over nature. Similarly, the artist had sought to harness time through the means of a scientific instrument—the clock.

The hundred-year-old photos of the Orpheus Clock
from my great-grandfather's catalog.

So began my search for our mystical "Orpheus Clock." I was con-
vinced the key lay in the name Orpheus, which symbolized the unique
character of the clock. Almost as soon as I started looking, I discovered
a complete book by P. Coole and E. Neumann, entitled aptly *The Or-
pheus Clocks*. It seemed about ten were in the series, albeit by different
goldsmiths. One clock was in the Bavarian National Museum in Mu-
nich, another in the British Museum in London, but our clock, I was
proud to discover, was considered the preeminent Orpheus Clock. His-
torians would say Jamnitzer's Orpheus Clock was "perhaps one of the
most beautiful clocks of [all] the Renaissance." I was beginning to see
why, of all the wonders in the Gutmann cabinet of curiosities, this was
the piece Böhler could not bear to part with.

At the beginning of the book was a full list of the clocks—the Gut-
mann clock was listed first. I was encouraged to see Eugen, along with

Otto von Falke, both mentioned. But then I became a little apprehensive when I read that our clock had been oddly renamed Fremersdorf 1.

I soon discovered that the Orpheus Clock had been purchased, apparently in 1962, by a certain Herr Fremersdorf. After several frantic searches, I assembled an outline of who Joseph Fremersdorf was. Born in Germany, he became a Swiss resident in the 1920s. There, after the war, Fremersdorf developed his passion for Renaissance and Baroque timepieces. He had made his fortune by selling shoes, lots of them.

The next big break came with an old 2002 Christie's catalog. They were offering a rare eleventh Orpheus Clock, which Coole and Neumann had not included in their book. By way of comparison, Christie's mentioned the other famous Orpheus Clocks at the end of their catalog entry. Yet again, the Gutmann clock (now Fremersdorf 1) was first on the list. Except this list also included its current location: the Landesmuseum Württemberg in Stuttgart, Germany.

In 1973, Joseph Fremersdorf had bequeathed the finest clocks from his collection to the historical museum of the State of Baden-Württemberg. This generous donation included our clock.

As I looked over my shoulder toward the painting on the wall, Eugen was definitely smiling. I'm sure Fritz would have appreciated this moment, too. It was almost exactly sixty-nine years since Julius Böhler's truck had carried away the Orpheus Clock from Bosbeek, along with Eugen's other treasures. Fritz had tried so hard to preserve our family's legacy, and now after all this time, this lost masterpiece was within my grasp. I knew I had a lot more to do, but for the moment I was overcome with a warm sense of satisfaction.

I immediately wrote to the Landesmuseum in Stuttgart. I took it as a good sign when I discovered that the museum had a much-respected historian as head of provenance research, Dr. Anja Heuss. She soon wrote back to me to confirm that the Orpheus Clock was indeed in the museum's collection. There was one snag, though: she was under the impression that the clock had been sold by my family to the Bachstitz Gallery in The Hague, long before the war.

Several items from Eugen's collection had, in fact, been offered to

Kurt Bachstitz, but on consignment only. Fritz had arranged all this while Eugen was still alive. However, Bachstitz then included all these artworks in his 1922 catalog, with unfortunate results for me and my family. Everybody now believed Bachstitz owned these artworks.

Eventually, I was able to prove to Dr. Heuss that most of the Gutmann artworks had not been sold by Bachstitz, but had been returned to Fritz, as custodian of the family collection. Fortunately, the Bachstitz Gallery stock cards were now accessible in a Dutch archive. I then sent the Landesmuseum a copy of the relevant card, which clearly indicated that the Orpheus Clock had been returned to Fritz's office in July 1924.

When I provided Anja Heuss with copies of the contract Fritz was obliged to enter into with Julius Böhler and Karl Haberstock, in March 1942, along with the Munich 1945 "Restituted" lists, she became convinced that the clock in her museum belonged to my family. The Orpheus Clock was clearly marked as number 103 in that forced transaction. By the next time she wrote to me, she was certain not only one Gutmann clock was in the museum, but actually three.

I tried not to let my expectations soar too high. I was almost sure I knew at least one of the other clocks. I had already seen on the Landesmuseum's website a picture of an automaton clock that looked identical to the wonderful Ostrich, with its flapping wings and drum-beating monkey, which had once been Lili's favorite. When Dr. Heuss confirmed that this was indeed one of the other clocks, I reassured her that this piece had in fact been successfully returned after the war and that my father, along with his feuding cousins, had sold it at the end of the 1950s, through the Manhattan antique dealer A La Vieille Russie. It appeared to be just an odd coincidence that Fremersdorf had bought the Ostrich automaton, too. The third clock, however, was a different matter. I could not believe my luck. It was Item 106 from the Böhler list: the "Square Table Clock," which had also disappeared from under the nose of the eager lieutenant.

The bland, generic title of Square Table Clock for this amazing instrument was a great understatement. While our Round Table Clock had to share a book with at least eight other masterworks, the so-called

Square Table Clock had all 120 pages of a book just to itself. The title was *The Great Astronomical Table Clock of Johann Reinhold: Augsburg 1581 to 1592*.

Johann Reinhold's clock had not just one dial, like most, but nine dials in total. The main top, or horizontal, dial was by no means as beautiful as the Orpheus Clock's, but was still impressive. Its finely etched gold frame enclosed a distinctive thick gold circle, which, in turn, encircled a twenty-four-hour dial. Under the widely latticed gold dial was a silver astrolabe that kept track of the sun and the moon. Each of the four sides of the square clock exhibited two smaller dials. There were two zodiacal dials (one ornamental and one scientific), two intricately decorative twenty-four-hour dials, and one dial that alternated between the cycles of the sun and the moon. One dial was for the planets, another for the weeks and the months, and one final dial followed the twenty-eight-year solar cycle of the Julian calendar. Reinhold had reached the high point of clockmaking in the Renaissance. It was a veritable sixteenth-century computer, and a beautiful one.

I tried to find out who had sold the two Gutmann clocks to Fremersdorf. Anja Heuss replied that the collector, rather significantly, had left no information about how or where he had acquired them. It continued to amaze me how serious collectors, especially those who had published academic treatises, managed to overlook (conveniently) the whole issue of where a valuable artwork had actually come from. I pointed out that the Böhler family had opened its own gallery in Lucerne, Switzerland, Fremersdorf's adopted home. The notorious Theodor Fischer had been one of the gallery's financial backers. All we knew for sure was that Fremersdorf had acquired the two clocks before 1962, while he was living in Lucerne.

One most revealing piece of information that Fremersdorf did make a note of was that, at the time he acquired the clocks, they still had sand and dirt in them. He deduced that they must have been buried for some while. Immediately I had an image of Böhler and Sauermann frantically burying the two Renaissance masterpieces in

the sands by Lake Starnberg, just before the Munich Collecting Point truck arrived to pick them up.

I uncovered a little more background information. Edgar Breitenbach had been the Monuments officer in charge of the investigation of the missing pieces from the Silbersammlung. His speciality was "second-generation loot"; this referred to items looted by the Nazis and then stolen again by desperate Germans in the chaotic months following the Allied victory. Unfortunately the trusting and understaffed Allied officers often enlisted the help of the local population. In this case a Bavarian State policeman called Georg Denzel was put in charge of moving the 225 pieces to the Munich Central Collecting Point. Denzel continued working for the US occupation forces until 1948, when he was finally let go. Ultimately Breitenbach's investigation proved inconclusive. Denzel, Sauermann, and Böhler all had opportunity and motive. However, I found a statement by Dr. Hoffmann, an associate of Böhler's, where he admitted, much later in 1953, that only 216 pieces had been turned over.

I was fortunate to be dealing with a provenance expert of Dr. Heuss's caliber. She soon agreed that the Orpheus and Reinhold Clocks should be considered for restitution and quickly requested a decision from the state ministry in charge.

There was one catch. I had already pointed out that the Silbersammlung, or what was left of it, belonged to all qualified heirs of Eugen Gutmann, not just the Fritz Gutmann branch. Dr. Heuss recommended that I work on a family agreement while the ministry considered the return of the clocks. In anticipation of this I had already begun to sound out various cousins. My fear was that my entreaties would fall on deaf ears.

No substantial effort to bring the family together had been made in well over a half century. Just four years before finding the clocks, I had felt a new attempt at reconciliation, with one particular branch, was called for. Some unsubstantiated duplicate claims had been filed

in Holland, based, I assumed, on bad advice. Unfortunately, my stab at establishing normal relations had quickly fizzled out. Sadly, one of the cousins with whom I had tried to reach an understanding had died suddenly. Now we had a new opportunity: I was dealing with a different cousin and I had something tangible to offer. Anja Heuss had already let it be known that, in the event the ministry agreed to a restitution, the museum would like to buy back at least one of the clocks.

This time the tone seemed far less confrontational. I was happy to put the competing Dutch claims aside (after all, they had already been settled in my favor). Most of us could not remember when the previous generation's rifts had started, or the reasons why our parents had fallen out. I proposed that we start with a clean slate. The only equitable way to sidestep all the old wrangles about who got which share was to make sure that each entitled branch of the family, in the future, received an equal share. After a fair amount of back-and-forth, this time we reached a consensus, perhaps because no outside lawyers were involved. After all, I had two golden carrots to tempt them with. The third branch of the family was delighted to be included—I think that they had been cut out of most of the settlements back in the fifties. I would get my expenses and a reasonable fee for my efforts; the rest was to be divided proportionally. It was also agreed that from this point on I would be the family's legal representative for all claims relating to the Eugen Gutmann Collection.

In October, as I was drafting the final version of our new family contract, I heard from Dr. Heuss again. The Ministerium für Wissenschaft, Forschung, und Kunst Baden-Württemberg had agreed to return both clocks. I was jubilant and awash with feelings of vindication and pride.

This was a historic moment. Just two years earlier, the grandchildren of Herbert had been returned a Franz von Lenbach portrait of Bismarck, which was found hanging in the Bundestag in Berlin. However, for my branch of the family, the children and grandchildren of Fritz, this would be our first direct restitution from Germany.

Everything had gone so smoothly I knew the other shoe had to

drop, and then it did. The ministry had received our family agreement but was unsure whether it would satisfy the letter of the law in Germany. Under normal circumstances, to comply with the German laws of inheritance, I would have to obtain a document called an *Erbschein*. Unfortunately, this public deed or certificate of inheritance could only be obtained in a probate court. The thought of spending two years in a German court terrified me. Maybe I could forestall any such action with the certificate of heirship that the Dutch government had issued me ten years earlier. I could not help thinking about Bernard and how hard it had been for him to prove he was his father's heir. I would have to prove not just that I was my father's heir, not just that I was my grandfather's heir, but that I was my great-grandfather's heir.

More months went by. The museum seemed eager to strike a deal. Dr. Heuss and the museum director, Dr. Ewigleben, were applying as much diplomatic pressure on the ministry as was politically advisable. To back up my position, I had the museum forward to the ministry a family tree that had been compiled by the new Dresdner Bank in Frankfurt. I suggested that if the minister had any questions, he should contact Michael Jurk, who was president of the Eugen-Gutmann-Gesellschaft (the Dresdner Bank and Commerzbank historical society), which had been named after Eugen. I tried to emphasize that any unnecessary legalistic delays would be in violation of the spirit of restitution.

While we were waiting, my second cousin Nadine died. She had been one of the few cousins we had always been on friendly terms with. I was very upset about her loss; I was also getting rather frustrated. Nadine was a great-grandchild of Eugen's and would also have been one of the beneficiaries from any clock settlement. At the risk of appearing melodramatic, I decided to inform the museum and the ministry that, while we had been waiting for a conclusion to this restitution, one of the heirs, Nadine von Goldschmidt-Rothschild, had passed away. She had been the last of our immediate family who still lived in Germany (and the last of the Rothschilds in Frankfurt). I feared that this generation, which suffered so much during the war, would soon be completely

gone. I appealed to them that, where possible, reparations should be made directly to those who were personally deprived at the time.

I had even more bad news to share. My dear aunt Lili, who was now ninety-two, had just suffered an accident; she had slipped in the street and broken her hip and was in the hospital in Florence. Dr. Ewigleben, the director of the museum, was horrified at my news and promised to press the ministry for a quick decision. Nevertheless the bureaucratic process ground on inexorably.

On the bright side, my amazing aunt was determined to escape the clinic she had been sent to. She quickly abandoned the walker they had given her and started practicing daily with crutches. Her strength and resolve were remarkable. I laughed when she told me, on the phone, that she could not bear all the old people in the clinic. I wondered how many others were actually over ninety-two. One of the reasons for her determination was that the Eugen-Gutmann-Gesellschaft was hosting an April event in the grand auditorium of the Commerzbank tower in Frankfurt to honor her father and his collection. A Dutch art historian was to give a lecture focusing on Fritz's taste and, in particular, on the Hieronymus Bosch, which was now in the National Gallery of Canada. Lili was to be the guest of honor and had set her heart on attending. She had also very much hoped that I would join her. I had done my best to make it a double event, with our going, after Frankfurt, to Stuttgart to accept the return of the clocks. Instead, I had to wait in Los Angeles for the ministry in Stuttgart to finally process our family contract.

I kept myself busy with a new claim against the French government, for a second painting by Liotard, another still life, and with a small claim in Holland for a lovely majolica dish. Meanwhile, Aunt Lili did make it to Frankfurt, on crutches no less, where everybody from the Dresdner and Commerzbank made a big fuss over her.

Not until June did I receive news from the ministry in Stuttgart, but at last it was good news. They were sending me a contract that would officially transfer the two incredible clocks back to the Gutmann family. Part of the agreement was that we would give the Landesmuseum first rights of refusal.

Excited, I called my brother and all the cousins with the good news. I was enjoying the accolades, and it felt wonderful that we were all on the same side for the first time in decades. Then I called dear Lili, who had made it safely home to Italy after her Frankfurt jaunt. She was fast approaching ninety-three and learning anew how to navigate the bumpy streets of Florence. When I broke the news about the clocks, I could sense her delight. I relished the opportunity to bring her good tidings. But Lili also had a surprise for me. She was already planning a new trip to Germany, and this time I had to join her. It was really an order.

The Eugen-Gutmann-Gesellschaft was planning a big celebration during the first week of October in Dresden for the 140th anniversary of the Dresdner Bank. The whole family was invited. This time I had to make sure I could take care of all our family business in Stuttgart, too.

I was encouraged by a letter from Dr. Ewigleben informing me that the museum would have its evaluations done by mid-September. I had been assembling our own estimates for almost a year. Sheri Farber at Christie's had provided me with the auction results of the Rothschild and Wernher Orpheus Clocks. Lucian Simmons at Sotheby's had also been helpful. I felt well prepared. The ministry, the museum, and I agreed our meeting would take place on October 9 in Stuttgart.

I began to plot what would be a fairly extensive tour of Germany. I had unfinished business with other museums. Now, possibly for the first time in my life, I was looking forward to going to Germany.

May and I arrived in Stuttgart toward the end of September. Our first stop was in Tübingen, where we spent a lovely day with my father's companion, Eva, bringing her up-to-date with my many exploits. She was pleased to see us, but a little stunned to think that Bernard had spent his last years so close to the fabulous gold clocks, yet so far away. We visited his grave and laid some new flowers. I was grateful for the opportunity to reconnect with my dear father. Whether I liked it or not, I had deep roots in Germany.

We took the train to Augsburg, the home of so many of the amazing Renaissance goldsmiths and silversmiths, whose work Eugen had

treasured. Augsburg also included among its favorite sons, at least until recently, the other man who had stripped our family home in Bosbeek—the infamous Karl Haberstock. Behind the lovely Baroque facade of this historic Bavarian city, if you looked closely, you could still see occasional vestiges of the Third Reich. A huge Nazi-era eagle had been preserved above a doorway at the railway station—just the swastika under its talons had been removed. I reminded myself that Augsburg had been home to the first Nazi newspaper.

My main reason to come here was to visit the state museum housed in the Schaezlerpalais. This museum was home to the Karl and Magdalene Haberstock Foundation for the Promotion of Science, Education, and Culture. Ever since I had received the Karl Haberstock catalog, which had led me to discover our Franz von Stuck, I knew that the city of Augsburg was the custodian, among other things, of the antiques Frau Magdalene Haberstock had, so generously, donated in 1957. I was convinced Julius Böhler had transferred much of it to Karl Haberstock, from Böhler's share of the loot from Bosbeek. Haberstock had not turned over many pieces to the Allied authorities at the end of the war. I was fairly sure much of it was in Augsburg to this day—including even Louise's set of six mocha-coffee cups.

Even though the city of Augsburg had finally seen fit to remove the bust of the notorious Haberstock from the entrance to the Palais in 1999, I was not aware that the state authorities had also, discreetly, removed Frau Haberstock's antiques from the museum. I wondered, rather self-importantly, if they had known I was coming. I never heard back from the curator I was trying to reach. Clearly this unfinished business would require some serious effort when I got home.

May and I decided to sightsee. I was intrigued by the Fuggerei, which was the oldest public housing complex still in use, founded by Jakob Fugger the Rich in 1516. I remember my father mentioning that a Prince Fugger had been at school with him, in Zuoz. As we entered the walled enclave, I went into a little alcove to ask, in my best German, for two tickets to the museum section. What followed was the oddest experience. The old woman behind the counter just looked at

me with such unashamed and unmistakable hatred. Suddenly I felt ice run through my veins. I wondered what it was she saw—was it somebody wearing a yellow star?

I repeated loudly in an authoritative German tone, "Two tickets please?" Very begrudgingly, she pushed the tickets toward me. May and I moved on quickly. Chillingly, May had also felt the same sensations from several feet away. The museum seemed to be all about the destruction of the complex toward the end of the war (and its subsequent rebuilding). History had been turned on its head. For the Augsburgers, the British were the instigators, the RAF the villains, and the Germans were the victims. For a second I wondered if the evil woman knew I was English, but then I realized I spoke German with, if anything, a hint of a French accent. We left in a hurry.

I was relieved the next day when we arrived in Dresden. Lili and her son Enrico were there to greet us. She was now moving nimbly about on just one stick; gone even were the crutches. As we made our way to dinner across the Neumarkt, she seemed to navigate the cobblestones with ease. Her cane came in handy for pointing out the Baroque wonders of the beautifully reconstructed Frauenkirche. For so many years after the war, the East German authorities had left the remnants of the eighteenth-century church as a pile of rubble on the side of the Neumarkt place. Like a native Dresdner, my aunt seemed to take enormous pride in the skilled restoration of the high-domed church—perhaps it was a symbol of reconciliation between the old and new Germanys. Dinner was traditional, hearty, local fare in what had been an old wine cellar. An accordion was playing, and men were humming old drinking songs. As the singing got louder, May and I instinctively began to feel uncomfortable. May thought it was a scene out of *Cabaret*. Lili, by comparison, appeared to take it all in her stride. She was enjoying herself and nothing was going to stop her.

The next day the Eugen-Gutmann-Gesellschaft had rented a bus, which took us along the river to Pillnitz Castle for a formal luncheon. The many speeches extolled the influences on German life and the economy that had been brought about by the now-combined Dres-

dner and Commerzbank. The dark period between 1931 and 1945 was barely touched on—how the Dresdner Bank, which had essentially been a Jewish bank, became the bank of choice for the SS. (During the Nuremberg trials, the chairman of the board of the Aryanized bank was sentenced to seven years in prison.) To the modern Dresdner's credit, in 2006 they published an exhaustive four-volume history, *The Dresdner Bank in the Third Reich*.

The speeches at lunch emphasized the postwar innovators and the original driving force: Eugen Gutmann. Lili took great pains to explain to the new Commerzbank powers-that-be our family connection to both banks. Jacob and Eugen von Landau had been instrumental in the founding of the Commerzbank, and Louise's first cousin Kurt Sobern-heim was one of the first directors. One way or another, the Gutmann–Von Landaus had been connected to just about every bank in Germany before the war; some had said that was part of our problem. All the bankers and officials were keenly interested in my forthcoming book.

Our return trip to Dresden was pleasant. We returned leisurely by boat, along the river Elbe, to the Florence of the North. Just out of sight, on the hill above, was the fairy-tale castle Schloss Schönfeld, where our great-great-grandfather Bernhard had lived nearly 140 years before.

Back in Dresden, we went to a performance at the Semper Opera House. Again there were many family ties. Bernhard had helped finance the rebuilding in 1869, after the first time it had burned down. In 1945, again all but a shell had remained. Now we were sitting in the almost identical third incarnation. My great-grandmother Sophie, who sang here, would hardly have known the difference. But I'm sure she would have enjoyed the good production of *Tosca*.

The next day, after breakfast, we walked to the last surviving branch of the Dresdner Bank that had kept the name. (The others had all become Commerzbank.) The manager and a city official greeted us. Cameramen were there to take our picture next to a copy of the bust of Eugen, which was in the lobby. The original bust, by Hugo Lederer, had been smashed to the ground when the Brownshirts had stormed

into the Berlin headquarters in May 1933—that fateful day when they began burning books in the Opernplatz just in front of Dresdner Bank.

On our last day in Dresden, May and I made straight for the Grünes Gewölbe (Green Vault), one of Eugen's and my favorite places. The Saxon Kings' enormous treasure-house never ceased to amaze. As I stood spellbound by all 140 jewel-encrusted figures that make up Johann Dinglinger's masterpiece, *The Birthday of the Grand Mogul*, I felt Eugen looking over my shoulder again. In the afternoon, we went to the Jewish cemetery, which had survived so miraculously, to pay our final respects. Everybody was in place: Bernhard on the east wall, surrounded in marble by his wife and many of his children; Alfred, somewhat independently, on the south wall with his favorite daughter. It was all quite reassuring, but just in case anything happened to the cemetery, I must have taken photographs of about one hundred headstones.

It was time to get back to business. Lili returned to Italy, while I rented a car and drove quickly, right across Germany, back to Stuttgart and the clocks. When we arrived at the Old Castle the next morning, we were greeted by Dr. Heuss, as well as Dr. Irmgard Müsch, the curator of clocks and scientific instruments, and Moritz Paysan, the head restorer. The Renaissance castle, we learned, was home to the Württemberg State Collection and consisted of a staggering eight hundred thousand objects. We were led down the ancient stone stairs of the tower that housed the clocks. Our hosts proudly explained that the collection consisted of nearly seven hundred unique timepieces, dating from the fifteenth to the nineteenth centuries. However, they only exhibited the most exceptional pieces, maybe forty at a time. When we reached the bottom of the stairway, May and I felt as if we were entering Aladdin's Cave. Each priceless timepiece was illuminated with invisible lights, sheltered in its own Gothic alcove. We went past an exotically domed clock that looked as if it had been made for the Ottoman Sultan, and then I caught sight of the Orpheus Clock.

Our clock was more golden than I had realized and slightly larger. Once more I had that strong sensation of reconnecting with my ancestors. The privilege of holding what had once been lost was humbling.

Yet again, I had underestimated the beauty of the artwork. I began to think of how, almost exactly fourteen years before, Nick and I had held our Degas *Paysage* for the first time.

A little farther on was the amazing Ostrich, also much larger and more imposing than I had ever imagined. Dr. Müsch proudly demonstrated that, on the rare occasions he was carefully wound up, his wings would still flap, just as they had in 1575. Still deeper in this chamber of marvels we came upon the Reinhold Clock, beautifully lit and shinning in its own Gothic showcase. Moritz Paysan opened the case for me and invited me to pick it up. At first I could not; I had not taken into account its deceptive weight. Johann Reinhold had ingeniously fit together endless cogs and wheels, all made of brass and iron, so that all nine dials could operate independently. Moritz, interestingly, confirmed Fremersdorf's first impression: on his first attempt to restore the mechanisms, to his surprise he'd discovered sand still inside.

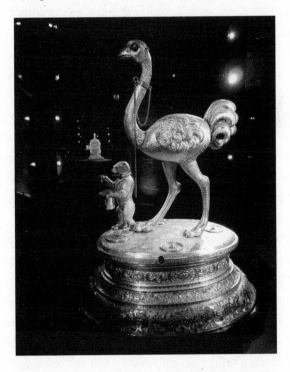

The Ostrich automaton on display in Stuttgart.

After lunch we made our way to a pleasantly airy conference room, on the other side of the castle complex. Dr. Ewigleben made the introductions. It all seemed very agreeable, but I could not help noticing that, apart from May, I was on my own and about to face nine Germans across the table: two senior officials from the ministry, one translator, and six principals from the museum. I took a deep breath and tried to remind myself that legally the clocks were already ours.

Before arriving in Stuttgart I had already sent the museum and the ministry an aggregate chart of the high and low auction estimates that both Christie's and Sotheby's had suggested. As soon as the political niceties were over, the senior ministerial counsel outlined the estimates they had received from their expert. To my relief, they were not so far off the mark. It was important to keep a clear objective, and I had a number below which I would not go. The ministry's counsel then made their offer. I countered by pointing out that, under normal circumstances, a private buyer pays a premium for the privilege of taking an artwork off the market. I was quick to add that I had already made some concessions, largely because of the exemplary way the museum had conducted the restitution. Also, my family appreciated the way our clocks had been cared for, not to mention the spectacular way they were exhibited. Then I spelled out what I would accept. I had a duty to secure the best possible compensation for my family, not least because of the inordinate time we had been deprived of our legacy. Dr. Ewigleben and the counsel for the ministry looked at each other and then back at me: "We accept your terms." I had done it. It was agreed.

"We also regret what happened to your family," the official continued. "We are grateful, however, for the opportunity to set, at least, this matter straight."

We got up from the table, and one by one they all shook my hand. They thanked me for my reasonable and constructive approach.

"I am also grateful that my family's clocks have found such a good home," I offered in reply.

Eventually Lili and Eva, and many others, would come to visit our

Orpheus Clock and our Reinhold Clock. Lili even got to see her favorite Ostrich again.

May and I emerged in the October sun exhausted and elated. With deep satisfaction, that evening I broke the news to all the family. Soon, I was receiving thank-you messages from all sorts of unexpected places, and from descendants of Eugen I barely knew. Eighty-four-year-old Alexander, from the shores of Lake Constance in Switzerland, touched me particularly as he recalled his mother telling him how they had been cut off from any Gutmann inheritance. If there had been a curse because of the Silver Collection, had I helped break it?

It occurred to me that the clock, as it turned, counted the good times along with the bad. For many years my family had suffered greatly. I was hoping this fortunate occasion symbolized a new, peaceful, and successful era for the Gutmanns.

Before returning to Los Angeles I had to visit one more museum, the Germanisches Nationalmuseum in Nuremberg. After my fairly thorough tour of the museum, one item caught my eye on the way out, a Bohemian crystal cup. I was beginning to develop a photographic memory for at least Fritz's and Eugen's collections. I was almost certain I had seen the cup before. This would be a good test. May and I quickly took a dozen pictures of it. As we headed back to Stuttgart and the airport, I began to cross-reference my Eugen Silbersammlung photo file from my laptop on the train. Soon, there it was, the exact image: *von Falke number 108; crystal bowl, silver-gilt stand, Prague ca. 1600.* I quickly sent off an e-mail inquiry. When we got home, I sent a more formal letter. The last response I received was that they were still looking into it. I added them to the growing list of museums that are supposed to get back to me.

It is time to return to my quest. I will have to end my book.

POSTSCRIPT: ON REFLECTION

On the trail of the missing Tetzel Cat,
with a nineteenth-century copy in Nuremberg, 2012.

While the Orpheus Clock negotiations were well under way, I discovered an unexpected but vital clue about the whereabouts of our two missing Francesco Guardi landscapes. All of which brought back strange memories of my father. I now realized Bernard had been so close in his pursuit of these beautiful Venetian capriccios. I must have been ten or so

when he took me to a secluded palazzo in Venice, belonging to a collector he suspected. What was stranger, though, was that the paintings had, I now realized, been in the collector's Mayfair apartment in London all along, just a block or so from Shepherd Market, where we lived at the time. I remember Pa laughing strangely when he recalled how he had never been invited to their London home.

Years later I picked up the trail in an art gallery in Zurich, where I posed as a Guardi collector. Now finally I had proof of who had sold them. I contacted the auction house involved, which not surprisingly was rather embarrassed. They wanted to close the case discreetly; accordingly they made me a reasonable offer, even though under Swiss law my family no longer had good title. The alternative was court, and I accepted their offer with a heavy heart. The bitter pill of compromise was always hard to swallow. These two paintings, among the many of Fritz's collection, I would most dearly have loved to keep. At least I had closed another case and settled an old mystery.

Several other cases, including a major compensation issue with the French government, were calling for my attention. One day I would also have to find time to file an appeal for the money the Dutch government had forced my father and aunt to pay. Furthermore, the legalities of the sale of Bosbeek continued to bother me, and now a question had arisen of property in Berlin that had once belonged to the family. The list seemed endless, but before I immersed myself in the next round of legal battles, I realized I needed time to reflect. I had been so busy, I had barely had time to assess the remarkable events of the past several years, and the enormous changes that had taken place in my life.

Growing up in London in the fifties and sixties, I indentified with little except for the exciting new music that was springing up all around. The Stones and the Kinks had been favorites. The breaking down of old barriers was exhilarating. The last thing on my mind was the career in banking my parents suggested. The rigidity of life in the financial district represented exactly what I was trying to distance myself from.

In contrast, the rebellious spirit of the emerging music business was particularly appealing. The music world offered a welcome haven for England's misfits, young men such as myself.

When my father died and those boxes arrived, I had for several years been a distributor of rock music in LA—an exciting and challenging enough way to earn a living, but still one that focused on the increasingly trivial whims of pop culture. Suddenly I was to be thrust into the world of Renaissance art, Jewish history, and the horrors of the Second World War. Yet I adapted quickly. I was finally extricating myself from the 1960s and reentering the world of my roots—the world I was probably educated for. Almost overnight, my dormant passion for art and history found a vital focus. I was grateful for this new purpose in life.

At the beginning, some reminded me, "You can't change the past." Many friends suggested I should move on, that no good would come from lingering in the past. But what if the past was not over? I found that my family's history was not pulling me back but pushing me forward. In the middle of the night I would sit bolt upright realizing so much was still to be done.

Even if my father had explicitly told me not to follow in his path, I'm not sure I would have listened. I can be just as stubborn as he was. Besides, I took the arrival of those boxes, combined with his silence, to be an implicit appeal to finish his life's work.

My brother and I had also inherited Bernard's determination. I don't think for a minute I ever thought I was embarking on a fool's errand. One man can make a difference. Despite our adversaries all being rich and powerful, I always had faith that right would prevail, however long it took.

From the earliest age I had carried with me an unidentified sense of loss. Growing up in a silent void, I only recognized much later in life the invisible "elephant in the room," the Nazi cataclysm that had almost obliterated my family. Whether unconsciously or not, I had clearly been affected by my forefathers' suffering, and as a result I found it difficult to rest. Only by addressing their unfinished business,

reaching back to change the past however minutely, did I find some solace. As I embarked on this quest to find my family's lost treasures, a solution to my underlying grief emerged. The more I traced our hidden artworks, the more my family's buried history resurfaced. As I placed yet one more piece of the shattered jigsaw puzzle back together, the lost lives became tangible once more. With each piece came a little renewed pride. Today I am comforted by knowing my place in all this. I no longer suffer from an isolation of rootlessness. My roots are deep and wide, with ancestors that go back many centuries and relatives on four continents.

Of course I never actually heard any voices nor saw any visions, but over the last years I have felt profoundly the presence of my father, my grandfather, and my great-grandfather. A French psychologist coined the term *psychogenealogy*, or "ancestor syndrome"—where some of us are links in an unconscious chain through the generations. Another psychotherapist, in Jerusalem, working with Holocaust survivors and their children, also developed the theory that survivors often designated a particular child as a "memorial candle": one who took on the mission of preserving the past and connecting to the future. This concept struck a particular chord with me. Many times I felt I had inherited what appeared to be ancestral memories.

More than once during my research, an unknown artwork has stood out as I instinctively recognized something Fritz or Eugen had collected. It dawned on me that at least some of the art my family had lovingly collected might also serve as memorial candles. After all, the art, along with the family, had suffered, too. The Stuck ripped from its frame, the Renoir locked in a dank repository, the Orpheus Clock buried in the sand. The difference, I suppose, was that art had the potential for immortality. Unlike humans with their brief lives, these beautiful objects could reach across the generations, each with a story to tell if only one could unlock its secrets.

I have stared at Lenbach's portrait of Eugen so many times con-

vinced it might speak to me at any moment. I have studied, endlessly, the Man Ray portraits of Fritz and Louise in my library, certain they had a message to decipher. While Fritz looked off into the distance, almost wistfully, Louise with her deep, aching brown eyes seemed to look straight into my soul.

Each time I recovered any piece of their collection, however small, it felt like a significant vindication for my once-maligned family. Many would tell me how proud Bernard, and Fritz and Louise, and Eugen must be. I have often felt them looking over my shoulder. How often I have wondered if they can see all that has happened. I certainly hope there is a way they know we still care.

ACKNOWLEDGMENTS

From the day I conceived this book it would take nearly ten years to complete. Throughout, numerous well-wishers helped pave the way. Others provided inspiration from near and far. There are so many to whom I am grateful for making *The Orpheus Clock* become a reality. Although my acknowledgments are in no meticulous order, I must begin with my great-grandfather Eugen Gutmann, who found the clock in Paris and began the Gutmann collection. Then there is my grandfather Fritz Gutmann, who continued the collection and tried so hard to preserve our family legacy. My father, Bernard Goodman, also deserves special recognition for his silent determination while saving countless documents, whose significance would only become apparent decades later.

Special thanks go to my indomitable aunt, Lili Collas-Gutmann, whose courage and perseverance acted as a source of infinite strength and inspiration. My brother, Nick Goodman, generously provided steady encouragement and wise counsel throughout. Patiently he read every single word I wrote, as did my dearest wife, May Quigley-Goodman. Their guidance made my task lighter. Inevitably, there were some bleak periods through which I would not have emerged had it not been for May's constant nurturing and unwavering support.

Several members of my extended family also offered support, both spiritual and practical, including Eva Schultze-Dumbsky, Francis

Fitzgibbon, Jean-Paul Froidevaux, and the late Nadine von Goldschmidt-Rothschild.

My quest might well have ground to a halt without the talents of several skilled professionals. In particular I'd like to thank Tom Kline, Willi Korte, Barry Rosen, Anne Webber, Rebecca Friedman, Connie Walsh, and Terry Higham for their counsel and encouragement. In addition I would like to express my appreciation to a host of dedicated experts: Helen Junz, Rudi Ekkart, Evelien Campfens, Tonie Brandsie, Perry Schrier, Evert Rodrigo, Rik Vos, Maarten Meijer, René Pottkamp, Marie Hamon, Anne Georgeon-Liskenne, Marc Masurovsky, and Randy Schoenberg.

There were many who helped with outstanding research and skilled translation, such as Christine Koenigs, Helen Hofhuis, Frank van Putten, Uwe Hartmann, Monika Flacke, Ilse von zur Mühlen, Horst Kessler, Richard Winkler, Cornelia Kruppik, Katrin Lege, Michael Jurk, all those at the Getty Research Institute, and Carmen Ketola, who made such a sensitive translation of my grandfather's poem.

Along my journey I have been inspired and enlightened by countless authors and journalists, including Hector Feliciano, Shuchen Tan, Lien Heyting, Walter Robinson, Morley Safer, Melanie McFadyean, the late Marilyn Henry, Gerard Aalders, Corinne Bouchoux, Michael Bazyler, Jonathan Petropoulos, Robert Edsel, Nancy Yeide, Jane van Nimmen, Elena Ceccarini, and Annie Jacobsen—from the encyclopedic Lynn Nicholas to the Proustian Edmund de Waal.

I am particularly appreciative of the relations that have emerged between my family and the two great auction houses. At Christie's a special thank-you must go to Sheri Farber for her untiring assistance. Also, Monica Dugot and her skilled restitution department have been a constant support. Other notables include Marc Porter, Jop Ubbens, Nicholas Hall, James Hastie, Toby Woolley, and Anthony Phillips. At Sotheby's, the most knowledgeable Lucian Simmons and the author Richard Aronowitz have both become valued colleagues.

It has been particularly gratifying to have encountered several collectors and museum officials who acknowledged the fundamental

necessity for Holocaust-era restitution, notably Suzanne Delehanty, Philip Furmanski, Abe Somer, Anja Heuss, Cornelia Ewigleben, Irmgard Müsch, Moritz Paysan, Scott Schaefer, Douglas Druick, and the late James Wood.

And lastly I must thank my dear friend, the writer Hunter Drohojowska-Philp, without whom this book might never have been completed. It was her sober advice that, among other things, led me to my wonderful agents, Eric Lasher and Maureen Lasher. With the help of Gordon Dillow, the Lashers began to shape my rambling notes into a coherent entity. From there I was introduced to the talented team at Scribner: Colin Harrison, Katrina Diaz, Alexsis Johnson, and Susan Moldow. I am indebted to them for their patience and expertise.

I am truly fortunate, thanks to all those mentioned above and those whose names elude me, to be able to offer this book to my children, James Goodman, Emma Goodman, Tara Goodman, and Rebecca Goodman, and all the generations that will follow.

APPENDIX 1

GUTMANN FAMILY TREE*

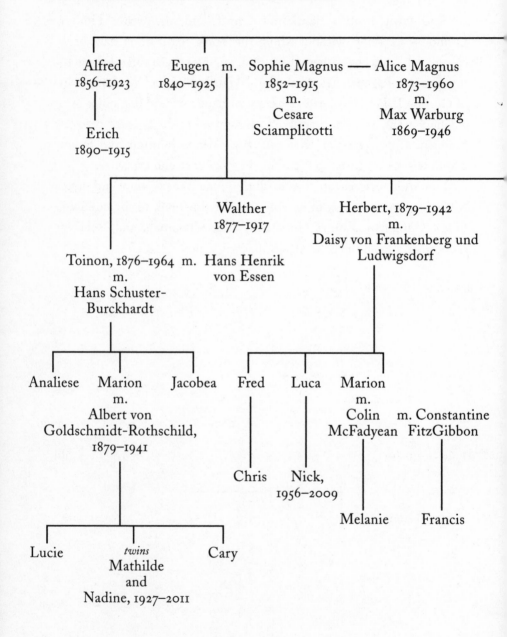

Alfred
1856–1923

Eugen m. Sophie Magnus
1840–1925 1852–1915
 m.
 Cesare
 Sciamplicotti

Alice Magnus
1873–1960
m.
Max Warburg
1869–1946

Erich
1890–1915

Walther
1877–1917

Herbert, 1879–1942
m.
Daisy von Frankenberg und
Ludwigsdorf

Toinon, 1876–1964 m. Hans Henrik
m. von Essen
Hans Schuster-
Burckhardt

Analiese Marion Jacobea Fred Luca Marion
 m. m.
 Albert von Colin m. Constantine
 Goldschmidt-Rothschild, McFadyean FitzGibbon
 1879–1941

Chris Nick,
 1956–2009

Melanie Francis

Lucie *twins* Cary
 Mathilde
 and
 Nadine, 1927–2011

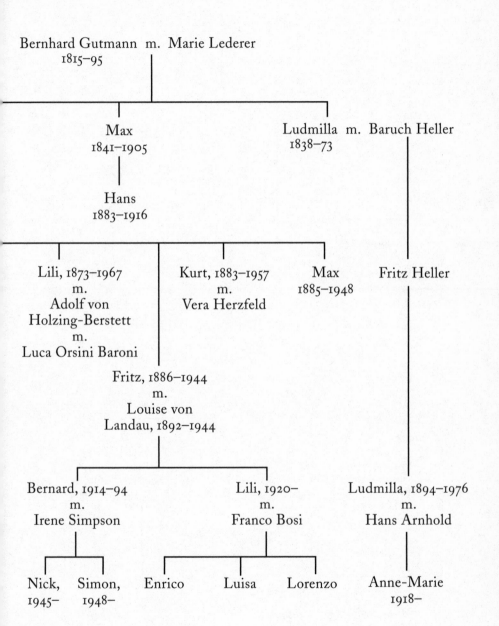

Bernhard Gutmann m. Marie Lederer
1815–95

Max
1841–1905

Ludmilla m. Baruch Heller
1838–73

Hans
1883–1916

Lili, 1873–1967
m.
Adolf von
Holzing-Berstett
m.
Luca Orsini Baroni

Kurt, 1883–1957
m.
Vera Herzfeld

Max
1885–1948

Fritz Heller

Fritz, 1886–1944
m.
Louise von
Landau, 1892–1944

Bernard, 1914–94
m.
Irene Simpson

Lili, 1920–
m.
Franco Bosi

Ludmilla, 1894–1976
m.
Hans Arnhold

Nick,
1945–

Simon,
1948–

Enrico

Luisa

Lorenzo

Anne-Marie
1918–

*Only select marriages and children shown.

APPENDIX 2

RECOVERED ART
THE FRITZ GUTMANN COLLECTION RECOVERED

Please note that this is an incomplete and partial list and by no means the definitive, complete catalog of art.

ARTIST	TITLE/ DESCRIPTION	PERIOD/ TYPE	RECOVERED/ SETTLED	PRESENT/ LAST LOCATION
Anon. von Calcar	Pietà sculpture	c.1425 Limewood	SG 2011	Catharijneconvent Museum, Utrecht
Baldung Grien, Hans	*Portrait of a Young Man, with a Green Background*	1509 Oil	SG 2010	Christie's, 2011
Barbault, Jean	Spanish lady (orig. ascrib. to Goya)	1750 Oil	BG 1946	London, private collection, 1981
Bartolom-meo, Fra	Madonna (seated) with child	Early 16th c. Oil/board	BG, LG 1954	Amsterdam, 1954
Bosch, Hieronymus	*The Temptation of St. Anthony*	15th c. Oil	BG 1946	National Gallery of Canada, Ottawa
Botticelli, Sandro	*Portrait of a Young Man with a Red Cap*	16th c. Oil/board	NG, SG 1998	Denver Art Museum, Colorado

ARTIST	TITLE/ DESCRIPTION	PERIOD/ TYPE	RECOVERED/ SETTLED	PRESENT/ LAST LOCATION
Boucher, François (attrib.)	Lady's portrait	18th c. Pastel and chalk	BG, LG 1954	Amsterdam, 1954
Boucher, François (school)	Sopraporte, pastoral scene	Late 18th c. Oil	NG, SG 2002	Christie's, 2003
Burgkmair, Hans	*Portrait of a Man,* red jacket, green background	1501 Oil/wood	BG, LG 1954	Museum für Kunst und Kulturgeschichte, Dortmund
Carriera, Rosalba	*Portrait of a Lady*	Early 18th c. Oil	BG, LG 1954	Amsterdam, 1954
Chiari, Giuseppe Bartolomeo	*Venus and Adonis*	17th c. Oil	NG, SG 2002	Christie's, 2003
Cranach, Lucas, the Elder	*Samson and the Lion*	1525 Oil/board	BG, LG 1954	England, private collection, 1974
Cuyp, Aelbert (attrib.)	Haan met Kippen	17th c. Oil	NG, SG 2002	Nick Goodman, LA
Degas, Edgar	*Paysage (Landscape with Smokestacks)*	1890 Pastel/ monotype	NG, SG 1998	Art Institute of Chicago
Devéria, Henri-Victor	*Amoureux dans le parc*	1860/68 Oil	NG, SG 2002	Simon Goodman, LA
de Wit, Jacob	Mythological scene	1751 Ink	NG, SG 2002	Lili Gutmann, Florence
Elsner, Jakob	*Portrait of a Man,* red background	1490/1500 Oil	NG, SG 2002	Christie's, 2003
Gainsborough, Thomas	*Portrait of a Young Woman*	18th c. Oil	LG 1954	Italian art market, 1960
Grammont	Flemish *feuilles-de-choux* tapestry	16th c. Wool and silk	NG, SG 2002	Christie's, 2003

ARTIST	TITLE/ DESCRIPTION	PERIOD/ TYPE	RECOVERED/ SETTLED	PRESENT/ LAST LOCATION
Greuze, Jean-Baptiste	Portrait of a young girl	18th c. Oil	BG, LG 1954	Amsterdam, 1954
Guardi, Francesco	*Il Canale Grande con San Simeone Piccolo*	Late 18th c. Oil	BG, LG 1954	Amsterdam, 1954
Guardi, Francesco	*Capriccio Architettonico con Campiello e Chiesa*	1770–80 Oil	SG 2013	England, private collection, 1994
Guardi, Francesco	*Paesaggio di fantasia con Isola della Laguna*	1770–80 Oil	SG 2013	England, private collection, 1994
Hackaert, Jan	Hunting scene in a wood	Late 17th c. Oil	BG, LG 1954	Mauritshuis, The Hague
Hals, Frans	*Portrait of Isaac Abrahamsz. Massa*	1635 Oil	BG 1946	San Diego Museum of Art
Holbein, Hans, the Elder	Head of Madonna (fragment of altarpiece)	1501 Oil	BG, LG 1954	Amsterdam, 1954
Isenbrandt, Adriaen	*Madonna and Child* (in the style of Gerard David)	16th c. Oil	BG, LG 1954	Paris, private collection, 1974
Jacquiot, Ponce (school)	*Mother and Child*	16th c. Bronze	NG, SG 2002	Simon Goodman, LA
Kangxi period	Garniture of five vases	1700/20 Porcelain	SG 2011	Christie's Paris
Kienle, Hans Ludwig	*Horse and Rider*, silver-gilt cup	1630 Silver and gold	NG, SG 2002	Art Institute of Chicago
Lencker, Johannes	*Triton and Nymph*, silver-gilt ewer	1625 Silver and gold	NG, SG 2002	Rijksmuseum, 2013
Levecq, Jacobus	*Portrait of a Young Man in Black*	Late 17th c. Oil	BG, LG 1954	Christie's, 2013
Liotard, Jean-Étienne	*The Tea Set* (Chinese tea service)	1781/83 Oil	BG, LG 1954	Getty Institute, LA

ARTIST	TITLE/ DESCRIPTION	PERIOD/ TYPE	RECOVERED/ SETTLED	PRESENT/ LAST LOCATION
Memling, Hans	Madonna (seated) with child, surrounded by angels	1510 Oil/board	BG, LG 1954	De Boer Collection, 1961
Oudenaarde	Flemish Game-Park Tapestry	16th c. Wool and silk	NG, SG 2002	Christie's, 2003
Petzolt, Hans	Silver-gilt double cups	1596 Silver and gold	NG, SG 2002	Detroit Institute of Arts
Renoir, Pierre-Auguste	Le Poirier	1880s Oil	NG, SG 1998	Christie's, 2010
Ricci, Marco	Capriccio of Roman ruins (statue and fountain)	Early 18th c. Gouache	BG, LG 1954	National Gallery, Washington, DC
Ricci, Marco	Capriccio of Roman ruins (figures and statue)	Early 18th c. Gouache	BG, LG 1954	London, private collection, 1982
Rocca, Michele	Rinaldo and Armida	Early 18th c. Oil	NG, SG 2002	Christie's, 2003
Schuszler, Angela	Eenden bij een vijver	1822 Oil	NG, SG 2002	Lorenzo Bosi, Tuscany
Schuszler, Angela	Kippen	1822 Oil	NG, SG 2002	Lorenzo Bosi, Tuscany
Signorelli, Luca (studio)	Baptism of Christ	16th c. Oil on wood	BG, LG 1954	London, private collection, 1955
Tyrolean Master (prev. Burgundian)	Narr Pock, jester to Maximilian I	1517/19 Oil	BG, LG 1954	Sotheby's, 2013
Unknown, Italian	Judgment of Paris	16th c. Oil on wood	BG, LG 1954	Amsterdam, 1954
van Goyen, Jan	Landscape with Two Horsecarts	1652 Oil	BG, LG 1954	Worcester Art Museum, Massachusetts

ARTIST	TITLE/ DESCRIPTION	PERIOD/ TYPE	RECOVERED/ SETTLED	PRESENT/ LAST LOCATION
Vigée-Lebrun, Élisabeth	*Self-Portrait*	Late 18th c. Chalk	BG, LG 1954	Amsterdam, 1954
von Stuck, Franz	*Die Sinnlichkeit*	1891 Oil	SG 2009	Christie's, 2010

Also, more than 240 antiques (Meissen, Louis XV furniture, etc.) returned by Dutch government in 2002 and several more in 2010.

THE EUGEN GUTMANN COLLECTION RECOVERED

Please note that this is an incomplete and partial list and by no means the definitive, complete catalog of art.

ARTIST	TITLE/ DESCRIPTION	PERIOD/ TYPE	RECOVERED/ SETTLED	PRESENT/ LAST LOCATION
Jamnitzer, Wenzel, and Family	Orpheus Clock	1560/70 Gold, bronze, and iron	SG 2011	Landesmuseum Württemberg, Stuttgart
Reinhold, Johann	Great Astronomical Table Clock	1581/92 Gold, bronze, and iron	SG 2011	Landesmuseum Württemberg, Stuttgart

SG = Simon Goodman
BG = Bernard Goodman
LG = Lili Gutmann
NG = Nick Goodman

RELATED BIBLIOGRAPHY

Aalders, Gerard. *Nazi Looting: The Plunder of Dutch Jewry.* Berg, 2004.

Bazyler, Michael. *Holocaust Justice.* NYU, 2003.

Benjamin, Walter. *Berlin Childhood around 1900.* Belknap/Harvard, 2006.

Bernstein, Elsa. *Erinnerungen an Theresienstadt.* Ed. Ebersbach, 1999.

Bouchoux, Corinne. *Rose Valland—La Résistance au Musée.* Geste Editions, 2006.

Boymans Museum. *Meesterwerken uit vier Eeuwen, 1400–1800.* Van Waesberge, Hoogewerff & Richards, 1938.

Brown, David Alan, and Jane Van Nimmen. *Raphael & the Beautiful Banker.* Yale University Press, 2005.

Ceccarini, Elena. *Gli Orsini Baroni.* ETS, 2010.

Chernow, Ron. *The Warburgs.* Vintage Books, 1993.

Dean, Martin. *Robbing the Jews.* Cambridge University Press, 2008.

Diamant, Adolf. *Chronik der Juden in Dresden.* Agora, 1973.

Elon, Amos. *The Pity of It All: A History of Jews in Germany, 1743–1933.* Metropolitan, 2002.

Engelmann, Berndt. *Germany without Jews.* Bantam Books, 1984.

Falke, Otto von. *Die Kunstsammlung Eugen Gutmann.* Meisenbach Riffarth, 1912.

Feliciano, Hector. *The Lost Museum.* Basic Books, 1997.

Ferguson, Niall. *High Financier: The Lives & Time of Sir Siegmund Warburg.* Penguin Press, 2010.

Francini, Esther Tisa, Anja Heuss, and Georg Kreis. *Fluchtgut—Raubgut.* Chronos, 2001.

Gutmann, Kurt. *La Vérité est en Marche*. Orell Füssli, 1917.

Hofmann, Tom. *Benjamin Ferencz, Nuremberg Prosecutor and Peace Advocate*. McFarland, 2014.

Hondius, Dienke. *Return: Holocaust Survivors and Dutch Anti-Semitism*. Praeger, 2003.

Judt, Tony. *Post War: A History of Europe since 1945*. Penguin Press, 2005.

Kendall, Richard. *Degas Landscapes*. Yale University Press, 1993.

Kessler, Horst. *Karl Haberstock: Umstrittener Kunsthändler und Mäzen*. Deutscher Kunstverlag, 2008.

Landau, Wilhelm von. *Travels in Asia, Australia and America*. George Landau, 1888.

Lederer, Zdenek. *Ghetto Theresienstadt*. Edward Goldston, 1953.

Mosse, W. E. *The German-Jewish Economic Elite. 1820–1935*. Oxford, 1989.

Nicholas, Lynn. *The Rape of Europa*. Vintage Books, 1994.

Petropoulos, Jonathan. *The Faustian Bargain*. Oxford, 2000.

Polack, Emmanuelle, and Philippe Dagen. *Les Carnets de Rose Valland*. Fage Editions, 2011.

Schacht, Hjalmar. *Confessions of "the Old Wizard."* Houghton Mifflin, 1956.

Schmidt, Ulf. *Hitlers Arzt Karl Brandt: Medizin und Macht im Dritten Reich*. Aufbau Verlag, 2009.

Smyth, Craig Hugh. *Repatriation of Art from the Collecting Point in Munich*. SDU, 1988.

Spier, Jo. *Dat Alles Heeft mijn Oog Geziehen*. Elsevier, 1978.

Stedelijk Museum. *Italiaansche Kunst*. Druk de Bussy, 1934.

Valland, Rose. *Le Front de l'Art*. Réunions des Musées Nationaux, 1997.

Ziegler, Dieter. *Der Bankier Eugen Gutmann, 1840–1925*. E. G. Gesellschaft, 2009.

PHOTOGRAPH CREDITS

INTERIOR

Pp. 3, 17, 18, 41, 45, 64, 65, 74, 76, 77, 78, 79, 113, 128, 143, 158, 163, 179, 199, 220, 254, 292, 298, 311, 314: Courtesy of the Goodman family

P. 91: Courtesy of Museum für Kunst und Gewerbe Hamburg

P. 94: Courtesy of the Marion Gutmann family

P. 135: Courtesy of Ing. Radek Fiala, Prague

P. 169: Courtesy of Hans Krol, Heemstede

P. 221: Courtesy of the Goodman family with permission from Sotheby's

P. 234: Courtesy of Roger Dohmen, *Het Parool*

P. 255: Courtesy of Bayerische Staatsbibliothek, Fotoarchiv Hoffmann

P. 264: Courtesy of KMA, Schaezlerpalais, Augsburg

P. 272: Courtesy of Museum Boijmans Van Beuningen, Rotterdam

P. 287: Courtesy of Getty Images

INSERT

1: San Diego Museum of Art

2: National Gallery of Canada

3: J. Paul Getty Museum, Brentwood

4: Art Institute of Chicago

5: © 2010 Christie's Images Limited

6: Denver Art Museum

INDEX

ABOUT THE AUTHOR

Born in London shortly after World War II and educated at the Lycée Français in London, then at Munich University, Simon Goodman entered the music business in the late 1960s. After specializing in breaking new British artists abroad, Goodman then established an alternative distribution network in the United States in the early 1980s. Goodman's father had secretly begun searching for his own father's lost treasures, looted by the Nazis, a legacy that Simon later inherited. Goodman is married to actress and writer May Quigley and has one son and three daughters. He lives in Los Angeles, where his search for his family's treasures continues.